Kenneth Clark

The Romantic Rebellion

Other works by Kenneth Clark

The Gothic Revival Landscape into Art Leonardo da Vinci (Penguin) Leonardo da Vinci Drawings at Windsor Castle (Phaidon) Piero della Francesca (Phaidon) The Nude Looking at Pictures Ruskin Today Rembrandt and the Italian Renaissance Civilisation

Kenneth Clark

The Romantic Rebellion

Romantic versus Classic Art

John Murray Sotheby Parke Bernet © Programme Investments 1973

John Murray (Publishers) Ltd 50 Albemarle Street London W1X 4BD ISBN 0 7195 2857 7

Sotheby Parke Bernet Publications Ltd 34 New Bond Street London W1A 2AA ISBN 0 85667 010 3

This book is based on the television series which is a VPS-John Brabourne production in association with Sotheby's and W. H. Smith.

All rights reserved. No part of this publication may be reproduced, stored in a retrieval system, or transmitted, in any form, by any means – electronic, mechanical, photocopy, recording or, other – without the prior permission of the

publisher.

Stockton - Billingham LIBRARY Technical College

25683

759.05

Printed in Great Britain by Jarrold & Sons Ltd Norwich

Contents

1	David	19
2	Piranesi a	nd Fuseli
3	Goya	69
4	Ingres I	97
5	Ingres II	121
6	Blake	147
7	Géricault	177
8	Delacroix	199
9	Turner I	223
10	Turner II	245
11	Constable	265
12	Millet	285
13	Degas	309
14	Rodin	331
	Index	361

Preface

The rise of a consciously romantic style and its long struggle with orthodox classicism is one of the most dramatic episodes in the history of art. It is exceptionally well-documented, it touches life at many points, and it continued from generation to generation with the relentless ferocity of a saga. The subject has interested me for the last thirty years, and during that time I have given a number of lectures on the *dramatis personae*. Some of them were given at Oxford in 1947, some in the Duncan Phillips Gallery in Washington; a few were written quite recently. A year ago I was asked to make them into television programmes. I would have been sorry to see them disappear, and I believe that television is the ideal medium with which to arouse people's interest in art. So I set to work on the task of cutting and patching; the result was put on film and is now printed as a book. I hope it will serve as an introduction to a large and fascinating subject; and I believe it contains some passages of criticism which, since they are the result of long and happy scrutiny of the painters in question, may contain some grains of truth. That is all I can claim.

In putting the television scripts back into printable language I have been much helped by Miss Jane Boulenger; and once more the placing of the illustrations is the work of that prince of editors, Peter Campbell.

K. C. 1973

Acknowledgements

Acknowledgement is due to the following for their permission to reproduce illustrations in this book. References are to plate numbers; bold figures denote colour plates. Academy of San Fernando, Madrid (photo Manso), 55, 56; Alinari, 2; Art Gallery and Museum, Glasgow (Burrel Collection), 237; Art Institute of Chicago, 162; Ashmolean Museum, Oxford, 234; Austrian National Library, Vienna, 123; Birmingham Art Gallery, 9; British Museum, London, 131; Brooklyn Museum (gift of James H. Post, John T. Underwood and A. Augustus Healy), 245; The Dean and Chapter of Winchester, 114; Fogg Art Museum, Massachusetts, 99, 113; Fitzwilliam Museum, Cambridge, 189, 199 (photo Stearn & Sons); Frick Collection, New York, 7; John Gay, 32; Giraudon, 4, 69, 70, 71, 72, 79, 81, 82, 84, 85, 89, 139, 147, 159, 164, 166, 250; Goethe Museum, Frankfurt, 40; Hans Hinz, 75; IBM Corporation, 233; Kimbell Art Museum, Fort Worth, 137; Kunsthaus, Zurich, 36, 39; Lady Lever Art Gallery, Cheshire (photo Leonard Card), 187; The Louvre, Paris, back cover, 1, 1, 5, 5, 6, 6, 8, 10, 12, 13, 14, 14, 15, 17, 18, 19, 22, 76, 77, 80, 83, 86, 87, 88, 90, 91, 98, 100, 102, 103, 133, 135, 136, 138, 140, 148, 149, 150, 152, 153, 156, 158, 165, 216, 218, 219, 221, 222, 224, 228, 230, 239, 246, 248, 252, 253; Mansell Collection, 130, 155, 160, 204, 231, 262; Mas, 45, 58; Metropolitan Museum of Art, New York, 23, 241, (Harris Brisbane Dick Fund, 1935), 42, (Bequest of Mrs H. O. Havemeyer, 1929. The H. O. Havemeyer Collection), 247, (Wolfe Fund, 1931), 9; Musée des Beaux-Arts, Cherbourg, 217; Musée des Beaux-Arts, Lyon (photo J. Camponogara), 11; Musée des Beaux-Arts, Lille, 3, 62; Musée des Beaux-Arts, Nantes, 10; Musée des Beaux-Arts, Rouen (photo-Ellebé), 134; Musée Granet, Montauban, 78; Musée Ingres, Montauban (photo Resseguie), 92, 93, 95, 96; Musée Nationale, Malmaison (photo Laverton), 16; Musée Rodin, 257, 264, 265, 270, 273, 274; Musée Royaux, Brussels (photo ACL), 20; Museum of Fine Arts, Boston, 225, (Arthur Girdon Tompkins Residuary Fund), 244, (gift of Robert Treat Paine), 240, (Shaw Collection), 229; Museum of Fine Arts, Brussels (photo ACL), 11, 94; Museum of Fine Arts, Budapest, 157; Museum of Fine Arts, Massachusetts, 227; Museum of Modern Art, Dublin (photo Barry Mason), 226; Museum Narodvic, Warsaw, 3; National Gallery, London, front cover, 12, 15, 97, 181, 182, 194, 212, 213, 238, 243, 254; National Gallery, Oslo, 24; National Gallery of Scotland (photo Annan), 200; National Gallery of Art, Washington (Andrew W. Mellon Collection), 2, (Widener Collection), 16, 73; National Museum, Stockholm, 35, 145; National Museum of Wales, 21, 168, 223, 236; Norton Simon Foundation, Museum of Art, Los Angeles, 251; Phaidon Press, 259, 260, 261, 266, 268, 269, 271, 272, 275, 276, 277; Philadelphia Museum of Art, 17; Phillips Collection, Washington, 154; Photographic Records Ltd, London, 8, 21, 22, 23, 24, 25, 26, 27, 28, 30, 31, 33, 34, 104, 107, 109, 110, 112, 115, 116, 117, 119, 120, 121, 122, 127, 128, 129; Ponce Art Museum, Puerto Rico, 141; Prado, Madrid (photo Manso), 43, 44, 48, 49, 51, 52, 53, 57, 60, 64, 66, 67, 68; Reinhart Collection, Winterthur, 161; Royal Academy of Arts, London, 38, 207; Royal Holloway College, London, 202; Statens Museum for Kunst, Copenhagen, 7; Tate Gallery, London, 18, 37, 106, 124, 125, 132, 142, 169, 171, 172, 174, 175, 176, 177, 178, 179, 180, 183, 184, 185, 190, 191, 192, 193, 195, 196, 197, 249, 258, 263, 278; Toledo Museum of Art, Ohio, 220; Victoria and Albert Museum, London, 19, 20, 167, 198, 201, 203, 206, 208, 211, 214, 215; Walker Art Gallery, Liverpool, 186; Walters Art Gallery, Baltimore, 13, 101; John Webb, 29, 50, 59, 65, 74, 105, 108, 111, 118, 143, 144, 188, 209, 210, 267.

Illustrations

Louis Tilester ation

C	facin	ng page
1	David, The Sahine women enforcing peace by running between the combatants (detail). Louvre, Paris	64
2	Goya, Marquesa de Pontejos. National Gallery of Art, Washington	65
	Goya, Young Majus. Musée des Beaux-Arts, Lille	80
4	Goya, The Pilgrimage to San Isidore. Prado, Madrid	81
5	Ingres, Madame Rivière. Louvre, Paris	112
6	Ingres, Baigneuse de Valpinçon. Louvre, Paris	113
7	Ingres, Madame d'Haussonville. Frick Collection, New York	128
8	Blake, Glad Day	129
	Blake, Whirlwind of Lovers. (Illustration to Dante's Inferno.) Birmingham Art Gallery	176
10	Gros, Napoleon on the Battlefield of Eylau (detail). Musée des Beaux-Arts, Nantes	177
11	Géricault, Madwoman. Musée des Beaux-Arts, Lyon	192
12	Delacroix, Ovid among the Scythians. National Gallery, London	193
13	Delacroix, Sea of Galilee. Walters Art Gallery, Baltimore	208
14	Delacroix, The Death of Sardanapalus (detail). Louvre, Paris	209
15	Turner, Hero and Leander. National Gallery, London	224
16	Turner, Keelman heaving in Coals by Night. National Gallery of Art, Washington	225
17	Turner, Burning of the Houses of Parliament. Philadelphia Museum of Art	256
18	Turner, Sunrise between two Headlands. Tate Gallery, London	257
	Constable, Brighton Beach. Victoria and Albert Museum, London	272
	Constable, Tree trunks. Victoria and Albert Museum, London	273
	Millet, Faggot Carriers. National Museum of Wales, Cardiff	304
	Millet, Spring. Louvre, Paris	305
	Degas, At the Milliner's. Metropolitan Museum of Art, New York	320
	Degas, Girl having her Hair done. National Gallery. Oslo	321

Black and white illustrations

1 DAVID

- 1 Self-portrait. Louvre, Paris
- 2 Raphael Mengs, Parnassus. Villa Albani, Rome
- 3 Count Potocki on Horseback. Museum Narodvic, Warsaw
- 4 Belisarius recognised by a soldier who had served under him, as he receives alms from a woman. Musée des Beaux-Arts, Lille
- 5 The Oath of the Horatii. Louvre, Paris
- 6 Poussin, Rape of the Sabines. Louvre, Paris
- 7 Poussin, Testament of Eudamidas. Statens Museum for Kunst, Copenhagen
- 8 The Lictors bringing back to Brutus the bodies of his sons. Louvre, Paris
- 9 The Death of Socrates. Metropolitan Museum of Art, New York
- 10 Madame Récamier. Louvre, Paris
- 11 The Death of Marat. Museum of Fine Arts, Brussels
- 12 & 13 Monsieur Sériziat and Madame Sériziat. Louvre, Paris.
- 14 The Sabine women enforcing peace by running between the combatants. Louvre, Paris
- 15 Madame Verninac. Louvre, Paris
- 16 Napoleon crossing the Alps. Musée Nationale, Malmaison
- 17 Leonidas at Thermopylae. Louvre, Paris
- 18 Pius VII. Louvre, Paris
- 19 Madame Tangry and her Daughters. Louvre, Paris
- 20 Mars disarmed by Venus. Musées Royaux, Brussels

2 PIRANESI AND FUSELI

PIRANESI

- 21 Self-portrait (engraving)
- 22 Inspector visiting the sluice gates of Albano (engraving)
- 23 Carceri d'Invenzione, Frontispiece, first edition 1750
- 24 Carceri, Frontispiece, second edition, 1760
- 25 Carceri, Plate VII, first edition
- 26 Plate VII, second edition
- 27 Architectural drawing. British Museum, London
- 28 View of the Temple of Jupiter (engraving)
- 29 The Mole of Hadrian from Antichita Romane
- 30 One of the plates added to the Carceri for the 1760 edition
- 31 Carceri, Plate III, second edition
- 32 Liverpool Street Station (photograph by John Gay)
- 33 *Carceri*, Plate XV
- 34 Carceri, Plate XIV, first edition

FUSELI

- 35 Sergel, Lovers (drawing). National Museum, Stockholm
- 36 The Three Witches from Macbeth. Kunsthaus, Zurich
- 37 Lady Macbeth seizing the Daggers. Tate Gallery, London

- 38 Theseus and the Minotaur (drawing)
- 39 Fear. Kunsthaus, Zurich
- 40 The Nightmare. Goethe Museum, Frankfurt
- 41 Polyphemus. Private Collection, Switzerland

3 GOYA

- 42 Giant (monotype). Metropolitan Museum, New York
- 43 Winter. Prado, Madrid
- 44 The Manikin. Prado, Madrid
- 45 Portrait of himself at work. Private Collection, Madrid
- 46 Charles III. Private Collection, Spain
- 47 The Duchess of Alba. Hispanic Society of America, New York
- 48 Nude Maja. Prado, Madrid
- 49 Clothed Maja. Prado, Madrid
- 50 & 51 Frontispiece to Caprichos and drawing for it. Prado, Madrid
- 52 King Charles IV of Spain and his Family. Prado, Madrid
- 53 Detail of 52
- 54 Condesa de Chinchon. Private Collection, Spain
- 55 Procession of Flagellants. Academy of San Fernando, Madrid
- 56 A Tribunal of the Inquisition. Academy of San Fernando, Madrid
- 57 & 58 Decorations from the cupola of San Antonio de la Florida, Madrid
- 59 'Why?', The Disasters of War, Plate 32. Prado, Madrid
- 60 The Third of May, 1808. Prado, Madrid
- 61 Disparates, Plate 3
- 62 Old Women. Musée des Beaux-Arts, Lille
- 63 Disparates, Plate 2
- 64 The Vintage. Prado, Madrid
- 65 Caprichos, Plate 63
- 66 Saturn devouring his Children. Prado, Madrid
- 67 Vicente López, Portrait of Goya at the age of eighty. Prado, Madrid
- 68 The Pilgrimage to San Isidoro. Prado, Madrid

4 INGRES I

- 69 Self-portrait. Musée Condé, Chantilly
- 70 Ambassadors of Agamemnon sent to pacify Achilles, finding him in his tent with Patroclus occupied in singing the exploits of Heroes. Ecole Nationale des Beaux-Arts, Paris
- 71 Romulus Conqueror of Acron. Ecole Nationale des Beaux-Arts, Paris
- 72 Napoleon I on the Imperial Throne. Musée de l'Armée, Paris
- 73 David, Napoleon in his Study. Samuel H. Kress Collection, National Gallery of Art, Washington
- 74 Flaxman, Illustrations to Hesiod
- 75 Venus wounded by Diomed. Private Collection
- 76 Stratonice and Antiochus (drawing). Louvre, Paris
- 77 Mademoiselle Rivière. Louvre, Paris
- 78 Monsieur Granet. Musée Granet, Aix-en-Provence

79 Madame Devauçay. Musée Condé, Chantilly

80 The Apotheosis of Homer. Louvre, Paris

81 Baigneuse. Musée Bonnat, Bayonne

82 Venus Anadyomene. Musée Condé, Chantilly

83 Oedipus and the Sphinx. Louvre, Paris

84 Jupiter and Thetis. Musée Granet, Aix-en-Provence

85 The Dream of Ossian. Musée Ingres, Montauban

86 Grande Odalisque. Louvre, Paris

87 Drawing for the Grande Odalisque. Louvre, Paris

5 INGRES II

88 The Stamaty Family (drawing). Louvre, Paris

89 The Misses Montagu (drawing). Private Collection

90 The Forestier Family (drawing). Louvre, Paris

91 Paganini (drawing). Louvre, Paris

92 Drawing for 93. Musée Ingres, Montauban

93 Christ giving the Keys to St Peter. Musée Ingres, Montauban

94 Tu Marcellus Eris. Museum of Fine Arts, Brussels

95 The Vow of Louis XIII. Musée Ingres, Montauban

96 Drawing for 95. Musée Ingres, Montauban

97 Madame Moitessier. National Gallery, London

98 Monsieur Bertin. Louvre, Paris

99 Madame Reiset. Fogg Art Museum, Cambridge, Massachusetts

100 La Source. Louvre, Paris

101 Odalisque à l'esclave. Walters Art Gallery, Baltimore

102 Bain Turc. Louvre, Paris

103 Drawing for Bain Turc. Louvre, Paris

6 BLAKE

104 Page from America

105 Ghost of a Flea

106 Visionary Head 'The Man who taught Blake painting'

107 Glad Day (engraving)

108 'Vitruvian Man' from Scamozzi's Architecture

109 & 110 Engravings of a Hellenistic bronze from Antiquities of Herculaneum

111 'Albion adoring the crucified Christ' from Jerusalem

112 Joseph of Arimathea among the Rocks of Albion

113 St Michael. Fogg Art Museum, Cambridge, Massachusetts

114 Initial from the Winchester Bible

115 Titlepage from Songs of Innocence

116 Titlepage from The Book of Thel

117 Page from The Marriage of Heaven and Hell

118 Page from America

119 Illustration from Steadman's Expedition against the Revolted Negroes of Surinam

120 'Urizen' from Urizen

- 121 'Plague' from Europe
- 122 The Ancient of Days
- 123 God the great Architect (manuscript illustration). Austrian National Library, Vienna
- 124 Newton. Tate Gallery, London
- 125 Nebuchadnezzar. Tate Gallery, London
- 126 Werewolf, drawing from the Rossetti Manuscript
- 127 'One Law for the Lion and Ox is Oppression'. Page from *The* Marriage of Heaven and Hell
- 128 Page from Milton
- 129 'The Eagle of Inspiration' from Milton
- 130 Page from Job, 'Then the Lord answered Job out of the Whirlwind.'
- 131 St Peter, St Thomas, Beatrice and Dante with St John descending. Illustration to Dante's Inferno. British Museum, London
- 132 Pity. Illustration to Macbeth. Tate Gallery, London

7 GERICAULT

133 Gros, Buonaparte visiting the victims of bubonic plague. Louvre, Paris

- 134 Charging Cuirassier. Musée des Beaux-Arts, Rouen
- 135 Leda and the Swan (drawing). Louvre, Paris
- 136 Head of a white Horse. Louvre, Paris
- 137 Portrait of a Youth. Kimbell Art Museum, Fort Worth
- 138 The Raft of the Medusa. Louvre, Paris
- 139 Study for The Raft of the Medusa. Louvre, Paris
- 140 Jamar in his Studio. Louvre, Paris
- 141 Ward, Lioness with a Heron. Ponce Art Museum, Puerto Rico
- 142 Stubbs, A Lion attacking a Horse. Tate Gallery, London
- 143 English scene (lithograph)
- 144 English scene (lithograph)
- 145 Decapitated Head (detail). National Museum, Stockholm
- 146 Slaves (drawing)
- 147 Madman. Musée des Beaux-Arts, Gand
- 148 Madwoman. Louvre, Paris

8 DELACROIX

- 149 Self-portrait. Louvre, Paris
- 150 Self-portrait as Hamlet. Louvre, Paris
- 151 Tigers (drawings)
- 152 Dante and Virgil crossing the Styx. Louvre, Paris
- 153 Orphan Girl in a Cemetery. Louvre, Paris
- 154 Paganini. Phillips Collection. Washington
- 155 Massacre at Chios. Louvre, Paris
- 156 The Death of Sardanapalus. Louvre, Paris
- 157 White Stallion frightened by Lightning. Museum of Fine Arts, Budapest
- 158 Liberty Guiding the People. Louvre, Paris
- 159 The Sultan of Morocco. Musée des Augustins, Toulouse
- 160 The Women of Algiers. Louvre, Paris

- 161 Tasso in the Madhouse. Reinhart Collection, Winterthur
- 162 Lion hunt. The Art Institute of Chicago
- 163 Achilles and a Centaur. Assemblée Nationale, Palais Bourbon, Paris
- 164 Attila, drawing for the Palais Bourbon ceiling. Musée Condé, Chantilly
- 165 The Entry of the Crusaders into Constantinople. Louvre, Paris
- 166 Jacob Wrestling with the Angel. St Sulpice, Paris

9 TURNER I

- 167 Cloisters, Salisbury Cathedral (watercolour). Victoria and Albert Museum, London
- 168 Ewenny Priory (watercolour). National Museum of Wales, Cardiff
- 169 Buttermere Lake, with part of Cromack Water, Cumberland, a shower. Tate Gallery, London
- 170 Plate from the Liber Studiorum
- 171 Frosty Morning. Tate Gallery, London
- 172 The Tenth Plague of Egypt. Tate Gallery, London
- 173 Bonneville. Private Collection
- 174 The Shipwreck. Tate Gallery, London
- 175 The Fall of an Avalanche in the Grisons. Tate Gallery, London
- 176 The Goddess of Discord choosing the Apple of Contention in the Garden of the Hesperides. Tate Gallery, London
- 177 Snowstorm: Hannibal and his Army crossing the Alps. Tate Gallery, London
- 178 Crossing the Brook. Tate Gallery, London
- 179 The Bay of Baiae, with Apollo and the Sibyl. Tate Gallery, London
- 180 Forum Romanum. Tate Gallery, London
- 181 Ulysses deriding Polyphemus. National Gallery, London
- 182 The Fighting Temeraire. National Gallery, London
- 183 Peace, Burial at Sea. Tate Gallery, London
- 184 Snowstorm, Steam-boat. Tate Gallery, London

10 TURNER II

- 185 Hastings. Tate Gallery, London
- 186 The Falls of Clyde. Walker Art Gallery, Liverpool
- 187 The Falls of Clyde. Lady Lever Collection, Port Sunlight, Cheshire
- 188 Tree (watercolour). British Museum, London
- 189 Venice, Storm at Sunset (watercolour). Fitzwilliam Museum, Cambridge
- 190 Italian Hill Town, probably Tivoli. Tate Gallery, London
- 191 Procession of Boats with distant Smoke. Tate Gallery, London
- 192 Interior at Petworth. Tate Gallery, London
- 193 Petworth Park: Tillington Church in the distance. Tate Gallery, London
- 194 Rain, Steam, Speed. National Gallery, London
- 195 Light and Colour. Tate Gallery, London
- 196 Shade and Darkness. Tate Gallery, London
- 197 Norham Castle. Tate Gallery, London

11 CONSTABLE

- 198 Dedham Vale. Victoria and Albert Museum, London
- 199 Study of a winding river valley. Fitzwilliam Museum, Cambridge
- 200 Dedham Vale. National Gallery of Scotland, Edinburgh
- 201 Page from a sketch-book. Victoria and Albert Museum, London
- 202 Barges on the Stour. Royal Holloway College, Engelfield Green, Surrey
- 203 The Stour. Victoria and Albert Museum, London
- 204 Boat Building near Flatford Mill
- 205 Stratford Mill, with Boys Fishing. Private Collection
- 206 Sketch for The Hay Wain. Victoria and Albert Museum, London
- 207 Salisbury Cathedral from the Meadows. Private Collection
- 208 The Leaping Horse (sketch). Victoria and Albert Museum, London
- 209 The Leaping Horse (drawing)
- 210 Old Sarum. Mezzotint by David Lucas after Constable
- 211 Stonehenge. British Museum, London
- 212 The Cenotaph (drawing). National Gallery, London
- 213 The Cenotaph. National Gallery, London
- 214 Willows by a Stream. Victoria and Albert Museum, London
- 215 Cottage in a Cornfield. Victoria and Albert Muscum, London
- 12 MILLET
- 216 Gréville Church. Louvre, Paris
- 217 Madame Roumy. Musée des Beaux-Arts, Cherbourg
- 218 Nude in Bed. Louvre, Paris
- 219 Nude (drawing). Louvre, Paris
- 220 The Quarriers. Toledo Museum of Art, Ohio
- 221 Two Bathers. Louvre, Paris
- 222 La Couseuse. Louvre, Paris
- 223 Peasant Family. National Museum of Wales, Cardiff
- 224 The Winnower. Louvre, Paris
- 225 The Faggot Carriers (drawing). Museum of Fine Arts, Boston
- 226 Gleaners (drawing). Municipal Gallery of Modern Art, Dublin
- 227 Gleaners. The James Philip Gray Collection, Museum of Fine Arts, Springfield, Massachusetts
- 228 The Gleaners. Louvre, Paris
- 229 The Sower. Museum of Fine Arts, Boston
- 230 The Angelus. Louvre, Paris
- 231 The Shepherdess. Louvre, Paris
- 232 The Man with a Hoe. Private Collection, San Francisco
- 233 The Water Carrier. IBM Corporation
- 234 Vigneron (drawing). Ashmolean Museum, Oxford
- 235 The Flight into Egypt (drawing). Private Collection
- 236 The Storm. National Museum of Wales, Cardiff
- 237 November. The Burrell Collection, Glasgow Art Gallery and Museum
- 13 DEGAS
- 238 Girls of Ancient Sparta inciting the Boys to wrestle. National Gallery, London

- 239 The Belleli Family. Louvre, Paris
- 240 The Duke and Duchess of Morbilli. Museum of Fine Arts, Boston
- 241 Portrait of a Lady with Chrysanthemums. Metropolitan Museum of Art, New York
- 242 The Rape. Private Collection
- 243 Beach Scene. National Gallery, London
- 244 Carriages at the Races. Museum of Fine Arts, Boston
- 245 Mademoiselle Fiocre in the Ballet 'La Source'. Brooklyn Museum
- 246 The Musicians of the Orchestra. Louvre, Paris
- 247 The Dancing Class. Metropolitan Museum, New York
- 248 Rehearsal on the Stage. Louvre (Jeu de Paume), Paris
- 249 Little Dancer aged Fourteen. Tate Gallery, London
- 250 The Cotton Exchange at New Orleans. Musée des Beaux-Arts, Pau
- 251 The Ironers. The Norton Simon Foundation and Norton Simon, Inc., Museum of Art, Los Angeles
- 252 The Ironers. Louvre (Jeu de Paume), Paris
- 253 L'absinthe. Louvre (Jeu de Paume), Paris
- 254 Woman washing herself. Louvre (Jeu de Paume), Paris
- 255 Three Dancers. Private Collection
- 256 Three Figures

14 RODIN

- 257 Walking Man
- 258 The Age of Bronze
- 259 St John the Baptist
- 260 Torse d'Adèle
- 261 The Gate of Hell
- 262 La Belle Heaulmière
- 263 Meditation
- 264 The Prodigal Son
- 265 Woman squatting

266 Fauness

267 Drawing of a nude. British Museum, London

268 Eve

269 The Three Shades

270 Danaïd

271 The Thinker

- 272 The Burghers of Calais (detail)
- 273 Study for Balzac

274 Balzac

275 Rose Beuret

276 L'aurore

- 277 The Cathedral
- 278 La Duchesse de Choiseul

Dedicated to COLIN CLARK

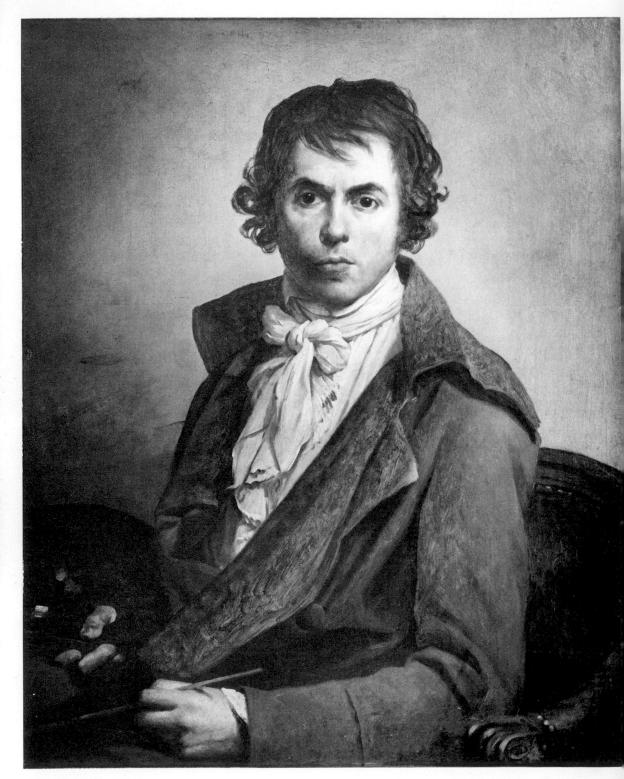

1 David, Self-portrait

David

Classic and romantic are wide-ranging words. They can be applied as critical terms to the art of any epoch. We can say that Giorgione is a romantic painter or that Mondrian is a classic painter, and the words help to define the artist's character. At all times some artists have appealed to our emotions by analogies, buried memories or the sensuous use of colour; others have satisfied our need for order and permanence by creating structures or compositions that seem complete in themselves. In European painting of the sixteenth and seventeenth centuries these two intentions existed happily beside each other. Such differences as occurred were chiefly technical - the dramatic shadows of Caravaggio or the fluid handling of Rubens. Often the words classic and romantic could be applied to the same painter. Poussin, as a young man, painted a number of deeply sensuous pictures that can be called romantic; his later work is the epitome of classicism. Some of Rembrandt's greatest works are based on classical construction; Raphael himself had a strong vein of romanticism, and as the following pages will show, classicism and romanticism in artists of the first rank always co-exist and overlap.

In the middle of the eighteenth century there appeared a division between classic and romantic art far deeper and more definite than anything which had preceded it; and this division was supported by two pieces of theoretical writing that appeared at almost exactly the same time.

In 1755 Winckelmann, the first man of outstanding gifts to occupy himself with the history of art, published a book called *Reflections on the Imitation of Greek Art*, which was to become the sacred text of classicism. And in the following year, Burke, the philosopher-statesman, published his *Inquiry into the Origins of the Sublime*, which described the aims and categorised the subject matter of romanticism. This divergence was not merely technical; it gave visible expression to a change in philosophy, which was later to manifest itself in all the arts.

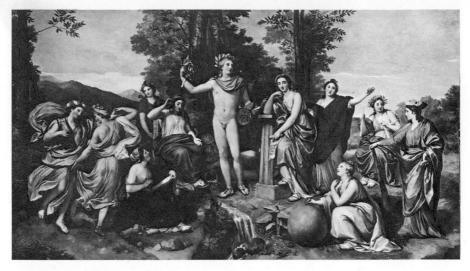

² Raphael Mengs, Parnassus

The classicists believed, in Winckelmann's words, that 'art should aim at noble simplicity and calm grandeur'; the romantics said that art should excite the emotions, and in particular the emotion of fear, which was the source of the sublime. As it developed romanticism proposed a new set of human values. It became a rebellion against the static conformity of the eighteenth century; and in art this became a rebellion against generalised forms borrowed from Greco-Roman sculpture, and against the prohibition of colour and movement as expressions of vital force. Winckelmann had said, 'Beauty resembles the most limpid water drawn from a pure source, which is all the healthier for being tasteless'. Not unexpectedly, the art produced in conformity with this doctrine is almost entirely uninteresting to us. The artist who conformed most closely to Winckelmann's theories was a German painter resident in Rome named Raphael Mengs, and his masterpiece is the ceiling he painted for the most famous collector of his time, the Cardinal Albani [2]; and although it is undoubtedly insipid, it is not at all pure. It is made up of the fashionable clichés of the time and is fundamentally frivolous. It does not reflect life, but some vapid dream of connoisseurs and collectors.

The man who revolted against this unreal style, Jacques-Louis David, was himself a classicist; but his classicism was nourished by a contact with nature and a passionate involvement with human life and society. In politics as well as in art he was a rebel of the oldfashioned kind. He was born in Paris in 1748, and was at first content to paint in the various styles then current, but in 1775, after heroic struggles, he won the diploma of the Paris Academy and was sent to Rome. When he arrived at the Villa Medici, Winckelmann's influence was at its height. The excavations of Pompeii and Herculaneum were not twenty years old. It was a moment almost as intoxicating as the first Renaissance, of which discoveries in our own time, such as that of early Chinese art or the art of primitive peoples. gives us only a pale reflection. David filled his mind with the history of Rome, his sketch-books with the outlines of ancient sculpture, and returned to Paris in 1780 determined to revive in painting the virtues of the ancients. Characteristically, one of his first pictures, the Count Potocki on Horseback [5], is still in the eighteenth-century style - one of the last great bravura pieces of the ancien régime. But in the same year, 1781, he attempted something more serious, and took Poussin as his model. His Belisarius Begging for Alms, in which the aged general is recognised by one of his old soldiers [4], might have been painted in the seventeenth century, even down to the noble landscape in the background. It is Davidien in its large gestures, and we find for the first time a feature which is almost like a trade-mark in David's best work, one which undoubtedly had for him an unconscious symbolism, the open palm of the hand. The Belisarius was much admired, but David realised that it was not the kind of classicism which the age demanded, or which he was destined to paint. It was too traditional, too much a picture for the connoisseur. His classicism must be revolutionary, and must appeal to the people, and to those friends of the people, the philosophers. The result was The Oath of the Horatii [5].

The Horatii is one of those works on which it would be easy to write a short book. It is really what some art historians want works of art to be, a perfect illustration to social history. Although it was commissioned by Louis XVI, it illustrates the new moral earnestness, and the stoicism which preceded the French Revolution. 'You love art too well', wrote David to his pupil Gros, 'to occupy yourself with frivolous subjects. *Vite, vite, mon ami, feuilletez votre Plutarque.*' (Quick, quick my friend, turn the pages of your Plutarch.) This spirit is expressed no less by its subject than by the combination of realism

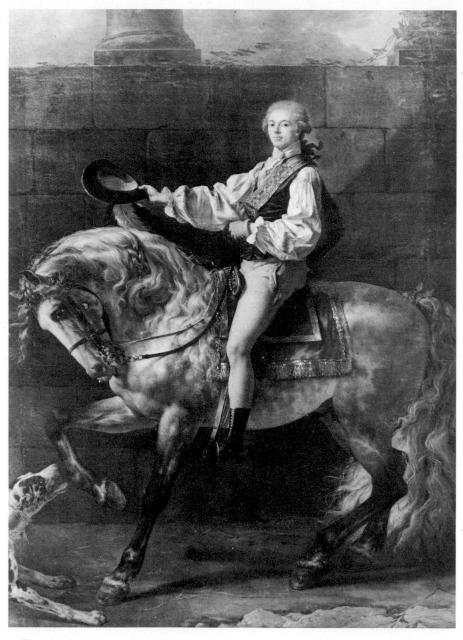

3 David, Count Potocki on Horseback

and archaic rigour in the style; and it is the grave acceptance of fact which separates it from the vapid orthodox classicism of Mengs. In the frontal composition, in the concentrated action, in the elevated expressions and accurate accessories, it is perfectly classical; but David has been too much in earnest to suppress the truth in favour of ideal

form. His open hand, quite consciously the central symbol of the design, gains its force from a particularisation which would have made Winckelmann shudder. He would also have been shocked by the Tuscan Doric pillars, which were considered outside the canon of classical elegance. David had chosen them consciously (for the first time, I believe) as symbols of uncorrupted Roman virtue, and primitive strength. The whole picture is, indeed, a perfectly conscious piece of propaganda, which was planned like a political campaign. The original idea, which does not occur in Corneille's drama, seems to have come from a slightly questionable source - from a ballet by Noverre, which in turn was inspired by the miming of David Garrick. The continual interplay between classic and romantic is further illustrated by the fact that the poses of the brothers seem to have been invented by Fuseli. Once the motive of the picture was decided upon David announced that it could be painted only in the sympathetic atmosphere of Rome, and he set out thither with a retinue of

4 David, Belisarius recognised by a soldier who had served under him, as he receives alms from a woman

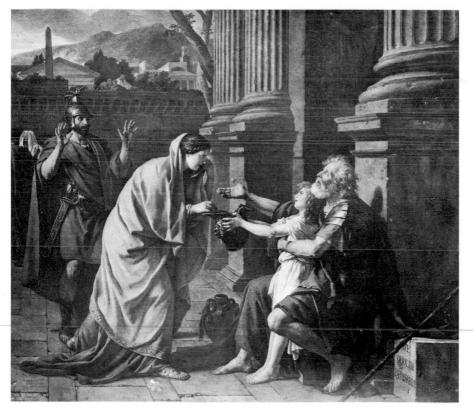

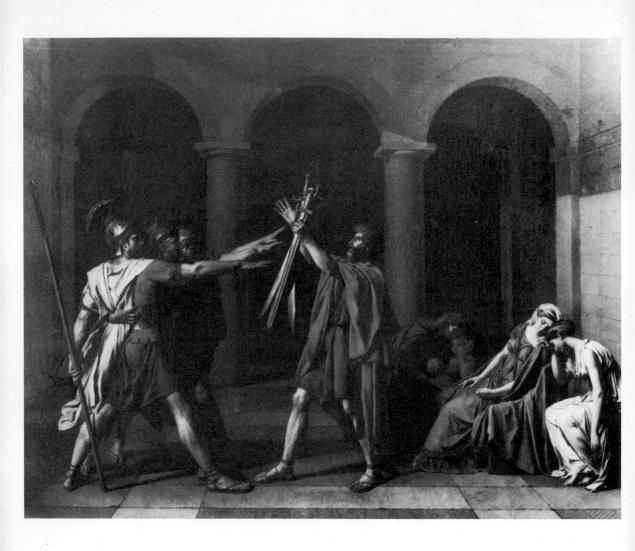

5 David, The Oath of the Horatii

pupils and attendants. The execution took eleven months of systematic labour; the only part of it to give any trouble was the father's right foot, which he repainted twenty times, and to the end did not consider sufficiently ideal. In 1785 the *Horatii* was exhibited in David's studio in the Piazza del Popolo, and the crowds who visited it strewed in front of it a carpet of flowers. The painting was then taken back to Paris, where, in spite of official opposition, it created an effect of which those of us who remember the first appearance of Picasso's *Guernica* may be able to form some conception. Suddenly, through a work of art, men became conscious of moral responsibility.

The Oath of the Horatii remains a very impressive picture. The unified totalitarian gesture of the brothers, like the kinetic image of a rotating wheel, has an almost hypnotic quality. Whatever its origins whether in Poussin or Fuseli - it retains the excitement of a personal discovery, and a similar use of repetition was to reappear in classical art from Flaxman to Seurat's Chahut. In the Horatii it is a convincing symbol of determined action, and is contrasted with the soft lines of the women on the right, sensuous, passive, incapable of heroic sacrifice. To realise how personal, and, as we say, original, a style David has created in the Horatii we have only to contrast it with Poussin's Rape of the Sabines [6] which is supposed to have inspired the figure of the leading brother. David's extraordinary powers of elimination and concentration are at once apparent; and I think they must owe something to the study, in Rome, of Caravaggio. That the arch-classicist should have drawn inspiration from the great anticlassic seems at first surprising, until we remember that David was above all a revolutionary, in revolt against the frivolity of mere picture-making. At his best Caravaggio's realism, where one may also find the open hand, was based on the same ambition and because of this earnestness the influence of Caravaggio was already accepted in French classicism, for who can doubt that the darkness and dramatic concentration of Poussin's Testament of Eudamidas [7] also derives from the Roman revolutionary or indeed that David had seen a copy of this extraordinary work (the original was inaccessible) which contains so many Davidien characteristics, from the parallel composition to the weeping woman on the right. The Horatii has another quality which is contrary to the strict theory of classic art; it is handled with a feeling for the quality of paint. This sense of *jolie matière* was something which David retained from his unregenerate, prerevolutionary days, an indulgence of which he was only half ashamed, for he habitually used it in his portraits, and did not always succeed

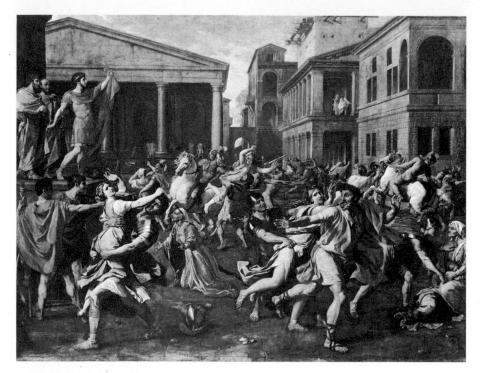

6 Poussin, Rape of the Sabines

26

in suppressing it in his histories. A recent cleaning has revealed in the figures of the women a good deal more charm of handling than was becoming in the Stoic style, and that is in complete contrast to the enamelled surfaces of Ingres.

The Horatii established David as one of the leaders of the national life. Thenceforward his pictures had the public importance of manifestos. It was a position to which unfortunately several artists since the time of Raphael had aspired, but none had achieved in anything like the same degree. David realised the dream which has proved fatal to so many painters of mediocre talent, and even those of real accomplishment such as Diego Rivera and Orozco – the dream that a painter can use his art to influence men's conduct. These were, of course, years when public opinion was particularly susceptible to the influence of art. The prophet of the movement, Jean-Jacques Rousseau himself, had been less of a philosopher than an artist. Doctrine was found in works which seem to us very harmless. We may think that *The Marriage of Figaro* was written solely to give us pleasure, but in 1785 it was considered a political bombshell, for from 1780 to 1790 every play and every ballet was interpreted in a political sense –

a fact which is not surprising when we remember the recent fate of Shostakovitch, or re-read the third book of Plato's *Republic*. Only in England, perhaps, does this influence of the arts on the life of the State seem incredible and absurd.

The two great pictures which David painted in these years between the Horatii and the Revolution were both celebrations of stoicism and sacrifice. The first, *The Death of Socrates* [9], is the least Davidien of his major works; the history and ethos of Greece was less in harmony with his character than those of Rome. No doubt he chose the subject as an example of sacrifice, but the motives which led Socrates calmly to accept the hemlock were too complex and disinterested for a man whose mind moved in the realm of action. As a result the picture, though admirably composed, is curiously lacking in David's personality and, consequently, in style. The open palm of action has grown extremely small, and it has been given to the tiny figure of Xanthippe, who was originally seated at the foot of the bed, but whose place has been taken by Plato (who, in fact, was only twenty-five, and not present on that occasion). He is one of the very few motives in David's work drawn direct from life, and he is the most impressive figure in the whole composition. But the very lack

7 Poussin, Testament of Eudamidas

of style in this picture made it a perfect example of classicism. Much to the alarm of English academicians it was proposed to send the *Socrates* to the Royal Academy of 1788, and a critic wrote that it was 'a picture which would do honour to Athens in the Age of Pericles, which after ten days successive observation seems to me absolutely perfect in all its parts'. These words appear in all the books on David as having been written by Sir Joshua Reynolds who is said to have seen the picture in the Salon of 1787; but they are not in Reynolds' style and as far as I know he never mentions David.

In his next picture [8] David returned to his *Plutarch* and to the world of the will. It represents the lictors bringing back to the house of Brutus the bodies of his two sons whom he had condemned to death; one of those incidents in Roman history which do not appeal to a humanitarian age but which, in 1789, seemed to be the summit of patriotic virtue. It was a subject calculated to inflame opinion because it dealt with traitors, those well-known creations of popular excitement at times of crisis or revolution, and the picture's success as a piece of propaganda was immediate. Its continued success as a work of art is also, to my mind, considerable. The figures are, as usual, all taken from the antique - the Brutus direct from the statue in the Capitoline. Even the furniture was copied from the antique, and made by the great ébéniste Jacob. But the idea of putting the figure of Brutus in shadow in a corner of the composition seems to me a real stroke of imagination; and the group of mother and daughters, skilfully combining Niobe and a bacchante, is beautifully designed. It shows that David, contrary to what used to be supposed, was enough of a man of the eighteenth century to be deeply appreciative of femininity. This is obvious enough when one remembers his portraits, but feminine figures also play an essential part in his compositions. His pictures with, if I may so express it, an exclusively male cast, the Socrates and the Leonidas, are painted with considerably less warmth and personal interest. The reason is that in his greatest paintings the real heart of the drama lies in the conflict between the masculine and the feminine spirit. We are moved precisely because this was a conflict within David himself. It is true that David was, as his contemporaries said, 'the painter of the will'; and in the Horatii and the Brutus the will enjoins the sacrifice of sentiment to duty: but only after a struggle with the painter of Madame Récamier [10]. In the work which David himself believed to be his masterpiece the feminine actually triumphs.

28

The Brutus was exhibited in 1789, and during the next four years

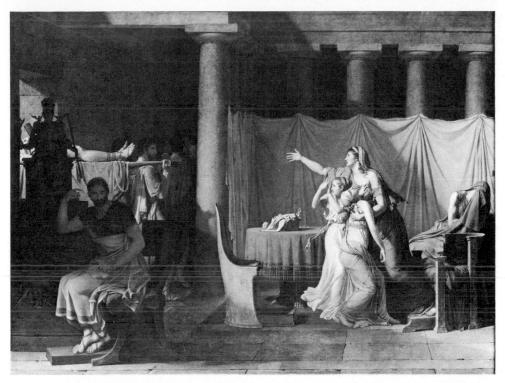

8 David, The Lictors bringing back to Brutus the bodies of his sons

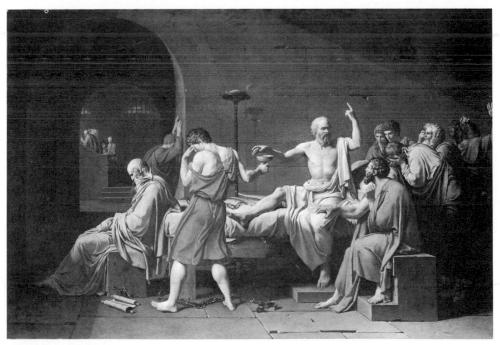

9 David, The Death of Socrates

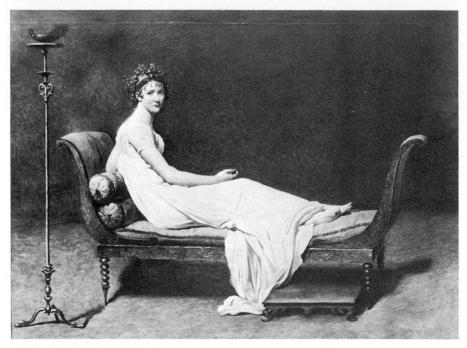

10 David, Madame Récamier

the movement, in which David's picture had played its part, reached a crisis and completely swamped all those who were connected with it. The artist who succeeds in influencing events leaves the free world of contemplation for the limited world of action; and very soon he finds that he must give up art for politics. David swore the Oath of the Tennis Court, became a member of the Convention, and voted for the death of the King. Much of his time was spent in organising fêtes and processions (in which his lack of invention was painfully evident), in designing uniforms and in his administrative problems connected with the Academy. I ought to add that he fulfilled these last functions with remarkable fairness and restraint – not a single artist was guillotined, and he nominated for public honour painters of such unrevolutionary character as the aged Fragonard and Madame Vigée Lebrun. He also found time to begin a vast picture of the Oath of the Tennis Court; which was cut up, so that we can deduce it only from the preliminary drawings. He also produced one masterpiece; his memorial to Marat.

The *Marat Assassiné* [11] is, to my mind, the greatest political picture ever painted. It is almost the only justification of the popular belief that an event which has aroused public emotion may immediately become the subject of a work of art. Pictorially this was a

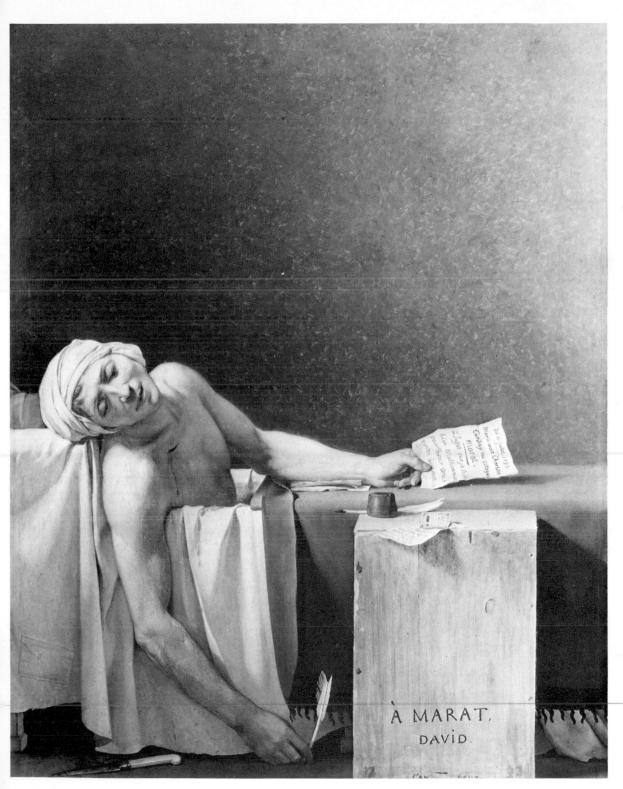

11 David, The Death of Marat

triumph for the classic discipline. David, who was in the habit of pondering every detail, had to paint with great speed, yet the whole design has an air of concentration and finality which is usually the result of prolonged elimination. David's classical training also enabled him to strike a perfect bargain with 'the ideal'. The figure, no less than the wooden box and the *trompe l'œil* papers, gives the impression of absolute truth, even though we know that Marat's face and body were ravaged by disease which David dared not represent.

The Death of Marat has a special interest for us today. It proves that totalitarian art must be a form of classicism: the State which is founded on order and subordination demands an art with a similar basis. Romantic painting, however popular, expresses the revolt of the individual. The State also requires an art of reason by which appropriate works may be produced as required. Inspiration is outside State control. The classic attitude towards subject matter – that it should be clear and unequivocal – supports the attitude of unquestioning belief. Add the fact that totalitarian art must be real enough to please the ignorant, ideal enough to commemorate a national hero, and well enough designed to present a memorable image, and one sees how perfectly *The Death of Marat* fills the bill. That it happens also to be a great work of art makes it dangerously misleading.

A few months after completing this picture David's political career was over, and on the 13th of Thermidor he was imprisoned and in danger of his life. His first prison had a pleasant view over the Luxembourg Gardens, which he recorded with a freedom and naturalism that shows he was a born painter. His second prison was less agreeable and rival painters erected a guillotine outside his window. He also painted a self-portrait [1] signed 'David in Vinculis'.

No imprisonment, no threat of the guillotine even, would have distressed David so greatly as the modern view that he is chiefly memorable for his portraits. He was, indeed, an admirable portrait painter, whose work in this field anyone can enjoy. Two of the most charming examples are the blithe *Sériziats* [12–13], painted immediately after his release, who seem to reflect David's first sense of well-being at liberation from prison and from politics. They are certainly pleasanter to look at than the implacable Brutus; and Madame Sériziat's white dress and bunch of flowers is a foretaste of the 'primitivism' of Ingres (also very like early Caravaggio). But to maintain, as Monsieur Maurois did in a book entitled *David*, ou le génie malgré lui, that the whole of his labour on historical pictures

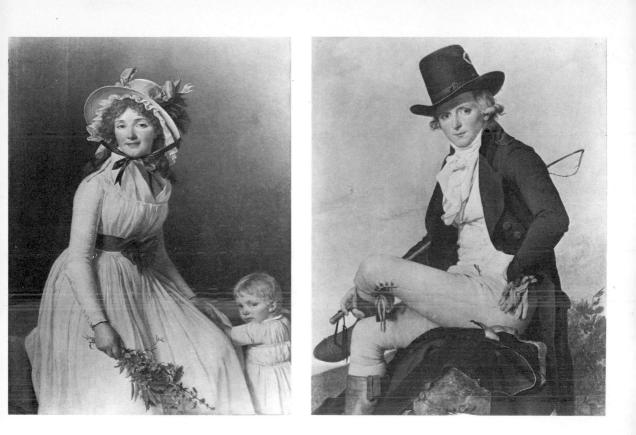

12 & 13 David, Madame Sériziat and Monsieur Sériziat

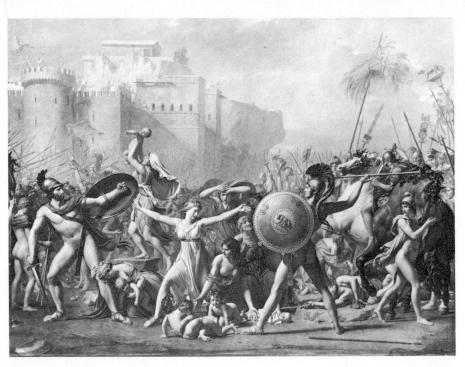

14 David, The Sabine women enforcing peace by running between the combatants

was misdirected, is a shallow paradox which would have been treated in fine style by French critics if it had been expressed by an Englishman.

While he was in prison David also made the drawing for his next great work, The Sabine women enforcing peace by running between the combatants. The theme has changed from stoic patriotism, which overrides domestic affection, to conciliation effected by the tender emotions. There is no real reason why this theme should have been less inspiring than the sterner moral of his revolutionary works; but unfortunately in the painting's execution other influences intervened. The drawing made in prison shows the two heroes, Romulus and Tatius, clad in Roman armour. In the picture [14, 1] they are nude. David has allowed his friend, Quatremère de Quincy, a disciple of Winckelmann, and a most dogmatic theorist of pure classicism, to persuade him that only thus can he achieve the ideal. These figures are not only improbable in a field of battle; they are also rendered down to the smoothness and vacuity of restored Hellenistic sculpture. David defended their nudity in a pamphlet; but the theory of generalised form was considered axiomatic and needed no defence. 'In the Horatii,' said David, 'I showed too much knowledge of ana-

tomy. In the *Sabines* I shall treat this part of the art with more skill and taste. This painting will be more Greek.' Yet David himself was aware of the dangers of classicism. He had always set himself up to be the enemy of academism. He would not employ professional models, and although the poses of his figures are taken direct from other works of art – the Romulus, for example, is taken from Flaxman – he always painted them from the life, from friends and pupils, and from a queue of society ladies who waited outside his studio in hope of being immortalised as Roman matrons. His portraits show us how skilfully he could generalise direct from his model, as one can see in

15 David, Madame Verninac

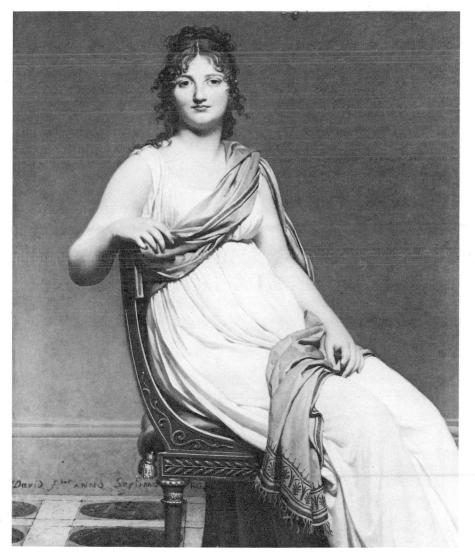

his portrait of Madame Verninac [15]. Incidentally, she was Delacroix's sister, and Delacroix kept the picture in his bedroom all his life – another proof of how the conflict between classic and romantic is largely artificial. In his histories David tuned each form up to the concert pitch of the ideal, and we can perhaps only tell by ear when a string has been screwed too tight. In the *Sabines*, for example, I feel that the group of Hersilia and the Sabine women is perfectly harmonious, but my ear is slightly offended by Romulus and shocked by Tatius, though David thought that they were the chief beauties in a picture which he always regarded as his masterpiece.

After 1799 David, in common with other revolutionaries, adopted a new hero – General Buonaparte; and no man has ever been made to look more heroic than the First Consul, in a totally unrealistic but stunningly effective memorial to his greatest exploit, crossing the Great St Bernard [16]. The First Consul had inspected the Sabines and made the rather obvious remark that it did not resemble a real battle. Nevertheless, he tried, unsuccessfully, to take David to Egypt on his campaign. On his return Buonaparte visited David again and asked what he was about to paint. 'Leonidas at Thermopylae', was the reply. 'Tant pis,' said Napoleon, 'you are mistaken, David, to waste time on painting the defeated.' No wonder that the work which David carried out for his new master was less ideal than his great pictures of the eighties, was even, for all its colossal accomplishment, slightly commonplace. The Coronation of Napoleon does not come into the history of classicism, but into that of official painting. To recognise its merits we need only compare it with the attempts to paint the last four coronations in England. Of course it is more skilful, but it is of the same family. The heads of the ladies are very accomplished, and might have been painted at any epoch - I should have guessed about 1900 – but they are not art. They prove the high power of idealisation in David's earlier works, even those like the Horatii, which seem realistic. Only when he came to Pope Pius VII [18] has David been moved by the beautiful Italian modelling of his head, and perhaps by the sentiment patiens quia aeterna, and has given it the lasting character of form. He also did an independent likeness of the Pope, which shows that he had not lost his powers as a portrait painter. The Holy Father had expressed some concern at sitting to a painter who, as he put it 'had killed his King and would easily make a bonfire of a poor old Pope of papier maché'. But David was delighted. 'I will have painted an Emperor', said the old revolutionary, 'and now at last a Pope'.

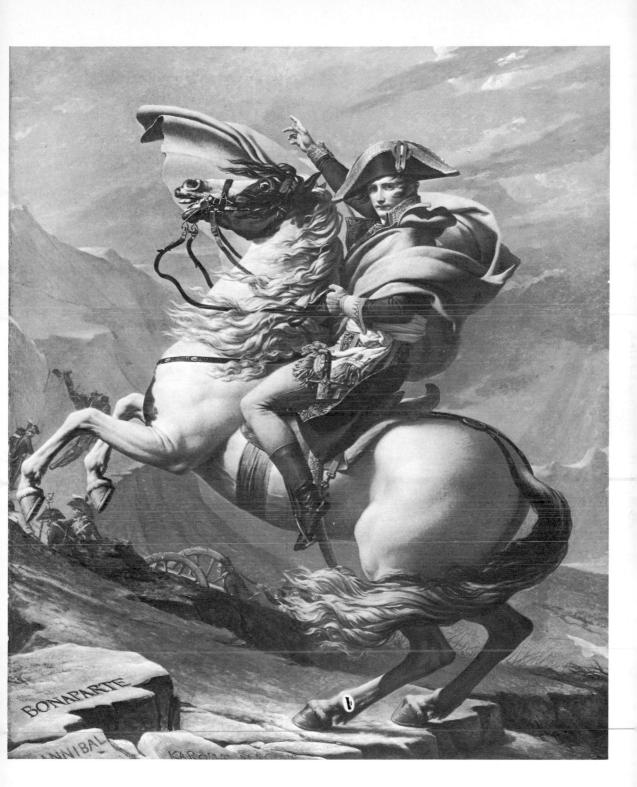

¹⁶ David, Napoleon crossing the Alps

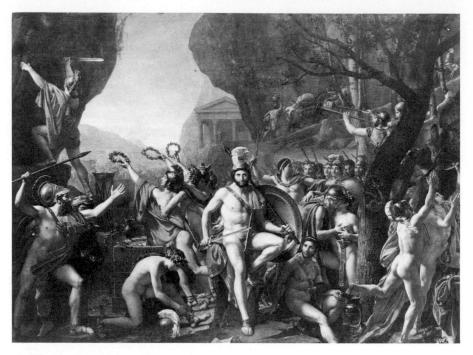

17 David, Leonidas at Thermopylae

To say that David betrayed his ideals or allowed himself to be corrupted by Napoleon would be an over-simplification. But, alas, however much an official painter may wish to retain his integrity, the practice of executing commissions and the thousand distractions of public life so sap his powers of concentration that when he returns to the kind of painting which he has always sincerely desired to achieve, he can no longer do so. His hand, responding more truthfully to the situation than his brain, refuses to obey his will. It was courageous of David to return to his *Leonidas at Thermopylae* [17], especially at a moment when defeat may have seemed to the Emperor almost too interesting a subject for art; but to my eye the picture is completely dead. David himself seems to have been unconscious of any falling off in his powers, and regarded the *Leonidas* as at least equal to the *Sabines*.

To understand the reason for this we must read the account of David's intentions preserved by the engraver, who took a proof of the *Leonidas* for the artist to correct. They are literary and moral. He describes at great length the thoughts that are passing through the hero's mind, and which are all expressed in his head – painted, David says, with inspiration. The classic doctrine that a picture

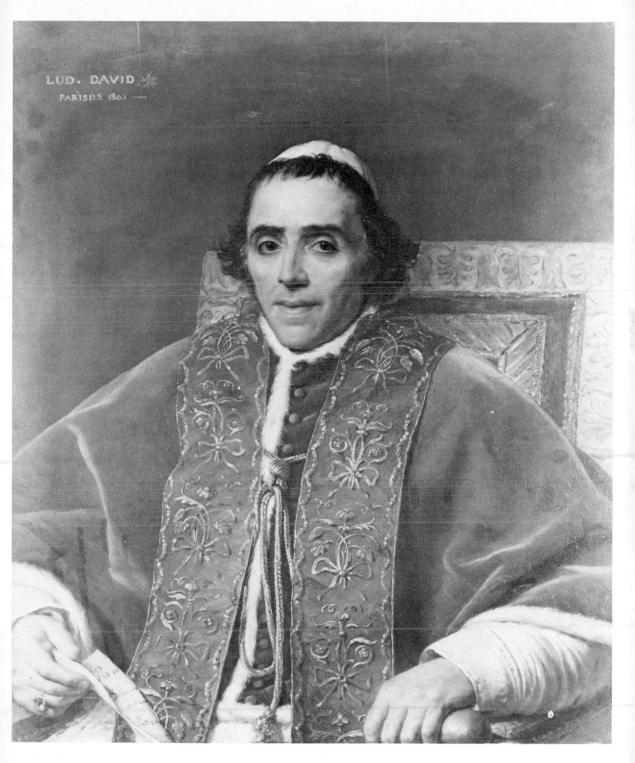

18 David, Pius VII

should be like a heroic poem is pushed to its limit. But at this distance of time David can communicate with us only through pictorial means; and from this point of view the figure of Leonidas is a failure. It is taken from a gem in Winckelmann's *Monumenti Inediti* and many of the other figures are derived from antiques. The *Leonidas* is indeed an extreme example of neo-Classical generalisation. Every living particularity has been smoothed away, and we do not feel in compensation any intellectual grasp of abstract form. This, which was once considered the summit of classicism, now appears to be its dead end. We may think of it when we come to look at Géricault's *Cuirassier* and Ingres' *Jupiter and Thetis*, both painted in the same decade.

After the Restoration David was exiled to Brussels, and the pictures painted there show a pathetic decline. The most interesting of them the wonderful portrait of Madame Tangry and her daughters [19], is now thought to have been executed by his pupil Navez, although the drawing and design is surely by David. By returning to the truth, he has recaptured in it some of the genuinely classical quality of the eighties. The heads have the frontality and the unflinching regard of Roman funerary monuments, and the grave realism of Roman portrait busts. Even the hats remind one of the grotesque coiffures of Trajanic empresses. This Roman quality may be contrasted with the Alexandrine decadence of his last picture, the Mars disarmed by Venus [20]. It is a painfully bad picture. The cupid undoing Mars' sandal is really vulgar. Such qualities of style as it retains are due to his old love of the ballet - the source that had inspired the Horatii and Hersilia. The Three Graces have exactly the character of old ballet prints, including the champagne bottle shoulders and the too prominent pink faces; the Venus is actually a portrait of Mademoiselle Leseuer, the prima ballerina of Thêatre de la Monnaie in Brussels. We see that David, who once believed himself to be the creator of fashion, was actually blown about like anyone else by the winds of contemporary style. As a matter of fact, the Mars and Venus is more like the late antique painting as we know it in the frescoes from Herculaneum than is the Horatii; but the virtues of classic art have been completely lost. The long conflict between the masculine and feminine principles is over: Mars is disarmed. Rome is succeeded by Alexandria; and we realise how much the character of David's work depended on the romantic projection of his own moral struggle.

40

The decadence of David's style was not due solely to personal

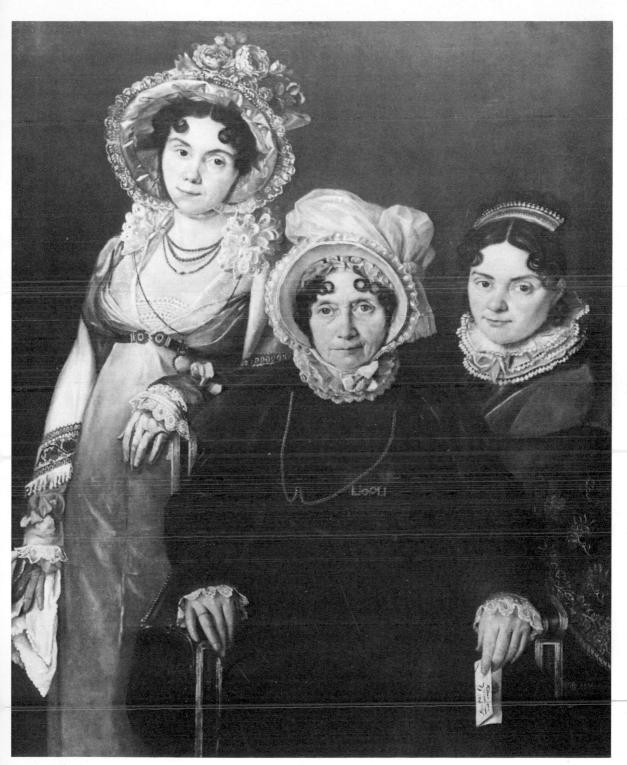

19 David, Madame Tangry and her Daughters

reasons; it was also the reflection of a general failure of classicism, both as style and as a philosophy, to express the spirit of the revolutionary age. However much the various phases of the French Revolution may have modelled themselves on Roman history - the early phase on Republican virtue, the later on Imperial grandeur - the fact remains that classicism depended on a fixed and rational philosophy; whereas the spirit of the Revolution was one of change and of emotion. What we call romanticism was inevitably the living impulse of the nineteenth century, and after about 1815 classicism (except in architecture) became an art for connoisseurs except when it was saved by its old ally, realism. Fortunately in these years the highly specialised style of neo-classicism had been adopted by a man of genius - Ingres. It is symbolic that Ingres should have painted the candlestick in David's most feminine picture, the Madame Récamier. I am not saying that Ingres was a less great artist than David: on the contrary, I have an unbounded admiration for him. But I do think that in two or three of his works David achieved, through imagination and design, a moral and philosophic stature, which the pure aestheticism of Ingres could not achieve.

20 David, Mars disarmed by Venus

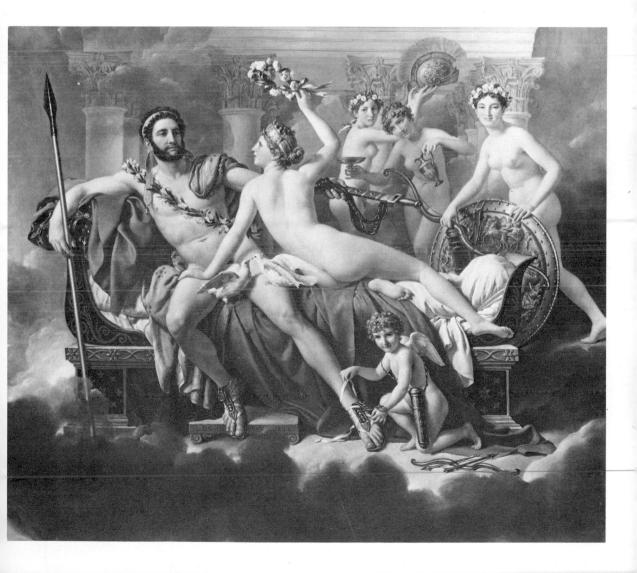

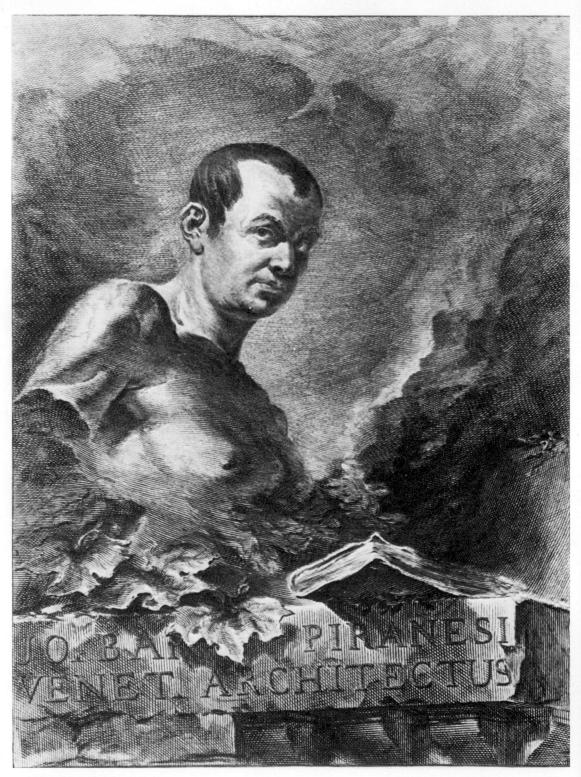

21 Piranesi, Self-portrait

Piranesi and Fuseli

Hunting down a date for the origin of eighteenth-century romanticism used to be a favourite sport among art historians, and they very often settled on June 1764, when Horace Walpole dreamed that he was in the hall of an ancient castle, and on the uppermost banister of the staircase saw a gigantic hand in armour. When he awoke he wrote the first horror story, The Castle of Otranto. This date is too late. Readers of Voltaire's Candide will remember how the smooth surface of common sense optimism was cracked by the Lisbon earthquake of 1755. It was the eighteenth-century equivalent of the sinking of the Titanic. The immediate effect of the earthquake was extraordinary. Madame de Pompadour gave up rouge for a week ('she has offered it up', said Horace Walpole, 'to the Demon of Earthquakes') and for a fortnight the stakes wagered at White's were substantially reduced. 'Never before', said Goethe (who was six at the time), 'has the Demon of Fear so quickly and so powerfully spread horror throughout the land'.

It is arguable that the Romantic movement first showed itself as an expression of fear; and this was spelled out in the first philosophical treatise on the subject, Burke's *Inquiry into the Origins of the Sublime*. This original, intelligent and extremely boring work is based on the proposition that 'what soever is fitted in any sort to excite the ideas of pain and danger, that is to say, whatever is in any sort terrible, is a source of the sublime'; from which Burke deduces 'the sublime effect of darkness, or destructive power, of solitude and silence and the roaring of animals'. Almost forty years were to pass before Blake was to describe these same agents of the sublime as 'portions of eternity too great for the eye of man' in language which Burke would have considered clouded with enthusiasm.

Although the year 1755 is as defensible as any date of the kind can be, an extraordinary prelude to the Romantic movement and to the imagery of the fear had taken place in the preceding decade: the series of etchings known as the *Carceri d'Invenzione* – the *Imaginary* Prisons - by Giambattista Piranesi. Piranesi is an example of the well-known paradox of history that cultures are destroyed from within. He was the first Fifth-Columnist of the eighteenth century. By birth he was a Venetian, a native of the city which, in the eighteenth century, offered the enchantments of pleasure in their most liberated form, and the earliest visual experience to form his imagination was undoubtedly the sumptuous decors of the seven theatres of Venice. The reigning princes of theatrical design were the Bolognese Bibiena family, and it was from them that the young Piranesi learnt his mastery of fantastic perspectives; his mastery of etched line to convey light and shade he learnt from that source of equable light, Canaletto, and that fountain of joy, Tiepolo. But early in life he left the city of light and colour and became a Roman and spent most of his life in Rome at the height of the Classical revival. He was the most renowned antiquarian in the city; and he has a good claim to be reckoned the first great artist of romanticism.

Piranesi was born in 1720, the son of a stone-mason, and was trained to become an architect, but his amazing skill in drawing architecture must have shown itself early, because at the age of twenty he was chosen to accompany the new Venetian ambassador to Rome. It is a proof of the cheerful, eupeptic character of the early eighteenth century - the age of Marco Ricci and Panini - that the ruins of ancient Rome seemed to strike people as light and cheerful. This is not the effect they have on us today, even after two centuries of tidying-up: and it was not the effect they had on Piranesi. For thirty years he drew the ruins of Rome with relentless accuracy; but he never ceased to find them terrifying and oppressive. In this he was closer to the men of the Renaissance than to the eighteenth century. Cellini thought that the Coliseum was haunted by ghosts and demons; Piranesi's views are inhabited by wild and shadowy creatures, or by those cripples and hunchbacks which, as his biographer records with disapproval, he insisted on drawing instead of antique statues. Even when an inspector of ancient monuments visits the sluice-gates of Albano [22] he is reduced to insignificance by the trunks of ancient trees. From the first Piranesi saw those incomprehensible vaults not as the former setting of a polished social life, but as prisons. In his earliest series of etchings, done at the age of twenty-two, his prison is actual. It is in fact entitled Dark prison with instruments for the punishment of criminals. Compared with the later prisons it is relatively prosaic; but already there is the oppressive cyclopean architecture, and those recurring emblems of frustration, grilles and

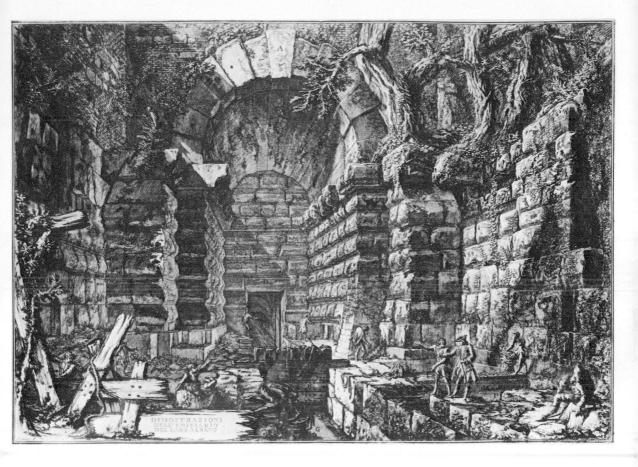

22 Piranesi, Inspector visiting the sluice gates of Albano

pointless galleries. Three years later the prisons become hallucinatory and metaphysical, in that extraordinary series of etchings known as the *Carceri d'Invenzione*.

The *Carceri* or *Prisons* exist in two different forms. The first was largely designed in 1745 and published in 1750 and a new edition (in fact the third) appeared in 1760. To this edition Piranesi added a couple of plates, and reworked most of the others. In some he added only a few details, but others were transformed. In most cases (not quite all) there was considerable gain in power and intensity, and it is from the 1760 edition that the *Prisons* are generally known. A comparison of the two sets throws a revealing light on Piranesi's mind and, indeed, on the creative process in general. All the ideas came to him in the first series. They were inspirations. Apparently Piranesi was not at first aware of how revealing these ideas were; or perhaps, in 1745, he could not quite accept the fact that these dreams of fear and frustration were a communicable form of expression, worth pushing to their extremity; whereas after the Demon of Fear had been released in 1755 he felt able to do so.

The frontispiece itself offers an example. In the first edition [23] it still has some of the harmless fantasy of a Venetian *capriccio* – and in fact the series is entitled *Capricci* – Piranesi's name does not appear, only the name of his publisher. Seen in the light of the other

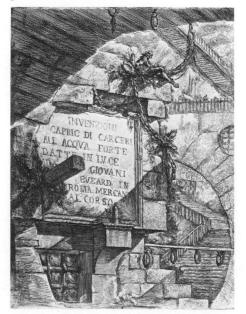

23 Piranesi, *Carceri d'Invenzione*, frontispiece, first edition

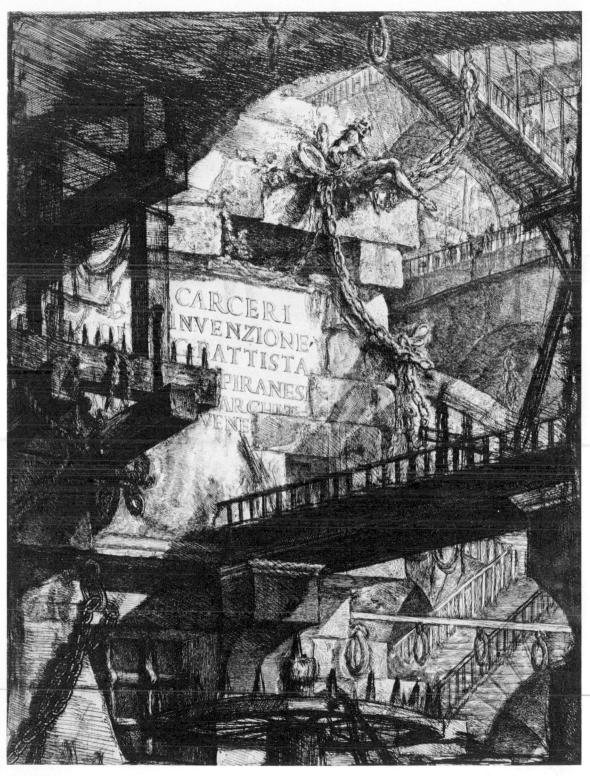

24 Piranesi, second edition of 23

plates, the staircase and upper galleries have a nightmare character. But when Piranesi returned to the plate for the second edition we are no longer left in doubt [24]. A large, toothed wheel occupies the foreground, a pointless and sinister bridge crosses the middle of the scene, and a vertiginous cat-walk appears high above our heads. This zig-zag of crazy diagonals is added to all the plates in the second edition, and thereby increases our sense of frustration. A zig-zag line is notoriously the graph of enraged neurosis, and in the whole composition its function is expanded [27]. Every time our eye undertakes a journey, it is sent back, sharply and painfully. There is never a smooth transition – that essence of classicism – between the two points. No doubt this exacerbated criss-cross expresses something deep in Piranesi's character, for it appears in an almost abstract form in drawings of the 1760s.

The other change which Piranesi made in the second edition was an increase in actuality. In the first state the prison, disturbing though it is, remains a sketch, with many parts left vague, and the imagination can still take comfort in certain unoccupied areas of light [25]. How much more appalling when, in 1760, every square inch is made horribly factual, so that one cannot avoid climbing up those spiral staircases and hurrying dizzily along those terrible gangways which end in air [26]. To this task of making his dreams more concrete, Piranesi could now bring all the skill in accurate representation which he had acquired in fifteen years of etching the ruins and modern buildings of Rome.

Rome in the middle of the eighteenth century must have been the most beautiful place in the world - and the most paradoxical. First there were the vast buildings of papal Rome arising out of traffic-free streets, surrounded by smaller versions of themselves in the same style. Although the great epoch of building was over, a succession of benevolent Popes and Cardinals had given the feeling that this colossal stability would go on for ever. The Roman palaces were the weightiest monuments of self-confidence ever erected. Next to those came certain buildings which had survived from antiquity and were still used for human habitation. In these conversions the level of prosperity has gone down - broken pediments, crumbling walls. There is an uncomfortable feeling of devouring time. Then came those ruins of antiquity which, from their situation or their instability, had been allowed to decay, magnificent complex structures, that no reasonable architect would have dared to restore. And finally there were those great projects of antiquity which had been reduced to

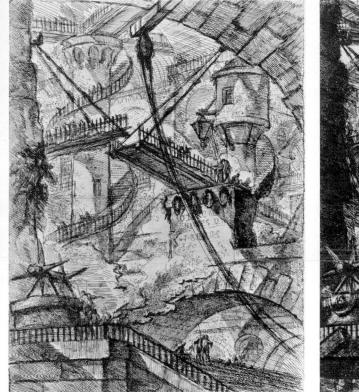

25 Piranesi, Carceri, Plate VII, first edition

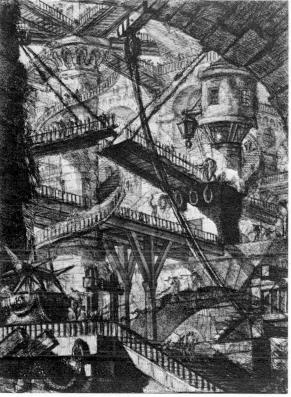

26 Piranesi, Carceri, Plate VII, second edition

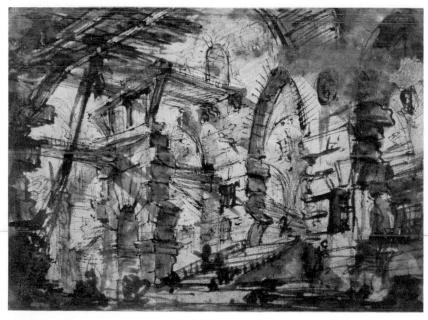

27 Piranesi, architectural drawing

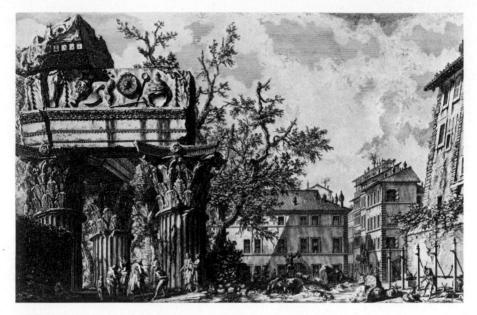

²⁸ Piranesi, View of the Temple of Jupiter

little more than gigantic molehills or uncovered rabbit warrens. So antiquity, 'that boundless charmer', becomes a subject of dread and melancholy, of emotions at the opposite extreme to the pure, limpid water that Winckelmann, at the same epoch, was proposing as the proper analogy to her art.

It was Piranesi who discovered this paradox in our attitude to antiquity. Although views of the churches and palaces of the seventeenth century occupy half of his book on Rome, he was not in the least interested in them, and it is hard to believe that many of the plates in the 1750 edition were executed by his own hand. They are mere topography, executed like line engravings rather than etchings, and lack altogether that dramatic feeling of light which is so remarkable in Piranesi's own more personal work. But when buildings begin to emerge from the ground, his feelings become engaged. He enjoys the gigantic scale of an architecture that can compete with the heaped-up detritus of millennia [28]. Finally, when he comes to Albano, which is, so to say, virgin soil, his emotions can be released, and this gives to his vision an intensity and a power of combining solidarity with micromanial detail that has never been equalled [29]. To have delineated every stone in proper perspective, and yet to have made the whole a moving work of art, is a technical feat which could have been achieved only under the pressure of strong feeling.

This is the experience that Piranesi brings to bear on the second

²⁹ Piranesi, The Mole of Hadrian

edition of his Prisons. After fifteen years he had become far more skilful, but the original dream had lost none of its power over him. In fact without his first visions to work on he could not achieve any intensity at all. The two plates which he added to the Prisons in 1760 are concoctions [30]. He has gone all out to make them effective, has filled them with reliefs representing what were to become the standard symbols of fear: lions, bound captives and so on, and has even included a scene of torture. They are infinitely less disturbing than the earlier plates, which affect us by purely architectural and, as it were, abstract means. It is hard to imagine a better illustration of Coleridge's distinction between the fancy and the imagination. In fact some of the most moving plates were left practically unchanged. To the superb invention on plate 31 with its great stone drum glaring at us defiantly like the hero of Fidelio, he added only the small criss-cross in the foreground and an extra gallery in the middle distance. By defining some of the details more closely, and inking the plate more heavily, he has taken away the sunny atmospheric look of the first edition which mitigated its sinister purpose. One profoundly romantic design with a group of gigantic prisoners - whether real or sculptured one

30 Piranesi, one of the plates added to the *Carceri* for the 1760 edition

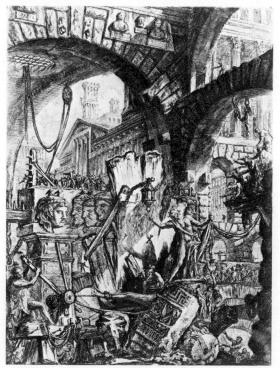

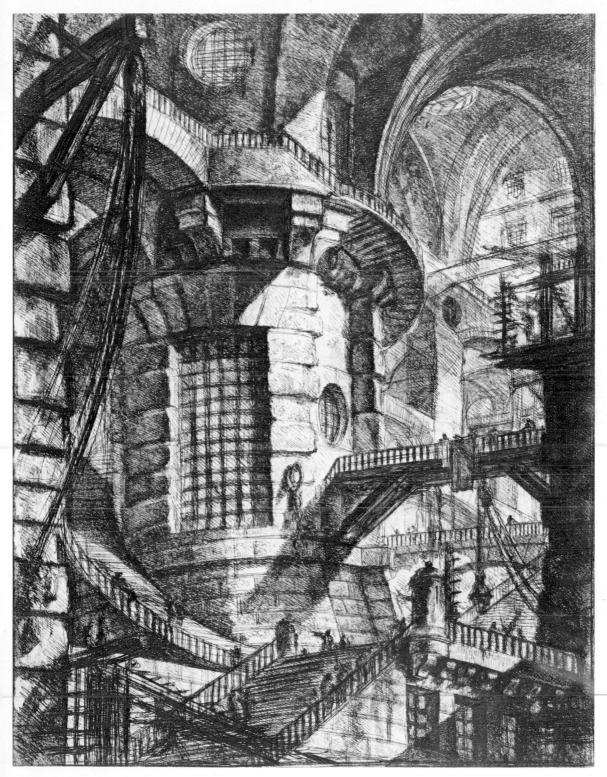

31 Piranesi, Carceri, Plate III, second edition

T019493

cannot tell – he did not change at all, so that we may say that by 1760 the emotional impulse of the *Carceri* had become more intense, more sustained and more self-conscious; and Piranesi had recognised it as something which the spirit of the time would accept, as it would not have done fifteen years earlier. With his greater technical resources he was able to give his intensified emotions a more fearfully convincing statement. But the original visions on which the whole depended came to him at this astonishingly early date of 1745.

How did they come to him? Bianconi, Piranesi's first biographer, who took a poor view of him, said that they were the result of a feverish dream, but that, of course, could not be the real basis of such a sustained and elaborate piece of work. We know that Piranesi, in his youth, was a strange and solitary figure. Even after he had married a daughter of the Corsini's gardener and had become the most successful engraver in Rome, he remained an eccentric, as one can guess from his self-portrait [21], where he emerges from the clouds with an air of Baudelairean disillusion. Those who had read his autobiography claimed that it was the equal of Cellini and Casanova rolled into one - unfortunately it was lost in the early nineteenth century. I cannot help wondering if this solitary dreamer did not intensify his dreams by the use of opium; it was certainly used in medicine, and so I suppose that in those prepaternalist days it could be bought by anyone with the toothache. In the nineteenth century people took it like aspirin. De Quincey, who comes immediately to mind as we look at the Prisons, tells us how Coleridge described to him Piranesi's Carceri - he called them 'the Dreams' - and said that the architecture was gothic, but otherwise his description, as recorded by De Quincey, is remarkably apt and vivid; after which they agreed that the superimposed arches, the interminable staircases, the pointless and vertiginous galleries, represented precisely the dreams of an opium-eater in the earlier stages [33]. The evidence of our two most eminent drug addicts cannot be disregarded.

Nevertheless, I think it is true to say that the fears and frustrations of Piranesi's prisons are common to us all, and we recognise their authenticity immediately. Of the bad dreams of the eighteenth century they, and not Walpole's gigantic hand in armour, are the ones which have retained their power. Indeed they may have increased it. The factories and railway stations of the nineteenth century [32], which so often achieved a Piranesian confusion and gloom, had become the prisons of industrial society. They were the visible aspect of the economic imprisonment; men and women passed

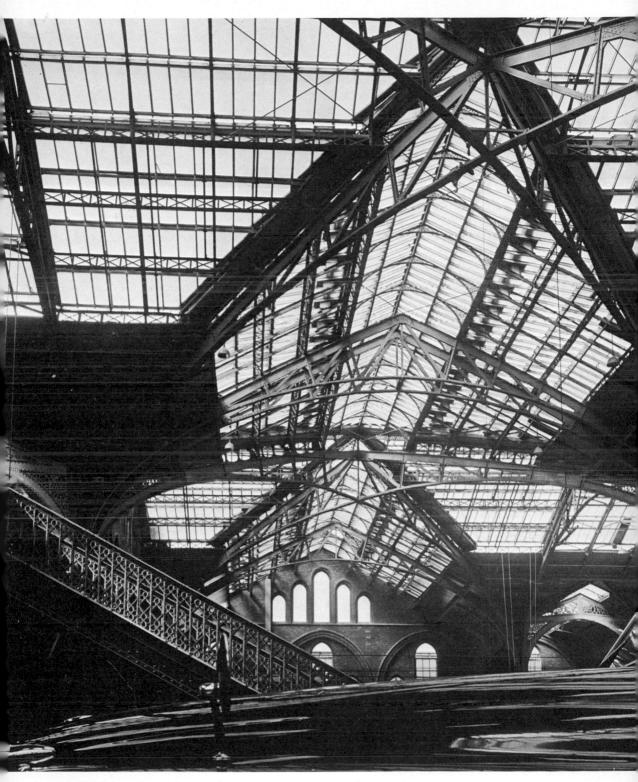

32 Liverpool Street Station (photograph by John Gay)

their days in frustrating journeys, leading only to incomprehensible work. You must go up the stairs to obtain a permit, then take it over to one of those little round towers to be stamped; unfortunately this office is closed, and you are instructed to go up to the top gallery, but in doing so you have taken a wrong turning and have infringed the regulations, so you must come down and visit the office of the security officer [34]. Of course, Piranesi could not possibly have foreseen the advantages of a well-organised state but, like all great artists, his work gives a fresh message to different ages. He fascinated the men of the late eighteenth century, in whom the Lisbon earthquake had, in Goethe's phrase, released the Demon of Fear; he spoke directly to the age of Coleridge and De Quincey; and he still speaks compulsively to the age of Kafka.

Piranesi transcends his time. But during his later years there was taking place in Rome a fashionable movement in the arts, which was to spread throughout Europe. This was also anticlassical but the object of repudiation was not so much antique sculpture as the paintings of Raphael. Ultimately this reaction was based on Michelangelo, not the high-Renaissance Michelangelo of the Sistine ceiling, but the terrible Michelangelo of *The Last Judgement*. If one wished to create an art of fear one could not do better than to imitate The Last Judgement. Michelangelo's sinners are fear personified; his devils are truly alarming. In addition to these awe-inspiring embodiments of retribution, the eighteenth-century artists were much influenced by a sixteenth-century Bolognese mannerist named Tibaldi. He is not a familiar name today, partly because his frescoes in Bologna University and the library of the Escorial are relatively inaccessible; but in his own time he was known by his fellow-citizens as il nostro Michelangelo riformato, and in the eighteenth century his work was popularised by a book of engravings published in 1756. These were the foundations of an anti-classical movement in eighteenth-century Rome, that appealed to the great irrationals cited by Burke, fear and destruction - to say nothing of sex, which Burke did not mention. They are at the opposite pole to Winckelmann's pure tranquillity or David's moral earnestness. I think it is probable that the first man to exploit this kind of stylised violence was Sergel, the Swedish sculptor, whose sculptures are more or less classical, but whose drawings are often quite the reverse [35]. He practised, with great power, the bold Roman style of the late eighteenth century, which was still going strong when Géricault visited the city in 1816.

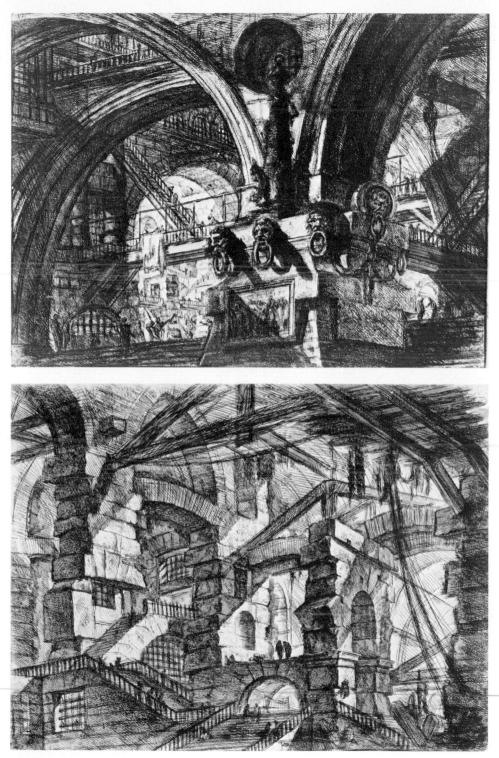

33 & 34 Piranesi, Carceri, Plate XV and Carceri, Plate XIV, first edition

The man who carried Mannerist romanticism back to the countries of the Romantic movement, England and Germany, was the Swiss painter, Fuseli. He was born in Zurich in 1741. As a young man he was ordained, but the priesthood was less to his taste than the Bohemian life of the *literati*. His friends were the poets and philosophers of German romanticism in its first liberal phase, and Fuseli found himself in disagreement with authority. In 1764 he was forced to leave Switzerland, and chose as his place of refuge the country of Shakespeare. Paradoxically his first work was a translation of

35 Sergel, Lovers

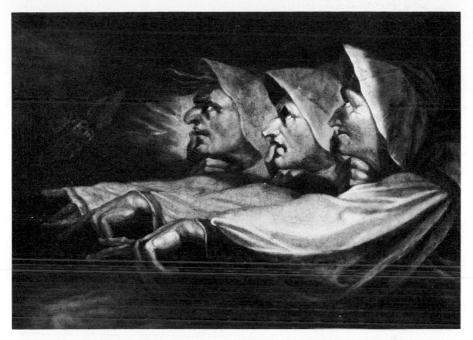

36 Fuseli, The Three Witches from Macbeth

Winckelmann's *Reflections on the Paintings and Sculptures of the Greeks.* Sir Joshua Reynolds persuaded him to give up literature for painting, and in 1769 Fuseli went to Rome where he gained a reputation as a master of the sublime. After nine years he returned to England and his sublimities – modish, crotic and bizarre – made a welcome variety in the serried lines of powdered wigs and blameless classical heroines on the walls of the Academy where he became Professor of Drawing, and later Kceper. He lived on in England till 1825, an object of dread and curiosity. The English like to have a few public figures, such as Sickert and Sir Thomas Beecham, that shock them a little sometimes. Fuseli, by his sarcasm, his profanity and his pugnacity, became a national institution and, unlike some of those who shock in our own day, he kept it up to the end.

Like many small, fierce men, Fuseli was obsessed by greatness – only Dante, Shakespeare, Milton and Michelangelo would do for him; and his ambition can be stated in a sentence – to render the most dramatic episodes of Shakespeare in the pictorial language of Michelangelo. He, more than anyone, exploited the fearful imagery of *The Last Judgement*. Of course Fuseli's Michelangelesque bogies never achieve the high seriousness of Michelangelo, but in their way they are effective, and they appeared at exactly the right moment.

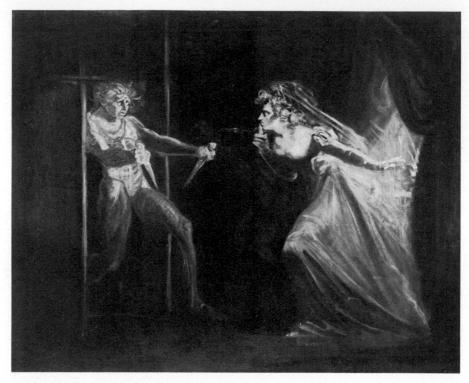

37 Fuseli, Lady Macbeth seizing the Daggers

Fear, which Burke had shown to be part of the sublime in 1756, had, by the time of Fuseli's return, become the object of self-conscious relish. For example, in 1773 a critic named Aikin published a book entitled On the Pleasures derived from Objects of Terror and an Enquiry into the Kinds of Distress which excite Agreeable Sensations. Moreover, Shakespearean revival, which had begun in the early eighteenth century, was passing into a new phase - no longer 'gentle Shakespeare', but the Shakespeare of ghosts and witches, violent death and the shedding of blood: in fact the Shakespeare of our own time. Macbeth was the crucial work, and critics discussed endlessly the propriety of the supernatural. This climate of opinion suited Fuseli perfectly. I cannot say that his famous painting of the three witches [36] is much more successful than those characters usually are on the stage. But his Witches' Cauldron has, I think, a sense of visual drama which is not trivially descriptive; and his innumerable drawings of Macbeth and the witches often show real imagination. Although he was an illustrator rather than a painter, a few pictures are so free and vigorous that one may reasonably call them Expressionist, and one of

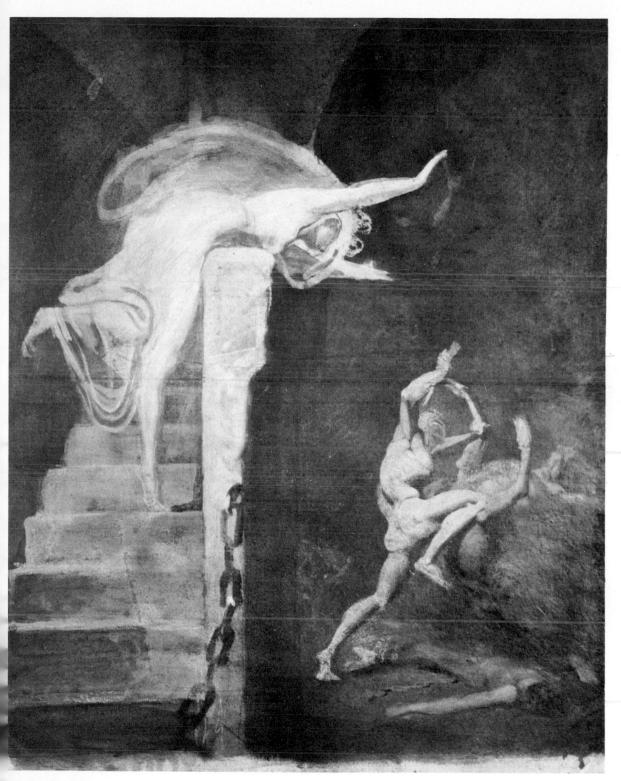

³⁸ Fuseli, Theseus and the Minotaur

them, a picture in the Tate, of Lady Macbeth with the dagger [37] must have been a strange apparition among the polished canvases of 1800 – as strange, for example, as Eduard Munch's *Sick Girl* was in 1895.

Now that sixteenth-century Mannerism has come back into fashion, it is no insult to say of Fuseli that the more Mannerist he is the better. I much prefer him when he exchanges the majestic armour of Michelangelo for the considerably lighter accoutrements of Tibaldi, and in consequence is more mobile and more independent. There is in Tibaldi something corrupt, cynical, frivolous and macabre, which is a relief after the solemn grandeur of an orthodox follower of Michelangelo like Daniele da Volterra. Tibaldi's frescoes in the Palazzo Poggi at Bologna illustrate the *Odyssey* with conscious cynicism, making the principal characters lascivious and absurd. Some of Fuseli's best drawings, for example, his *Theseus and the Minotaur* [38], show the same anti-heroic and cynical spirit.

Fuseli's works form a kind of anthology of Romantic themes, ghosts, witches, giants – and horses, which play such an equivocal role in the iconography of romanticism right up to the time of Picasso. In general, they are concerned with the two great irrationals,

39 Fuseli, Fear

64

1 David, The Sabine women enforcing peace by running between the combatants (detail)

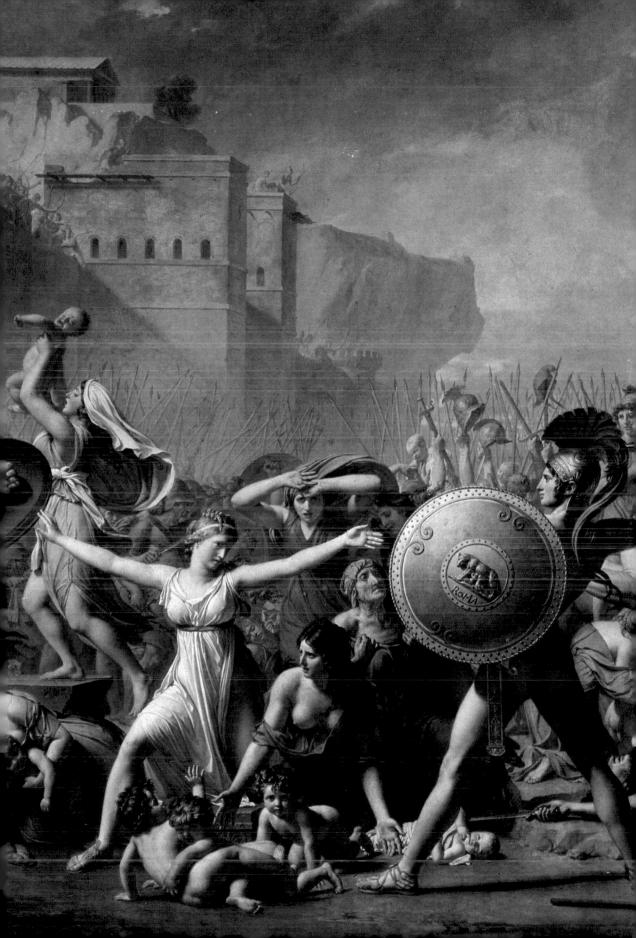

40 Fuseli, The Nightmare

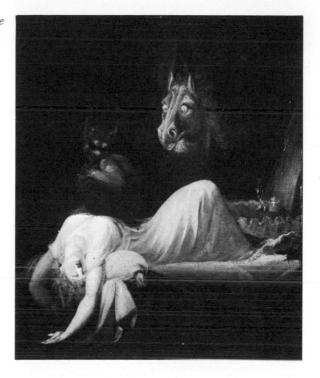

fear and sex, both of them communicated through dreams. Fuseli's first public success was in fact entitled *The Nightmare*[40], and was a parody of a picture by Reynolds called *The Dream* which had been exhibited and admired at the Academy a few years earlier. Once more classic doctrine and romantic practice mingle and overlap. In the Fuseli the goblin, the horse's head and the distorted pose were thought to have a very disturbing effect. That such a ridiculous work should have been admired shows that Fuseli had revealed to his time some hidden neurosis which was awaiting realisation. Artists who bring diffused emotional needs into focus are not by any means always of lasting value; in fact, they frequently degenerate into exploitation and trickery – the laws of libel prevent me from naming several contemporary examples. However, I think that Fuscli's response to fear was genuine. One of his drawings which has a delicate unforced emotion rare in his work is simply entitled *Fear* [39].

As for the other great irrational, many of Fuseli's most famous drawings are charged with allusions to sex. He was famous in his lifetime for his erotica, and after his death Mrs Fuseli (for unbelievably there was such a person) is said to have destroyed several hundred in her oven. However, a number have survived, and are of a ferocious obscenity more frightening than provocative. The ones in which

41 Fuseli, Polyphemus

sexual symbols are contained in the forms rather than revealed in their content are more effective. His visions of sleeping women, stirring uneasily under the influence of disturbing dreams, reflect a real imaginative need. Even the ladies of Reynolds and Gainsborough must have felt these fears and desires; and as we all know, the Age of Reason produced the Marquis de Sade.

All this makes Fuseli a portent in the history of romanticism, but not necessarily an outstanding artist in his own right. However, I think there are a number of his works that must be taken seriously. One of them is his *Polyphemus* [41], the least classical figure in antique literature, who lacked even the merit of symmetry. Once more we can go back to Tibaldi, whose *Blinding of Polyphemus*, although painted in the mid-sixteenth century, has the violence and the vulgarity of a nineteenth-century romantic. In this instance I think Fuseli has surpassed his model, because his *Polyphemus* has real imaginative force. He has seen the giant as a half-formed soul, midway between a gorilla and Rodin's *Penseur*, who has been outwitted by the human cunning of Ulysses.

Romanticism was a northern movement, a rediscovery of those natural forces, mists, mountains, dark rivers, impenetrable forests that are part of the European imagination but which had lain dormant during two centuries of Mediterranean authority. The artists, who in Rome itself propelled the first wave of international romanticism, Sergel and Fuseli, came from the north, the land of giants, monsters and heroes. It would be easy to present Fuseli as the successor to late gothic Swiss painters like Nicklaus Manuel Deutsch, or even to out and out Mannerists, like Goltzius; and it is interesting to speculate what would have become of him if he had gone back to Switzerland. But in settling in England he influenced such different artists as Romney and Mortimer. Above all he influenced - one may almost say, created - the style of Blake. Two more different beings can hardly be imagined; Blake who said that every thing that lives is holy, and meant it; and Fuseli, obsessed with fear, sex and violence in all its forms. And yet Blake wrote of him the famous but inaccurate doggerel:

> The only man that e'er I knew Who did not make me almost spew Was Fuseli; and he was both a Turk and Jew And so good Christian friends, how do ye do?

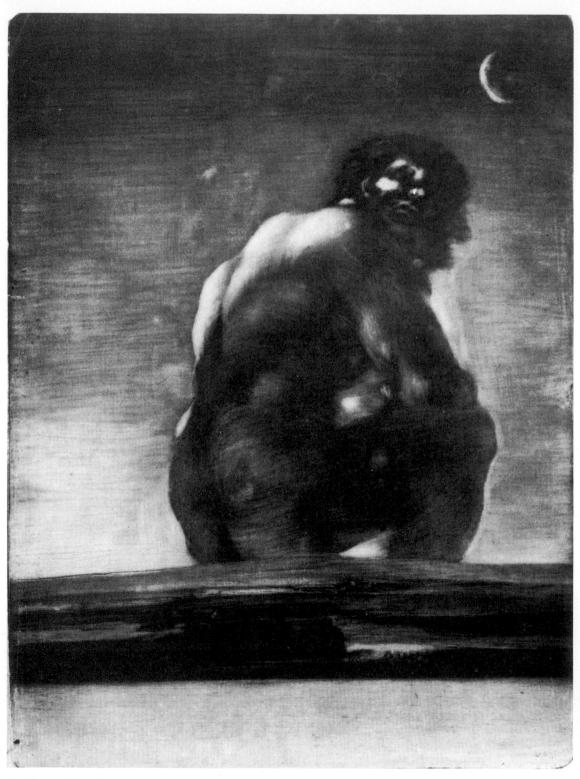

42 Goya, Giant (monotype)

Goya

At about the same time that Fuseli painted his giant Polyphemus (and shortly before Turner painted Ulysses deriding Polyphemus) another and more formidable giant loomed over the European horizon [42]. He emerged from the imagination of Francisco Goya, and as usual he shows the love-hate relationship of classic and romantic art, because although his torso is derived from one of the sacred images of classicism - the Torso of the Belvedere - the general effect of this image is unquestionably romantic. But have these words any meaning in talking about Goya? He is such an individual artist, and so much a genius that perhaps we should not think of him as part of a movement, still less the exponent of a fashion like Fuseli. The fact remains that almost every element in what I may call the 'iconography of romanticism' was used by Goya - witches, tortures, shipwrecks, assassinations - the whole works; but used, of course, with incomparably greater skill and imaginative power than the horror-comics of the early nineteenth century.

Francisco Goya was born near Saragossa in 1746. His father was a master gilder – not well off, but self-sufficient. Francisco was not only a born painter, but a tough, adventurous young man. At twenty-four he managed to make his way to Italy, and before he was thirty he landed one of the best jobs in Spain, principal designer to the Royal tapestry works. His designs are simply large pictures in a style which derives to some extent from the Tiepolos, father and sons. The father, Giambattista, ended his days in Spain, and although he had gone out of fashion by the time that Goya was a young man – replaced by the harmless Raphael Mengs – Goya could see that the Tiepolo style (especially that of the son, Gian Domenico) was exactly what he wanted to express his zest for life, everyday life - fairs, picnics, fun and games, a winter journey, a village wedding. They are brilliantly well done. I suppose no other painter of the time could have made such an easy, decorative composition as the scene of men in the snow bringing back an enormous pig [43] And what an appetite his work

43 Goya, Winter

reveals. Goya enjoys everything, enters into everything: he accepts the pleasant side of things. All the same, there is usually something disturbing, even in the early Goyas – some sharp flavour in his delicious eighteenth-century macedoines. In the very earliest of the tapestry cartoons one finds suspicious-looking characters that one would not find in a Tiepolo; and there is already an uneasiness about the crowd. And what about the famous picture of women tossing a dummy man in a blanket [44], one of the last of the tapestry cartoons? A charming theme for Fragonard, but the equivocal limpness of the manikin and the witch-like glee of the central woman already foreshadow the *Caprichos*.

All the same, the majority of Goya's tapestry designs are charming decorations, and they were very successful, so much so that two years later he became a court painter. This is one of the paradoxes about Goya. Though he was a born revolutionary, not only as a painter, but as a man, and had a low view of those in authority, he spent most of

44 Goya, The Manikin

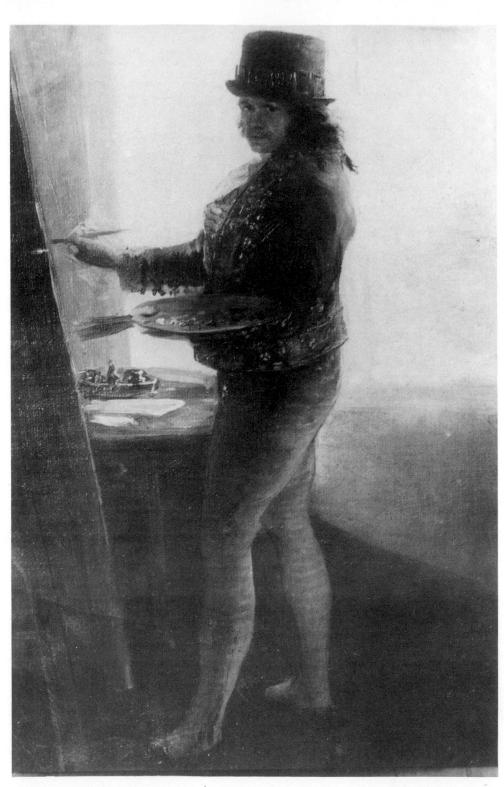

45 Goya, Portrait of himself at work

his time working for the court, and for what used to be called society; yet he never made the slightest concession. This is part of the tradition of Spanish painting. Cervantes said, 'Where truth is, God is, truth being an aspect of divinity.' This was the conviction of Velasquez, and Goya's first royal portrait, of the old King Charles III [46], has no flattery about it. In one way it is a traditional picture – it is a version of the portraits of Philip IV out hunting that Velasquez had painted about a hundred and fifty years earlier. But Velasquez had an almost inhuman gift of detachment which makes him one of the most mysterious of painters; he never shows us what he thinks about his sitters. Compared with him, Goya is like a novelist; we can almost hear him saying under his breath 'absurd, grotesque, a scarecrow: but not a bad old buffer, after all'. Goya's portraits had an immense success, which is not surprising when one sees how poised and elegant he could make people look [2]. All the *beau monde* of Madrid wanted to be painted by him, and they forgave him everything. I suppose there was a good deal to forgive. He was what used to be called a broth of a boy - quarrelling, fighting, bull-fighting and of course a great one for the girls. Incidentally, he was married to the sister of the painter Bayeu, and had nineteen children. From a portrait of himself at work one can see that he was [45] like one of those small tough

46 Goya, Charles III

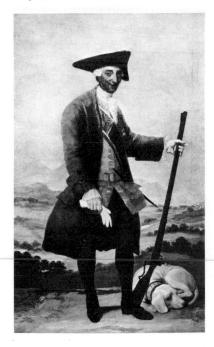

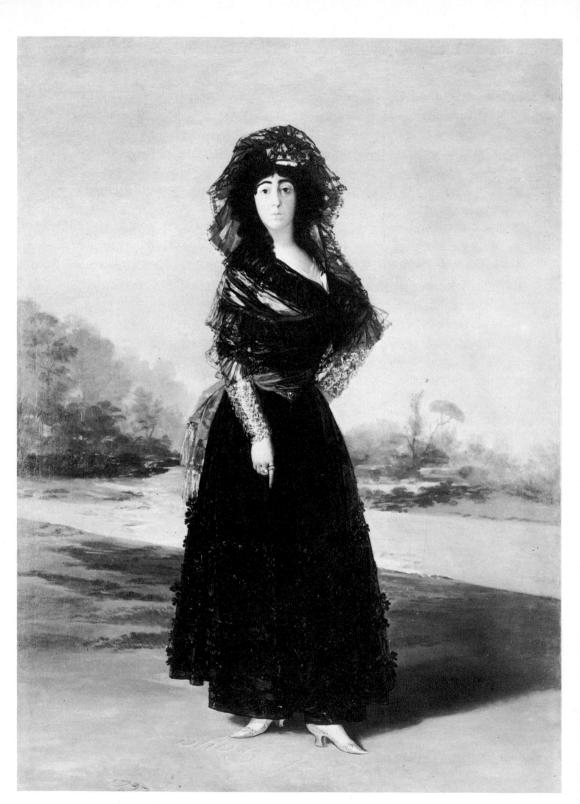

⁴⁷ Goya, The Duchess of Alba

Spanish bulls that he was later to depict so accurately. The funny hat he wears had a practical purpose – there are candlesticks all round the brim, so that he could work at night.

A good many of Goya's escapades are perhaps legendary – anyway, I do not see how we could know if they were true, unless, like Casanova, he had written an autobiography. But one was certainly true: his love affair with the Duchess of Alba, the queen of Spanish society, for after her husband died he went to live with her. In one of his portraits of her [47] she is wearing two rings, one inscribed 'Alba' and the other 'Goya', and is pointing down to the ground in which she has inscribed in the dust the word 'Goya'. All the same, she was not (as is sometimes said) the model for the famous picture known as the Maja Desnuda [48]. We do not know who was but one thing is certain, the fortunate owner of that neat little body was not the owner of the head. They do not fit and Goya would never have made such an awkward relationship between the head and the body if they had been painted from the same model. About ten years later he did a clothed figure in the same pose [49], much more freely painted, and I think a better picture.

Up to the age of fifty Goya had a glorious time. Then, in 1792, he had a mysterious illness. We do not know what it was, but presumably it was a form of syphilis as he thought he had brought it on himself. It knocked him out for about a year, and at the end of it he was deaf: not just hard of hearing, like Reynolds, or gradually losing his hearing, like Beethoven, but suddenly stone dcaf. This man who had been in the thick of life was suddenly cut off from it. For some reason human beings without their voices became for him grotesque and revolting and the solitude of his deafness was invaded by horrible monsters. In the next few years he began the series of etchings which he described with the same word that Piranesi used for his prisons, Caprices, and are called by the Spanish equivalent, Caprichos. They were published in the last year of the Century of Reason. Almost half the plates in the Caprichos are concerned with the supernatural; the rest are drawn from real life. One of them, which seems to have been intended as a frontispiece, shows Gova asleep on his drawing board, his folded arms supporting his sleeping head [50]. He is assailed by the emissaries of witchcraft, cats, bats and owls; and on the front of his desk is the inscription 'The Sleep of Reason Brings Forth Monsters'. One can interpret this inscription in two ways: either that when we are asleep our dreaming mind produces the bogies and witches which fill half Goya's plates; or, that human beings, when they abandon reason, fall

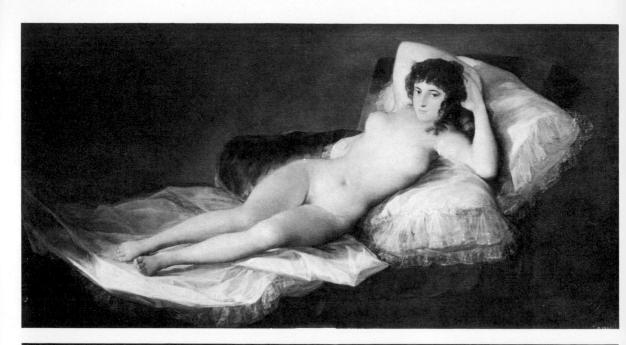

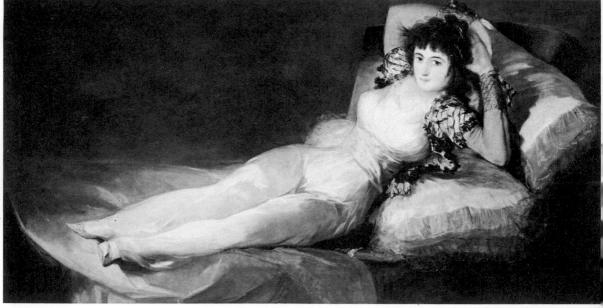

48 & 49 Goya, Nude Maja and Clothed Maja

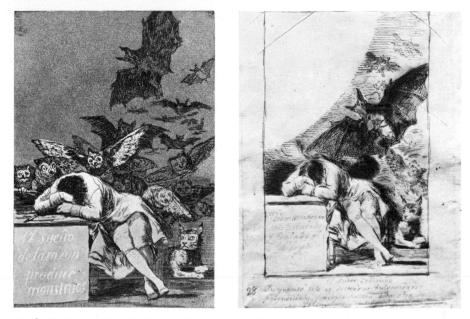

50 & 51 Goya, frontispiece to Caprichos and drawing for it

into the horrible practices that are illustrated in the other half of the series. The second is the more attractive interpretation, because it gives the Caprichos a philosophic basis, and also because the scenes of actual life are, to our taste, the more interesting part of the Caprichos. Goya shows an extraordinary skill in combining the vividness of a flashlight photograph with the durability of a long-sought design. The horrible incidents seem to have formed precisely the pattern of light and dark in his mind which could give them permanence. But I am inclined to think that Goya had the former interpretation in mind, because on the drawing for the etching [51], in place of the 'Sleep of Reason', is an inscription which begins 'Idioma Universal'. This must, I think, refer to the imagery in the supernatural scenes, and it is true that these monsters are of a kind which have haunted the human imagination throughout history. Creatures with heads growing out of their legs, dwarfs with enormous hands, old women with one eye, faceless figures wrapped in sheets, goats and donkeys enacting human roles and, of course, witches, do seem to be members of a regular cast, or universal idiom, of fear. They appear in antique art, in Oriental art, in the margins of medieval manuscripts, in Bosch and Brueghel, and in Arthur Rackham. But as we grow older, and as the world grows older, they cease to alarm us. Goya's dwarfs are cases for proper treatment; his witches a problem for the social-worker.

I suppose this is part of a general decline in a belief in the supernatural among educated people; and in addition we all know of actual horrors much more terrifying than those in the 'Universal Idiom'.

It is a surprising fact that Goya presented the plates of the *Caprichos*, this savage attack on society and the Church, to the King. Late in life he said that he had done so to escape from the Inquisition. I think he did so because the King liked them, and thought them funny. This kind old man continued to employ Goya in spite of his deafness, and even learnt sign language in order to communicate with him. Goya certainly rendered him immortal – and also the Queen. These royal portraits [52] are often thought to be satirical – of course they are not: they are simply true. Since Van Dyck we have grown accustomed to the idea that portrait painters must be flatterers, but in the seventeenth and eighteenth centuries great people were so sure of their status that they did not really mind what they were made to look like as individuals. In their portraits the later Medici look like criminal lunatics: they did not care – they were the Medici. The Queen of Spain in Goya's portrait of the royal family looks to us

⁵² Goya, King Charles IV of Spain and his Family

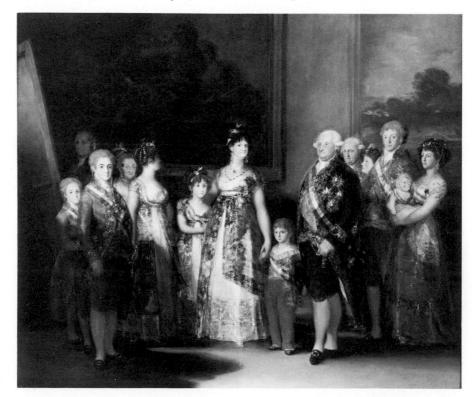

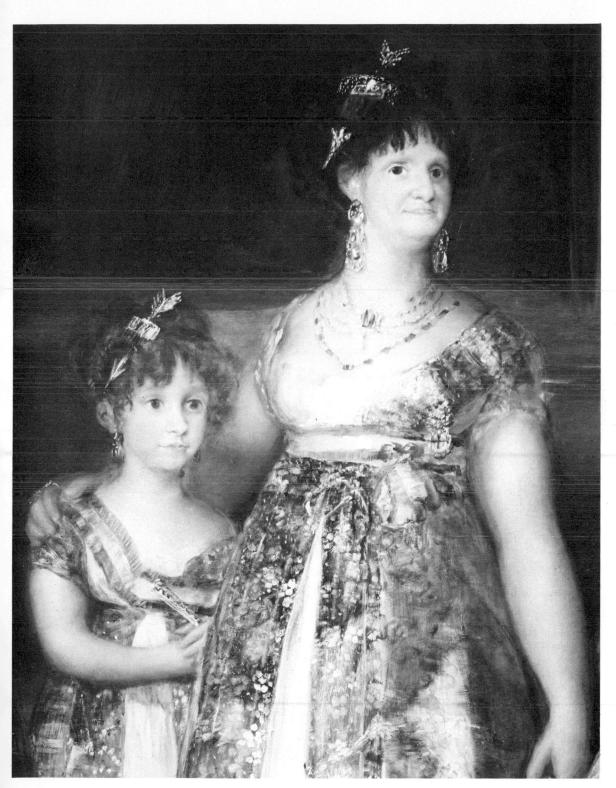

53 Goya, Detail of 52

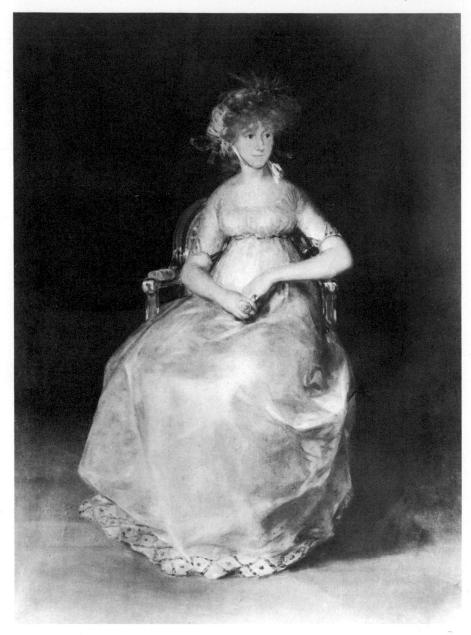

54 Goya, Condesa de Chinchon

ugly, vicious and common [53], but I am quite sure she did not think so. I suppose Goya must have known what he made her look like but he was not at all a squeamish man – he may have liked her. She had a number of lovers, including a very able and energetic man called Godoy, who was for many years the real ruler of Spain.

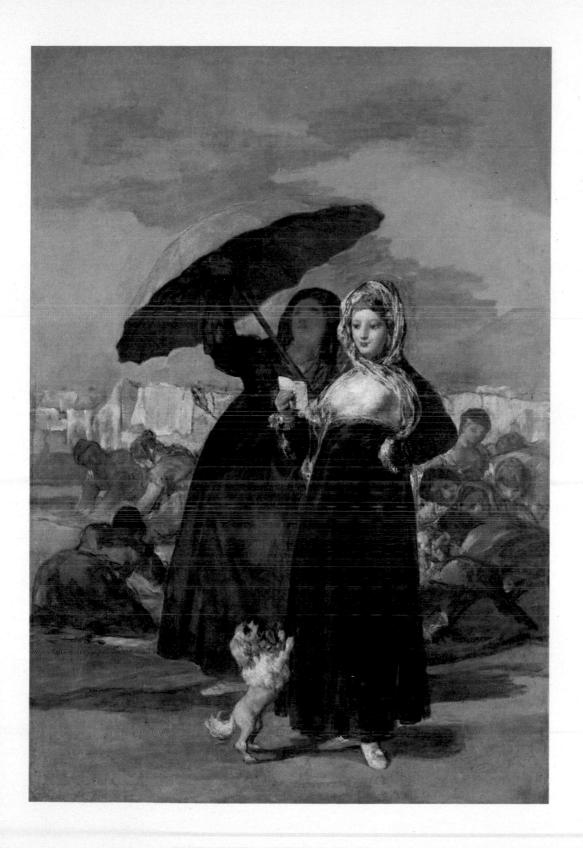

Goya recovered from his illness – not from his deafness – and achieved ten years of fame as a portrait painter. And what marvellous portraits they are. The society beauties of Reynolds and Gainsborough are almost entirely devoid of psychological insight but those of Goya show a sensibility to states of mind that has never been equalled. His *Condesa de Chinchon* with ears of corn in her hair is a sort of Ophelia; and she did in fact go mad [54]. Yet at first sight she is a society beauty.

Goya also painted pictures of life – but a different life from that of the tapestry designs. He seemed to be obsessed with all the horrible things which could happen to humanity when reason lost control, and he painted a number of pictures of madhouses, which were infinitely squalid in Spain in the eighteenth century. We know from Hogarth that they were the same in England, and that fashionable people used to visit them for amusement, just as people today go to horror films. It was this element of 'getting a kick out of it' that may have influenced Goya. There is really no element of pity in his pictures but there is a feeling of indignation against the authority which deliberately suppresses or perverts reason. This comes out clearly in two pictures of the activities of the Church: a procession of flagellants [55], with terrifying masks and grotesque head-dresses; and a tribunal of the Inquisition [56] where, in a nightmare travesty of justice, people are being condemned for opinions they may not even have

55 Goya, Procession of Flagellants

56 Goya, A Tribunal of the Inquisition

known they had. They are marvellously painted. Goya had always been good at painting crowds, and I suppose that his deafness helped. If one turns off the sound of the television one becomes intensely aware of the gestures and facial expressions of the performers; they become over life-size and slightly grotesque. This is how Goya saw humanity for almost forty years, and it is not surprising that those faces and gestures began to obsess him.

There is no doubt that Goya thought that one of the drugs chiefly responsible for the sleep of reason was the Church, and he had the lowest possible opinion of ecclesiastical institutions. However, this did not prevent him from painting religious pictures, completely sincerely because, like all Latin people, however little he believed in Christianity, he felt himself to be within the structure of the Catholic Church. One of his finest works was the decoration of a church near Madrid called S. Antonio de la Florida [57–58]. He used the kind of device that would have appealed to Tiepolo. He painted a balcony round the drum of the cupola, and behind it he put a crowd of loiterers who are supposed to be watching the saint raise a man from the dead. Very few of them are interested in this unusual event. They are interested in each other or themselves, and show very well the curious tension between the individual and the collective, which is the essence of a crowd. Everyone is intensely alive, and this is largely due to the vitality with which they are painted.

57 Goya, Detail of the cupola of San Antonio de la Florida

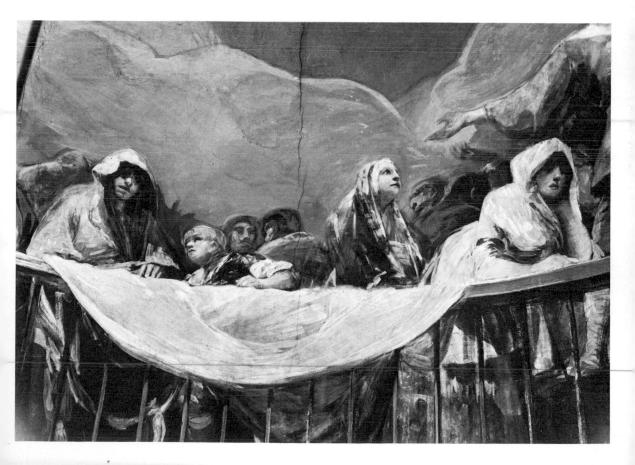

58 Goya, Detail of the cupola of San Antonio de la Florida

When one sees them close to, they are made up of great slashes of paint which come together when seen from below. Of course this is not religious painting – it is a scene of life. The strange thing is that Goya, who was so fond of painting the inhabitants of hell, could not paint the inhabitants of heaven at all. The angels he put into his church are the young people of Madrid as he saw them, and not looking at all holy or sexless, as angels are supposed to be [58].

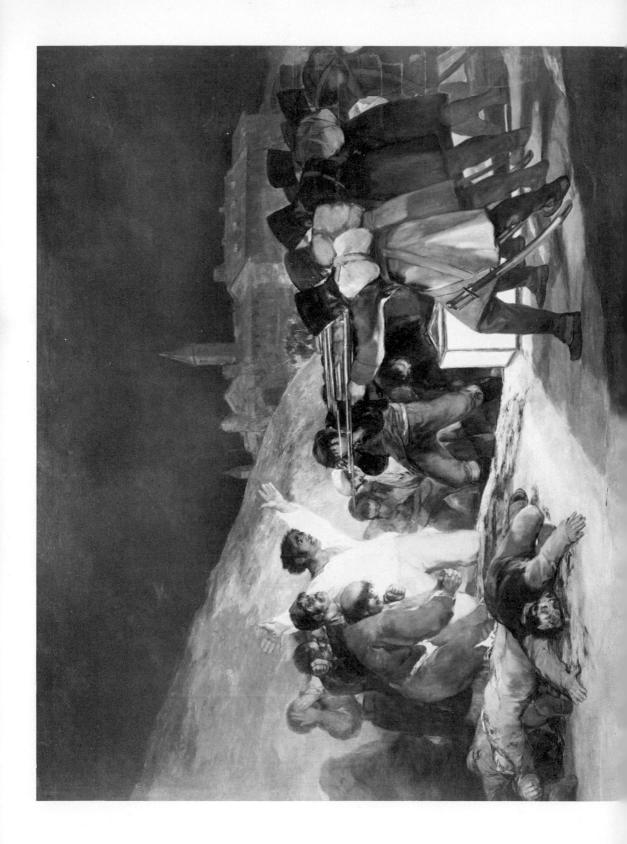

In 1808 a second crisis took place in Goya's life, and also in the history of Spain. The King abdicated, and Napoleon sent his armies to take over. Everybody outside England knows what an occupying army means. Goya was in an uneasy position. He had been in favour of the revolution, he had no reason to think highly of the monarchy, and he wanted to keep his job. At first he made friends with the invaders, but when he saw how they behaved – wanton destruction, ruthless butchery – his Spanish patriotism, or sympathy for ordinary human beings, re-asserted itself, and he left a record of the French occupation which is the most terrible and damning indictment of human cruelty ever made; and in saying that I am not forgetting the films made since the last war. Many of the etchings he made of the disasters of war [59] one cannot bear to look at.

Goya also did two large paintings of episodes on the 2nd and 3rd of May when the French asserted their authority in Madrid. Certain old-fashioned loyalists had shown a little fight. Two army officers had got hold of a gun on a hill above the city and let off a few rounds at the invaders. In reply the French general ordered that five thousand of the locals should be shot - just anybody who happened to be about. A firing squad found a convenient spot (it was just outside the present Ritz Hotel) and in the marvellous picture known as The Third of May, 1808 [60], we see them at work. This, to my mind, is the greatest picture Goya ever painted. It is completely original: the first time in the history of art that a painter has been able to take the direct transcript of an actual scene and make it into a great work of art. It looks like a flashlight photograph and has none of the build-up of other big pictures of historical events, even the best of them. Delacroix's Massacre at Chios [155] was painted in 1824, far later than the Goya, yet how much less modern it looks. One feels that all the figures in it have been posed and done from studies, whereas the Goya seems to have been done from one blinding flash of memory. As a matter of fact, it was painted about six years after the event and is not the record of a single episode, but a grim reflection on the whole nature of power. Gova was a man of the Age of Reason, and after his illness he was obsessed by all that could happen to humanity when reason lost control. In The Third of May, 1808, he shows one aspect of the irrational, the pre-determined brutality of men in uniform. By a stroke of genius he has contrasted the fierce, formalised repetition of the soldiers' attitudes, the steely line of their rifles, and the hard shapes of their helmets, with the crumbling irregularity of their target. As I look at the firing squad I remember that artists have been symbolising merciless conformity by this kind of inhuman repetition since the very beginning of art. One finds it in the bowmen on Egyptian reliefs, in the warriors of Asshur-nasir-pal, in the repeated shields of the giants on the Siphnian Treasury at Delphi. In all these monuments power is conveyed by abstract shapes. But the victims of power are not abstract. They are as shapeless and pathetic as old sacks; they are huddled together like animals. In the face of Murat's firing squad they cover their eyes, or clasp their hands in prayer; and in the middle a man with a dark face throws up his arms, so that his death is a sort of crucifixion. His white shirt, laid open to the rifles, is like a flash of inspiration which has ignited the whole design. The scene is, in fact, lit by a lantern on the ground, a hard white cube in contrast to the tattered shape of the white shirt. This concentration of light, coming from low down, gives the feeling of a scene on the stage; and the buildings against the dark sky remind me of a backcloth. Yet the picture is far from being theatrical in the sense of seeming unreal, for at no point has Goya forced or over-emphasised a gesture. Even the purposeful repetition of the soldiers' movement is not formalised, as it would have been in official decorative art, and the hard shapes of their helmets seem to deliver their blows irregularly. The Third of May, which seems to have been painted about 1814, shows that Goya's skill as a painter continued to grow and develop after the age of sixty. Indeed two of his most brilliant per-

61 Goya, 'Strange Madness', Disparates

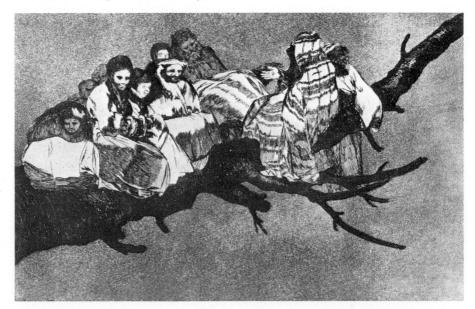

62 Goya, Old Women .

63 Goya, 'Madness of Fear', Disparates

formances were painted when he was over seventy. They represent two states of Woman – the young ones [3] nearly bursting with life, and a pleasure to the eye; the old ones [62] more horrible than pitiful, all their vitality turned to malice, waiting for Time's broom to sweep them away.

By this time Goya had ceased to be a realist. He was interested in the emotions aroused in him by certain visual experiences, and most of what he saw became mixed up with his own nightmare world. The supernatural meant a great deal to him. Even Murat's soldiers, whose brutalities he had set down with such ruthless realism, are frightened by an apparition [63]. He had certain obsessive fantasies [61]: one of them was flying, and he portrayed a large variety of flying figures. He was also obsessed, as many troubled minds have been, with men looking like animals and animals behaving like men. In 1819, when he was seventy-three, he bought himself a house near Madrid, which was known as the 'House of the Deaf Man', and he decorated it according to his fancy. The canvases are in the Prado, in the next room to the tapestry designs. You pass from the picture of a vintage [64], the most enchanting vision of a happy, fruitful life, to the picture of Saturn devouring his Children [66], which Goya had in his dining-room. The horrible fantasies are the familiars that the deaf old man chose to have constantly before his eyes in his own house.

64 Goya, The Vintage

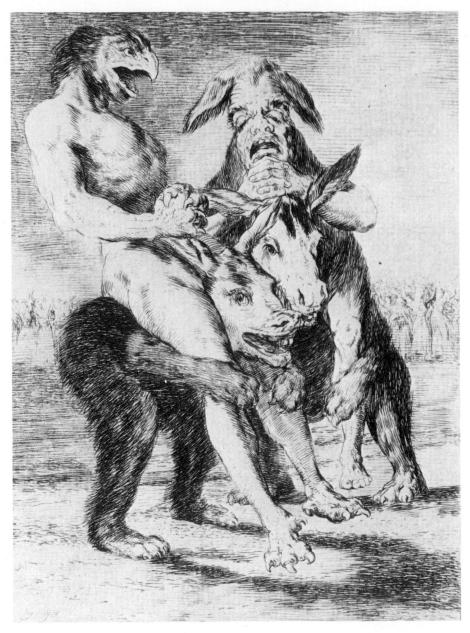

⁶⁵ Goya, Caprichos

Growing old is disagreeable, but it does not always involve quite such a catastrophic change as this. What had happened? That he was obsessed by these bogies [68, 4] and had to externalise them? Yes: but they are not entirely bogies – that is what makes these private pictures so much more disturbing than the animal-headed monsters of

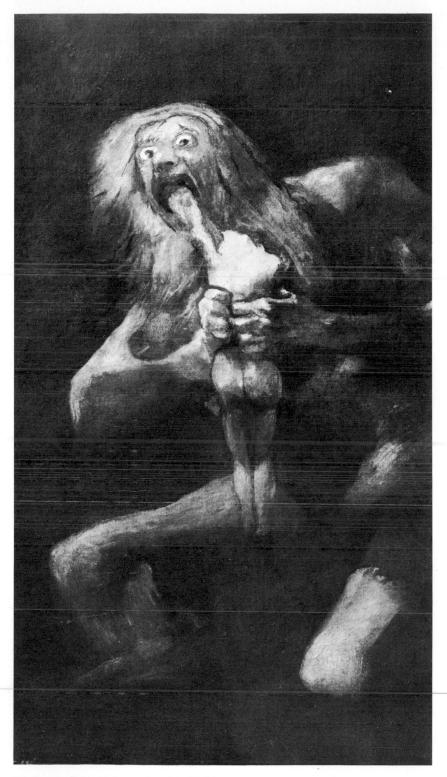

66 Goya, Saturn devouring his Children

67 Vincente López, Portrait of Goya at the age of eighty

the Caprichos [65]. Goya has brought his haunted imagination and his observation of human beings into the same focus. The best of the decorations still represent the crowd, but many times more monstrous and diabolically possessed. As Monsieur Malraux has said, with unusual simplicity, 'He is the greatest exponent of agony that Europe has known'. No wonder Goya means so much to us today. His letters give no sign of melancholia: they are full of fight, of high spirits, even, when he was over eighty. I suppose it is possible that Goya was less frightened of his monsters and horrified by his horrors than people nowadays assume. In a saturnine sort of way he may have rather enjoyed them; and he certainly got satisfaction from the reckless, masterly way he rendered them in paint; because these private pictures are painted with a freedom that never occurs again in European art till the time of the Expressionists. Goya escaped from the classical tradition in a way that Géricault and Delacroix never did. Somebody once asked Goethe, at the end of his life, the difference between classicism and romanticism, to which the author of Werther (who was no doubt sick of the question) gave the shortest reply on record: 'Classicism is health, romanticism disease.' If that were true, Goya's last pictures would be the climax of romanticism, for never has disgust with human life infected a mind more completely and caused a more catastrophic disease of the imagination.

At the end of his life Goya left Spain. A violent reaction was taking place under an evil-looking booby of a king, Ferdinand VII, the third – and worst – of Goya's royal masters. I suppose the old revolutionary did not feel too comfortable, although he remained the court painter, and said that he was going to France only to take the waters. He actually went to Paris in 1824, and saw the Salon which exhibited Constable's *The Hay Wain* and Delacroix's *Massacre at Chios*. On the way back he was painted by Vincente López [67] at the age of eighty-two, and wrote at the time: 'I can't sec, or write or hear – I have nothing left but the will – and that I have in abundance.'

68 Goya, The Pilgrimage to San Isidoro

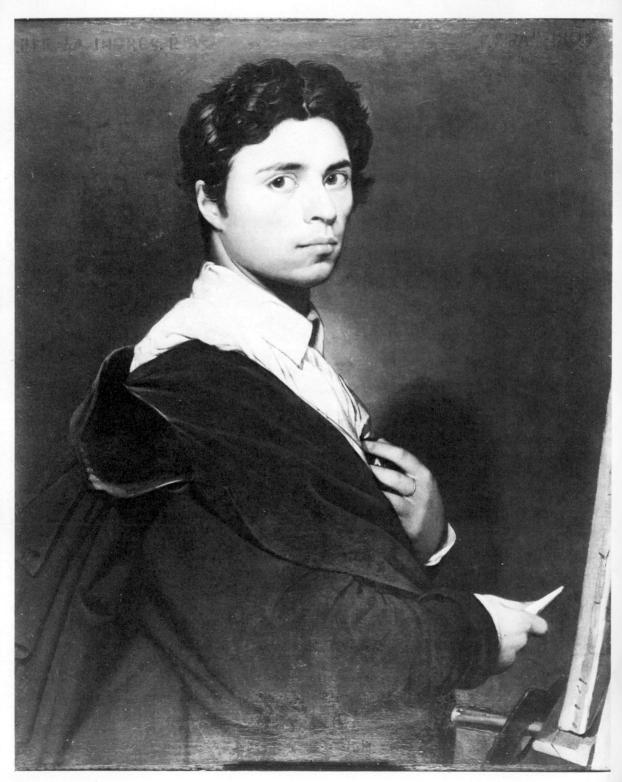

69 Ingres, Self-portrait

Ingres I

4

The Years of Inspiration

For over a hundred years Ingres was generally considered the model and high priest of classic art, and his famous dictum 'Drawing is the probity of Art' used to be written up in academies, to frighten naughty students, all over the Western world. I have even seen it in the art school of Bombay. This reputation would have pleased him. During his lifetime he built himself up as a little god of orthodoxy. He stumped out of exhibitions if they contained romantic pictures; he was a dismal and repressive director of the French Academy in Rome; and if one of his followers showed the least sign of spirit he would cry 'Traître!' But this disobliging image gives a false impression of his art. It could be argued that he painted only three purely classic pictures. One of them [70] is the exceedingly boring Academy piece which, as a student, he submitted for the Prix de Rome. Its full title evokee eloquently the academic world - The Ambassadors of Agamemnon sent to pacify Achilles, finding him in his tent with Patroclus occupied in singing the exploits of Heroes. The title is better than the picture; it won the prize.

The second is a far more admirable work, the Romulus Conqueror of Acron [71], painted in 1812 for a room in the Quirinal, which, although boring at first sight, is an impeccable and convincing piece of Greco-Roman design. The third is a genuinely moving piece of classicism entitled Tu Marcellus Eris [94], Virgil reading the Aeneid to Augustus, a work so severely concentrated that in the final version even the figure of Virgil has been cut out. The rest of his paintings, however classical in content, are not at all classical in style. An intelligent contemporary, Theophile Silvestre, went so far as to describe him as 'un peintre Chinois égaré dans les ruines d'Athènes' – a Chinese painter astray in the ruins of Athens. I do not suppose Silvestre had ever seen a genuine Chinese painting, but he had the right idea. The sinuous line and the absence of shadow in Ingres' best work has some-

thing oriental about it, as has his combination of sensuality and cold detachment.

In all this he differed radically from his master, David. David believed in action and, as classic theory dictated, that painting should influence conduct. Ingres was what we nowadays call a pure artist. He was, I believe, the first painter to whom the term 'art for art's sake' was applied in a pejorative sense, for the writer called de Langevais goes on to complain, in words that have a painfully familiar ring today, of his egotistical detachment from all sentiments of community or solidarity. I resist the temptation to contrast David's Horatii [5] with Ingres' Bain Turc [102] and put forward as a juster comparison, a picture in which Ingres himself is making one of his rare attempts to be an official artist. Plates 72 and 73 show portraits of Napoleon by Ingres and David, done within a few years of one another. That of David is doggedly realistic; and his determination to take into account all the facts - the facts of the furniture no less than the wrinkled stockings - is subservient to his political intention. The clock stands at ten past four; the candle has burnt out. 'You are right, David,' said Napoleon when he saw it, 'all night I work for the happiness of my subjects and the day of their glory'. The Ingres, on the other hand, is like a gigantic bibelot, a cameo, an ivory consular diptych, or, perhaps consciously, an Ottonian miniature. It is a dazzling piece of design. The virtuosity with which Ingres has played with those arcs and diagonals, the balance between rational and irrational shapes, all this holds us spellbound like a piece of exhibition skating, and for considerably longer. Art for art's sake? Not entirely, for we have already conceded something in comparing it with a cameo – with a work in which perfection, durability and finality are themselves symbols of authority. It is divine authority the deified emperor and not the supreme servant of the state. David's Napoleon has the realism of late Republican art in Rome. Ingres' Napoleon has the decorative magic which the Emperor assumed when he once more made his capital in the old Greek Empire. The authority of perfection; the magic of a style which fastens on the object like a bird of prey on its victim: these are the characteristics which the youthful Ingres, who had not yet gone to Rome when he created this objet de culte, had already imposed on classic idealism.

Jean-August Dominique Ingres was born in Montauban in the year 1780. He was, as one can see from his self-portrait [69], a true southerner; short, olive-skinned, with large brown eyes – not unlike

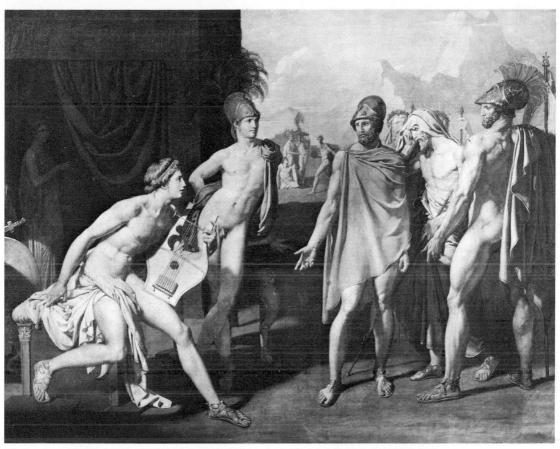

70 Ingres, Ambassadors of Agamemnon sent to pacify Achilles

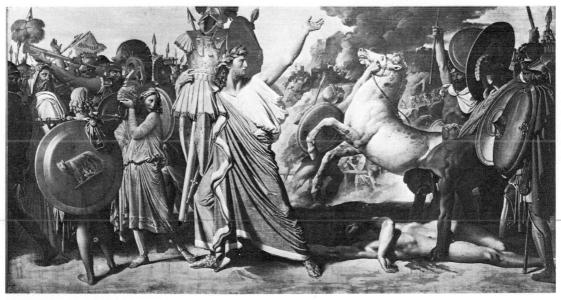

71 Ingres, Romulus Conqueror of Acron

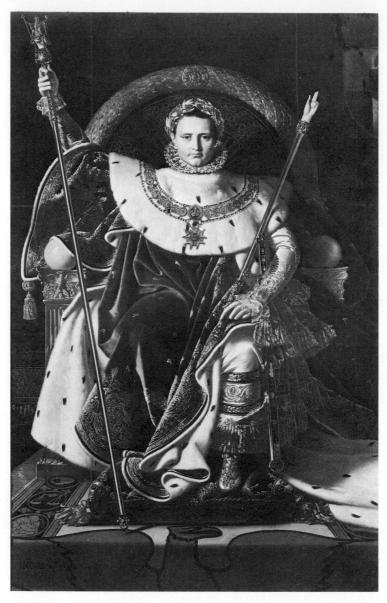

72 Ingres, Napoleon I on the Imperial Throne

the young Picasso. His father was an artist (his grandfather had been a master tailor) and Ingres was from the start destined for the arts. His education was scanty and, like so many of those who have recreated the antique world for us, he knew no Greek and practically no Latin. Throughout his life he was embarrassed by his lack of culture, although he maintained, with some truth, that by spending 100 his youth in Toulouse he drank in more of antiquity than was possible

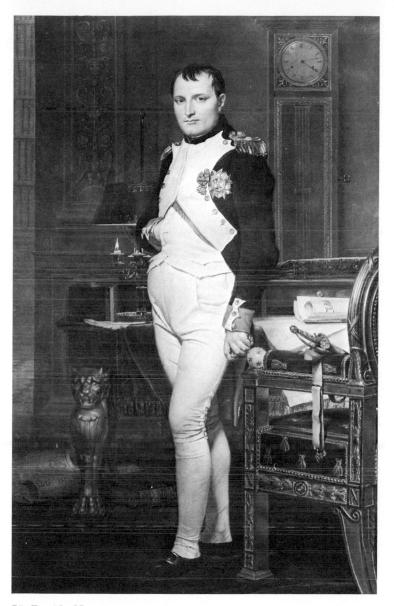

⁷³ David, Napoleon in his Study

to more systematic students in the north. In 1797 he came to Paris and entered the *atelier* of David, where he worked on the *Madame Récamier* [10], not only on the candelabra and accessories, but on the actual figure. It was three years after this that he won the Prix de Rome with that picture of Achilles and the Ambassadors of Agamemnon, which I have already mentioned as an example of classicism at its purest, its most derivative and its most boring. The figures are 101 taken from engravings of antique statues in Visconti's Museo Pio Clementino. In his determined effort to be respectable the young man from Montauban has not betrayed a spark of his own personality. Curiously enough the picture was much admired by the English sculptor Flaxman – I say curiously, because it was precisely thanks to Flaxman that Ingres was able to escape from this orthodox classicism, and discover a style with which to begin the lifelong process of discovering himself.

The origins of this style date back to 1766 when Sir William Hamilton published, in four magnificent volumes, etchings of his collection of vases, Etruscan vases, as they were then called, which shows that early Greek art was not at all like the vapid Hellenism of the Museo Pio Clementino. Their style, which could be inaccurately, but reasonably, associated with the time of Homer, was vital and decorative, welcoming sharp contrasts of tone and passages of decorative detail, relying for its effects on pure outline and silhouette. It was the last of these qualities which appealed particularly to Flaxman, and in 1783 there appeared his two volumes of illustrations to the Homeric poems.

Flaxman's engravings [74] may not now seem very impressive to us as works of art, but they had two qualities which made them extremely influential in their own time. First, their inexhaustible invention, and secondly their power of representing everything by pure outline. These two qualities were particularly important to Ingres. It is a mistake to say (as is often said) that he had no power of imagination, but the central formal ideas which lay almost out of reach at the back of his mind were so obsessive that they restricted free invention. The exact reverse was true of Flaxman; and precisely because he was devoid of a dominating central idea he could pour out inventions. The fact that they were diluted and descriptive did not make them less valuable to those greater artists who were in need of a precipitant. The emptiness of their facile outlines was even a sort of recommendation, because they were like a suit of clothes in which a more substantial idea could be decently covered. David, when he was shown Flaxman's designs, said: 'Cet ouvrage fera faire des tableaux'; and it did, his own as well as those of Ingres.

This inventiveness was of value to Ingres only because it was expressed in a style which was perfectly congenial to him, that of the pure outline. Ingres was one of those artists to whom the outline was something sacred and magical, and the reason is that it was the means 102 of reconciling the major conflict in his art, the conflict between

74 Flaxman, illustrations to Hesiod

abstraction and sensibility. The difference between what we see and a sheet of white paper with a few thin lines on it is very great. Yet this abstraction is one which we seem to have adopted almost instinctively at an early stage in our development not only in Neolithic graffiti but in early Egyptian drawings. And in spite of its abstract character, the outline is responsive to the least tremor of sensibility. Outline had a further recommendation to Ingres; the quality which Blake, the friend of Flaxman, describes in his Descriptive Catalogue, in these words, 'A great and golden rule of art, as well as of life, is this: that the more distinct, sharp and wiry the bounding line the more perfect the work of art.... What is it distinguishes honesty from knavery, but the hard and wiry line of rectitude and certainty in actions and intentions.' Ingres would certainly have recoiled in horror at the sight of one of Blake's drawings, but he would have agreed with his sentiments; and I suppose this explains the famous saying of Ingres' with which I began – 'Le dessin c'est la probité de l'art.' The

103

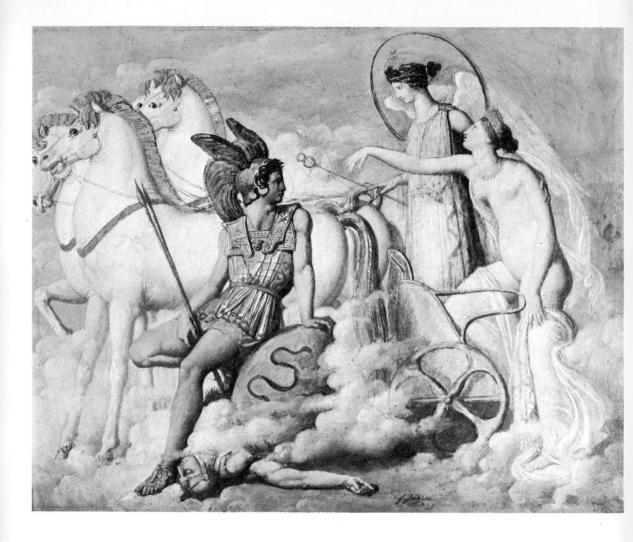

75 Ingres, Venus wounded by Diomed

earliest drawing in which Ingres is completely himself is one in which the love of Antiochus for Stratonice was discovered when the sight of her cured his illness [76]. This story, which Ingres could never read without tears, occupied his mind for the next sixty years. The figure behind Antiochus is pure Flaxman but Ingres' line already has a variety, and a power of conveying relief of which Flaxman was incapable.

Ingres was also making a direct study of Greek vases, and he must have spent much of his time between 1801 and his departure for Rome in 1806 copying them or tracing them (he was a great believer in tracing as a means of self-education) from books of engravings. An exquisite little picture [75] of *Venus wounded by Diomed* seems to be the first result of these activities. It is made up of motives from vases engraved by Tischbein. The contrast to the *Agamemnon and Achilles* is complete, and we see at once how archaic art has allowed Ingres to release his natural gifts, his sense of precise and intricate pattern, the cameo-like completeness of his design, even his peculiar response to the female of which I shall have more to say.

Once this style was achieved Ingres was immediately able to apply it to other subjects. Indeed his first delight in it gave to his eye a sharpness and to his hand a precision which he never excelled. The portrait of *Madame Rivière* [5], painted in 1805, remains almost his

76 Ingres, Stratonice and Antiochus

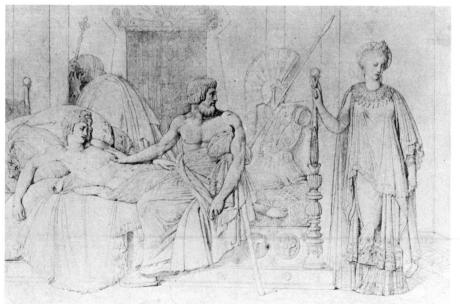

masterpiece. By lighting her from in front, so that the shadows only just begin to appear at the edge of the contours, he has preserved the linear character of the design, as Manet was again to do in the Olympia. The drawing is more sharply accented than in Ingres' later work. He might perhaps have come to consider the arc of her shoulder as too much simplified and, under the influence of Greek vases, the drapery as almost archaic. But on the whole this is Ingres 'tel qu'il fut' - as he was, and as he was to remain for the next sixty years. The study of Greek vases has allowed him to accept as decoration the dark clusters of Madame Rivière's curls; and we see how this linear style has allowed him a marvellous interplay between the abstract and the physical. The fullness of form of Madame Rivière's corsage is conveyed with a simplicity and a sense of preordained pattern which is the great achievement of classic art. As Hazlitt said of Poussin, 'It denotes a foregone conclusion', and yet it is responsive to the most delicate sensuality. Mademoiselle Rivière [77], painted at the same time, expresses a different, and more complicated, sentiment, and one unique in Ingres' work. She has evoked in him a succession of symbols of Spring – the snake, the snowdrop, the tulip and its sheath, the young bird. This straight Spring shoot is lapped round by the folds of a fur boa, which seems to retain some of its animal life. To find a parallel to the design we must look to the Italian quattrocento; for the sentiment to Leonardo, who alone could look on this kind of beauty with the same combination of intensity and detachment. Madame Rivière could never understand what Monsieur Ingres saw in her daughter. A few years after this picture was painted the exquisite sitter died of consumption.

Because in 1806 any artist earlier than the mature Raphael was considered primitive, the primitivism of Ingres' work was then, and for fifteen years, considered shocking. It was not altogether unprecedented. There was a coterie among David's students who actually called themselves 'the primitives' but Ingres' feeling for *quattrocento* art was far more serious than that of these forgotten pre-Raphaelites of 1800; and it was confirmed, when at last he arrived in Italy in the Autumn of 1806. His famous remark on arriving, 'Comme on m'a trompé' – how they have deceived me – was presumably aroused by his realisation that *quattrocento* art was superior to that of orthodox classicism. The drawing of Stratonice and the Mademoiselle Rivière show us that he had made this discovery before he had left Paris, so perhaps, like all famous sayings of 106 the great, it is apocryphal; but the greater wealth of *quattrocento*

77 Ingres, Mademoiselle Rivière

78 Ingres, Monsieur Granet

painting, which he saw in Italy, had the effect of strengthening his conviction and enriching his style.

Ingres must have gone to Rome with a reputation as a portrait painter, and soon after his arrival he received commissions. The result is a series of portraits which are the most easily appreciated of all his works. Anyone can see that *Granet* [78] and *Madame Devauçay* [79] are beautiful pictures. They are even without that sharpness of colour which disturbs the sensitive in his later work. The Granet also shows his skill in designing with contrasts of light and dark tone which, like Madame Rivière's curls, he had learned from the Greek vases. The Poussinesque landscape is something which disappeared from Ingres' work after about 1807 and shows how completely he had assimilated the tradition, which goes from Piero to Seurat via 108 Poussin and Corot.

9 Ingres, Madame Devaucay

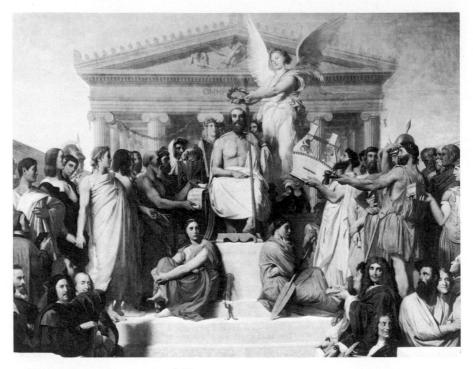

80 Ingres, The Apotheosis of Homer

'The portraits of Holbein', said Ingres at the end of his life, 'are above everything: or rather, they are only surpassed by the portraits of Raphael.' Madame Devauçay is the first illustration of this theme. We are fortunate in having the drawing in which Ingres finally fixed the design, and it shows how severely abstract was the scaffolding of his portraits. In the picture, although every shape retains its identity, for example the compact and decisive shapes created by the necklace and the dress, Ingres has managed to give a certain softness of modelling; the arm and an expression to the head prevent any theoretical dryness. Monsieur Ingres forbade his friends from pronouncing the name of Raphael before his works - 'Compared with him', he said, 'I am so high' (bending down) 'no, so high' (bending till he almost touched the floor). And so we may feel when we compare his Apotheosis of Homer [80] with The School of Athens, but when we confront Madame Devauçay with one of Raphael's portraits, the comparison is not far-fetched. I may add that Ingres' approach is slightly more 'primitive' than even an early Raphael. Incidentally, Madame Devauçay (who had been the mistress of the French Ambassador to the Holy See) lost all her money and came to Ingres as 110 an old lady to confess that she must sell her portrait. Ingres did not recognise her. He persuaded his friend, Monsieur Reiset, to buy it for a very large sum, and it is now at Chantilly. *Madame Devauçay*, like *Madame Rivière*, presents in a discreet manner the *primum mobile* of Ingres' art, the tension between his intellect and his senses. The connection between beauty of form and sex is extremely obscure, and is perhaps one of those subjects best left alone. At any rate one can say that with Ingres it was so close as to amount to identity. It was only in his rapture at the sight of the female figure that Ingres could realise his inner ideal of order. It is true that this ideal forced the female figure to conform to some strange rules: on the other hand, without his particular emotion the idea could not have come to life. I believe that this state of mind is commoner than is supposed, and that an inability to accept it naturally was the ruin of such an artist as Burne Jones.

The Baigneuse [81] in the Bonnat Collection in Bayonne is perhaps the most abstract of all Ingres' nudes, in fact the line below the breast is one of the few contours in Ingres where we question his dependence on nature; and although certain passages, like the breast and hand, are characteristic, she is not quite at the centre of Ingres' imagination. This position was occupied by two nude figures which took shape during his first years in Rome, and remained there for the rest of his life, the Baigneuse de Valpinçon [6], and the Venus Anadyomene. It is in the Grande Baigneuse more perhaps than in any other picture that Ingres has succeeded in embodying his idea. We can recognise this, not only because it speaks to us in the accents of fulfilment - it shows what Blake calls 'the lineaments of gratified desire' – but because Ingres used the figure in several other works, and fifty-five years later made it the centre of his last outpouring of essences, the *Bain Turc* [102]. It is before this picture more than any other that we are reminded of the phrase of Baudelaire, the disciple of his great adversary, who yet understood him so well; 'If the island of Cythera had commissioned a picture from Monsieur Ingres we can be sure that it would not have been gay and playful like that of Watteau, but robust and nourishing like love in the antique world.' In the Grande Baigneuse this sensuality is achieved not only by the pose and the outline, but by the enchanting delicacy of the reflected light, which reveals the modelling of the uneventful back. This is something which Ingres hardly ever permitted himself again, and we see, as often in his colour, that confined within 'the hard and wiry line of rectitude' was a natural painter, who could easily have taken a totally different direction. Fortunately he felt able to realise

e 111

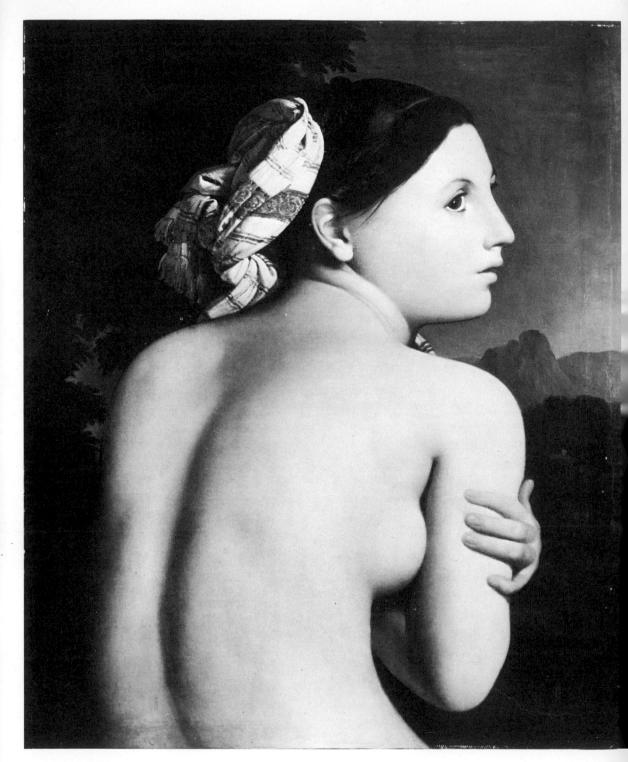

81 Ingres, Baigneuse

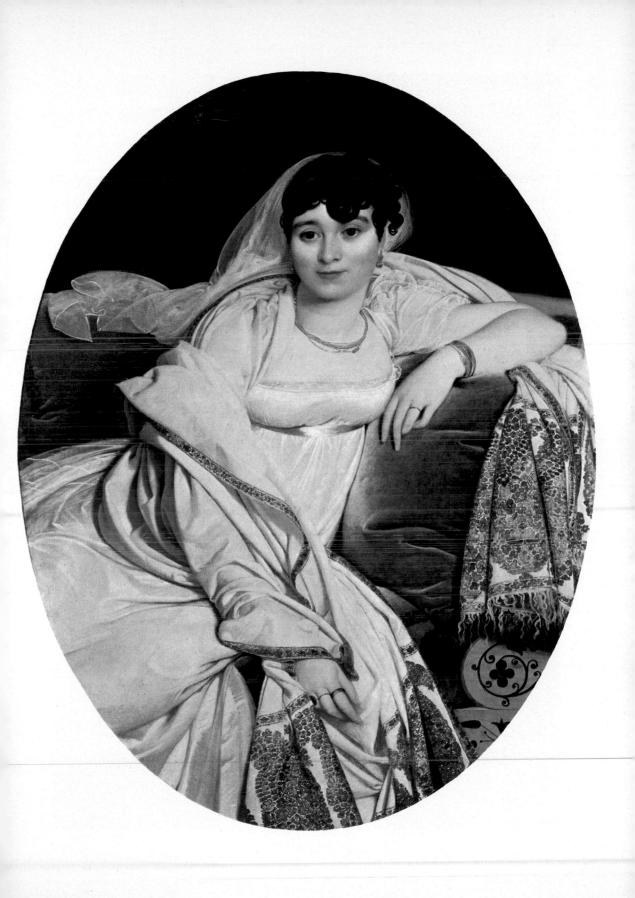

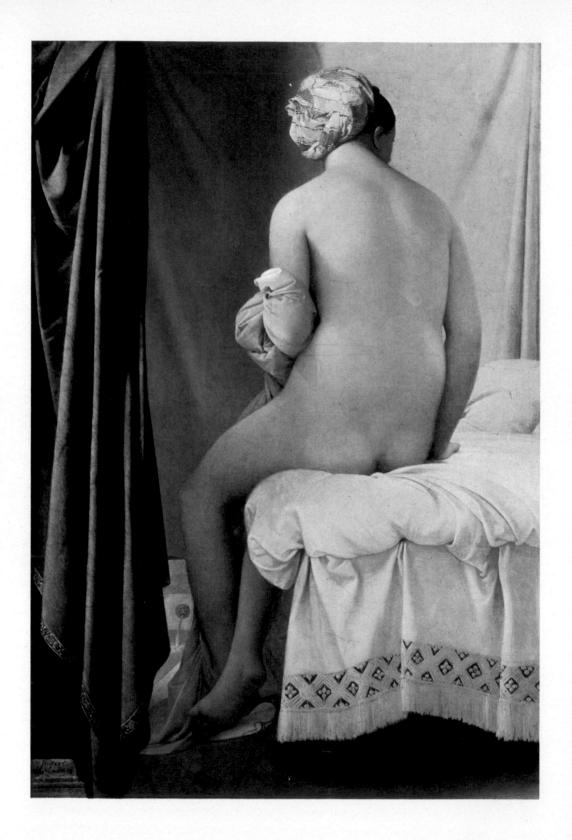

this figure almost as soon as he conceived it (or rather discovered it, for it is in fact the adaptation of an erotic print). Of the central image to which I have referred, one remained in his studio as a drawing and cartoon seemingly beyond his powers of realisation – the *Venus Anadyomene* [82]. It was finally carried out forty years later, when the demands of self-criticism were less rigorous and, beautiful as it is, the picture at Chantilly lacks the clarity of largeness of facture of the *Grande Baigneuse*.

An even greater disaster befell the third Eve to emerge from his side in that year of marvels: the reclining figure known as the Dormeuse de Naples because it was sold to Murat, King of Naples. When his kingdom collapsed the picture was lost or destroyed, and we know it only through a drawing and much later replicas, which prove that she was quite as beautiful as her sisters. These figures leave us in no doubt as to what gave the twenty-eight-year-old Ingres the impetus to create masterpieces: it was the female body, or (since it is equally evident in Madame Rivière's corsage), in the modern idiom, sex. However, one must in fairness admit that in the same year of inspiration, 1808, he did a male nude of great beauty and distinction, the Oedipus guessing the riddle of the Sphinx [83]. Perhaps you may feel that I should have included this among Ingres' classic paintings, but his contemporaries condemned it as Gothic, I suppose on account of the sharp delineation of every shape - look at the intervals between Oedipus' hands and the Sphinx's bosom. Ingres himself was furious when a friend said that he had idealised the model. 'I do not idealise. I am the very humble servant of the model before me.' The frightened Theban in the background illustrates the point I have made that in every classic artist there is a romantic artist struggling to escape, Incidentally, this is one of the few passages in all his painting with which Ingres expressed himself satisfied. A year or two later the romantic escaped entirely, and painted, for the ceiling of Napoleon's bedroom in the Quirinal, a scene from the Emperor's favourite poet - The Dream of Ossian [85]. Napoleon never slept there, and the picture, much damaged, was bought back by Ingres, who unfortunately decided to convert it from an oval into a square, thus destroying some of the feeling of dream-like buoyancy. Even so it remains a haunting work.

If critics attacked such a restrained and beautifully polished piece of academism as the *Oedipus*, Ingres very properly decided that his next picture would (as nurses say) 'give them something to cry for'. He determined that it should be an uncompromising evocation of 113

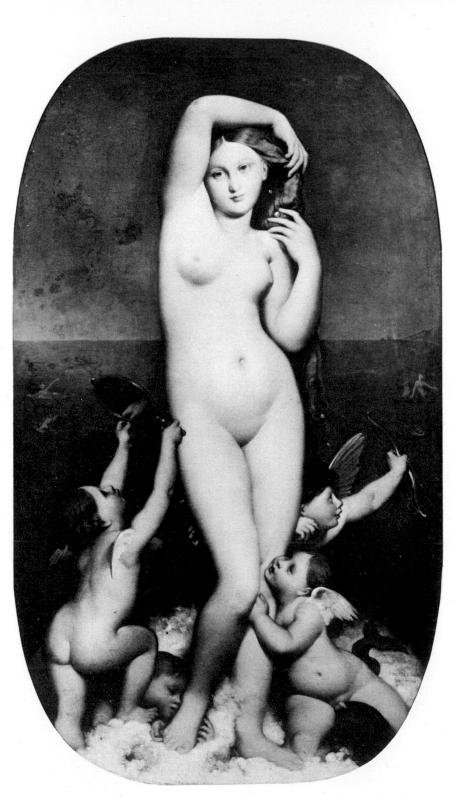

82 Ingres, Venus Anadyomene

the Homeric world, containing all that he had learnt from Greek vases and from the recently imported pediment of Aegina. He wished, he said, that his picture should exhale a perfume of Ambrosia. The result was the *Jupiter and Thetis* [84], the most wilful of all his historical pictures, but also, to my mind, the most beautiful. Even as late as 1810, when he was surrounded by genuine specimens of ancient art, he did not forgo the help of Flaxman, as two engravings from the *Homer* show. That Ingres at the height of his powers should

83 Ingres, Oedipus and the Sphinx

115

84 Ingres, Jupiter and Thetis

need the stimulus of these miserable outlines is as mysterious as the pollination of an orchid. However, to change the metaphor, the pearl which formed itself round this scrap of matter is entirely his own. The strange hieroglyphic of the female body, the neck like an amorous swan, the elongated arms, boneless, distorted, and yet disturbingly physical, are all from the centre of his being. Unfortunately, the drawings for this composition are lost, so that we cannot 116 trace the steps by which Ingres poured the wax of his physical

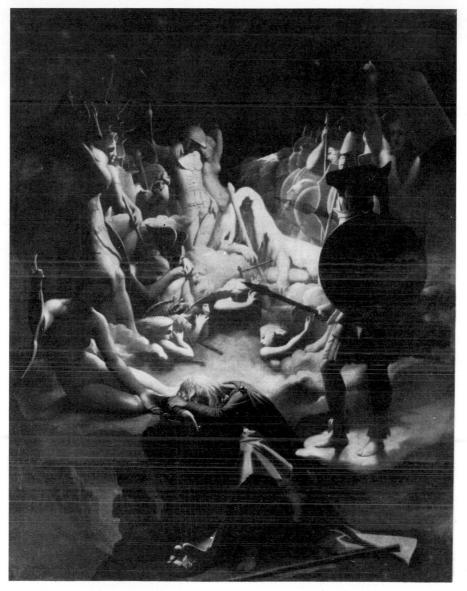

⁸⁵ Ingres, The Dream of Ossian

sensations into the mould of his imagination. I would give a lot to see the genesis of the marvellous hand, half octopus, half tropical flower, which caresses so insinuatingly the impassive Jupiter. In spite of Ingres' archaeological researches, the style of the picture is entirely that of this time – the epoch of Percier and Fontaine. Yet his belief that he was aspiring to the painting of the ancients was to receive a remarkable *a posteriore* justification through the discovery of the Villa Item. It is hard to believe that the figure of a kneeling 117

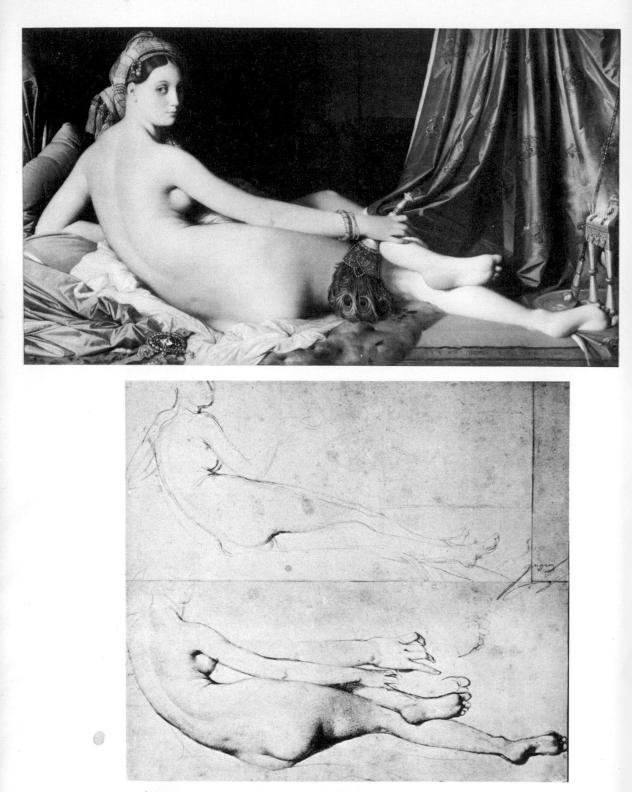

86 & 87 Ingres, Grande Odalisque and drawing for it

woman in the Dionysiac ritual, was never seen by Ingres; but in fact it was unearthed only in 1847.

The Jupiter and Thetis, painted in 1811, marks the summit of Ingres' years of inspiration. In the years that followed at least two more female figures were realised - although whether they were conceived then or earlier we cannot say. One of them I think must have been a fresh idea, the extraordinary work known as the Grande Odalisque [86], originally painted for Caroline Murat as a pendant to the Dormeuse de Naples. There is no trace of her in earlier drawings, and there is something perverse and complicated about her - not at all like 'L'amour antique' - which suggests to me that Ingres was coming to the end of his response to the female body. Also she is painted with a deliberate sharpness of colour - 'as if to put your teeth on edge' contemporary critics said - which twists away from the restrained, harmonious colour of 1808. Contemporary critics in general were horrified by this strange creation, and discovered (which shows how hard critics worked in those days) that she had three vertebrae too many. Certainly she is the most extreme example of the deformations which Ingres' pre-ordained, rhythmic pattern inflicted on the object of his delight; and in later years, when Ingres had made himself the pattern of orthodoxy, it was a great satisfaction for the rebellious to point out that she was 'out of drawing'. She is the culmination of a series of drawings of unequalled beauty, in which we see with what deliberation, with what inner conviction [87] Ingres has sought her peculiar pose; a pose which appears to be credible and simple, and is, in fact, complex and almost, but not quite, impossible. As always with Ingres, the last refinements of drawing are to be found not in the drawings themselves but in the picture, so that we must set our teeth and face those acid blues and bottle greens (if we do not perversely enjoy them, as 1 do) in order to receive the full benefit of the long, sweeping line of back and arm enclosing the small round breast, the fruitful volume of the thigh; and the final plastic sequence from left foot to right.

Ingres was thirty-four when he painted the *Grande Odalisque*. He had passed through twelve years of inspiration, and already in 1814 it seemed that he was beginning to lose his way.

119

⁸⁸ Ingres, The Stamaty Family

Ingres II

The Painter of Modern Life

The year 1814, the year of the exhibition of the Grande Odalisque, was a turning point in the life of Ingres. For this one can find a few political reasons, although personally I think they are unimportant. With the fall of Napoleon, life in Europe changed. Ingres' chief patron, Caroline Murat, was driven out of Naples and could not take delivery of her Odalisque. Even in Rome the number of his sitters diminished. He had not sold many of his early paintings and his chief means of livelihood had been portrait drawings in pencil of the numerous visitors of all nationalities who passed through the city. For them to be drawn by Ingres was a sign that they had reached the centre of Roman society. These portrait drawings kept Ingres' pot boiling, but they are practically never pot-boilers, because he obviously enjoyed doing them – not only the heads, but the accessories; and he did them with a skill that has never been surpassed. He had begun the practice as a young man, and one of his earliest portrait groups, the Forestier Family [90], was done just before he left for Italy, in 1806. They were his friends, and he was engaged to marry the young lady in the centre but later broke off the engagement, and the lady died a spinster. 'When one has been engaged to M. Ingres', she said, 'one does not marry.' Finally this high priest of the temple of Venus arranged his marriage by correspondence. His bride, whom he had never seen till he met her outside the gates of Rome, came to join him from France. The marriage was a great success.

Ingres' early portrait drawings seem nearly perfect, but in fact they improved; he gained in precision and concentration; and his study of the *quattrocento* taught him to take advantage of any decorative possibilities in dresses or accessories. Holbein was the obvious model although, strangely enough, the delicacy of Ingres' touch gives an effect more like Holbein's English successor, Nicholas Hilliard. His increased mastery can be seen by comparing the 121

5

89 Ingres, The Misses Montagu

30 Ingres, The Forestier Family

Forestier Family with the Stamaty Family [88] painted in 1818. It is not only far better composed, but shows a surer sense of selection. Nothing is easier to copy than an Ingres portrait drawing, and nothing more difficult to do from nature, because consistently to render all tone and colour as line without lapsing into formalism is an almost impossible feat. Even his gifted pupils, Chasserieau and Flandrin, never succeeded, for when they came to the heads they tried to focus our interest by overmodelling, whereas Ingres is able to achieve these miracles of characterisation without changing by a nuance the focus and texture of the whole drawing. An example is a portrait of his friend Monsieur Leblanc done in Florence in 1821, which shows that Ingres' sense of elegance and his feeling for fashion was not confined to feminine attire. He also practised a slightly more official style for commemorating the eminent, where the head was given greater prominence. An example is the portrait of Paganini [91] – done before he had sold his soul to the devil – who was then the 123

object of Ingres' adoration, for Ingres was a passionate violinist. Later, in Paris, when Ingres heard him perform his diabolical circus tricks of virtuosity, he stamped on the floor, cried 'Traître!' and left the room. The majority of these drawings were simply the equivalent of photographs, taken of visitors to Rome. Two such young visitors. The Misses Montagu [89], show that although Ingres was not always able to endow these commissions with the plastic sensibility of his finest drawings, he vet could give them a charm of design, a clarity and a perfection of taste which such souvenirs usually lack. This side of his work appealed particularly to the English visitors, whose mournful, horse-like faces frequently appear in his drawings, and he received several invitations to England to do portraits in pencil: proposals which he described as insulting In his Roman years these immaculate drawings may have seemed a waste of his time as an artist. Actually, the unrivalled knowledge of how to convey character without over-emphasis, and how to give contemporary costume the style and decorative value of the fifteenth century were to be the saving of him as an artist in his later years.

If Ingres had died in 1815, the year after exhibiting the Grande Odalisque, we should think of him as the most gifted and the most misunderstood of all the great revolutionaries of the early nineteenth century. But he did not – any more than Wordsworth died in 1805. Like the poet he lived on to be over eighty, an object of veneration, a totem of respectability. In both cases this involved the suppression of something vital; but with Ingres the suppression was much less drastic than with the poet, and had rather more complex causes. It was not simply a decline in responsiveness: on the contrary, Ingres' sensations remained as strong as ever. It was a reason more closely connected with the doctrine of 'Art for Art's sake'. He had absolutely nothing to say about life - only about style; and the style that he had created with such pains was too limited and had become an end in itself. At the same time he was depressed by the continual attacks on his work, and began to experiment with other styles. In consequence he produced some of the worst pictures ever painted by a great artist. He tried historical subjects in the anecdotal style made popular by Horace Vernet and completely lacked the dash and bravura that made it possible for a painter like Bonington to succeed in this depressing genre. He tried the pietistic style which had been practised with success by a group of German artists in Rome, known as the Nazarenes, and produced a painful but memorable picture of 124 Christ giving the Keys to St Peter [93]. That he should have used in

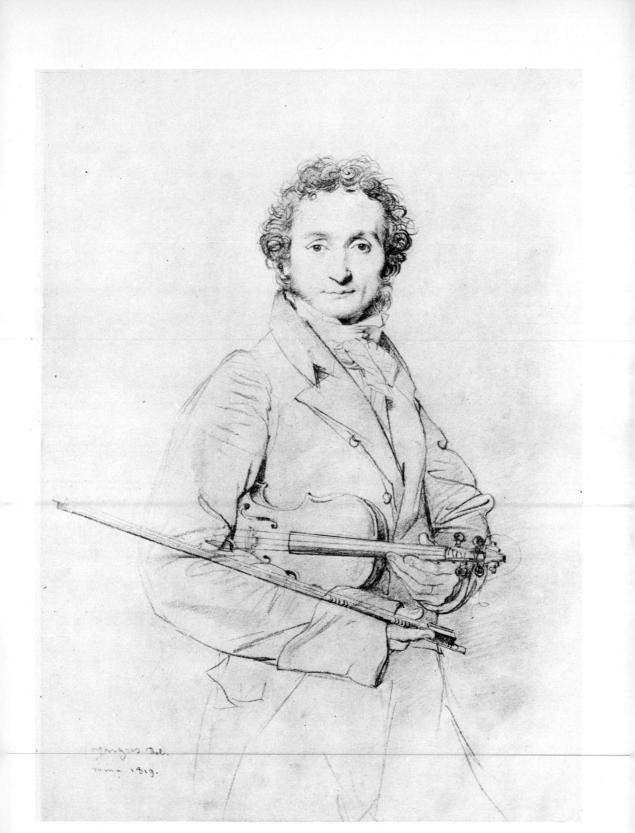

91 Ingres, Paganini

92 Ingres, Drawing for Christ giving the Keys to St Peter

this way the magnificent drawing he did for the kneeling St Peter [92] shows clearly Ingres' lack of self-knowledge. The picture had a greater success than Ingres had ever known, and various religious bodies competed for it. He also did a piece of extremely austere classicism, *Augustus listening to Virgil reading the Aeneid*: it was begun in 1812 and I feel that the surviving fragment preserved something of the years of inspiration, although it is dated 1819 [94].
126 Imagine doing this in the same years as those dreadful fancy-dress

93 Ingres, Christ giving the Keys to St Peter

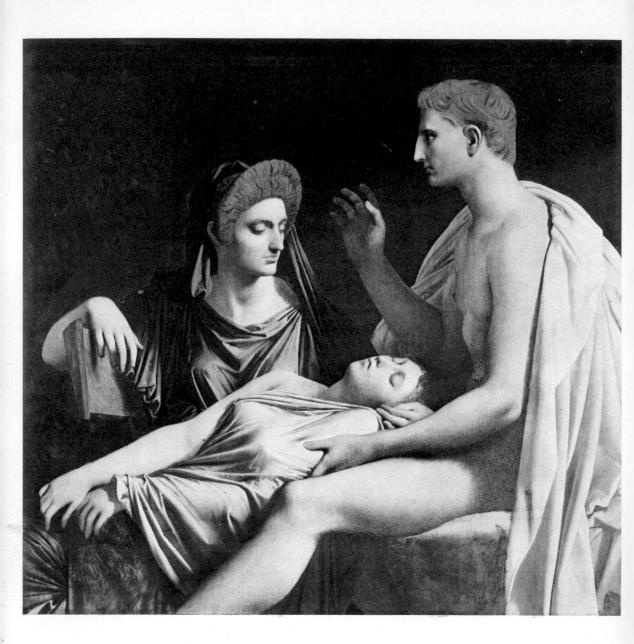

94 Ingres, Tu Marcellus Eris

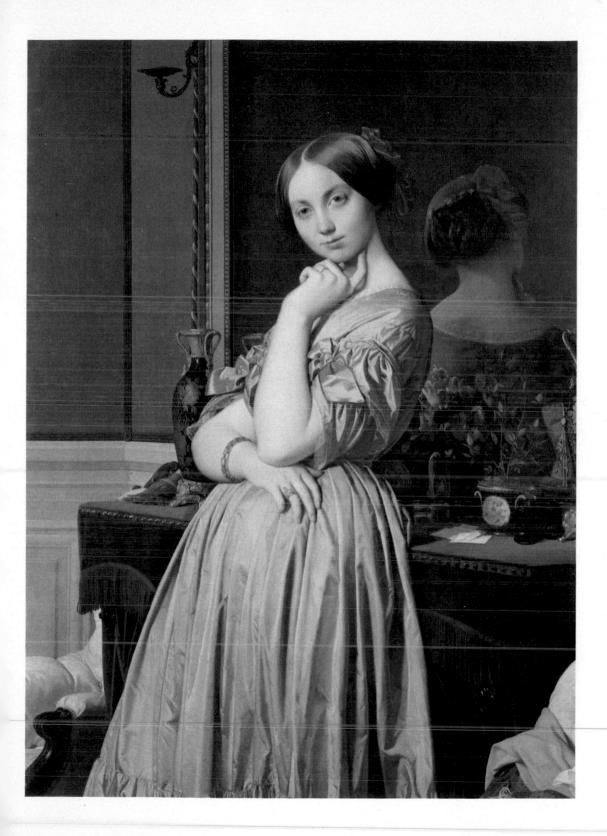

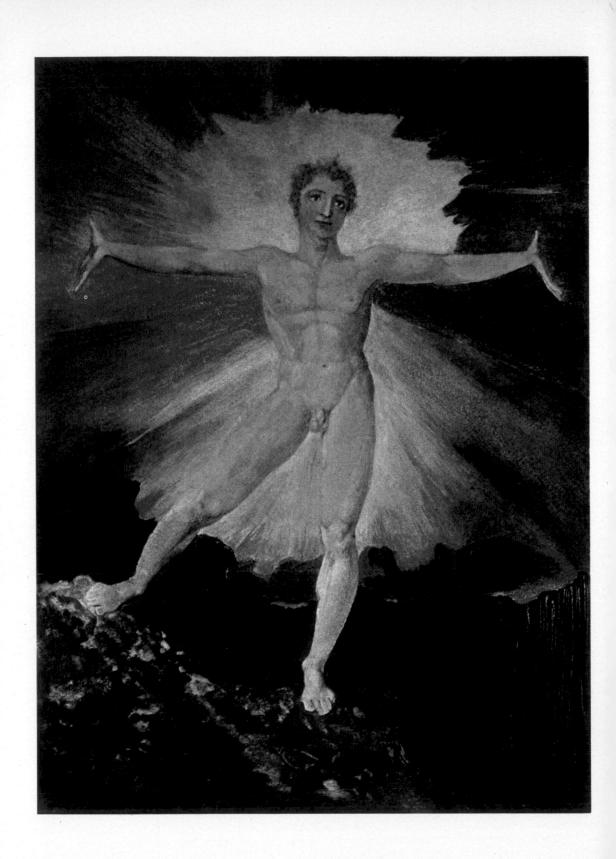

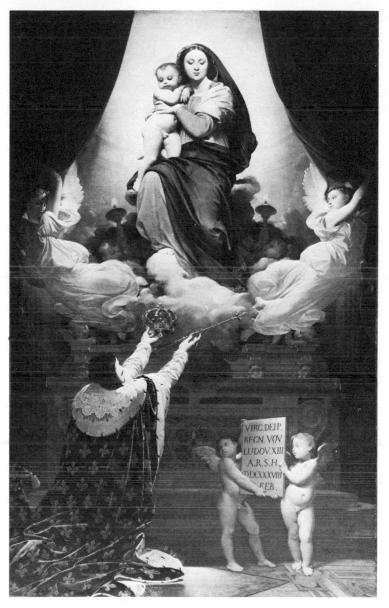

95 Ingres, The Vow of Louis XIII

pieces. What a muddle he was in! What got him out? The answer is Raphael. He threw himself on Raphael as a bewildered penitent might throw himself on God.

Even in his small costume-pieces Ingres had occupied himself with the life of Raphael, and produced, on the whole, the most tolerable examples of this genre. Then in 1820 he received a commission to paint a large altar piece for the cathedral in his native town of 129 Montauban, and he determined to make it a testimony to his worship of Raphael. He had secretly decided to paint an Assumption of the Virgin, but the subject selected for him, after prolonged discussions between Church and State, was The Vow of Louis XIII [95], which satisfied both parties. It did not satisfy Ingres. He put off work on it till he moved to Florence, and then it cost him three years of anguish -'I'd like to break the neck of the man who thought of that subject', he said. It was almost impossible for a painter with his limited imagination to combine the uninspiring person of Louis XIII with a celestial vision. In the end his agonies resulted in a picture more impressive than photographic reproduction would suggest. But it is not a complete success. I need not emphasise how greatly it differs from the Jupiter and Thetis or the Odalisque. To begin with it is a religious subject; and Ingres had not the faintest sympathy with the Christian religion. Then it is derived not from the quattrocento, but from the mature Raphael, although the Virgin's head is abstract and schematic beyond anything in Raphael's work. No doubt it represents a sincere desire on the part of Ingres to master a more voluminous style, but this led him to smother his delight in the ravishing outlines of the human body, and the conventional draperies of the high Renaissance did not allow that archaic precision with which he rendered the style of contemporary costume. We have only to look at the drawings [96] for the angels in *The Vow of Louis XIII*, of which a number are preserved, to see what has been lost. To sacrifice these beautiful forms on the altar of respectability - even when respectability took the form of Raphael - cost him a struggle: 'Un mal', as he said, 'qu'il est incroyable et impossible de définir.' It was a sacrifice approved by contemporary opinion. The Vow of Louis XIII was the first of his exhibited pictures to win public and official approval. At last, so it seemed, this gifted but perverse artist had conformed. The uncertainties, both spiritual and material, which had disturbed his last five years in Rome and his four years in Florence a long period in a painter's life – were over. Raphael to the rescue! Thenceforward Ingres became the unassailable dictator of academic orthodoxy.

For his role as the high priest of tradition, for which Ingres deliberately cast himself, he had one qualification – a sublime faith in art. He really believed that the truth had been revealed to him. He was one of the elect. He was possessed by a higher power, so much so that he used to refer to himself in the third person, as Monsieur 130 Ingres, even in his love letters. As a dictator he had a serious defect –

96 Ingres, drawing for The Vow of Louis XIII

lack of intelligence. Partly owing to having left school at the age of eleven, and partly owing to his impulsive, emotional character, he was incapable of reason. '*Pas le moindre logique*', as Delacroix said of his pronouncements, which are in fact the most muddle-headed and arbitrary of any ever made by a great artist.

During the rest of his life Ingres continued to spend time on religious pictures. He even did a long series of designs (full-size, in oil) for stained-glass windows, which shows how little he knew himself. As he was without a spark of Christian feeling, these pictures are merely assertions of orthodoxy, neither better nor worse than the images one used to find for sale outside a French church like St Sulpice. The last painting to which he devoted the best of his energies, *The Child Christ among the Doctors*, was finished when he was eighty-two. He sincerely believed it to be his masterpiece and, as his rival Delacroix said, it is sad.

Yet not so sad, because at the same age he produced some really superb pictures. Far sadder, it seems to me, is a picture painted when he was only forty-six, which should have been his masterpiece, The Apotheosis of Homer. Homer had inspired some of his happiest works; and in the preparation of this great machine he took infinite pains. The drawings from nature for the various figures are vigorous and sharply accented. The picture itself is dead. Hanging, as it does now, with the great Davids in the Louvre, it looks feeble and lacking in conviction, and must have looked most uncomfortable in its original position on the ceiling of one of the new antique galleries of the Musée Charles X. For all his passionate admiration of Raphael, Ingres has completely misunderstood him, and has lost the vitality of The School of Athens and the poetry of the Parnassus. Whether the abandonment of the archaic style had made him unable to realise his images, or whether a sudden decline of imagination was, after all, the reason why he lost his style, the fact remains that the two figures of the Iliad and the Odyssey, which would have been clear and memorable in 1817, are commonplace in 1827. The colour, because it is 'ideal', and not taken from contemporary dress and furniture, is timid and negative. The electric blue and ivory of *Thetis* had faded to a tearoom tint; and the paint barely covers the canvas. Contemporary critics complained of the niggardliness of matière in Ingres; but this was part of his theory of classicism. Le dessin, he said, was the whole of art. The procédés matériels de la peinture were very easy, and could be learnt in a week. Not true: but he had achieved them in the Granet 132 and maintained them as late as Madame de Senonnes.

The Apotheosis of Homer might lead us to suppose that Ingres' career as an artist was over; but this was not the case. Two things saved him. He could still respond with all his force to certain aspects of human personality; and, buried far down under his frock-coat, were those same obsessive images which had come to him during his period of inspiration. He could not add to their number, but he could take them as points of departure for further explorations into the world of forms. The first of these gifts manifested itself in a series of portraits which are as fine as anything he painted. It was through the portrait that he was able to continue that direct contact with the physically real which his narrowing concept of historical painting denied him. His portraits are far from mere imitation. They are true creations involving all his faculties. They respond to his imaginative needs in the very choice of sitter (and after 1830 Ingres could choose his sitters), and they satisfy his sense of the ideal, for the poses almost all go back to some classic origin. The sitters were chosen because they suggested some classic design. For example, after one or two false starts, he suddenly saw Madame d'Haussonville [7] in the pose of a muse on an antique sarcophagus – a pose also reproduced by Ghiberti. There followed interminable readjustments (all great portrait painters have demanded complete collaboration from their sitters, but none more than Ingres) so that, while retaining the ideal basis, full justice should be done to the sitter's individual charm and to the elegance of her toilette. And here one notices how admirably Ingres responded to contemporary fashion. All the praise which Baudelaire bestowed on Constantin Guys for having discovered the style of modernity, the seriousness of fashion, applies far more forcibly to Ingres. We can understand his pleasure in the shawls and classic draperies of the First Empire; but how marvellously he sees the point of the Second. Even Victorian furnishings of a kind which have hardly yet returned to favour, contribute to the general effect of elegance and sumptuousness. Ingres' colour was part of his sense of chic; he follows exactly the colours of a dress and the furnishings of the prevailing mode, which we accept easily enough when the mode is Empire, but less gladly when (as with Madame d'Haussonville's bluish-lilac dress) it is Louis-Philippe. It is not, of course, a colourist's colour, but it has a bite and a reality which is something more than the colouring of taste. The poet Baudelaire, combining, as usual, prejudice and insight, said: 'Monsieur Ingres loves colour in the same way as a fashionable dressmaker.' He may not have known that Ingres' grandfather was a master tailor, but he certainly knew that 133 Madame Ingres, the only person who had the slightest influence on her husband, had herself been a modiste. Ingres' feeling for chic and fashion was a part of his profound appreciation of the feminine, and he brought to it the same rigour that he applied to the female body. In his drawings for his portraits it is almost comical to see with what intellectual application he imposes design on these frivolous shapes. A long series shows how he arrived at the exact balance of Madame d'Haussonville's pose and related to it the chimney-piece, with its Victorian bric-a-brac, and to the reflection in the mirror. But beyond this, there is in Ingres' portraits a remarkable human *rapport* with the sitter. He loved the gentle Madame d'Haussonville. He did not love her formidable sister-in-law, the Princess de Broglie, and expresses his feeling in the line of her long, stiff neck (however, he did love her hands). For years he refused to paint the Baronne de Rothschild, but once having met her he was enchanted by her wit and humanity, which he expressed not only in her face, but by her position low down in the canvas.

The most extreme example of Ingres' contrivances is the portrait of Madame Moitessier [97] in the National Gallery in London. He accepted a commission to paint her in 1844, chiefly because he could see her in the pose of an Arcadian goddess in a famous wall-painting from Herculaneum, of which he owned two copies. It allowed him to use his favourite conjunction of the hands and the head in a more majestic manner than the reflective muse had done. No doubt Madame Moitessier was majestic - 'Junoesque' is the word used by all contemporaries - but this type of beauty does not greatly excite us, and I fancy that, even for Ingres, it did not have the same immediate appeal as the melting grace of Madame d'Haussonville or the intelligence of Madame de Rothschild. He constantly referred to Madame Moitessier's 'terrible beauté', but in the early studies he left her face a blank. He originally intended to have her daughter at her knee, but the wretched child fidgeted, so Ingres dismissed her and threw away the canvas. He felt under an obligation to the family, however, and in 1851 he started another portrait of his 'Juno' standing, almost full length. The head is still uninteresting, but the accessories show an ever-increasing devotion to fashionable dress. The rings, the bangles, the cameo brooch: all these were selected by Ingres for their contemporary character. The picture was greatly admired, but Ingres was still haunted by his original conception. Poor Madame Moitessier! Never has a sitter collaborated so uncomplainingly over a period of 134 more than twelve years: but by 1856 she was rewarded by the ulti-

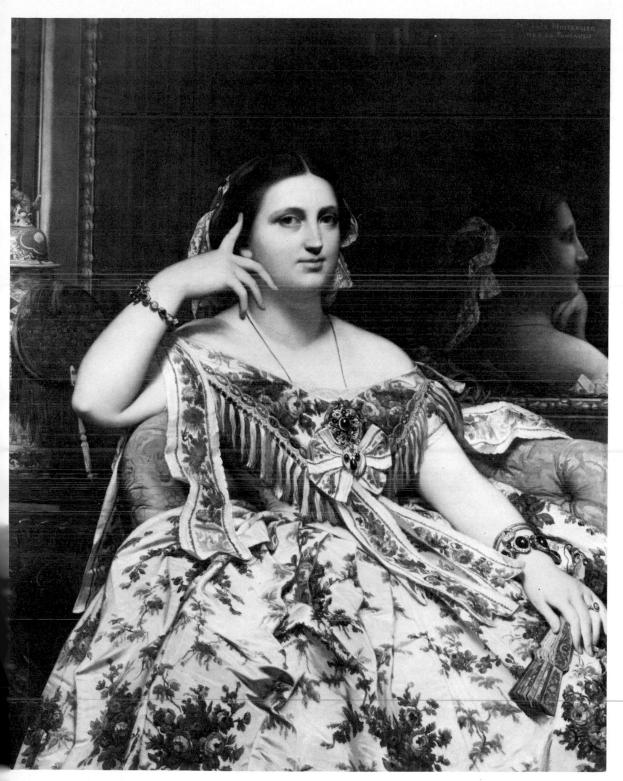

mate masterpiece of the peintre de la vie moderne. She is, of course, back in the pose of the Arcadian goddess of Herculaneum, her head following the original pose even more closely than in the studies of 1845. Ingres again used the device of the mirror, which had proved so effective in Madame d'Haussonville. Numerous studies for the right hand, progressively less naturalistic, show him finding his way back to the submarine insinuations of the Thetis. The accessoires accumulate: brooch, bangles, fan, and Imari vase, and finally came the dress. I say finally, because originally the dress was dark, and until the last stage it was yellow. We do not know how or when Ingres took the perilous decision to paint his Juno in a white dress of flowered Lyons silk. It was something entirely new in his work, and needed to be handled more freely than the interlacings of his favourite shawls. In fact the flowers show an eighteenth-century lightness of touch, as of one of those painters of Sèvres porcelain who later communicated their skill to Renoir. And yet all this festivity is marvellously under control. Every tassel is severely part of the design. The left-hand ribbon, running up to the arm, and at exactly the right angle to the stick of the fireshade, is a piece of abstract design worthy of Léger. But her head defeated him and in the end he decided to make it an ideal portrait in the high-Renaissance style. Madame Moitessier is no longer a character with whom one can have human relations. Impassive in her extravagant finery, she reminds one of some sacred figure carried in procession.

Exactly the opposite took place in what I suppose must be called the most popular of Ingres' portraits (because, like the *Mona Lisa* and *Whistler's Mother*, it has been used as an advertisement), *Monsieur Bertin* [98]. Monsieur Bertin had stood for many hours in a pose which is known to us through drawings, and his portrait was making no progress. Ingres was in despair, and as they sat together after the day's work he announced that he must abandon the commission. Whereupon Monsieur Bertin turned to him indignantly in the pose which has become immortal.

The human contacts of portraiture saved Ingres from the tyranny of art, so that he was even able to draw stylistic inspiration from the daguerreotype, for I cannot believe that his portrait of *Madame Reiset* [99] is uninfluenced by this new invention. She was a friend and one can feel it. It looks easy enough; but Madame Reiset has recorded that when he was painting it she used to hear Monsieur Ingres groaning and sobbing in the next room, so painful to him was 136 the attempt to combine truth and style. Another thing which saved

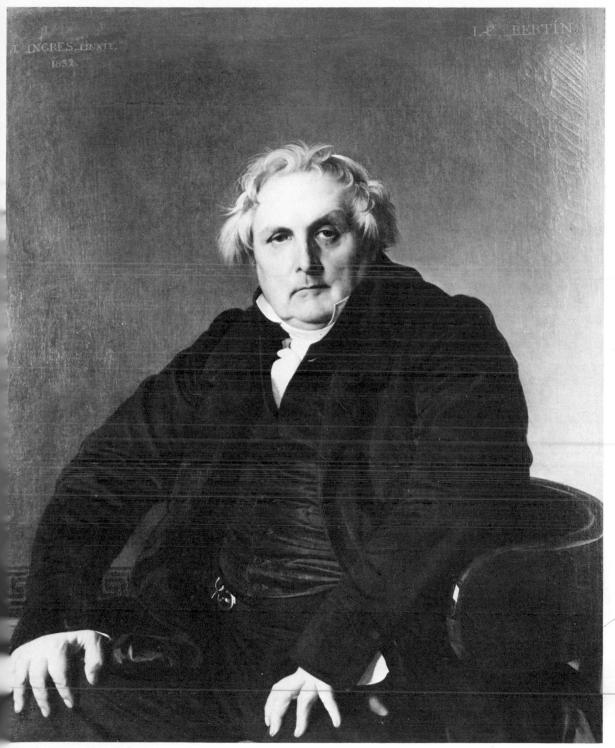

8 Ingres, Monsieur Bertin

⁹⁹ Ingres, Madame Reiset

him was the continued power to excite him of certain poses of the naked female body. These are, in general, poses which had obsessed him in the ten years 1806 to 1816, the last of which, the Angélique, was to be copied by Seurat. One of them I mentioned in the preceding chapter, the standing Venus which visitors had seen on the walls of his studio in Rome, and which was finally produced in two versions – the Venus Anadyomene and La Source [100]. The former is far closer 138 to his original intention, and retains the sensuous movement of the

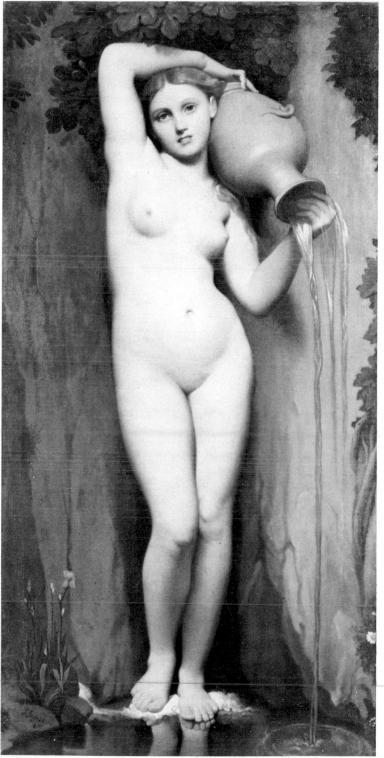

100 Ingres, La Source

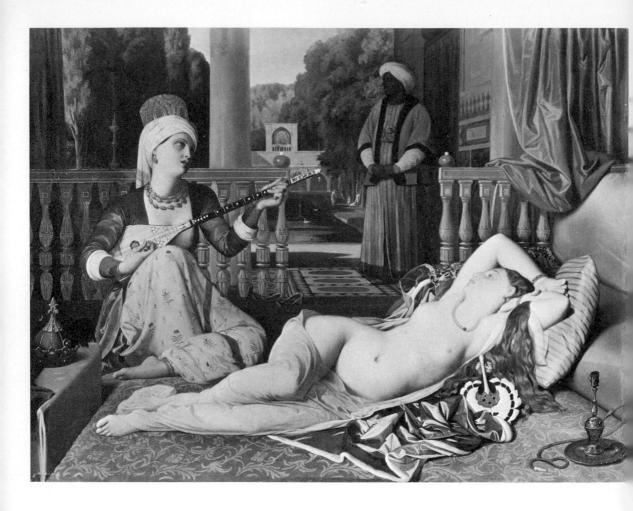

cartoon which had for so long defied completion. This gives it an independent, rhythmic life superior to *La Source*. On the other hand, these highly stylised contours, especially the outline of the left side, when carried out in the less abstract style of his later years, produce, to my eye, a certain inconsistency. *La Source*, is, by comparison, insipid and almost commonplace; she has certainly been very much prettified from the original drawing, and was partly executed by two pupils, but the naturalistic outline of the right thigh and breast is consistent and extremely subtle, and were it not for the feeble colour and the too obvious prettiness of the face, it would not be far from the masterpiece of which Ingres had always dreamed.

The curious limitations of Ingres' art, even when dealing with his favourite subject, are well seen in the great decoration which he undertook for the Duc de Luynes in 1843. The subject was to be The Golden Age, and Ingres decided that the composition should be made up entirely of nudes – what he called '*un tas de beaux paresseux*' - sporting, reclining, embracing. He was enchanted by the opportunity of assembling all the inhabitants of his imagination, and his notebooks are full of excited memoranda of motives. Pages from these notebooks (there are several hundred) show how he gave immediate visual shape to these fancies; and in addition to these scribbles he did drawings, from the life, of which four hundred have survived, many of them of incomparable beauty. Alas, the perfectionist who had spent a lifetime in trying to make three or four poses correspond with his inner pattern, was unable to control the fifty naked figures which were to furnish his paradise. It was for this reason, however disguised, that the work was left unfinished; and we can see from the remains, no less than from the Apotheosis of Homer, that Ingres lacked the gift of building up a large composition. Whereas the Apotheosis is tight, dry and self-conscious, The Golden Age is loose and uncontrolled: but the lack of architectonic sense is the same in both. Even the actual groups are by no means all convincing, for by this time Ingres was chary of adding new inhabitants to his central imaginative world. He did, however, revive one whom he valued greatly, and who had almost certainly been the idea behind the Dormeuse of Princess Murat. Ingres brought her to perfection in 1839 when he was in Rome, as Director of the French Academy. She reappears as an odalisque [101], who is accompanied by a slave playing a zither. The moment we see her we recognise that she is from the centre of his being: and as usual Ingres painted her several times.

This oriental scene, carried out with such loving detail, reveals a 141

curious fact: that although it was the Romantics who had first found inspiration in the East, it was the prophet of Raphael and the Greeks who really felt at home in the seraglio. Contemporaries recognised this, as my quotation from Sylvestre about the Chinese painter in the ruins of Athens made clear; although the word 'Chinese', to signify detached and linear, no longer seems to us the right word. It is more with the full and supple plasticity and the boneless undulations of Hindu art that Ingres is in sympathy; and of this too he must have been almost entirely ignorant. He seems to have found his material for these oriental fantasies in the collection of Baron Gros, who had brought them back from Napoleon's campaign in Egypt. However slight the original impulse, it was all that he needed as a corrective to the devitalised Raphaelism of the Homer. The masterpiece of this kind is the Bain Turc [102], painted in 1859 for the Prince Imperial. It was inspired by a passage in Lady Mary Wortley Montagu's letters. The figures are many of them old friends from the Roman period - chief among them, of course, the Grande Baigneuse. Many of the other ladies are taken directly from engravings in works on the Levant and it is sometimes said that not a single one of the figures was drawn direct from nature, but I cannot believe that a drawing such as plate 103 is not a response to a strong and rapturous experience. The circular form, which adds to the Hindu effect, is said to be an afterthought, and dates from 1863, when the Prince Napoleon's wife persuaded him that the picture was unsuitable for exhibition at Malmaison. Ingres took it back, adding the girl in the bath, for which he made an exquisite drawing. Later he repainted it and sold it to the Turkish Ambassador. He was eighty-three when it was completed; it is his last word on the subject with which he had occupied his mind for sixty years. In certain moods I must confess that I find the *Bain Turc* a slightly comic picture. No wonder that it was made into a greetings card, with the caption 'The whole gang misses you'. But the longer one examines it the less it appears to be merely an erotic dream. The intellectual rigour which Ingres applied to a ribbon or a frill is even more evident in these forms. The Bain Turc is, after all, by the same painter as the Tu Marcellus Eris, and although in one case we may feel that he has suppressed too much of himself, and in the other that he was given his obsessive idea almost too free a rein, these are still two poles of the same deeply serious devotee of art.

Poussin, writing in 1642 to his friend Chanteloup, said: 'The 142 beautiful girls of Nimes will, I am sure, have pleased you no less than

102 Ingres, Bain Turc

¹⁰³ Ingres, drawing for Bain Turc

the beautiful columns of the Maison Carrée – for the latter are, indeed, no more than copies of the former'. Ingres, who cannot have known this letter, notes on the page of scribbles for *The Golden Age*: 'The young people on the right must have that beauty which charms and transports. One must not dwell too much on the details of the human body, so that the members may be, so to speak, like the shafts of columns – such they are in the greatest masters.' That is why Poussin and Ingres are the greatest classical artists since Raphael. To them no abstraction – not even the crystalline geometry of a Greek column – could obliterate the sensuous nature of beauty.

¹⁰⁴ Blake, Page from America

Blake

The painters I have included in this series – classic or romantic – were the outstanding artists of their day; successful, influential, part of the whole European movement: all but one, William Blake. For a great part of his life Blake was miserably poor and worked only for a few patrons or friends, and until recently he was hardly known outside England. Most of his designs are on a small scale in a peculiar medium. Compared with the great canvases of David or Delacroix his prints must seem insignificant. So why do I include him? Because in his best work there is a concentration of poetry and a prophetic power that make him one of the key figures in the Romantic movement.

Everybody who writes about Blake begins by saying that he was a visionary. It is a vague term. All artists, even the most realistic, start from some kind of vision - that is what leads them to select what they need from the infinite diversity of appearances. But with Blake the word vision has a more precise meaning. He did not draw from nature because, as he said repeatedly, his visions were clearer and more vivid than his optical perception of the world around him. He saw these visions as a child; saw God put his head in at the window, saw the prophet Ezekiel sitting under a tree at Peckham Rye. There is nothing extraordinary in this; many imaginative children have similar experiences. What is exceptional is that Blake kept these intense powers of visualisation after the age of puberty. Exceptional, but not incredible, because this can be paralleled in other forms of mental activity. Some people have the gift of total recall and others can remember accurately whole pages of figures; physiologically these endowments seem to me quite as hard to explain as the accurate visualisation of images.

What was the nature of Blake's visions? His accounts of them suggest that, although obviously closely related, they were of several different kinds. The first was simply his poetic faculty that led him to see a natural event as something supernatural. 'It will be ques- 147

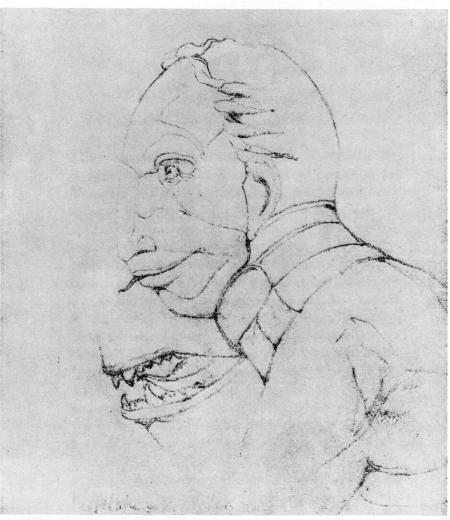

105 Blake, Ghost of a Flea

106 Blake, Visionary Head 'The Man who taught Blake painting'

tioned', he says in his *Descriptive Catalogue*, 'when the sun rises do you not see a round disc of fire somewhat like a guinea – Oh no, no, I see an innumerable company of the heavenly host crying "Holy, holy, holy is the Lord God Almighty".' The seventeenth-century poets, Traherne or Vaughan, might have said the same. The second was when an analogy became so strong in his mind that an ordinary experience was transformed: 'With my inward eye 'tis an old man grey. With my outward a thistle across the way.' These lines show that Blake was capable of switching from one kind of vision to another: in fact he was doing what we all do when we see pictures in the fire, but of course Blake's 'pictures in the fire' are far more precise than ours.

This leads us to visions of rather a different order which seem to have involved an element of hallucination. They are described in detail by Varley and Linell, in whose presence Blake drew a number of what are known as 'visionary heads' [106]. One must remember that Varley was an early spiritualist and he encouraged Blake to draw these heads in the middle of the night and in an atmosphere rather like that of a mediumistic seance. 'He was requested to draw the likeness of William Wallace,' says Linell, 'the eyes of Blake sparkled, for he admired heroes. "William Wallace," he exclaimed, "I see him now, there, there, how noble he looks - reach me my things."' Having drawn for some time with the same ease of hand and steadlness of eye as if a living sitter had been before him, Blake said: 'I cannot finish him; Edward the First has stepped in between him and me.' The other example is the famous Ghost of a Flea [105], printed by Varley in his Zodiacal Physiognomy. 'As I was anxious', says Varley, 'to make the most correct investigation in my power of the truth of these visions, on hearing of the spiritual apparition of a flea, I asked him if he could draw for me the likeness of what he saw: he instantly said "I see him now before me." I therefore gave him paper and pencil, with which he drew the portrait. ... I felt convinced by his mode of proceeding that he had a real image before him, for he left off, and began on another part of the paper to make a separate drawing of the mouth of the flea, which, the spirit having opened, he was prevented from proceeding with the first sketch until he had closed it.'

These accounts do not do Blake justice – any more than do the *Visionary Heads* themselves. He was far more genuine an artist than that. There was an element of clairvoyance in his work, but the visions that make his best work unforgettable were somewhere 149

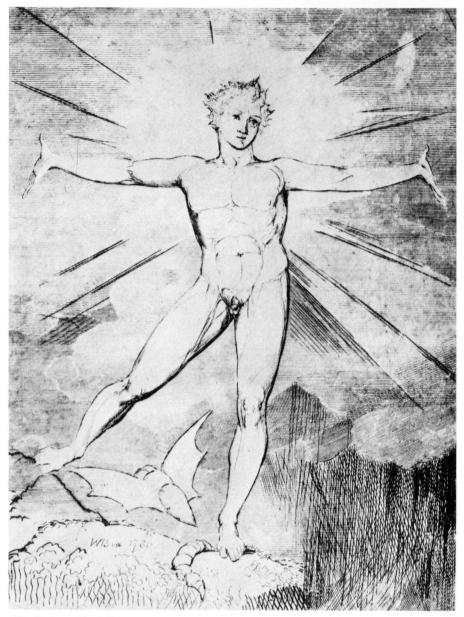

107 Blake, Glad Day

between the poetic analogy of the rising sun and the literal reality of the heads.

Where did these visions come from? Blake was very emphatic on this point. 'Vision or Imagination is a representation of what Eternally Exists, Really and Unchangeably. Fable or Allegory is formed by the Daughters of Memory. Imagination is surrounded by the Daughters
150 of Inspiration.' A graceful metaphor; but images must have some

point of departure, and the Daughters of Memory work on a rather deeper level than was recognised in Blake's time. They even contributed to the vision of a flea, which seems to be compounded of a plate in Robert Hooke's *Micrographia* and devils in a feeble copy of Michelangelo's *Last Judgement*.

The fact is that Blake's visions did come from memory. From his childhood onwards he had been an insatiable devourer of prints, and in 1784, on the death of his father, he set up as a print dealer. He continued to run the shop for three years, and a surprising variety of material passed through his hands including, as we can see from his work, illustrated books on Eastern religions, books on Assyrian sculpture and perhaps a few medieval manuscripts. Without doubt the items that influenced him most were prints after Michelangelo and the antique, especially of antique gems; and the book of engravings after the Bolognese painter Tibaldi, which I have mentioned already. These visual experiences, deeply buried in his unconscious mind, appeared vividly before his eyes, and seemed to him visions expressive of his dominant ideas, although they often had no relationship to the original purpose of the image.

Blake's earliest original design is the engraving known as *Glad* Day, dated 1780 [107]. No doubt that this figure was extremely important to him; it was one of his most durable and most consistent visions. It has long been recognised that Blake took the idea from a Renaissance diagram of a geometricised figure – known as Vitruvian Man – perhaps the wood-cut in Scamozzi's *Architecture* [108]. Blake was never afraid of contradictions, but nothing could be more paradoxical than that he should have found in this attempt to circumscribe man by reason, by the geometry that he detested, a symbol of liberated energy. But here a typical complication appears; Blake made a pencil drawing for *Glad Day*, and on the back did another of the same figure seen from behind. This backward view also became important to him, and appears in one of his last great prints, *Albion adoring the crucified Christ*, which comes near the end of *Jerusalem* [111]. It is not at all characteristic of Blake, whose approach to form

108 'Vitruvian Man' from Scamozzi's Architecture

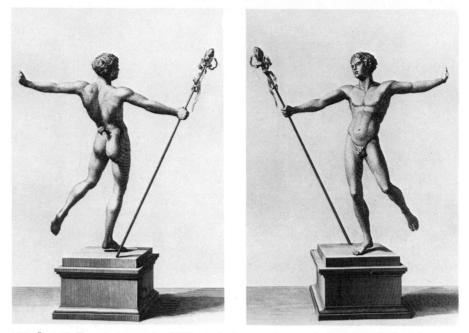

109 & 110 Engravings of a Hellenistic bronze from Antiquities of Herculaneum

was graphic, not sculptural, to draw a back and front of the same figure; but the anomaly is explained by the fact that in *The Anti-quities of Herculaneum*, a book which was certainly known to Blake, is an engraving of the front and back of a Hellenistic bronze [109, 110]. This bronze represents a Dionysiac figure dancing; so the title he gave the final version of this idea, the *Dance of Albion* [8], is correct.

Because Blake's visions often preceded his thoughts, he was not usually at his best in illustrating other people's work. His earliest watercolours depicting historical or legendary themes are very dull and feeble. His powers as an artist increased with the years, but at any time he could be almost incredibly bad when the subject failed to suck up from his subconscious one of his deeply buried images. But in 1787 Blake made a decision that was to release and transform his art. Instead of illustrating other people's writing he would use his visions to decorate or illuminate his own poems. The first result was the Songs of Innocence and the Songs of Experience. The word 'illuminate' suggests something very significant in Blake's character as an artist – his sympathy with the Middle Ages. He wrote, 'Greece and Rome, so far from being parents of Arts and Sciences, as they pretend, were destroyers of all art. Grecian is Mathematic Form; Gothic is Living 152

Living Form is Eternal Existence.' The Gothic artists were always in his mind. When he came to rework his very earliest engraving [112], which is a direct copy of a figure in Michelangelo's *Crucifixion of St Peter*, he inscribed it, 'This is One of the Gothic Architects who built the Cathedrals in what we call the Dark Ages. Wandering about in sheepskins and goatskins of whom the world was not worthy': one of those haunting pieces of nonsense with which Blake's writings

111 Blake, Jerusalem, 'Albion adoring the crucified Christ'

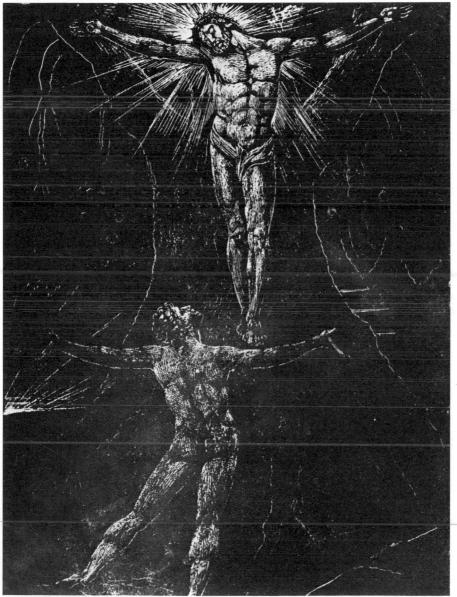

abound. He would have been more at home in an inward-turning thirteenth-century scriptorium than in the life-class of an eighteenthcentury academy.

Blake's first instinct was to decorate books rather than paint easelpictures. He evolved a technique of book decoration in which the background was etched away, the relief lines printed and the whole then coloured by hand. Although the basis of each copy was the same, the final results differed considerably. They were as much individual creations as medieval miniatures, which were usually based on earlier pattern-books. His first job as a boy had been to make drawings of the monuments in Westminster Abbey for a publisher named Basire, and he must have spent hours alone in that sacred, overwhelming place. This not only led to his lifelong obsession with recumbent figures but provided him with types. For example, the ruler or prophet with flowing, formalised beard was inspired by the effigy of Edward III. All this could be explained as part of that growing interest in the Middle Ages and its monuments which, since Horace Walpole, had provided a kind of fashionable overture to romanticism. But when one comes on a Blake drawing such as the St. Michael in the Fogg Museum, Cambridge, Massachusetts, [113] and compares it with an initial from the Winchester Bible [114], one must allow that the affinity goes far deeper. Blake has retained the formula of Mannerist drawing, and yet has given his design the rhythmic character of romanesque. One can even compare the unfunctional anatomy of his nude figure, with its calligraphic loops and flourishes, with the schematised drapery of a twelfth-century draughtsman. There is no doubt that medieval art has entered deeply into his form-creating unconscious. Again and again in studying Blake one finds how the fashionable Mannerist style, the style that he had learnt from Fuseli, is adapted to the far more purposeful rhythms of the Middle Ages.

The influence of medieval illumination coincides precisely with Blake's first illuminated book; and yet one must admit that in the plates of the Songs [115] the effect is not at all Gothic. It is far more rococo. Many of the pages remind one of a piece of eighteenth-century needlework, and perhaps for the same reason: that they take the closed symmetrical scheme of Hellenistic ornament as it has come down to us in Raphael's Loggie, and treat it asymmetrically. Was this rococo fairyland encircling the page Blake's invention? It certainly meant a lot to him, because he kept it up all through his life. It is worth noticing that at the same date the German artist Philip 154 Otto Runge was using very much the same kind of imagery; also

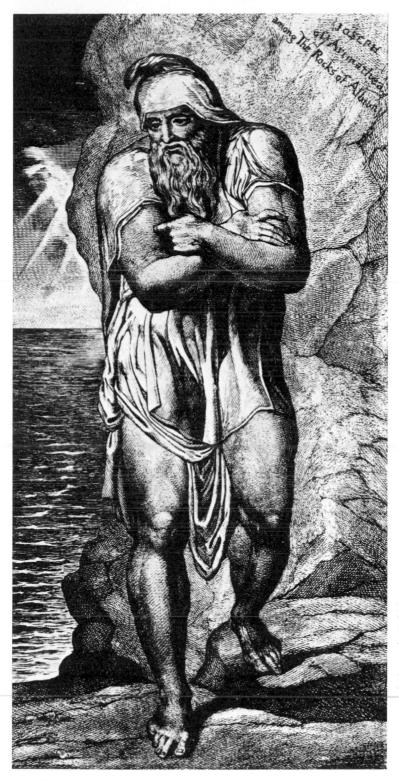

112 Blake, Joseph of Arimathea among the Rocks of Albion

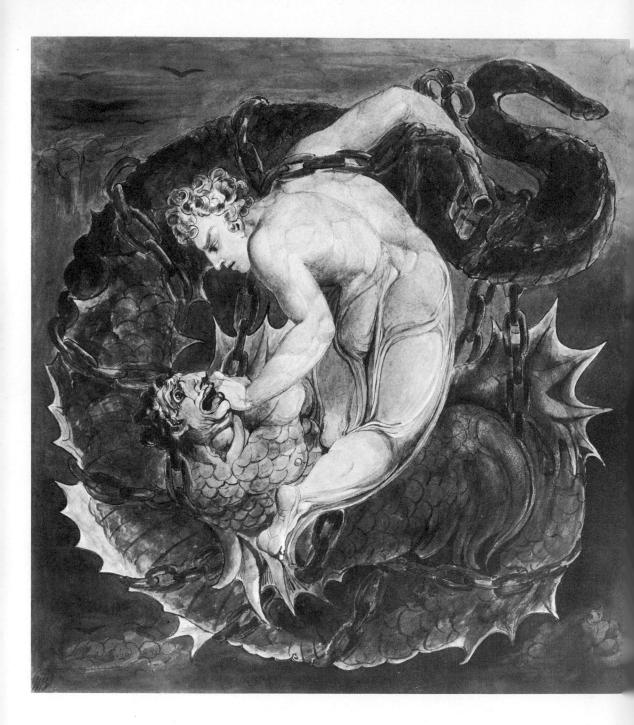

113 Blake, St Michael

that it continued up to the time of Dicky Doyle and the cover of *Punch*.

I have mentioned the Songs of Innocence and Experience together because, although there is no doubt that between the two Blake passed through some crisis of disillusionment, so that almost every hopeful, trusting poem in the first section is countered by an indignant and embittered poem in the second; yet the illustrations are all of a piece. They are in gay colours and filled, for the most part, with sprightly forms. In only one of them, The Poison Tree, is there any trace of horror or fear. Was this because Blake wanted to maintain the visual unity of the two sections? Or was it because, at that time, embittering experience had affected only a certain level of his mind? Perhaps a bit of both; because The Book of Thel [116], which seems to have been done during the years of disappointment, is also in this gentle, lyric vein. The designs connected with it are the most enchanting, though not the most powerful, that Blake ever did. They are like the poem itself, a hymn to the female principle of creation. What a tender, spontaneous, happy nature they reveal! Blake in his

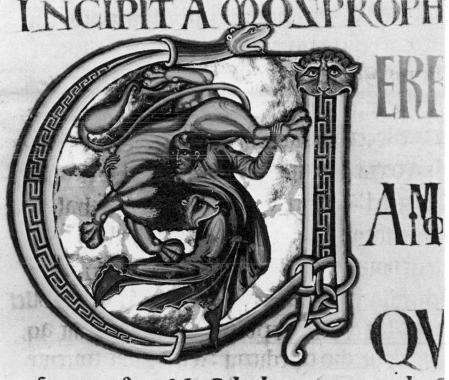

fur in pastoralibus dechecue. que uidit s

114 Initial from the Winchester Bible

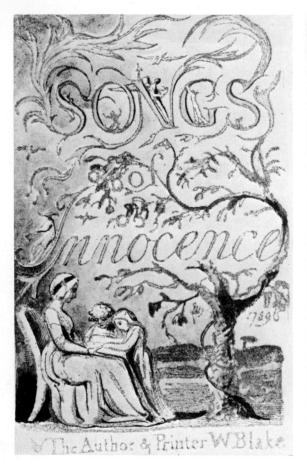

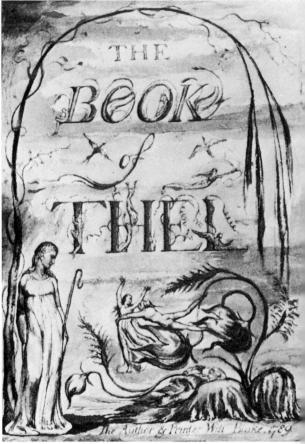

115 & 116 Title pages from Songs of Innocence and The Book of Thel

a new heaven is begun, and it is now as since its advent : Die Elernal Hell as And lo! Swedenborg is the Angel sitting the tand his writings are the linen clothes folded Now is the dominion of Edom, & the return of Tom onto Paradise ; see Isnich XXXIII & XXXV Chap. Without Contraries is no progression Altraction and Reputsion, Reason and Energy Love and (0) Bate, are necessary to Human existence From these controvies spring what the religious call need & Evil. Good is the passive that obeys Reason vil is the active springing from Energy Good is Deaven Evil is Hell 100

117 Blake, Page from The Marriage of Heaven and Hell

thirties must have been the most lovable of men. 'What shall I call thee?' 'I happy am, Joy is my name.' That word which meant so much to Coleridge and Wordsworth, and all the Romantics in their best moments, was embodied in the thirty-ycar old Blake: and joy continued even in *The Marriage of Heaven and Hell* [117]. The designs surrounding the text are expressions of flaming energy. Blake enjoys his defiant reversal of orthodox values: 'For the cherub with his flaming sword is hereby commanded to leave his guard at the tree of life, and when he does so the whole creation will be consumed and appear infinite and holy, whereas it now appears finite and corrupt. This will come to pass by an improvement of sensual enjoyment.' In the present conflict of young and old we know which side Blake would have been on. Then three years later came *America*, *Urizen* and *Europe*; and the decoration of those works show that a change had 159 come over that happy man, far greater than is visible between the *Songs of Innocence* and *Experience*. Of course the change is most painfully evident in the writings. Instead of the deceptive clarity of the lyrics, there is the darkness and confusion of the *Prophetic Books*. Instead of childlike song, there is shrieking, wailing, groaning and

118 Blake, Page from America

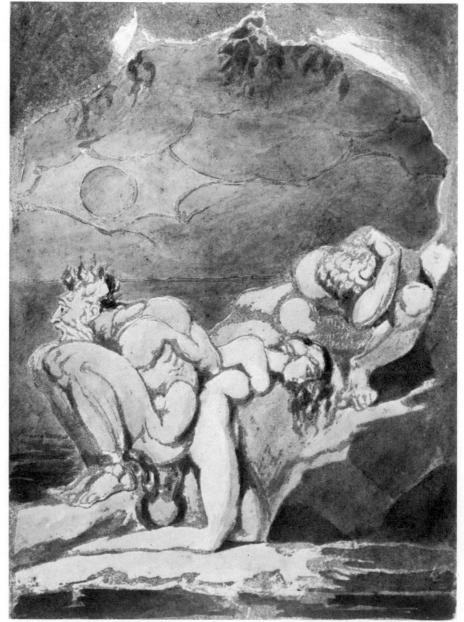

119 Blake, Illustration from Steadman's Expedition against the Revolted Negroes of Surinam

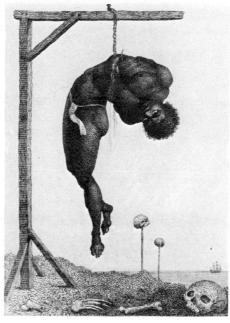

roaring on almost every page, so that we are deafened as well as confused. The change in the graphic work is not as catastrophic because the vividness of communication is maintained, but that too shows a preoccupation with violence and pain [104].

It is often said that Dlake's disillusion was due to the Torror that accompanied and succeeded the massacres of September 1792. Blake, like Wordsworth, had been an ardent supporter of the revolution in France in its early stages, but how much he hoped from it is hard to tell. Blake wore a red cap because he was a generous-minded man, but, as he later said, he had no business with such matters. It was not the collapse of revolutionary principles that worried Blake, but a growing realisation of the crucity and general beastliness of human beings. In addition to the Terror and Pitt's informers, I believe that he was deeply moved by the accounts of the slave trade that were published in these years. In 1793 he engraved the illustrations to Captain Steadman's Expedition against the Revolted Negroes of Surinam [119]. One can imagine the feelings of this tender-hearted man as he engraved Steadman's drawings of the revolting tortures inflicted on the slaves. It was at this date that he did the first of many depictions of crouching, fettered figures in the depths of despair [118]; and at this same time he began to draw on memories of Michelangelo's Last Judgement, Tibaldi and other Italian mannerists whose images

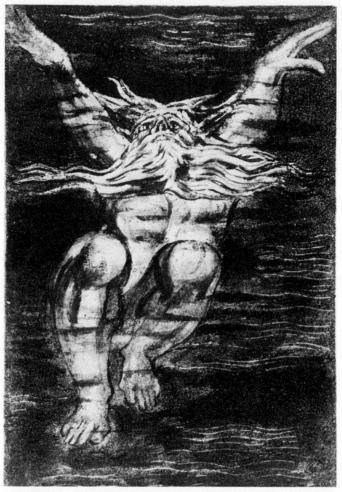

120 Blake, 'Urizen' from Urizen

he had kept far back in his mind during the years of confidence.

The most notable result of Blake's state of mind and his new style is the book called *Urizen*. For the first time he is concerned with an anti-body – with hate rather than love. *Urizen* is the embodiment of all that Blake hated – definition, restriction, measurement, materialism. If there was one combination of words that would have seemed to him to summarise all that was evil, it would have been 'dialectical materialism'. He conceived Urizen as the prophet of this religion [120] – Karl Marx drowning in the waters of materialism.

Much of Blake's imagery is capable of a dual interpretation, but the imagery of *Urizen* is relatively consistent; and his indignation has given it a new power. As a result the illustrations no longer encircle 162 and intrude upon the text, but are in separate frames and often occupy the whole page. They are illustrations and not decorations. When a subject penetrated to his image-making depths, Blake was a superb illustrator who could convey immediately and unforgettably the emotional impact of a situation. One sees it, for example, in two unforgettable images of *Plague* [121] and *Famine* in the prophetic book called *Europe*. One of the illustrations to *Urizen* is in the same vein, but most of them are ideal figures. I think one can properly call

121 Blake, 'Plague' from Europe

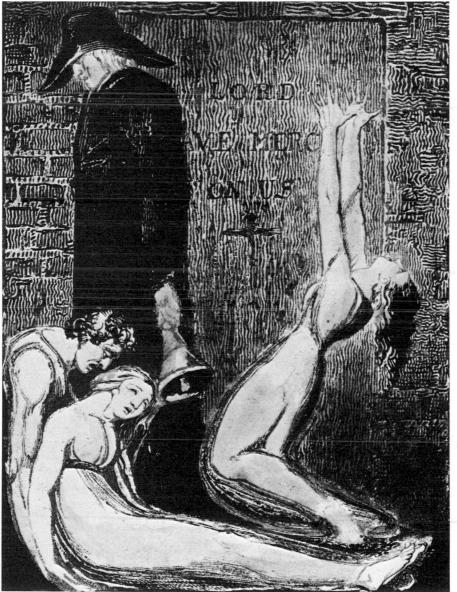

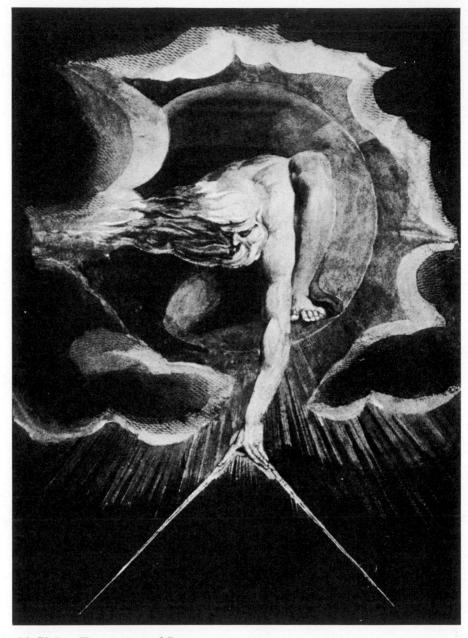

122 Blake, The Ancient of Days

them visions, based, no doubt, on Michelangelesque and Mannerist ingredients, but entirely personal.

In the same vein, and at about the same date, 1793, Blake did the series of large monotypes that are the most fully developed of his 164 graphic works. Two of them throw some light on the working of his

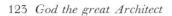

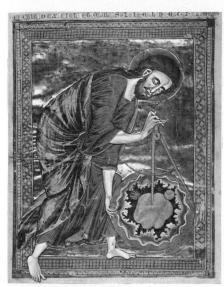

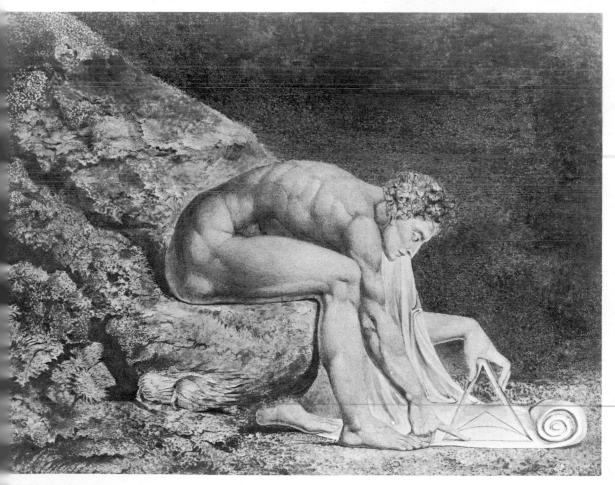

125 Blake, Nebuchadnezzar

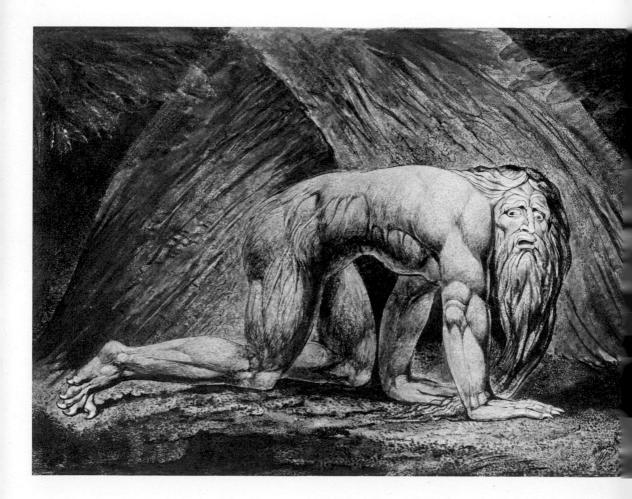

126 Blake, 'Werewolf', from the Rossetti Manuscript

imagination, the Newton [124] and the Nebuchadnezzar [125]. They were probably intended as a pair, and they illustrate the terrible results of Urizen's ascendancy - Newton on the higher plane, embodying the evil power of the measuring mind; Nebuchadnezzar on the lowest plane, showing material man reduced to a beast. The source of Newton's pose is easily found. It derives from Michelangelo's Abias, one of the ancestors of Christ, on the Sisting colling, known to Blake from an engraving. As so often, this Michelangelesque figure has encountered in Blake's imagination an entirely different image derived from the Middle Ages: God the Great Architect, setting out with his compasses the measurable boundaries of the world [123]. From the early thirteenth century onwards compasses had been the accepted symbol of geometry, and possibly a medieval image of God the Great Architect, like the one in a manuscript in the National Bibliothek, Vienna, was at the back of Blake's mind and inspired not only by the hand and compasses, but the look of intense concentration. This was the measuring, law-giving God of Genesis whom Blake regarded as the enemy of mankind, and he had already had a crack at him in one of his most celebrated plates - the design usually known as The Ancient of Days [122], although in fact it represents Urizen the Creator. Here the medieval symbol has been combined with memories of Tibaldi, who provided (in separate works) the leg, the arm and the windswept hair. This time Urizen has been too strong for him – because one cannot doubt that this magnificent 167

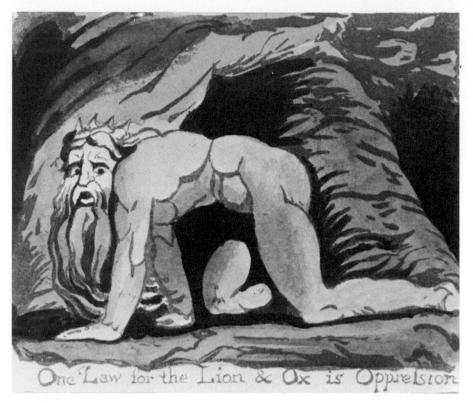

127 Blake, Page from The Marriage of Heaven and Hell

image meant a great deal to Blake. It is Urizen triumphant, the complement to Urizen drowning in the waters of materialism.

The figure of Nebuchadnezzar is a different story. There can be no reasonable doubt that it derives from a German engraving, probably a wood-cut illustration of a werewolf by Cranach, although there is some evidence of an earlier prototype. This figure, which strikes so painfully at the subconscious, evidently impressed itself on Blake at an early age, and appears in a pencil drawing in the Rosetti Manuscript $\lceil 126 \rceil$. Blake did not know what to do with it, and after a time included it at the end of The Marriage of Heaven and Hell, apparently illustrating the noble aphorism, 'One Law for the Lion and the Ox is Oppression' [127]. However, this use of the image was so obviously inappropriate that it remained in Blake's mind, unallocated, unfulfilled. Then suddenly he recognised what the vision was - it was Urizen's most degraded victim, Nebuchadnezzar; and all the horrible associations of the original werewolf are put back and even enhanced by clawed feet. For the student of visionary art the interest-168 ing fact is that an image comes first and takes up residence in the

mind long before the artist has any notion why it is there or what it means. Whether visions come from some great reservoir of symbolic images which are eternally there (and if one examines the recurrence of images in history this proposition is not quite as crazy as it sounds) or whether they are due to buried memories, their obsessive power over an artist's mind, and their clear, compulsive emergence in his work depends on a mental condition that can come and go. When, for some reason, they no longer present themselves to the mind's eye, alive or clamouring to be born, the visionary artist has a hard time – dark days. This is particularly true if he has lost the habit of feeding his mind on the observation of nature.

Between 1789 and 1794 Blake did not need to use his eyes. He was inspired. All his greatest works, poems and illustrations, were done within those five or six years. No wonder that there was a period of reaction when visions no longer came unbidden, and he was driven back to squeezing out and reassembling his memories. Blake knew that he had lost inspiration and, when he recovered it, described the loss in a moving letter written in 1804 to a friend:

'For now! O Glory! and O Delight! I have entirely reduced that spectrous Fiend to his station, whose annoyance has been the ruin of my labours for the last passed twenty years of my life. O lovely Felpham,* parent of Immortal Friendship, to thee I am eternally indebted for my three years' rest from perturbation and the strength I now enjoy. Suddenly, on the day after visiting the Truchsession Gallery of pictures, I was again onlightened with the light I enjoyed in my youth, and which has for exactly twenty years been closed from me as by a door and by window-shutters.'

This letter worries Blake scholars very much. Clearly twenty years (although repeated three times in the complete letter) is an exaggeration, but ten years (and Blake liked to deal in round figures) is not so far wrong. Heaven forbid that one should try to rationalise any of Blake's statements, but one might put it something like this: that his mind had been richly stocked with images, but that he had drawn on them too recklessly; he had repeated them till they had lost their vitality. The three years at Felpham, away from works of art, had refreshed him and, coming back to London, he had found himself at an exhibition of pictures that were, from all accounts, worthless copies, but which filled him with the sort of excitement that a fifteenth-century Florentine might have felt if suddenly confronted * Blake had retired to Felpham in Sussex, on the South coast of England.

128 & 129 Blake, Pages from Milton

with a row of Greco-Roman sarcophagi. Inspiration had returned, and entered his left foot like a star [128].

The recovery was not as complete as Blake had hoped. In the years after 1804 he did not immediately enjoy an outburst of creative activity comparable with that between 1789 and 1794. 'Tuesday, 20th January 1807', he writes in his diary, 'Between Two and Seven in the Evening - Despair!' The Eagle of Inspiration still hovered over his sleeping form [129]. This and other illustrations to Milton and Jerusalem show that authentic visions still appeared to him. But in the obscure years between 1810 and 1820 there must have been many more evenings of despair. We know that even in his later years, when he did some of his greatest work, he could feel that the doors of enlightenment were closed to him. When one of his young admirers, George Richmond, told Blake that he felt deserted by the power of invention, to his astonishment Blake turned to his wife suddenly and said, 'It is just so with us, is it not, for weeks together, when the visions forsake us?' Yet by this time he seems to have been enjoying a wonderful rebirth of visionary powers. A group of young men had discovered him living in poverty and almost total neglect, and had treated him like a prophet and sage. Through one of them, Linnell, he was given the commission that was to lead to his best-known work, the engraved illustrations to the Book of Job.

170

I made the point earlier that Blake's visions are convincing when

Who is this that darkeneth counsel by words without knowledge Then the Lord answered Job out of the Whirlwind Who maketh the Clouds his Chariot & walked on the Wings of the Wind. the Brops of the Dr a Father & who hath begotten Hath the Rain had as the Act directo March & 1825 by William Blake N & Foundary Caset Strand

130 Blake, Page from Job

they represent his own private world of poetry and mythology, and not when they illustrate someone else's. The Job is no exception to this rule. Blake had been brooding on the story of Job for almost forty years. It had been the subject of one of his greatest early lineengravings; and in the course of time he had entirely recreated the allegory in his own terms. In the Bible, Job is the victim of Jehovah, Blake's pet aversion, whom he used to refer to as 'Old Mr Nobodady', and Job's sin is primarily that of disobedience; in Blake's version the Almighty is the higher nature of Job himself, and thus indistinguishable in countenance, punishing him for the sins of materialism and complacency. By selection, emphasis and the inclusion of other Biblical texts he makes the Book of Job as expressive of his own philosophy as any of his prophetic books, perhaps rather more so, as it gives him a firmer guiding line and a more economical vocabulary, 'the only one of his Giants who attained form and proportion'. As a result the Job engravings achieve an almost classic consistency, exceptional in his art [130]. We are no longer disturbed by the peculiar mannerisms of Blake's drawing; we do not think of Fuseli or Tibaldi. We think, as Blake meant us to think, of the meaning of each episode, which is further enriched by the quotations that surround it. He also succeeded, as nowhere else, in assimilating the figures to the idea that they express, so that such a plate as Job's Sacrifice is a symbol of prayers ascending to God.

The other masterpiece of Blake's old age, the hundred large watercolours illustrating Dante, are the most inexplicable of all his works. They go clean contrary to my theory that Blake's powers diminished when illustrating another poet. Moreover, Dante's ideas are contrary to everything that Blake believed, and had always believed, with passionate conviction. If he hated both Aristotle and the hierarchy of Heaven, how could he tolerate Dante? If he thought the punishment of sins was evil, how could he illustrate The Inferno? Unanswerable questions. Yet I think that pictorially the Dante drawings are the finest things Blake ever did. Where Blake scholars have remained discreetly silent, only a rash man would offer an explanation. However, I cannot resist recording my belief that when, at the age of sixty, he learnt Italian and read Dante, he felt himself for the first time in the company of a superior being - a sharper imagination, a more powerful intellect. He had written: 'I must create my system or be enslaved by another man's'. He had created his system – and a pretty good muddle it is. At the end of his life he 172 had the humility and greatness to draw inspiration from another

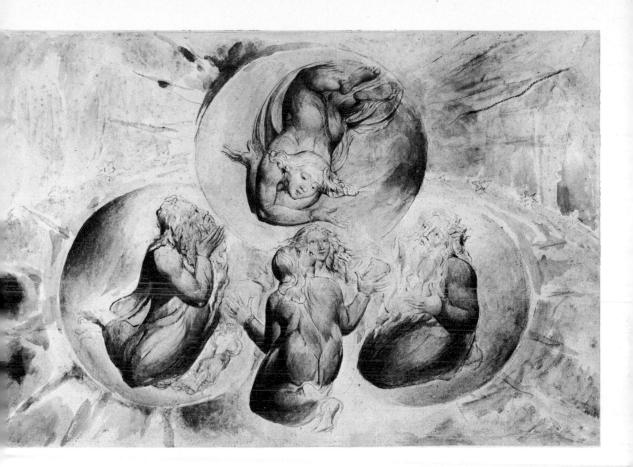

51 Blake, St Peter, St Thomas, Beatrice and Dante with St John descending

173,

man's. Those who visited Blake in his old age all dwell on his extraordinary serenity, as he sat up in bed at work on the Dante drawings. The watercolours themselves have a freedom, a lack of dogmatism that we do not find in the illustrations to his own prophetic books. I do not think it is fanciful to see in the best of them a feeling of the rhythms of medieval art. The one representing St Peter, St Thomas, Beatrice and Dante, with St John descending, has the design of a trefoil window [131]. Even more curious is the watercolour of Dante's whirlwind of lovers, one of the finest things Blake ever did, where the quasi-Mannerist nudes are made into a gigantic romanesque ornament. The so-called Celtic rhythm is unmistakable [9].

There is no doubt that Blake was a man of genius, a poet and prophet. But can we call him a great artist? It is partly a question of scale. We may agree that the men who illuminated the Bibles and breviaries of the Middle Ages were artists of the first quality, and Blake may be thought of as their successor. Like them, he not only illustrated narrative but found visible equivalents for metaphors. His interpretation of the rich and complex double metaphor of *Pity* in Macbeth combines a literal acceptance of the text with a marvellous imaginative sweep [132]; and like great medieval illuminators he could find vivid symbols for mystical concepts. In this way he expressed one very important aspect of the Romantic movement which would otherwise have been without pictorial expression: the need for a new religion or for a new interpretation of Christianity. Blake was a religious artist. I am not referring to his numerous illustrations to the Gospels, which are often weak and conventional, but to images like some of those in the Job and the Jerusalem, which seem to suggest divine energy more convincingly than anything since Michelangelo. And at the end of the Prophetic Book, Jerusalem, there is an illustration combining some memory of Indian sculpture with a print of the *Prodigal Son* that illustrates these lines:

All . . . Human forms identified, living, going forth and returning weariedInto the planetary lives of Years, Months, Days and Hours, reposingAnd then awakening into his Bosom in the Life of Immortality.

This is Wordsworth's pantheism on a different plane.

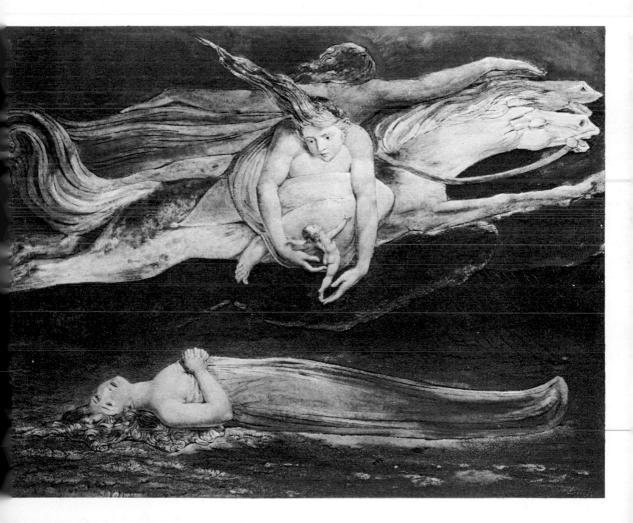

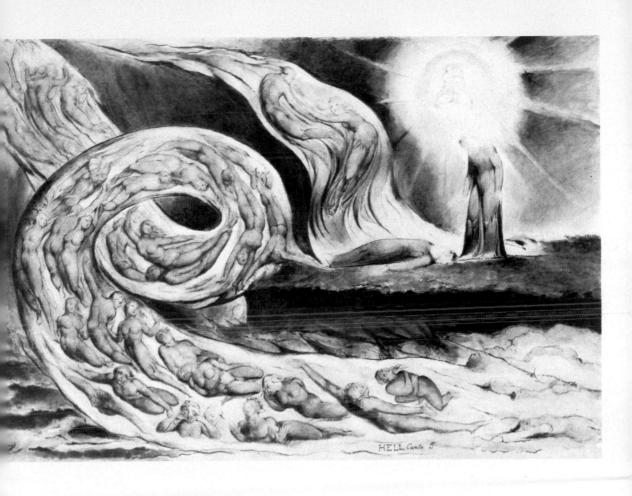

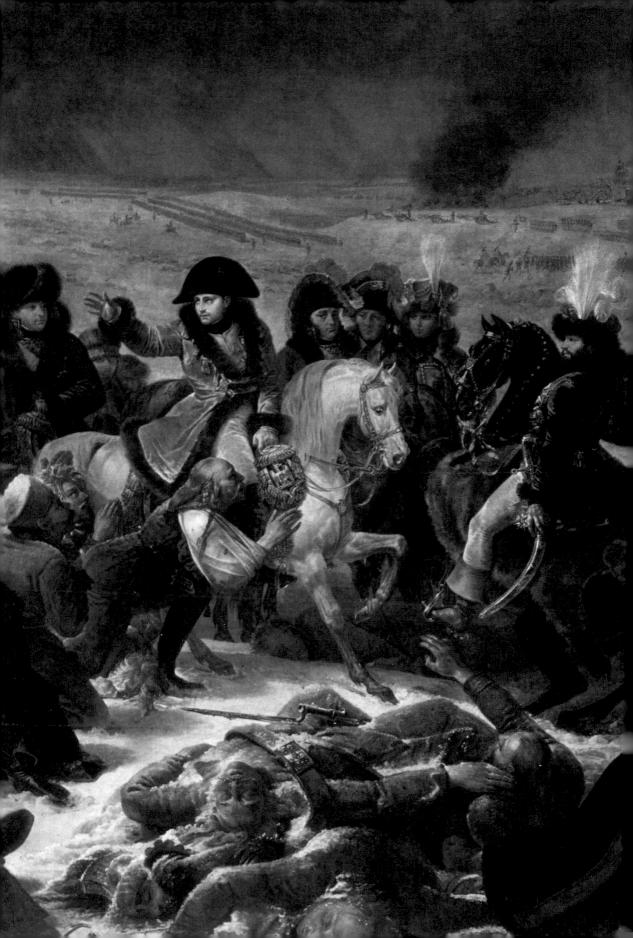

Géricault

The malaise of romanticism, the restlessness, the death wish and the worship of ungovernable forces, is usually associated with the name of Byron. In the art of painting it could, with equal justice, be associated with the name of Géricault. He was not, like the poet, a worldfigure, but he was undoubtedly a man of genius, recognised as such from the first, and he carried through one major work into which he put the whole of himself with a completeness that Byron never quite achieved in Childe Harold. There is one important difference, and from the point of view of a romantic artist it was perhaps an advantage. Géricault did not emerge from the comfortable background of Whig society (which Byron managed to make uncomfortable for himself) but from Napoleonic France. His youth was passed in the middle of the great adventure. It was a world of soldiers and horses, of plumed helmets and flashing sabres: a man's world which might have suited Byron better. Women hardly appear in the art of Géricault, except for a paralytic and a couple of old madwomen. He was less than ten years younger than Ingres; but what a vast chasm lies between them.

Before coming to Géricault, one must look at the curious figure who immediately preceded him and had so great an influence on his whole attitude to art, the painter known (somewhat misleadingly) as the Baron Gros. Jean-Antoine Gros was born in 1771, that is to say, twenty years earlier than Géricault. He was a born painter, and thanks to David he was sent to Italy, but got no further than Genoa, where he copied the work of Rubens and Van Dyck and watched the coming and going, the marching and unloading, that accompanied Napoleon's Italian campaign. Somehow he obtained an introduction to Joséphine Beauharnais, and accompanied her to Milan in 1796. There Gros painted a scene of the Italian campaign that pleased General Buonaparte, who made him his official painter with a military rank, *Inspecteur aux Revues*. He was also given the job of choosing masterpieces from Italian galleries to be sent to the Louvre. Instead of allowing him to go with the army to Egypt, the First Consul com-177

...

missioned him to paint The Battle of Nazareth. The sketch anticipates the style and the imagery of Géricault and Delacroix.

Immediately after this picture Gros made his first great contribution to the Napoleonic legend - a vast canvas of Buonaparte visiting men stricken with bubonic plague in the hospital at Jaffa [133]. As propaganda the subject is a stroke of genius, and I incline to think that it was invented by Buonaparte himself. It is not at first sight an assertion of power, but of compassion; and yet at a deeper level it recalls the power of the anointed king to cure illness at a touch – and, to give the image a heroic dimension, whereas the king ran no risk in touching for the 'king's evil', for General Buonaparte to touch these infected bodies was an act of sublime courage. This is the first example of romantic realism, and when one compares it with David's Sabine Women, painted only five years earlier, Gros appears as the real inventor of the Napoleonic style - and was immediately recognised as such. His next picture, equally vast, is an even more original work of art, although perhaps a less successful piece of propaganda. It shows Napoleon visiting the battlefield of Eylau the morning after the battle. Behind him is a snowy landscape, with the fires of war dissolving into a sombre sky. He is surrounded by his marshals; other ranks, liberated Poles and Lithuanians, kneel in adoration. The Emperor raises his hand and turns his eyes to heaven, as who should say, 'Would that I could have been spared this victory' - a sentiment often expressed by victorious generals; and the hypocrisy of this atonement is underlined by the appalling figures of dead and dying men in the foreground. This group [10] is certainly the most remarkable thing that Gros ever did. It was painted in 1808, the same year in which Goya conceived (but did not execute) his Third of $Ma\gamma$, and shows how artists were aware of the evil cruelty of the Napoleonic adventure long before it came to an end. Perhaps this, unconsciously, was why Gros collapsed as a painter. On the strength of this group one would have supposed that Gros was destined to become one of the great artists of the nineteenth century. But he was a weak character. Without a hero he was lost, and he never again painted a picture that moves us. Like Ingres he took refuge in historical reconstructions, which are no better than anyone else's, only bigger. With the fall of Napoleon he attached himself to the Bourbons, was made a Baron and took the place of the exiled David. He painted the most dreadful pictures, and he knew it. He had been overtaken, first by Géricault, then by Delacroix. One night 178 he put on his old uniform of Inspecteur aux Revues, walked out and

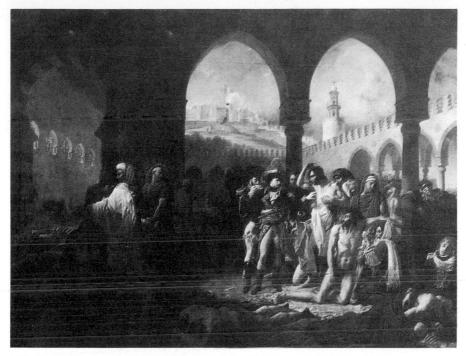

133 Gros, Buonaparte visiting the victims of bubonic plague (detail)

drowned himself in three feet of water.

The story of Baron Gros is sad. The story of Géricault is tragic. He was amazingly gifted, and at the age of twenty-three he improvised, in a few weeks, a picture of a charging *cuirassier*, which of course owes a great deal to Gros, but which has a vigour and a richness of paint that goes far beyond official painting. This (I illustrate the sketch in Rouen [134] which is more vivid than the finished picture) is the hieroglyphic of romantic figure-painting, which Delacroix enriched, but did not excel. A year later, when the Napoleonic adventure was almost over, Géricault worked on a picture of a wounded *cuirassier* leaving the battlefield. The sketches for it are very fine but Géricault was dissatisfied with the finished picture, and one can see why. When asked by a friend what was wrong, he said, 'It is because I lack the experience of suffering.' I should add that he was tall, athletic and so handsome that he had to shave his head to escape from the attentions of the opposite sex. However, he did get into quite serious trouble by making love to the young wife of his maternal uncle. At this time he wished to make his style more classical; and for these two reasons he went to Rome.

I said about Ingres that inside every classic artist there is a romantic 179

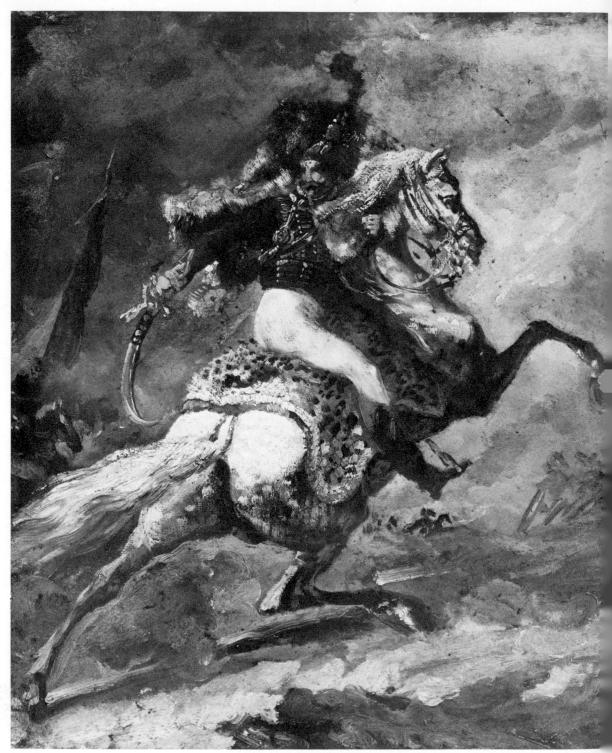

134 Géricault, Charging Cuirassier

struggling to escape. Géricault shows the other side of the coin. Within every romantic artist is a longing for the authority of classicism, but Géricault's vision of antiquity was very different from that of Winckelmann. The godlike calm, the stasis, the restraint of academic classicism were not in his nature, and his own reading of pagan mythology, though historically as defensible as that of Winckelmann, is Dionysiac rather than Olympian. Technically his drawings owe something to Prud'hon, but they have a restless energy which is pure Géricault. This sensual violence is most clearly seen in a magnificent drawing of *Leda and the Swan* [135], where the figure owes its unrest to the study of Michelangelo's tombs in the Medici Chapel, although the actual pose is that of the Illissus of the Parthenon, to which Géricault has added a fierce eroticism entirely forcign to the original. This recollection of the Illissus makes it certain that the Leda was done in Rome, for casts of Parthenon sculptures had been made there on their way to London, and we know that Géricault studied the frieze when he was looking for the stylistic basis of his next great work. How ironical that the Parthenon sculpture which

135 Géricault, Leda and the Swan

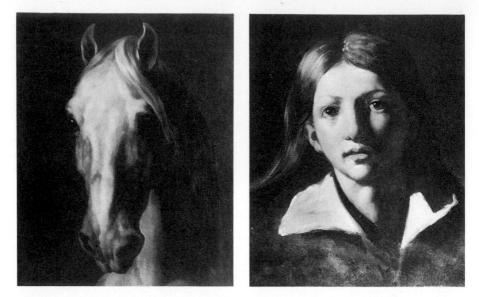

136 & 137 Géricault, Head of a white Horse and Portrait of a Youth

evoked nothing but poetry, controversy and hot air in England affected so deeply the style of a romantic artist who had not seen the originals!

In Rome the subject that absorbed him was the race of riderless horses - the so-called Barberi horses - that took place in the Corso at Rome as the climax to the carnival. One would have thought it ideally suited to him - his beloved horses, free, wild and in peril - and he determined to do the picture life-size. He made a number of studies - some rather too classical, others in a more Caravaggiesque style. They are vigorous and effective, but I find them rather artificial: the atmosphere of Rome, not only of antique art, but of such a work as Raphael's Heliodorus, was too much for him. Géricault needed more than free horses to jerk him back into reality. This seems to me the reason why he returned to Paris, though the reason usually given is that his young aunt by marriage was about to have a baby. The baby was born, and looked after by Géricault's parents; and no doubt there was a scandal and a row. The mother-aunt vanished from Géricault's life, and thenceforward he does not seem to me to have taken much interest in women. If one watches the head of a horse dissolving into a head of a boy [136, 137], one has a better idea of where his interests lay.

Even before the birth of his son he had begun work on his master-182 piece, *The Raft of the Medusa* [138]. Disasters at sea loomed large in

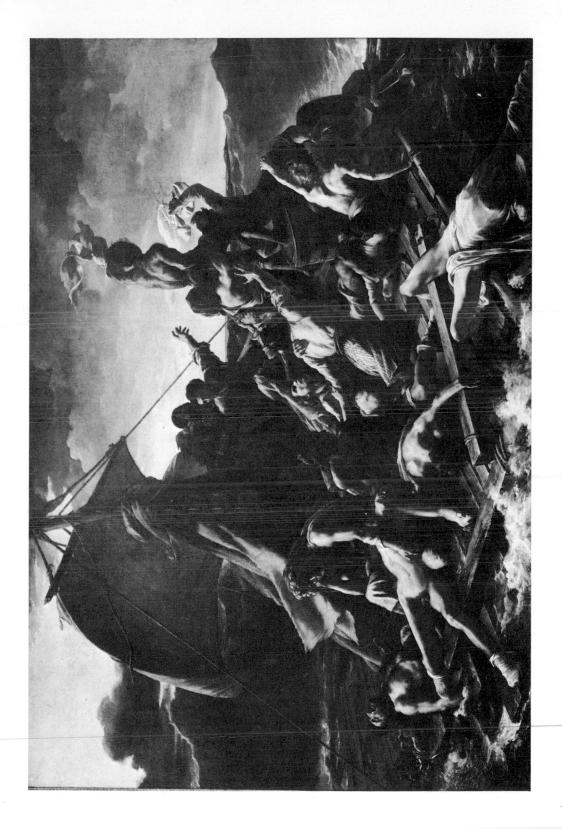

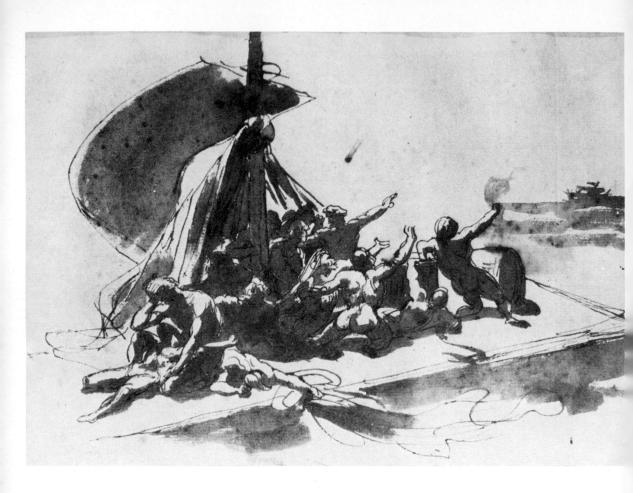

139 Géricault, Study for The Raft of the Medusa

the early nineteenth-century imagination; Caspar David Friedrich's Wreck of the Hope and Turner's Slave Ship were both real incidents. But the Medusa was slightly different in that for some reason it became a political issue, and a pretext for attacking the Bourbon government. Owing to some kind of bureaucratic carelessness the frigate Medusa foundered on her way to Senegal not far from shore. A hundred and forty-nine of the passengers, deserted by the aristocratic captain, were put on to a raft which was towed by sailors in the pinnaces. After a time the sailors cut the ropes, leaving the raft to drift out to sea. There followed every species of horror - a pointless mutiny and cannibalism. Finally the few survivors sighted a sail and were rescued. Géricault studied this grisly story in all its aspects. He interviewed the survivors. He even found the ship's carpenter, who had made the raft, and got him to make a model of it in the studio. Near a hospital he took a workroom so that he could study corpses and dying men. It was said to smell like a charnel-house. After making drawings of most of the episodes - one of the finest [139] shows the survivors hailing an approaching boat - he decided on the moment of sighting the rescue ship, and did an oil study now in the Louvre. It was then that the experience of his Roman years came back to him. The composition grew more academic as it went on and, as with David, more of the figures become nude. The drawings he did for these figures, like the one of the young man trailing in the water, which he added at the last minute, show what formidable talents went to the creation of this masterpiece.

In the end it is this studio work, rather than the study of corpect and hospital inmates, which is evident in the picture. To our eyes The Raft of the Medusa is a highly artificial performance made up of elements from Michelangelo, Caravaggio and Pierre Guérin, who had been Géricault's master; the pointing figures even remind one of Raphael's Transfiguration. But what struck contemporaries was its truth; and this was striking enough compared with the work of Girodet, or, indeed, with David's Leonidas. We can agree that certain figures are a link between Caravaggio and Courbet. If, as is natural in the work of a man still young, the component parts are derivative and artificial, in the original, the total effect of this great picture is moving and authentic. We feel, as Géricault intended we should, that all humanity is a raft of desperate men, surrounded by the dead and dying, but suddenly united by hope. This is a true theme of revolutionary art, a theme for Beethoven; the unity of movement and the way in which the composition rushes towards its 185

¹⁴⁰ Géricault, Jamar in his Studio

climax is worthy of a Beethoven symphony, and makes us forget, in our emotional response to the whole, certain conventionalities. I do not suppose that Géricault was aware of this, as, unlike David, Ingres and Delacroix, who were all passionate lovers of music, he seems to have had no interests outside art except horses. But it is remarkable that he chose as the subject of his next great painting the theme of *Fidelio*, the opening of a prison of the Inquisition in Spain.

All the figures in the *Raft* were painted from the life, some from the actual survivors; and two of his models have particular interest for us – one is the young Delacroix who is at the apex of the pyramid, the other a painter named Jamar, who posed for the dead son in the foreground. He lived with Géricault at the time; and I think there can be no reasonable doubt that the picture of a young man [140] which used to be called a self-portrait of Géricault, is in fact a portrait of Jamar. It has been rightly described as 'the classical image of a romantic artist'; this young dandy, accompanied by symbols of physical energy, art and death, might stand for any of the generation of Keats, Shelley and Byron.

The Raft of the Medusa had been exhibited at the Salon of 1819, and in the following year it was sent to London where it was shown alone, as was customary at that time, for a shilling entrance fee. Nearby, exhibited under similar circumstances, was another gigantic canvas, Christ's Entry into Jerusalem by Benjamin Robert Haydon. It is a mark of Haydon's almost crazy egotism that in the whole of his Journal, where he is constantly talking about the necessity of high art and heroic scale, he never once montions Géricault's picture. Yet it is clear that the two men represented almost exactly the same spirit. The descriptions of Géricault's endurances in painting the Medusa are only a little less extravagant than those which take up so large a part of Haydon's Journal. When someone complimented Géricault on the size of the Medusa, he made an answer worthy of Haydon himself or of Joyce Cary's Gully Jimson: 'It is a mere easel picture. Real painting must be done with buckets of colour on walls a hundred feet long.' However, a comparison of the two pictures reveals one striking difference - a difference often disregarded by modern historians of art, but still, I believe, of some importance: that Géricault could paint and Haydon could not. The grotesque feebleness of Haydon's drawing, his heavy, inarticulate shapes and congested composition have a pathetic interest for readers of his marvellous Journal and increase our respect for Haydon's skill as a writer.

Géricault followed the Medusa to England. The country of Shakespeare was also the country of the horse: and it was for this reason that he faced the notorious mists which, since the publication of Ossian, were known to envelop this island. There is no doubt that this visit, the details of which are exceedingly obscure, was of the greatest importance to Géricault's art, and to romantic painting in general. The Medusa is, as I have said, academic. It is also practically a monochrome. The best of English art in 1820 was unacademic, and had behind it a tradition of colouristic painting. It had also specialised in the subjects which Géricault loved, in horses and animals of all sorts. The most profound student of the horse – and to my mind one of the greatest English painters - George Stubbs, had gone out of fashion, but Géricault knew and copied his work on the Anatomy of the Horse, and also those pictures in which Stubbs depicted for the first time since Rubens the fierce animal impulses which were to play such a part in romanticism. The extent of Géricault's debt is evident in several of his drawings, although comparison makes clear the essential classicism of Stubbs. He also made free paraphrases of Stubbs's Horses Fighting, which he presumably knew from an engraving, and he must have found particularly sympathetic the series

141 Ward, Lioness with a Heron

188

142 Stubbs, A Lion attacking a Horse

of pictures representing *A Lion attacking a Horse* [142] in which Stubbs, in spite of his disparaging remarks about antique art, has used the same kind of closely-knit relief design which had inspired the Roman drawings of Géricault. Géricault does not mention Stubbs in his few surviving letters, but he does mention Ward; and in fact his debt to Ward is so great that it is quite difficult to distinguish between the paintings and drawings of Ward, and those which Géricault did in England. It is possible that he knew Ward's work before he went to England, and there is no doubt about the influence of such a picture as Ward's *Lioness with a Heron* [141], which shows the rich, stormy colour that Géricault was to learn from him and hand on to Delacroix.

The part played by lions and tigers in romantic art as symbols of passion and creative energy is extremely important, and I return to it in the chapter on Delacroix, but I may mention here how this idea, like so much of romanticism, was articulate in the eighteenth century, in Blake's *Tyger*, no less than in the tigers of Stubbs, and in Fuseli's reference to 'the colossal joys of the lion', which anticipates Géricault's 189

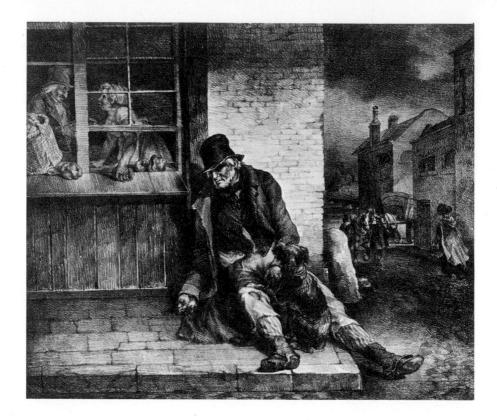

self-identification, 'Je commence un homme, cela finit en lion.'

The real object of Géricault's passion, however, was the horse, and horses are included in most of the work which he is known to have executed in England. They vary from cart-horses to thoroughbreds, from symbols of strength to symbols of speed and speculation. He seems to have been particularly impressed with the massive strength of English dray-horses, those splendid presences in our streets which, till quite recently, were a delight to all those who had not lost their sense of plastic richness, or exchanged it for the shallow excitement of streamlining. There can be no doubt that the drawings of horses were done in England, but almost the only painting he did there seems to have been his well-known picture of the Derby, now in the Louvre. It is, to my eye, a disappointing work, but it shows very clearly the influence of contemporary English painters. We have only to turn back to his Roman studies of the riderless horse-race to realise that Géricault was still in a formative stage, taking on the colour of 190 his surroundings. In his picture of the Derby he had taken on not

143 & 144 Géricault, English scenes (lithograph)

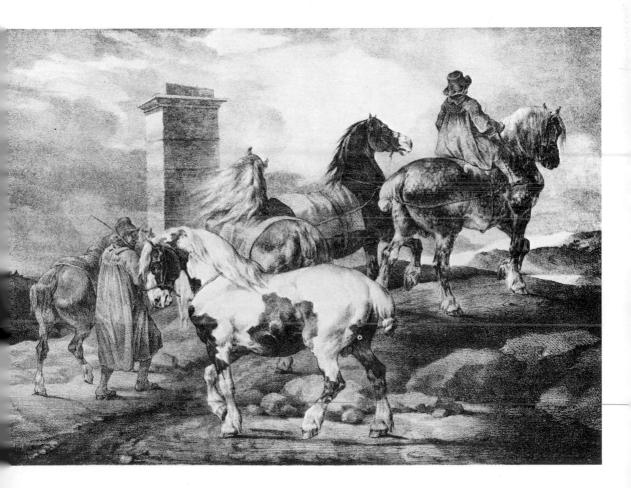

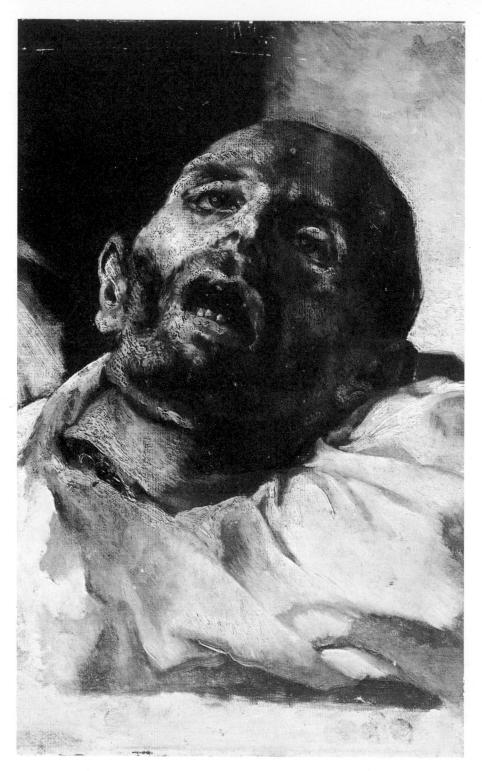

145 Géricault, Decapitated head (detail)

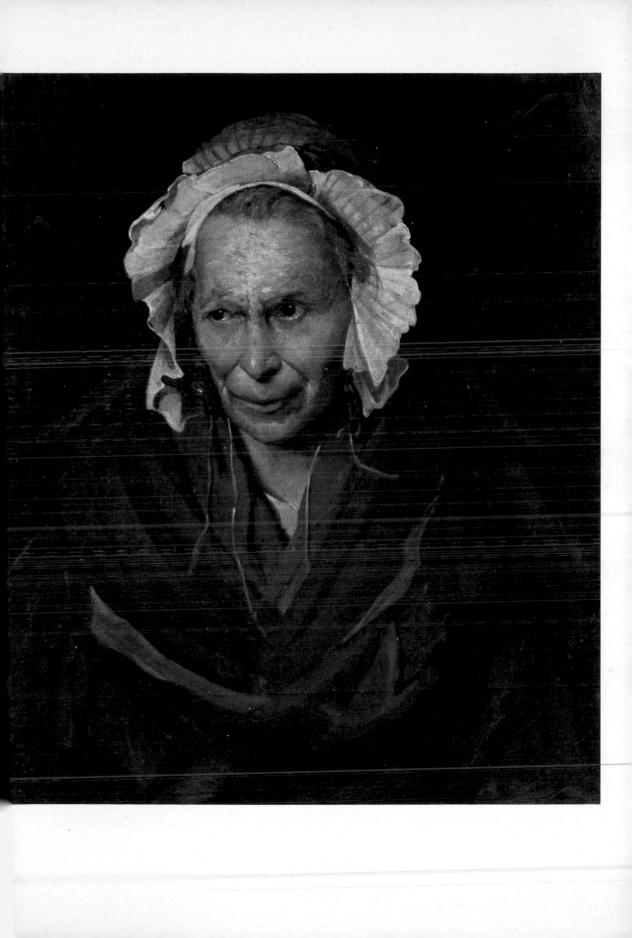

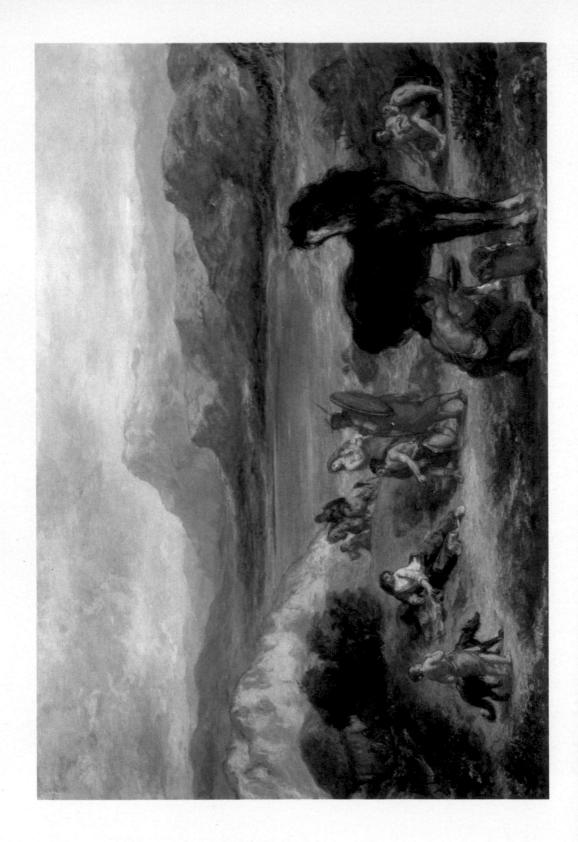

only the colour of English paintings, which is pure gain, but also the curious convention of the sporting print, which has made him sacrifice some of his natural sense of form.

Like all visitors to England in the first days of her prosperity he was chiefly struck by the brutality and squalor of English life. He did a series of lithographs [143, 144] which anticipate the writings of Mayhew and the wood-cuts of Gustave Doré. We see fearful bruisers, criminal-looking jockeys, broken-down street musicians, a paralytic woman, and finally that favourite national spectacle, a public hanging. No doubt England really was like that, but Géricault was in a deeply pessimistic frame of mind. While in London he attempted to commit suicide, and on his return to Paris his longing for death, which had always troubled his friends, had manifestly increased. He cared for nothing but riding the most dangerous horses. On one occasion he suffered a severe injury to his spine and before it had healed he insisted on riding again. The result was an infection which could not be cured,

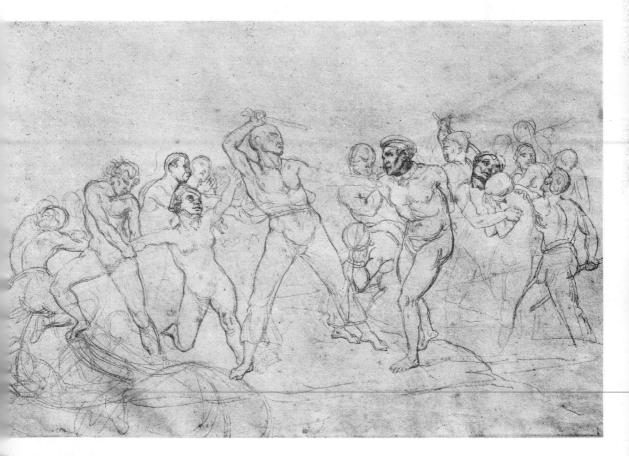

46 Géricault, Slaves

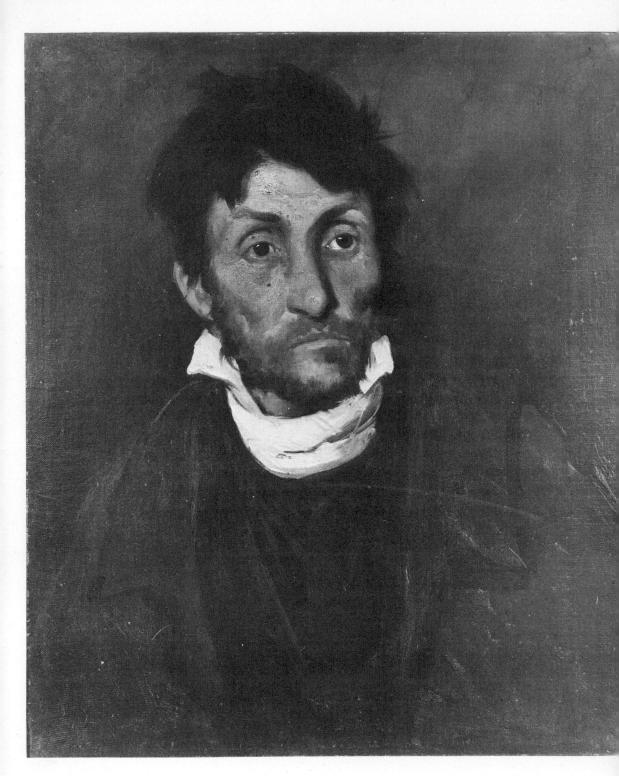

147 Géricault, Madman

¹⁴⁸ Géricault, Madwoman

and during the next two years he was a dying man. He made plans, for another composition on the scale of the *Medusa*; a scene of the slave trade. His choice of subject was probably influenced by his residence in England, where anti-slavery had for long made a special appeal to the popular conscience. But his drawings suggest that his interest was not purely humanitarian. Géricault's preoccupation with suffering and disease differed from Rembrandt's sympathy or even Beethoven's indignation; it contained some elements of that obsession with cruelty, which, in a few finely-tempered minds, complemented 195 the humanitarian movement of the nineteenth century. We cannot otherwise explain such drawings as [146] or the extraordinary series of paintings of decapitated heads [145], with which he was kept supplied by a prison. It was very much in this spirit that he undertook what are in some ways his finest works, the series of paintings of lunatics which occupied him in the year 1822-3. They could, I suppose, be considered as a development of the psychological studies of Lavater, and of Messerschmidt, the Austrian sculptor, yet they have a more humanitarian justification, since Géricault's friend, Dr Georget, was a pioneer in the humane treatment of insanity. These pictures show a remarkable restraint - in fact I cannot say that Géricault's male lunatics [147] look any madder than the majority of people one meets. On the other hand, his female lunatics are alarming images. The one in the Louvre [148] of a woman mad on gambling is pathetic (and I may add not in the least like the maniac gamblers whom I used to see in the Casino at Monte Carlo), but the child murderess in the Musée des Beaux Arts in Lyons [11] is really terrible: and what a masterpiece! That this subject should have inspired one of the greatest pieces of painting of the nineteenth century must have been unthinkable to the classic mind. It is also the contrary of that optimistic romanticism which regarded nature as a benevolent goddess. Wordsworth himself, it is true, was aware that nature can give a nasty bite to the hand which strokes her too possessively, but the Wordsworthians, including, above all, Ruskin, believed her to be the source of health, calm and moral law. To the Byronians, on the other hand, she was terrible and perverse. 'Nature averse to crime', said the Marquis de Sade, the precursor of the Romantic death wish. 'I tell you nature lives and breathes by it; hungers at all her pores for bloodshed, aches in all her nerves for the help of sin, yearns with all her heart for the furtherance of cruelty.' This is the tradition of romanticism to which Géricault belonged; and since it was the tradition which was to produce Baudelaire, Edgar Allan Poe, Swinburne and Rimbaud, and perhaps Dostoievsky, we cannot ignore it.

The lunatics were Géricault's last work. While still painting them, his mysterious illness (I suppose cancer of the spine) developed, and after a year of suffering he died at the age of thirty-three. Of all the romantics who died young, he is with Keats the most incomplete. It was only after his visit to England that he developed a sense of colour and shook off the mannerisms he had learnt in Rome. No doubt it was these very mannerisms which made him so acceptable 196 to his contemporaries, and on his death he became a figure of legend.

But I do not think that he was overrated. The Raft of the Medusa and the Madwomen are evidence that Géricault was potentially one of the greatest painters of the nineteenth century. By a rare piece of historical good fortune there appeared in the last year of his life an artist to realise and complete all his ambitions. The boy who had posed for one of the figures in *The Raft of the Medusa* exhibited his first great picture in the Salon in 1822. Friends pointed it out to Géricault and remarked on how much it owed to him – as indeed it does, in the whole design no less than in the nude figures of the damned. 'That is possible', replied Géricault, 'but it is a picture which I should like to have signed.' Delacroix is, to an extraordinary degree, the continuation and consummation of Géricault, taking over his forms no less than his subjects, his spirit and his ambitions; developing them with a steadiness of purpose and a detached intelligence which Géricault lacked.

197

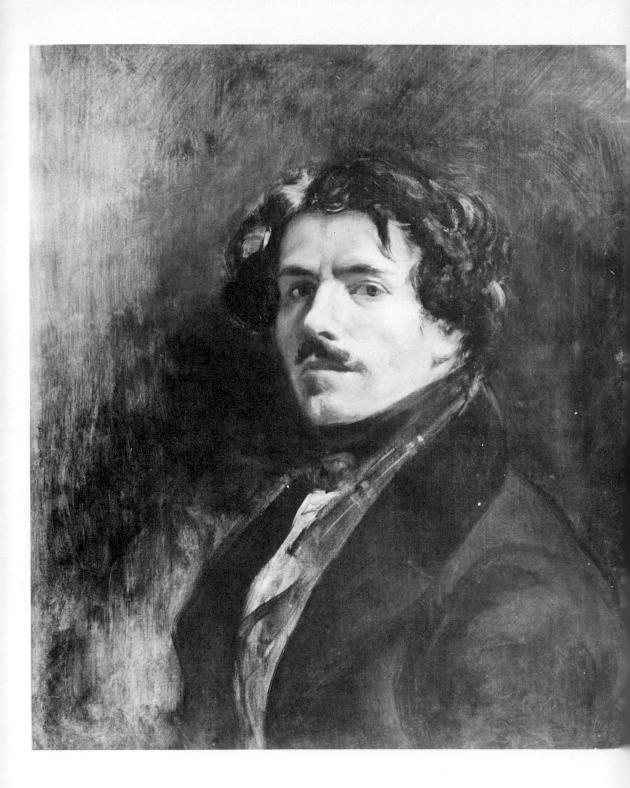

149 Delacroix, Self-portrait

Delacroix

Delacroix is, with Turner, the greatest master of romantic painting. Superficially no two men could be more different. Delacroix was an aristocrat, a man of the highest culture, and an admirable writer. Turner was plebeian, uneducated and incapable of writing a grammatical sentence. Delacroix was a neurasthenic, continually fussing about his health. Turner, until he lost all his teeth, had an iron constitution, and must have performed prodigies of endurance on his travels. Delacroix was a man of the world, who moved among the leading poets and men of letters of his time. His closest friends were Chopin and George Sand. Turner, apart from a few old cronies, preferred the company of sailors at Limehouse and lived anonymously in a series of lodging-houses. But Delacroix and Turner were united by two things, a passionate desire to express their feelings through colour, and a deep pessimism. Delacroix would have shuddered at the language of The Fallacies of Hope, but he would have agreed with the sentiments.

Eugène Delacroix was born in 1798. His father, an eminent public servant, was medically certified as incapable of having children in 1797, and there can be no reasonable doubt that Eugène was the son of one of the greatest statesmen and most intelligent individuals in Europe, Talleyrand. The physical resemblance is most striking; to his parentage we may also attribute Delacroix's aristocratic disillusion.

As all Delacroix's painting was, and was intended to be, a communication of his character, I must begin by drawing it in such outlines as may be filled in by the examination of his work. His selfportrait [149], painted at the age of thirty-seven, like most self-portraits, portrays the sitter in his most amiable mood, but it shows something of the energy, the will and the disdain which were scarcely concealed under the elegant exterior of a perfectly accomplished man of the world. One can see, too – what struck most forcibly all his contemporaries – that look of a wild animal in the powerful jaw and the narrowed eyes. 'The tiger', said Baudelaire in untranslatable 199

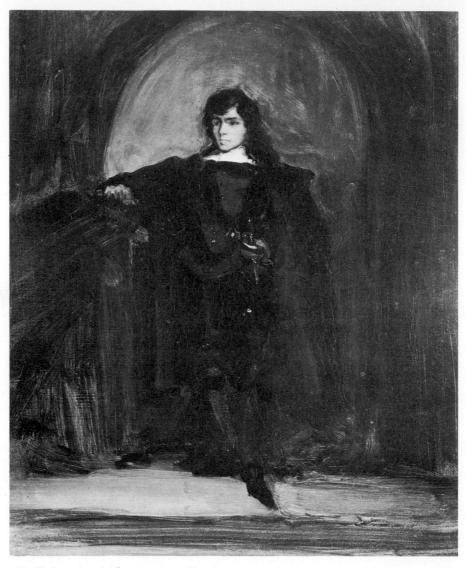

¹⁵⁰ Delacroix, Self-portrait as Hamlet

words, 'watches his prey with no more tense and concentrated gaze than does our painter when his spirit has fastened on an idea.' 'The tiger': that is the word which occurs on the first page of every writer on Delacroix, and with justification. From our point of view any of his drawings of tigers [151] is nearer to being a self-portrait than those which he painted with the aid of a mirror.

Nearly all Delacroix's great works involve the shedding of blood, many of them are scenes of indescribable carnage and ferocity. 200 At feeding time in the Paris Zoo he was, he tells us, '*Pénétré de*

51 Delacroix, Tigers

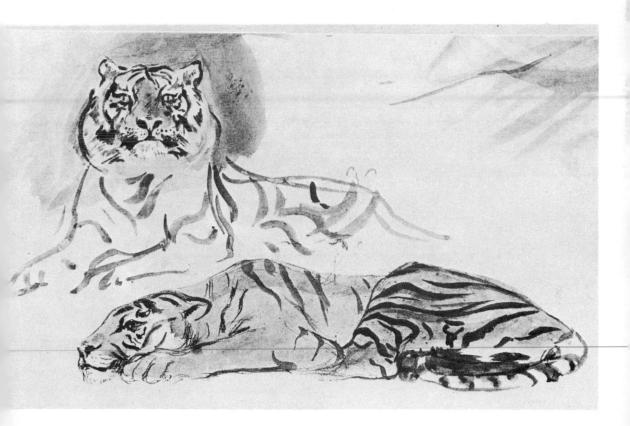

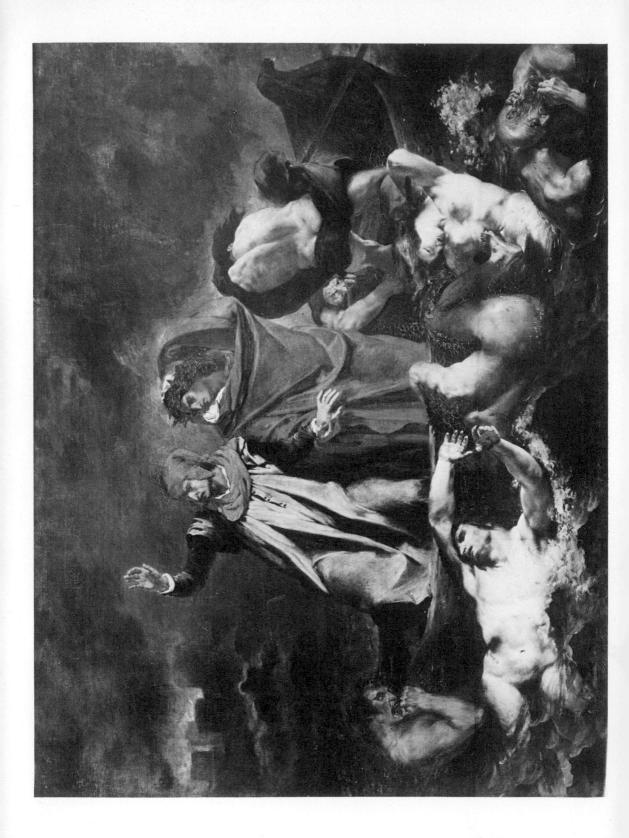

bonheur'. But there was another side to his nature, which gave the tiger its value. One of his earliest paintings shows him in the costume of Hamlet [150]; not, certainly, the irresolute Hamlet, but the Hamlet overburdened with intelligence, to whose questions about the destiny of man there is no answer. Delacroix grew less like Hamlet as he grew older, as I suppose Hamlet would have done. His unanswered questions settled into a sort of stoicism. He remained the glass of fashion out of sheer pessimism, and took an ironical pleasure in conforming to the usages of society. He was, in Baudelaire's sense, the highest expression of the dandy: but when he took off the suit in the English cut, which he was one of the first to introduce to Paris, and put on the costume of an Arab, we can see how the great pessimist was withdrawn from the world: above all from the prosperous, crassly hopeful world of the nineteenth century. It is with such an expression that he must have listened to enthusiastic descriptions of progress, one of the few subjects which irritated him into open contempt.

Such then was the young painter who, in 1822, exhibited the work which I mentioned in the chapter on Géricault, Dante and Virgil crossing the Styx: the picture which Géricault said he wished he could have signed, and which is certainly the fulfilment of his intentions [152]. It equals him in largeness, energy and emotional impact, and in two respects it excels anything in Géricault's work: it is the work of a natural colourist and it is fundamentally more imaginative. We are no longer conscious, as in Géricault, of the drawings from the model and the studies of corpses.

Delacroix was from the start a born illustrator. As a boy he did not train himself by drawing from the antique, but in copying prints after Gilray. Something of this caricatural instinct still survives in his marvellous little portrait of Paganini [154]. He started by looking for expression of character and animated gesture. He agreed with Leonardo that the first requisite of the painter of histories is the power of seizing those fleeting gestures in which men reveal their emotions, and said to Baudelaire, 'If you can't make a drawing of a man who has thrown himself out of a fourth floor window before he hits the ground, you will never be able to paint "de grandes machines".' This graphic skill was combined with a remarkable feeling for paint. A number of Delacroix's life studies have survived, and show that, had he chosen, he could have surpassed Courbet as a realist; and throughout his life he could produce beautiful passages of what is called pure painting. Just as a society lady was heard to say, 203

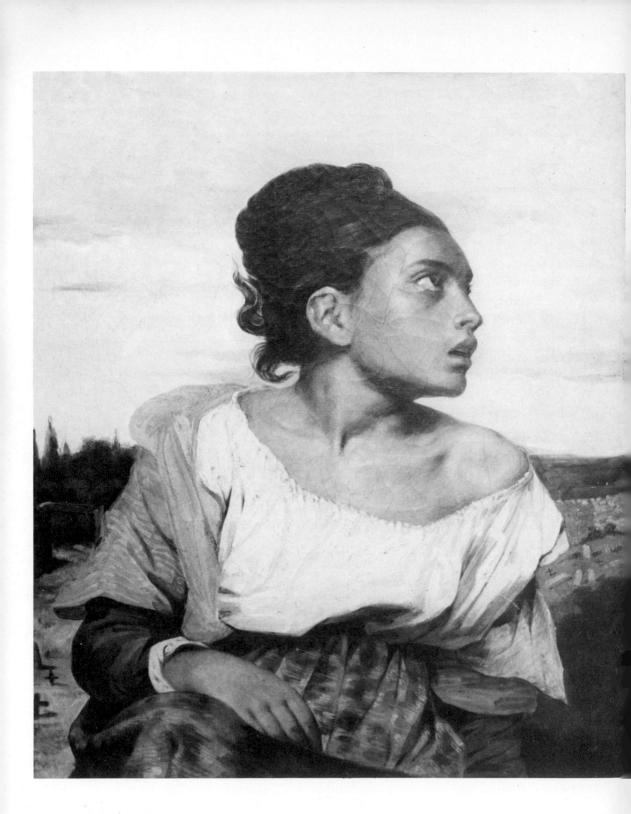

153 Delacroix, Orphan Girl in a Cemetery

'What a charming man Monsieur Delacroix is; what a pity it is that he paints', so I have heard artists of a certain vintage say, 'What a charming painter Delacroix could be; what a pity he chose such tiresome subjects.' In other words, what a pity he placed these agreeable gifts in the service of a great poetic imagination. The girl on plate 155 is only a study of a model, but from the expression on her face we see that she is a potential victim in the *Massacre of Chios* [155].

The Massacre of Chios is the picture in which Delacroix is first himself. The Dante, magnificent as it is, belonged to the tradition of Géricault and Guérin. Here in the accidental shadow and the relation of the figures to landscape, no less than in details like the silhouette of the horse, he speaks his own particular language, which was not to be greatly modified in the next thirty years. The picture was painted in

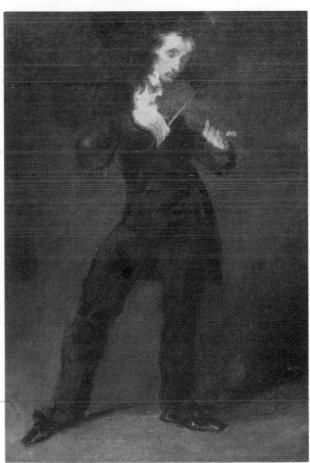

154 Delacroix, Paganini

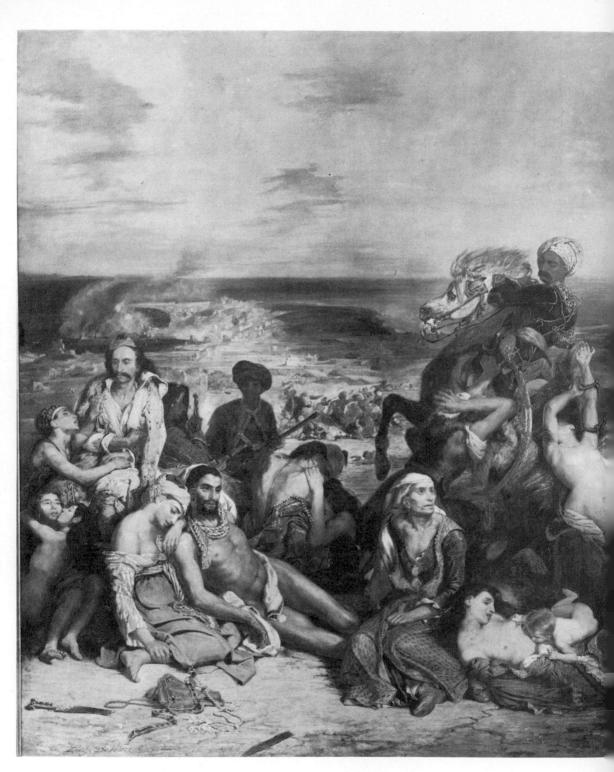

¹⁵⁵ Delacroix, Massacre at Chios

1824 and was already on the walls of the Salon when Delacroix saw the Constables, which had been sent over for exhibition; whereupon he had it taken downstairs, and in four days re-painted the background with touches of broken colour to give it sparkle. It also shows the peculiar density of Delacroix's design, a richness which occasionally amounts to congestion. In this, no doubt, he was following the precedent of Rubens but, not being heir to a current style, he never had Rubens' fluency. He had to work out the rhythms for himself and, although in his later pictures he achieved a greater unity of movement, he could never float along on the waves of a style, as his great predecessor had done. This had one advantage. As every group had to be worked out afresh we are made far more conscious of the dramas which they portray. The buoyant mastery of Rubens' style often prevents us from believing in the actuality of the scenes represented. I do not think it has ever occurred to anyone to feel sorry for the Amazons who are being slaughtered in the picture in Munich, any more than we feel horrified by the plot of Atalanta in Calydon. In each case the tune is so powerful that we do not listen to the words. But with Delacroix we are immediately conscious of the pathos of the scene; and form, colour and handling are consciously directed towards this end.

The year after the exhibition of the Massacre, Delacroix visited England. He was encouraged to do so by what he had seen of English painting, and he was impressed by Ward, and the English portrait painters. He also made friends with Bonington, whose Moorish ladies with their shining silks appealed to the most superficial part of Delacroix's imagination. Like Géricault the best results of his visit to England were his studies of horses, of which the most liberated is the famous watercolour of a white stallion frightened by lightning [157]. This horse, with violently flexed fetlock, with tail and mane like fountains in the wind, this extraordinary arabesque as vital and as irregular as a Hokusai, is Delacroix's doodle, his automatic writing, occurring again and again throughout his work whenever his unconscious took command. It shows how diametrically opposed he was to Ingres - whose central form was smooth, enclosed, self-contained. Delacroix, for all his love of the Elgin marbles and the music of Gluck and Mozart, was far from the classics in his inner core.

To this frenzied, Dionysiac side of his character Delacroix gave free rein in his next great picture – his second massacre, as he called it – *The Death of Sardanapalus* [156, 14]. It is the most liberated of all his works, the one in which he most unreservedly gratified all his 207

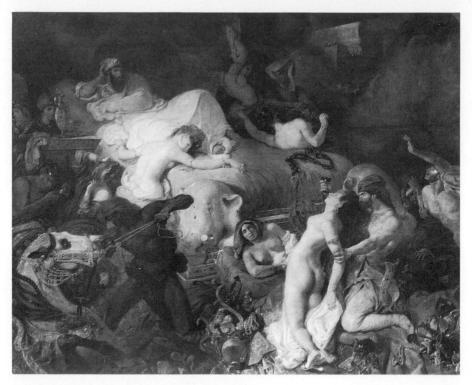

156 Delacroix, The Death of Sardanapalus

appetites. Like Ingres' Jupiter and Thetis it was not intended to conciliate opinion; and, in fact, it aroused bitter hostility. To the death wish of Géricault is added abundant sensuality. This last element is unusual in Delacroix, and it is responsible for a certain disunity in the picture. He had conceived *The Death of Sardanapalus* as a dark and sombre scene – the last moment of a tyrant whose pride forces him to involve in his own death everything that had delighted him in life. Delacroix was usually careful to preserve in his pictures the tone and colour which had from the first seemed to him expressive of the subject. But this is an exception; for he was so enchanted with the pink and gold of the Circassian slave on the bed, that he raised the pitch of the whole picture, so that it became a blaze of sensuous colour instead of a gloomy drama of destruction.

The Sardanapalus so greatly alienated official opinion that Delacroix might have been ruined, or at least prevented from painting on the heroic scale, had there not occurred in the following year the revolution of 1830. The new set of officials were anxious to reverse the policy of their predecessors, and Delacroix won their 208 approval by painting a political picture, *Liberty Guiding the People*

13 Delacroix, Sea of Galilee

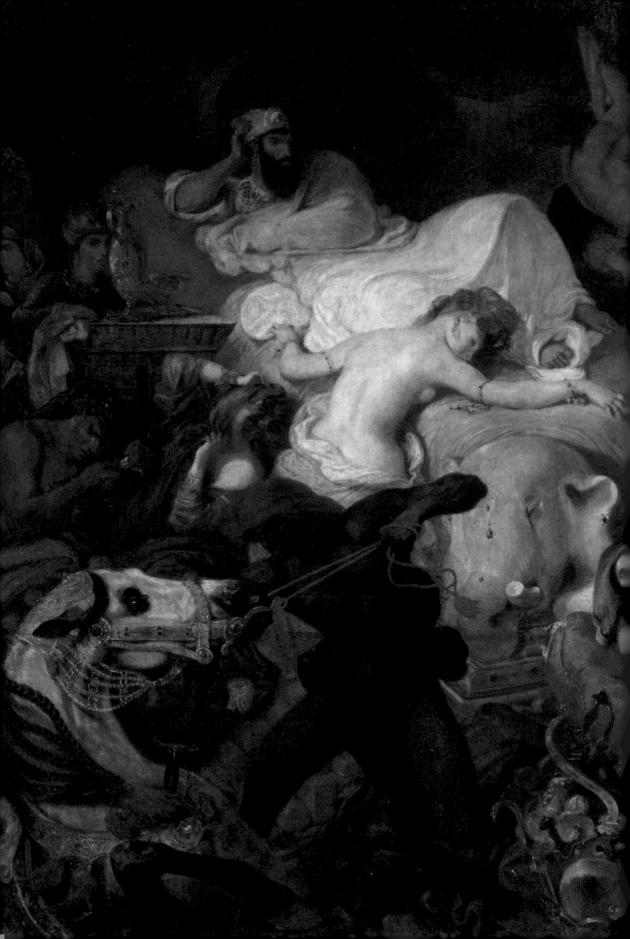

[158]. No doubt he painted it from conviction, although later in life he became entirely sceptical about politics in general and revolutions in particular; and his picture is as good as one has a right to expect from a piece of revolutionary propaganda. It has not, to my mind, the riveting concentration of David's propaganda pictures, but it remains an acceptable illustration of the Marseillaise. The *Liberty* was followed by a number of scenes of battle and civil commotion, painted with vaguely revolutionary sympathies, which are not his most interesting works, and there then occurred, in 1834, the turningpoint of Delacroix's career, his journey to Morocco.

Delacroix's visit to Morocco was rather like Turner's to Italy. He had been painting oriental scenes long before he went there; his stay there was short, and he continued to draw on his memories for the rest of his life. Just as Turner's months in Rome made him less classical, so Delacroix's in Morocco made him less extravagantly oriental. He had expected to find confirmation for the colour, ferocity and sensuality of his Byronic dreams: he found instead a way of life which, with his quick intelligence, he immediately recognised as far more classical than the waxwork classicism of the Davidiens. It was the dignity, simplicity and continuity of the life which enchanted him [159]. The gestures of the Arabs were, he said, like those of Cato

157 Delacroix, White Stallion frightened by Lightning

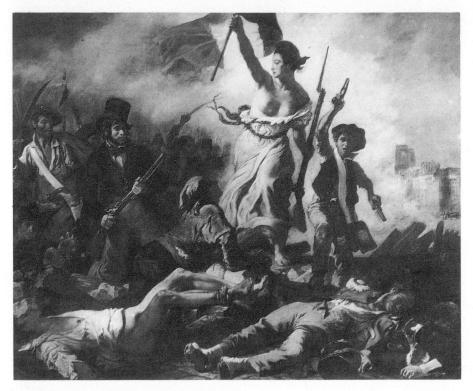

158 Delacroix, Liberty Guiding the People

the elder; their white robes took the large and simple lines of togas. I am not sure how far there was a vein of paradox in this, or how far it was an instance of the prestige of classical authority in Delacroix's mind. It is certain, though, that to this restless and self-conscious product of civilisation, the spectacle of a life which was still close to necessity but governed by unbroken tradition, was extremely satisfying. Thenceforward it provided a basis for his philosophy, and (for the two are inseparable) for his art. He filled his sketchbooks with memoranda as swift and evocative as Turner's sketches in Venice, and he did some finished drawings. The portraits of Morocco are full of that timelessness and resignation which Delacroix so greatly valued. These drawings and watercolours he later turned into paintings; even in 1860 he was still working on new subjects first suggested in the Moroccan sketch-books.

The picture Delacroix painted immediately on his return, The Women of Algiers [160], although a famous work, seems to me to have been overrated, although it is presumptuous of me to express such an opinion of a work which so greatly influenced Courbet, Manet and 210 even Henri Matisse. Its fame derived partly from its subject - for

Delacroix, The Sultan of Morocco

160 Delacroix, The Women of Algiers

¹⁶¹ Delacroix, Tasso in the Madhouse

Delacroix really did get into a harem – and partly from its colour, which I think must have suffered from the use of bitumen and siccatives. Even in its prime, though, the picture must have lacked both the poetry and the ferocity of the real Delacroix. Nor are we conscious of any underlying idea, except the rather bad idea, which Delacroix, in his notebooks, was inclined to support, that women should be kept in a harem. We are far closer to his mind in another immediate reminiscence of Morocco, the *Dervishes at Tangier*. It develops, in a new setting, a theme which had long played a part in 213

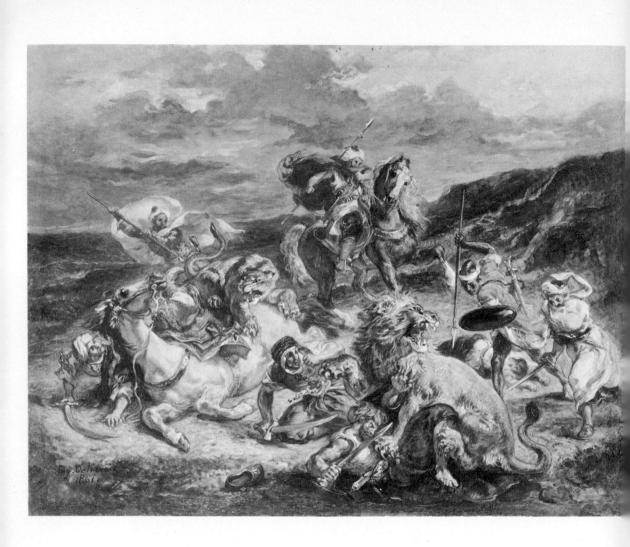

162 Delacroix, Lion hunt

Delacroix's mind, the filament which separates inspiration from madness. This theme first appears in a picture of the poet Tasso [161] who, when he became inconvenient, was put into a madhouse by the Duke of Ferrara. It was painted for Dumas, and was the subject of a sonnet by Baudelaire; and of course Baudelaire sees it as an image of how the world with all its grossness stifles the poet's dream. Delacroix's position was not quite as simple as that, because, although he believed so anxiously in the spirit, he believed even more deeply in the life-force – *le possible* – and, as Baudelaire rightly said, it was the savage part of Delacroix's soul that was dedicated in its entirety to the painting of his dreams. No man would have subscribed more sincerely to Blake's maxim, 'The tygers of wrath are wiser than the horses of instruction.'

The character of the lion or the tiger in the symbolic language of the imagination is ancient, persistent and revealing. It must represent one of those archetypal images, those ghost ancestors of the human spirit, which still await their explorer. The subject of the lion devouring the doe or horse was even mysteriously Christianised in the pulpits of the twelfth century. It was revived in the eighteenth century by the English painter George Stubbs, and occurs in the drawings of Géricault. But it was Delacroix above all who made it his own. In his sympathy with the colossal joys of the lion, he often made the victim not the passive animals, but man himself, more instructed than the horse. It was in such a frame of mind that he constructed those marvellous scenes of tiger- and lion-hunts which are the most personal of all his pictures; those which vibrate most intensely with the full power of his nature. The confusion and restlessness of such a group as that on plate 162 is made comprehensible in the original by its splendour of colouring. Every touch is part of a chromatic sequence calculated with an intelligence as cool as the superintending emotion is ardent.

These explosions argue a terrific vitality in the painter. In his middle years Delacroix was possessed of a demon of energy which allowed him to cover vast areas of canvas. He produced enormous pictures like the *Justice of Trajan* and, thanks to his friend Monsieur Thiers, he was given a large number of public commissions. Of these by far the most interesting are his decorations of the ceiling of the Library in the French Parliament House. The ostensible subjects are entirely commonplace – Apollo and the Muses, the great poets, philosophers, scientists, and so forth. They suggest the kind of encyclopaedic optimism which we find in the base of the Albert Memorial. 215 But in Delacroix's mind they became the exact reverse. His consciousness of the perils of the high-strung spirit - what we may call 'the Tasso motive' - became extended into an idea of the fragility of civilisation. This became Delacroix's theme: that the achievement of the spirit - all that a great library contained - were the result of a state of society so artificial and so delicately balanced that at the least touch they would be crushed beneath an avalanche of pent-up animal forces. To express this idea he painted at one end Orpheus bringing the benefits of civilisation to the Greeks, at the other Attila and his hordes annihilating the culture of Italy. The Orpheus scene is characteristic of him. He does not portray the primitive Greeks as beautiful figures from an archaic vase, but as savages. His own description is 'Orpheus is surrounded by hunters covered with the skins of lions and bears. They regard him with astonishment. Those who are older, wilder or more timid hide in the shadows of great rocks, and watch the divine stranger from a distance. The centaurs turn back at the sight of him, and retire into the heart of the forest.' In the painting we are in no doubt of Delacroix's sympathy with the suspicious old men, squatting like aboriginals, who see in this talkative interloper a threat to their settled, immemorial way of life. Perhaps it would be going too far to say that in the other chief lunette [164] he shows sympathy with Attila; but he has given to the leader of the Huns the same irresistible energy which he gave to his beloved wild beasts. The smaller scenes in the pendentives support, with great richness of poetic invention, the main theme. One of the most beautiful shows how Achilles [163], the hero of classicism, must be taught by a centaur, whose animal instincts gave him skills denied to men. In one of the vaults he had depicted Ovid among the Scythians, where the poet, who has been tainted by civilisation, sits in dejection while the barbarians try to revive his spirits by gifts of mares' milk and honey. Of this idea he did several easel pictures, one of which is in the National Gallery in London [12].

The greatest and most melancholy example of his feelings about the relations between barbarism and civilisation takes rather a different turn. It is *The Entry of the Crusaders into Constantinople* [165]. Delacroix called this his 'third Massacre'; but it is in fact very different in spirit from the other two. It has neither the indignation of *Chios* nor the frenzy of *Sardanapalus*. The sky is dark, and the Crusaders, silhouetted against the plundered city, are in a dark blue shadow. Because these barbarians are themselves exhausted, and no 216 longer intoxicated by Attila's blind energy of destruction, they look

163 Delacroix, Achilles and a Centaur

164 Delacroix, Attila, drawing for ceiling of Assemblée Nationale

on their victims with sorrow and perplexity. Having conquered the civilised world, they have no idea what to do with it. They will destroy it out of sheer embarrassment.

The Entry of the Crusaders into Constantinople is, on the whole, the most successful of Delacroix's large pictures. It is almost his last word on history and, in pictorial terms, it is carried out with the greatest consistency. It also contains some astonishing details. The two women on the right-hand side, the flowers beneath the foot, are a formal invention of great expressive power. The inverted head reminds us of Picasso's romantic drawings of about 1935 in line and wash.

Perhaps I have dwelt too much on Delacroix's disillusion. Although he often revealed his belief that crude animal vigour was preferable to an overstrained civilisation, he never lost a belief in the ultimate victory of the spirit. It was this which made him the only great religious painter of the nineteenth century. He was not himself a 218 believer, but certain elements in the Christian story moved him 165 Delacroix, The Entry of the Crusaders into Constantinople

deeply, especially those which show the lonely, individual soul triumphing over all the forces, physical and spiritual, which are mustered against it. For this reason one of his favourite subjects was Christ on the Sea of Galilee [13], which he must have painted dozens of times, with increasing freedom and expressiveness. In the earlier version he is still absorbed in the variety of human responses and danger. In the later versions he uses more purely pictorial means. Finally it becomes Delacroix's hieroglyphic – as it appears in horse, or lion or flying cloak, used to create a particular mood of excitement which comes to rest on the figure of Christ.

This belief in the ultimate victory of the spirit is expressed in his last great decorative painting, the *Jacob Wrestling with the Angel*, in S. Sulpice [166]. In the shadow of great oaks, symbols of his primitive nature, Man has struggled all night to resist that gift of spiritual perception which will so greatly sadden and complicate his existence. He charges like a bull against the impassive angel, but in the end he must succumb to his destiny. This perhaps is Delacroix's last word on the dualism which had absorbed him all his life.

In talking about Delacroix one inevitably finds oneself describing his subjects in literary terms that one would not apply to any of the other great painters of the nineteenth century except to Jean François Millet. There are, indeed, times when those subjects drawn from Shakespeare and Byron, with their over-rich and over-familiar associations, can come between us and our enjoyment of his purely pictorial qualities. Delacroix said of Ingres that his work was 'the complete expression of an incomplete intelligence'. Ingres (if he had had the wits) might have reversed the compliment. Delacroix was one of the most completely intelligent men of his century, but the very range and responsiveness of his mind made it almost impossible for him to be a painter. He could not abandon himself to his perceptions; he could not simplify his ideas till they reached a paintable form; he could not come to rest. Painting deals with stasis, with place, not with time. Delacroix, like a true child of that nineteenth century which he detested, was a native of time. Hence the restlessness which characterises even his most complete works, and is visible, for example in the flickering outline of the Good Samaritan's horse. It is no accident that this picture was a decisive influence on Van Gogh. The same restlessness is to be found in the late work of Constable, another painter obsessed by change; and it is something very different from the organised, bounding movement of the baroque.

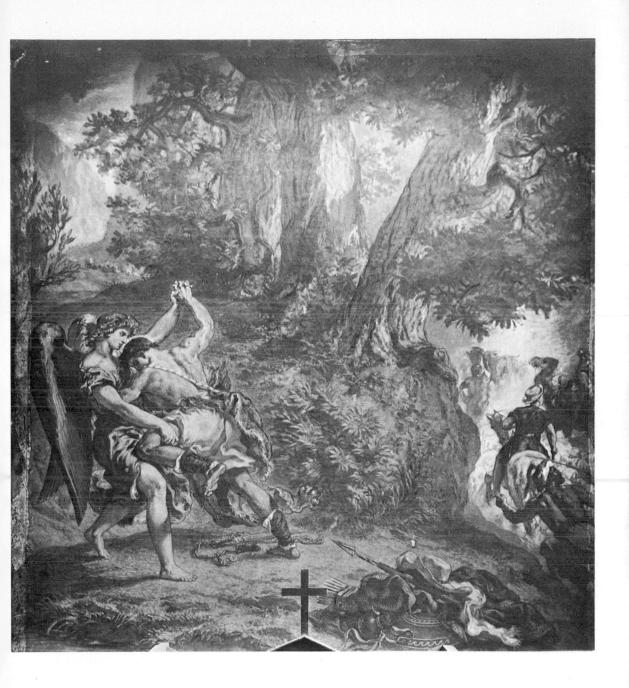

166 Delacroix, Jacob Wrestling with the Angel

167 Turner, Cloisters, Salisbury Cathedral

Turner I

The Popular Poet

Art critics are fond of saying that the great artists of the past are really our own creations; that every age takes from them what it wants, and rejects the rest, even though that which is rejected is what the artist's contemporaries, and perhaps the artist himself, valued most highly. That is one of those truisms that are not altogether true and vary from one artist to another. We probably do see Constable very much as his first patrons saw him; but it is true of Turner. Indeed three-quarters of the paintings by Turner which we admire most were not exhibited in his lifetime; many of them were not put on stretchers or seen by another human eye till over fifty years after his death. As late as 1939 about fifty more Turners were discovered in the cellars of the National Gallery, rolled up, and thought to be old tarpaulins. When cleaned, these pictures turned out to be the kind of Turners that speak to us directly today. They depend tor their effect entirely on light and colour and have no identifiable subject – nothing to distract us from the pure sensation. They are modern painting. Nevertheless, I feel sure that our understanding, and even our enjoyment, of Turner will be incomplete unless we have looked attentively at the kind of Turners that were admired by our ancestors. Above all we must remember that Ruskin, who knew Turner personally and understood his work far better than any of us, praised above all what one may call the poetic element in Turner. Turner was a great reader of poetry, in particular of James Thomson, Akenside and Byron. He took his subjects from these poets and everything in his exhibited pictures, from the conception of the whole down to the minutest detail, is calculated from some poetic effect. In this, at least, he followed the classic doctrine of Ut Pictura Poesis a picture must be visible poetry. In every other respect he was an arch-romantic, recreating the moods of all the great romantic poets -Wordsworth, Byron and latterly Shelley – by an appeal through colour to our emotions.

Turner was born on St George's Day, April 23, 1775. His father was a barber in the narrow London street of Maiden Lane, and Ruskin, in some of the most eloquent pages of Modern Painters, has contrasted Turner's upbringing with that of another great colourist, Giorgione. Giorgione was brought up in Venice. 'A city of marble, did I say? Nay, rather a golden city, paved with emerald. For truly every pinnacle and turret glanced or glowed, overlaid with gold and bossed with jasper.' Then Turner: 'Near the southwest corner of Covent Garden, a square brick pit or well is formed by a close set block of houses, to the back windows of which it admits a few rays of light.' Yes, but a small boy had not far to go to be among the flowers and vegetables of Covent Garden Market; and in five minutes, if he ran, he would be beside the Thames, and could cadge a lift in a boat to the mysterious forest below London Bridge, the forest of masts, feeding the imagination better, says Ruskin, than wood of pine or grove of myrtle. Ruskin goes on to imagine the small boy floating toward the ships, under the ships, and clambering up them - 'these the only quite beautiful things he can see in all the world, except the sky . . . which ships are also inhabited by glorious creatures, red-faced sailors, with pipes, appearing over the gunwales, true knights on their castle parapets.'

Such were the experiences that buried themselves in the mind of the boy Turner, the colour of cabbages and tomatoes, the lines of intricate rigging, the movement of water and of light; and these unconscious memories persist in some late works – the cabbage and tomatoes and celery for example, in a picture called *Pilate Washing his Hands*; the masts and gunwales, of course, in a hundred pictures. Quite early his father, the barber, discovered that his son had a gift for drawing. He saw that it could be a source of income, and exploited his son as relentlessly as did the father of Mozart – and with more material profit. In a few years Turner was able to produce the most marketable of all collectors' items, watercolours of picturesque scenery.

I need not enlarge on the reasons why watercolours of gothic architecture had become so fashionable in the 1780s. They were a part of the sentimental – as opposed to the violent – phase of the Romantic movement. Many artists had already succeeded in this genre, but such was the young Turner's talent and application that in a few years he came to do them better than they had ever been done before. His first drawings are mannered and conventional; 224 by 1797 he was doing watercolours like one of Ewenny Priory

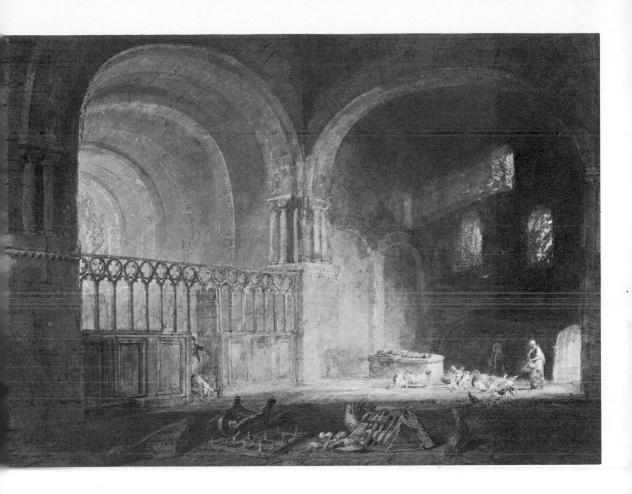

8 Turner, Ewenny Priory

16 Turner, Keelman heaving in Coals by Night

[168] which, to say the least, demanded a good deal of skill. Needless to say, they were immensely popular. Turner's work was never again received with such unanimous favour as when he was twenty-one. It was just what collectors wanted, and have wanted ever since: the conventional thing done skilfully with nothing to disturb prevalent assumptions. To be sure, they could have seen dangerous indications of originality in his pictures had they known where to look. There is some of Turner's restless rhythm in the traceries in the cloisters of Salisbury Cathedral [167]. But nobody noticed it, and by 1798 Turner could tell Farrington - the diarist and universal busybody of nineteenth-century English art - that he had more orders than he could execute. In 1799 he was elected an Associate of the Royal Academy.

At this date, when the topographical watercolours had reached their peak of accomplishment, the second Turner had begun to appear. This resulted from the first of those repeated escapes from the city which can be made the turning-points in Turner's career - his expedition to the Yorkshire dales and the Lake District in 1797. Ruskin has finely imagined the calming and liberating effect of those majestic scenes on the mind of a boy brought up in the cramped and noisy squalor of Covent Garden. A picture of Buttermere [169], which contains so much of Turner in design, in lighting and in sentiment, was exhibited in the Academy of 1798, and thus coincides conveniently with the appearance of Wordsworth's Lyrical Ballads. Admittedly the similarity does not go very deep. Turner's approach to nature was fundamentally pessimistic and catastrophic; Wordsworth's (in spite of the episode of the stolen boat in the Prelude) optimistic and teleological. But for about ten years Turner did produce a surprisingly large number of works in a Wordsworthian vein, ranging from the lyrical mood of Abingdon to the sterner spirit of resolution and independence, which is illustrated by some of his engravings in the series, known as the Liber Studiorum [170]. Although it is easily forgotten in our modern concept of Turner, the Liber was intended as a proof of his variety and resourcefulness, and was the basis of what one may call the second Ruskinian interpretation of his work: that Turner was above all the master of naturalism. Looking back through the mists and mirages of his later painting, this seems a curious delusion, but there is more support for it than one would suppose. To this phase belong the beautiful pictures of the Thames valley painted about 1807. As late as 1813, after two years of snowstorms and eruptions, he could still paint a masterpiece in this vein; although, in 226 fact, the Frosty Morning [171] is full of understated incidents that

) Turner, Buttermere Lake, with part of Cromack Water, Cumberland, a shower

show the influence of Turner's dramatic poesies.

Forty years ago there must have been many lovers of painting who found these naturalistic, lyrical Turners the most acceptable part of his whole output but in his own time they were quickly overshadowed by more spectacular triumphs. The most ambitious of these represented the Plagues of Egypt, Turner's first attempt to surpass the old masters by means of exaggeration. They contain remarkable passages inspired by the scenery of North Wales, which he had sketched in the previous year; but these are subordinate to the idea of historical painting - that extension of Renaissance art-theory which, through the genius of Nicolas Poussin, had spread to landscape painting. Poussin, of course, is the basis of the picture of the *Tenth Plague of Egypt* [172], commissioned by William Beckford, the creative patron of romanticism, perhaps as early as 1796, although not painted till three years later. It is interesting to notice that Poussin's influence predominated even before Turner had been to France, and when he visited the Louvre in 1802, Poussin was, with Titian and Paul Veronese, the artist on whom he took the most numerous notes: once more a romantic artist struggling to achieve classic order and authority. The nearest Turner ever came to achieving a Poussinesque composition is a picture of Bonneville [173], painted a year after the

170 Turner, plate from Liber Studiorum

171 & 172 Turner, Frosty Morning and The Tenth Plague of Egypt

Louvre visit and his first tour of the Swiss Alps. In spite of a construction based on verticals and horizontals, it contains failures of pictorial logic that Poussin could never have tolerated; the main right angle is quite out of proportion; and after a few minutes' analysis we recognise that the point of the picture does not lie in the design at all, but in the effect of light and the observation of nature. Curiously enough Turner took no notes on the Claudes in the Louvre – perhaps they were not visible – but he had plenty to study in England, and in some instances he tried so hard to subordinate himself to his model that he produced what are virtually pastiches.

Meanwhile, Turner had begun to paint pictures which were entirely his own, and characteristically they are concerned with the sea. All his life this was his true element, which he was to paint in every mood. At first he wished to give his sea-pieces some element of heroic drama, which for some reason meant painting the sea very black. The earliest of them, exhibited in 1801, is the so-called 'Bridgewater Sea-piece'. There is some memory of the Dutch sea-painters, with a horizontal background to steady the more dramatic movement. Four years later this traditional stabilising influence had gone and in its place is a design which only Turner could have conceived, a fearful

173 Turner, Bonneville

'4 Turner, The Shipwreck, 1801

175 Turner, The Fall of an Avalanche in the Grisons

mêlée of conflicting directions occupying a diamond-shaped area, an agitated lozenge in the middle of the composition. This picture, The Shipwreck [174], is one of Turner's first assertions that the force of the elements could not be conveyed by the traditional schemes of landscape painting. It might be said to be one of his first great anticlassical pictures, based on the endless conflict of northern line as opposed to the stability of Mediterranean mass.

It was some time before Turner ventured so far outside the norm again. In fact, in the next year he made one of his most sustained efforts to paint a classical, poetic picture - The Goddess of Discord choosing the Apple of Contention in the Garden of the Hesperides (already a pessimistic subject) [176]. From Ruskin onwards this picture has inspired many pages of eloquent admiration. But, alas, I, who worship Turner, cannot join in. The figures seem to me badly drawn and derivative; the whole foreground is boring and the picture only comes to life in the mountainous background. Turner's response to alpine scenery, recorded in dozens of magical watercolours is given a definitive form in these rocks and precipices; and the way in which he has turned one of them into a dragon is a stroke

232 of poetic imagination.

176 Turner, The Goddess of Discord choosing the Apple of Contention in the Garden of Hesperides

Turner's love of alpine scenery was, of course, closely allied to his love of mountainous waves, but it was even more specifically romantic. The Peace of Amiens had allowed him for the first time to travel on the Continent, and to begin that series of romantic pilgrimages which are, to some extent, a pictorial anticipation of Childe Harold. The scenery of the Alps had a valuable influence on Turner in two ways. First of all it satisfied his craving for all that was most extreme and potent in nature - the deepest gorges, the most precipitous crags, the most impetuous waterfalls, whirlwinds, thunderstorms and avalanches. However, I must not convey the idea (as the allusion to Byron may perhaps do) that these pictures were part of the rhetoric of romanticism. Turner differed from the fashionable storm-painters, such as John Martin, who were to succeed him, because their storms were to a large extent concoctions, put together like Hollywood sets, whereas Turner's storms were based on accurate observation. Of this there is a quantity of evidence left to us by people who had the misfortune to be in the same storm as Turner, and who afterwards saw it reproduced on his canvases. He had an extraordinary memory for natural phenomena, and the more violent they were, the more intensively were his powers of observation applied. One cannot guarantee that he had actually seen the rock falling on a miserable cottage [175] but he had certainly memorised enough of an avalanche to make us believe that he had been an eye-witness. We do know, however, that the most impressive of all these alpine storms was an actual experience, although it took place in Yorkshire, not Switzerland. Turner was staying with his closest friend, Walter Fawkes, when a storm blew up, and Turner started making notes on the back of a letter. When the storm had passed he turned to Mr Fawkes' son and said, 'There, Hawkey, in two years you will see this again and call it Hannibal crossing the Alps [177].' If this story is true (and there is no reason to believe that Hawksworth Fawkes was lying) it is an instance of how the creative process works in an unpredictable flash. Turner was always brooding on the war between Rome and Carthage, in which he saw a parallel with the Napoleonic wars (although which was Britain and which was France is never quite clear). But that a storm in the Yorkshire dales should have suddenly triggered off this great epic drama – for such, I think, it is – shows how far we are from understanding the nature of genius. Turner knew he had been inspired, and printed in the Academy catalogue for the first time some of his own poetry - perhaps the best he ever wrote:

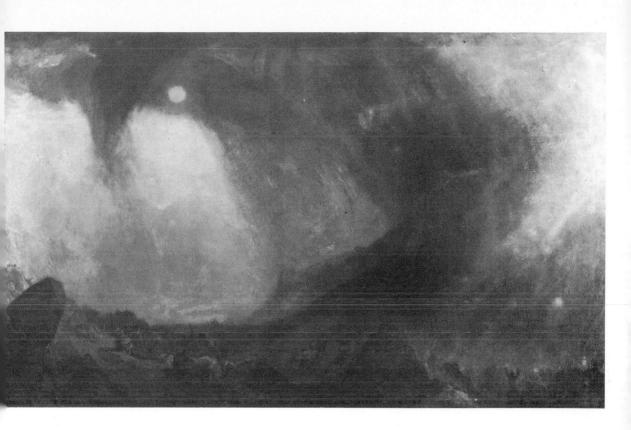

77 Turner, Snowstorm: Hannibal and his Army crossing the Alps

Still the chief advanced, Look'd on the sun with hope; low, broad, and wan; While the fierce archer of the downward year Stains Italy's blanch'd barrier with storm.

I have said that these alpine subjects were important to Turner in two ways. The second one was that they allowed him to develop a type of composition complementary to the agitated lozenge of *The Shipwreck*, one based on the vortex. The vortex was the expression of Turner's deep pessimism, for he thought of humanity as doomed

178 Turner, Crossing the Brook

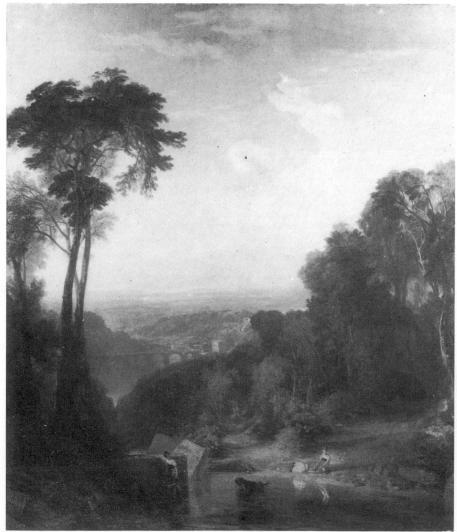

236

to a senseless round, which ultimately sucked man in to his fate. This obsession with the vortex gained a stronger hold on him as he grew older so that it came to underlie quite innocent-looking compositions. It appears first in his *Hannibal*.

It is characteristic of Turner's desire to do everything, to excel in every field, that the year after the Hannibal he should have sent to the Academy his Frosty Morning. A year later he painted a still more anodyne picture, Crossing the Brook [178]. This is popular painting and no mistake. It must have appeared on more calendars than any English picture, except perhaps Constable's Hay Wain. The poet Yeats used to say that he wanted to write a poem that would be on everybody's lips, and for a time Turner wanted to paint pictures which, through the medium of engraving, would be in everybody's hands. The trouble is that artists are peculiar and inconvenient people: they cannot become popular without sacrificing, or suppressing, a part of themselves. Turner was a profound pessimist, so a good deal of himself was suppressed when he painted Crossing the Brook, and the numerous other pictures in the 'keepsake style', which, through engraving, made his fortune. Having realised this we can enjoy the purely pictorial delights of the picture - the light passing over the road, and, as usual, the ravishing beauty of the background.

In 1819, at the height of his fame, Turner went to Italy. When I come to discuss his colour I will have a lot to say about the results of this visit. While he was in Rome he filled his sketch-books with quite straightforward notes of what he saw, and on his return he painted two large pictures, which really are very peculiar performances. They show that he had completely abandoned all attempt at classical composition. Instead of trying to arrange objects architecturally in a rectangle, he has accepted the fact that our field of vision is an ellipse, and he has made everything in the picture curve away from us, as it really does, if we concentrate on one point. In his picture of Rome from the Vatican with Raphael painting, he has focused on a circle, Raphael's Madonna della Sedia and, taking advantage of Bernini's colonnade, he has made everything revolve round it. The Forum [180] is also treated as an ellipse, and those fragments of masonry which had provided so many painters, from Poussin downwards, with materials for a stable, classical construction, have been transformed into a choppy sea. How like Turner to have chosen this sacred place of classicism to create romantic disorder.

These two Roman recreations were not, and never have been, 237

popular, but a year or two later Turner painted a memory dream of Italy which was for long among three or four of his most beloved works, The Bay of Baiae [179]. Looking back on my past writings on Turner I find that I have said some very harsh things about this picture, even that it made me feel slightly sea-sick, but I was judging its composition by the standards of Poussin and Cézanne. Once one has found the key to Turner's sense of design, this loop with which he seems to lasso the chief elements in his subject, classical prejudices can be forgotten. In fact, this swaying, involuted rhythm is entirely appropriate, because it has the quality of a dream; and this picture is a dream – northern man's dream of Italy, and of the golden world of antiquity. Turner gives a very small but very emphatic hint of how fallacious such dreams of happiness are by putting near the centre of his design a white rabbit, which is shortly to be eaten by a snake waiting in the shadow to the right. Of all the magical backgrounds in his work, this is surely the most enchanting.

Turner's next-great popular picture is also a subject from the classical past, Ulysses deriding Polyphemus [181]; it was painted in 1829. Ruskin called it 'the central picture in Turner's career'; and there is no doubt that it shows Turner at the height of his powers. Everything works, everything is superbly realised. I confess that I admire it more than I love it: it seems to me, in the grandest possible way, theatrical. Turner, in one of his gruff asides, said that it had, in fact, been inspired by a pantomime. Of course the effect of light is stunning. Turner never painted a greater sunset, which combines all his scientific knowledge of the sky with incredibly skilful transitions of colour. The idea of making the giant into an emanation or embodiment of a smoking volcano is a stroke of inspiration, but it seems to lack the dreamlike strangeness of his great poetic dramas of the 1830s. The most extraordinary of these is the Hero and Leander [15] in the London National Gallery and personally I find its passionate extravagance much more moving than the assurance of the Ulysses. All those crazy perspectives going in different directions, cut by inexplicable shadows, the towering architecture, the conjunction of sunset and moonrise, show the spirit of romanticism pushed to its furthest point, and expressed by progressions of colour which are really miraculous. Needless to say, this complex and wonderful poem was not popular; but two years later, as if to show he could still command public approval if he chose to do so, the old wizard produced the most popular of all his works, The Fighting Temeraire 238 tugged to her Last Berth to be broken up [182]. This is emphatically not

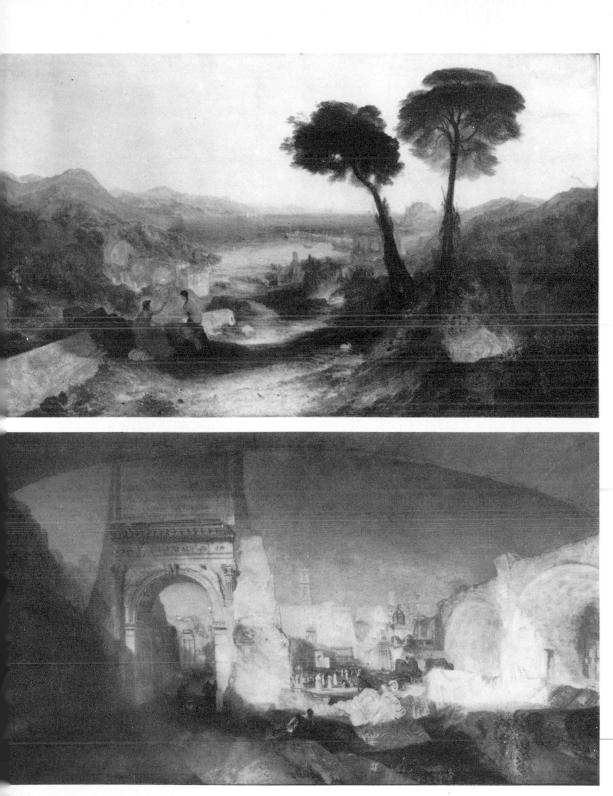

9 & 180 Turner, The Bay of Baiae, with Apollo and the Sibyl and Forum Romanum

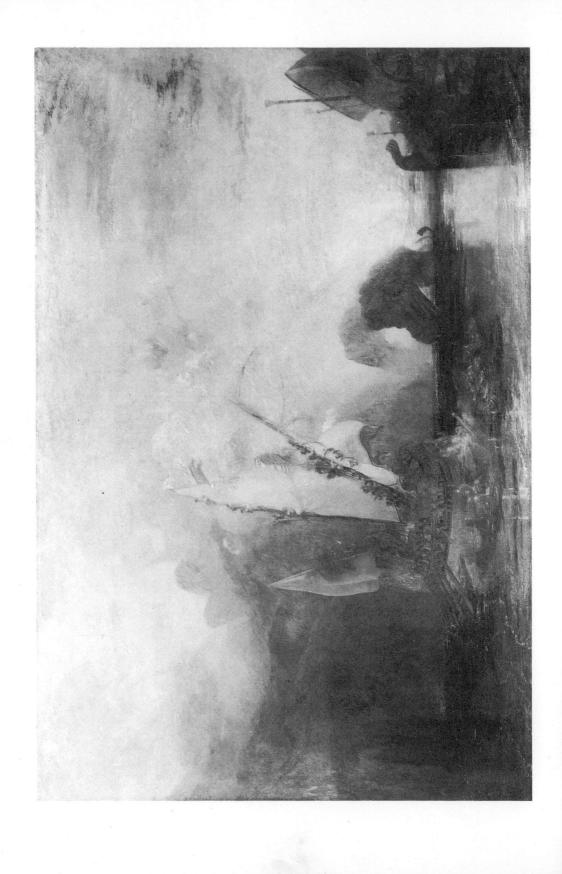

a picture for the pure aesthete. I still think that the balance between red and blue has been upset by some change in the pigments, especially one spot of red in the middle of the sunset which has lost transparency; but I can now respond to the sentiment, just as I can now enjoy certain Verdi operas, which I used to think were only good for a laugh. I am certain that Turner put his heart into this picture. That the ships which had been the glorious castles of his boyhood should now be towed away by a little tug with an impudent black funnel was to him a tragic event, demanding that red sky which he thought of as a symbol of tragedy and death.

If I have felt a resistance to the sentiment of *The Fighting Temeraire*, I have never felt any about Turner's last great popular picture, entitled *Peace*, *Burial at Sea* [183]. Turner intended it as a tribute to his friend, David Wilkie, who had died at sea. It is the pictorial equivalent of a funerary inscription, and it is well known how easily they can fail to succeed. But here Turner says all that he wants to say by the drama of light and dark, the fire reflected in the calm water, the fierce diagonal of smoke, and the black sails, like Hieronymus Bosch devils. I should add that the predominance of black, which is unique in Turner's work, is not only a symbol of

182 Turner, The Fighting Temeraire

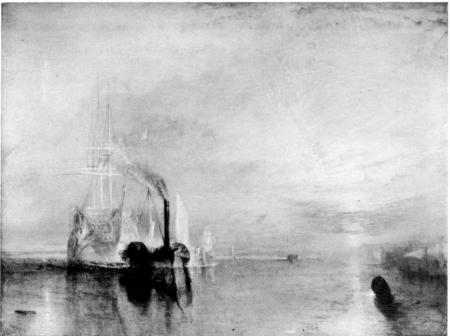

241

mourning, but an allusion to Wilkie's love of black, which contemporary critics had frequently contrasted with Turner's love of white. *Peace, Burial at Sea* showed that Turner could paint a clearly defined and comprehensible picture if circumstances demanded. He wanted it to be understood. But by this date, 1844, he had usually ceased to care whether he was understood or not, and he sent to the Academy a series of pictures which were referred to as 'Mr Turner's little jokes'.

The very same year as the *Burial at Sea* he exhibited a picture which would surely have been rejected by any hanging committee of the Royal Academy up to 1940. Its long Turnerian title (Turner's titles are a study on their own) is *Snowstorm – steam-boat off a harbour* mouth making signals in shallow water, and going by the lead. The Author was in this storm on the night the Ariel left Harwich [184].

183 Turner, Peace, Burial at Sea

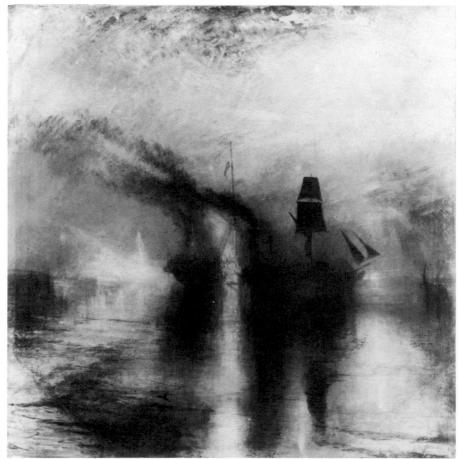

242

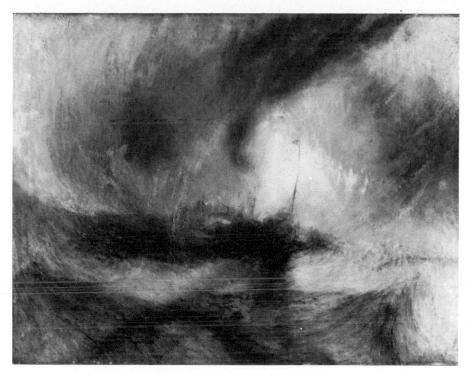

¹⁸⁴ Turner, Snowstorm, Steam-boat

Every word chosen to carry conviction that this is a sober record of facts. To someone who said that he liked it, Turner replied, 'I got the sailors to lash me to the mast to observe it. I was lashed for four hours and did not expect to escape, but I felt bound to record it.' That must surely be the furthest that any romantic artist has ever gone in the contemplation of the terriblo. It is not, of course, simply the record of an event: it is a supreme example of Turner's power of design. His loops and swathes and conflicting diagonals were never more gloriously employed. He once wrote that 'every look at nature is a refinement upon art'. In the *Snowstorm* observation has been completely assimilated into Turner's inner vision of what a picture should be, and it may therefore serve as a link between the poetic drama of his famous exhibited pictures and the equally poetic but less circumstantial visions which he painted purely for himself.

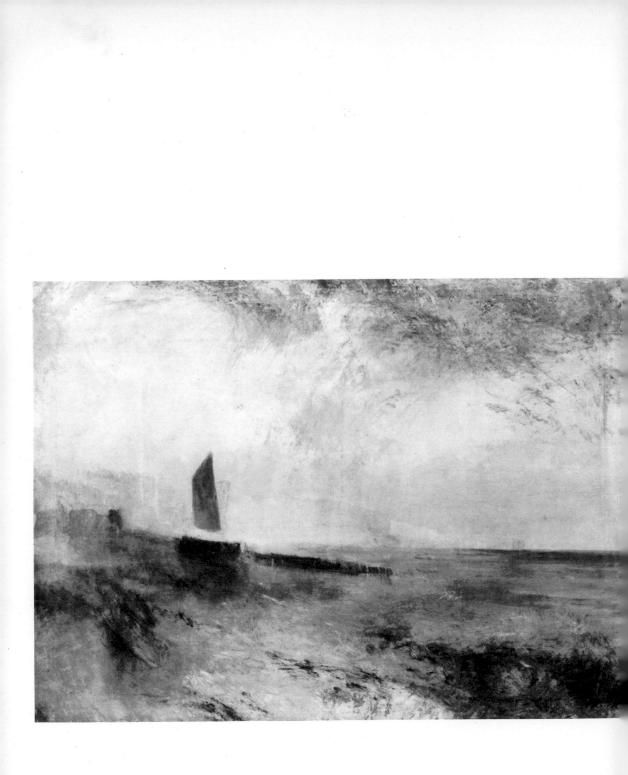

185 Turner, Hastings

10

Turner II

The Liberation of Colour

The Romantic movement discovered - or rediscovered - the importance of colour in painting. The references to colour in academic textbooks of the late eighteenth century are often incredible. The subject was treated as something improper, almost vicious. One can see why: colour appeals to the senses, and not to reason or the sense of duty. Yet the impact of modern painting is almost entirely due to colour. The first artist to realise that colour could speak to us directly and, as it would seem, independently of form and subject matter, was Turner. He did so by combining two almost opposite qualities. On the one hand he was an anti-intellectual; analysis, system, selfcriticism were entirely foreign to him. Although he was a great reader of poetry he could not write a grammatical sentence. His art was based on instinct, operating through the senses. On the other hand, he felt so strongly about colour that he took immense pains to study its effects, and even its theory. He, the least analytical of men, focused his disorganised but powerful mind on the problem of colour combination, and his ultimate liberation of colour was the result of a conscious, deliberate effort. As part of this achievement he painted a great number of pictures that were intended only for his own eyes. These are the pictures which, in the last twenty years, have brought him back into favour with young artists.

When they were first exhibited these pictures were referred to as 'late Turners', or 'unfinished Turners', or even 'sketches'. In fact, we do not know when they were painted, but we can see for ourselves that, far from being unfinished, they are the result of prolonged labour. As for being sketches, which I suppose means preliminary studies, they are usually the exact reverse; re-interpretations of subjects that he had already worked out in a conventional style. Look, for example, at the watercolour of the *Falls of Clyde* [186] done in 1802, and at a re-interpretation of the same motif that he used 245

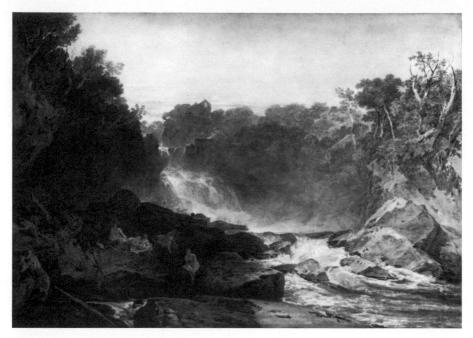

186 Turner, The Falls of Clyde

some thirty years or so later [187]. The original contents and even the composition are the same but, instead of conventional tints, there are the marvellous transitions of colour – all the way from blue to gold – which had become Turner's private language. His early seascapes, as we have seen, had been unnaturally black. In an early picture of Hastings the golden sail stands out against the darkness as an isolated colour. Later [185] the colour of the whole picture not only represents, but symbolises light. The sail, which in the early study of Hastings was the lightest tone in the picture, is now the darkest. Yet, if you compare the two in the originals, it is, in fact, a little lighter than the earlier sail. What an extraordinary transformation, and how did he achieve it?

As with Cézanne, I think it was partly through the use of watercolour that Turner first recognised the possibility – and for him the necessity – of painting in a lighter key. In academic circles it was assumed that respectable oils were dark, partly because the varnish of old masters had darkened with time, partly because the seventeenthcentury painters, who were the models of excellence in landscape, were in fact dark painters. Turner's first success as a painter of topographical watercolours gave him confidence in that medium long 246 before he had achieved it in oils; and among his early watercolours – 187 Turner, The Falls of Clyde

for the most part coloured with conventional tints of the trade – are several in which an effect of light has ravished him beyond his professional requirements.

After about 1806 Turner's mastery of the medium was so great that he anticipated many of the effects which we associate with his later work. It is at about this date that he began to erect a barrier between his private and his public work – and, I may add, between his private and his public personality - which was to last until his later years, when he could no longer be bothered to maintain it. One must picture him as small, silent, obstinate and secretive, with a powerful mind, but a hatred of intellectual pretension so strong that he spoke only in simple and often ungrammatical language. Only the public works are securely dated, and for a long while scholars were reluctant to admit that a watercolour such as $\lceil 188 \rceil$ – the summary of an immediate experience stated with the economy of a Zen calligrapher could be relatively early. In fact I think it is related to those direct transcriptions of nature which Turner made, chiefly in the Home Counties, about the year 1807, thus anticipating Constable by more than a decade.

Turner's early exhibited pictures look to us very dark but, curiously enough, connoisseurs like Sir George Beaumont, used to the still darker tone of the old masters, began to complain of Turner's lightness. In 1813 he told Farrington that 'much harm had been done by his endeavouring to make his painting in oils appear like watercolours'. I suppose he was thinking of something like the picture of *Somer Hill*, now in Edinburgh, exhibited in 1811. Turner and his imitators were spoken of as 'the white painters'; and in 1816, Hazlitt, the best English critic before Ruskin, wrote that Turner's pictures 'are too much abstraction of aerial perspective and representations not properly of the objects of nature as of the medium through which they are seen'. A fair criticism of the later pictures, but not, one would have thought, applicable in 1816.

Though the first records we have of Turner's systematic study of colour date from 1802, when he visited the Louvre and made in his sketch-book miniature copies and analyses of Titian and Paul Veronese, I think the critical stage in his liberation of colour was his visit to Venice in 1819, because it is there that the web of colour, reflected and refracted, fills the whole field of vision. His first watercolours of Venice are timid – almost apologetic – but they already show the use of red, pink and blue as the basis of a colour harmony 248 unthinkable in the north. The assimilation of this new range of

88 Turner, Tree

colour took time and trouble. The sketches done on the spot are enchanting; but the reconstructions of Venice put together by an additive process are forced and confusing. Taken by themselves they would justify the term 'vulgarian' so frequently used about Turner by critics of the last generation. On the other hand recollections of Venice done in a kind of dream-state are among his most beautiful works. The dream was so vivid that although Turner went to Venice only three times in his life, each for quite a short period, he was able to draw on a diversity of subjects: some quite clear, sharp records of experience, which are beautiful in their way. Many dreams of the Lagoon, done at all epochs, down to the very last, are among the most moving of his works [189].

As for his journeys south of Rome: much as I now love the $Ba\gamma$ of Baiae, I still feel uneasy about the way in which the finished parts are not related to the whole picture. A landscape of Rubens or Poussin has a scaffolding of form in which detail can be incorporated, and the scaffolding is part of the original idea. Whereas in Turner the first impulse was not an idea, but a sensation of light and colour. This sensation was not concerned with details; and the attempt to contrive them and to unite them by a switchback, northern rhythm makes me uncomfortable. Mediterranean coast scenes painted solely for his own satisfaction, in the same state of sensuous, dreamlike recollection as the watercolours of Venice, have an immediate impact. They do, in fact, contain some passages of high finish but these exist only at points where Turner's dream came into focus. Even more remarkable are certain oil studies which he may have made while he was still in Italy, if not on the actual spot. The view of Tivoli [190] gives a remarkable impression of truth, although it contains no identifiable details.

The subdued tone of these pictures tells us something important about the nature of colour. Fine colour does not mean bright colour or brilliant colour: more often than not it means the reverse. It is most difficult to give the unity of a new creation to a subject involving a quantity of bright colours - let us say a peasant wedding or a coronation ball. Even Turner's painting, called The Return from the Ball, contains hardly any bright colour. Fine colour implies a unified relationship, in which each part is subordinate to the whole, and the transitions between them are felt to be as precious and beautiful as the colours themselves. In fact, the colours themselves must be continuously modified and broken as part of the transition. Ruskin said in his Elements of Drawing, 'Give me some mud off a 251

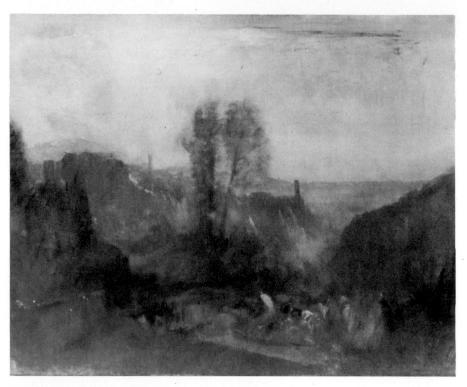

190 Turner, Italian Hill Town, probably Tivoli

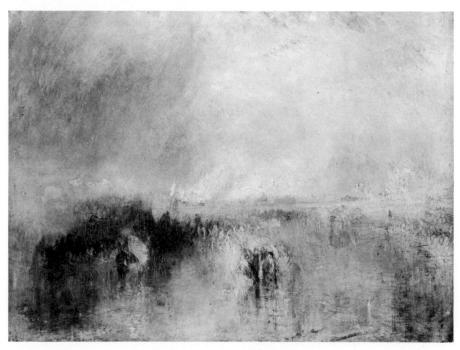

191 Turner, Procession of Boats with distant Smoke

city crossing, some ochre out of a gravel-pit, a little whitening, and some coal dust, and I will paint you a luminous picture, if you give me time to gradate my mud, and subdue my dust.' In many works by the greatest colourists – Rembrandt and Watteau are examples – there are very few identifiable colours. Watteau's *Enseigne de Gersaint* is almost a monochrome, in which colours are gradated and subdued in such a way as to achieve magical transitions. I mention it because Turner often referred to his debt to Watteau and painted a picture to express it. Of this type of gradated, near-monochrome, Turner could be a supreme master. Ruskin in one of his finest passages of criticism contrasts the brilliant page of a Persian miniature with a quiet, low tone of Turner's watercolour of a Swiss lake:

'There is not as much colour in that low amber light upon the hill-side as there is in the palest dead leaf. The lake is not blue, but grey in mist, passing into deep shadow beneath the Voirons' pines: a few dark clusters of leaves, a single white flower – scarcely seen – are all the gladness given to the rocks of the shore. One of the ruby spots of the eastern manuscript would give colour enough for all the red that is in Turner's entire drawings.'

Nevertheless, in the liberation of Turner's colour the brilliant, arbitrary colours of the Mediterranean – pinks, reds and yellows – shining against a blue sky and reflected in a dark green water, did have a decisive effect because they showed him how the whole of a visual impression could be transposed into brilliant colour equivalents without any feeling of artificiality. And since his colour was ultimately dependent on experiences, this was obviously easier to do in Venice or southern Italy. He hated green, and the fields of England, in their normal illumination, were not at all pleasant to him. His problem was to find under grey skies subjects which would allow him freedom to use his new range of colour. An immediate answer was provided by sunsets and sunrises.

The part played by sunsets in romantic art is too large a subject for a single chapter. Apart from their effect on the emotions and their appeal to the seeker of transcendental images, they gave landscapepainters the opportunity of introducing into their work one whole segment of the spectrum – red, yellow, orange and purple – which would otherwise have been excluded. It was often a perilous procedure leading to garishness, and one might have expected Turner, with his love of stunning effects to have sometimes forced the tone. But the remarkable thing about his sunsets, is their delicacy.

253

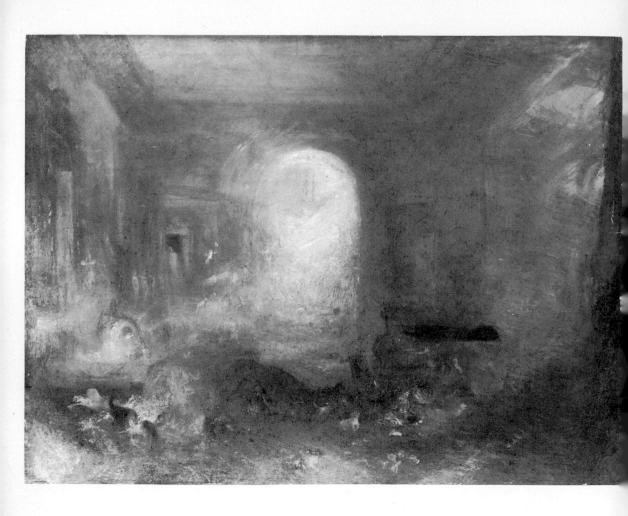

During the same years Turner experimented with strong body colour on tinted paper. By this means he sacrificed transparency, but gained instead unity and richness. Many of these small watercolours look like exercises in a single colour idea; and yet they are also deeply felt experiences. One can hardly resist the late nineteenth-century practice invented, I think, by Gautier but popularised by Whistler, of referring to them by some musical term – harmony or symphony. This is fundamentally misleading, because the beauty of the small watercolours is largely dependent on a delicate record of things seen. Without a preordained colour idea these observations would be commonplace; but without the joy in an actual experience, the harmony would become merely a matter of taste, and so lose its perennial powers to move us.

Both the first great sunsets and the small studies on tinted paper were done at Petworth; and after Venice, I think it was there, more than anywhere else, that Turner left free to realise his feeling for colour. Fine colour involves an unthinking response to sensuous delight. It is correctly associated with licence, and nowhere has licence seemed more amiable than at Petworth. The owner of Petworth House, Lord Egremont, was, legally, a bachelor; rich enough to override convention and friendly enough not to suffer from isolation. He said that his motto was 'Live and let Live'. It could have been 'Do what you will', and if ever a house was worthy of the inscription on the Abbey of Thelème, it was Petworth. 'The very flies at Petworth', said Haydon, 'seem to know that there is

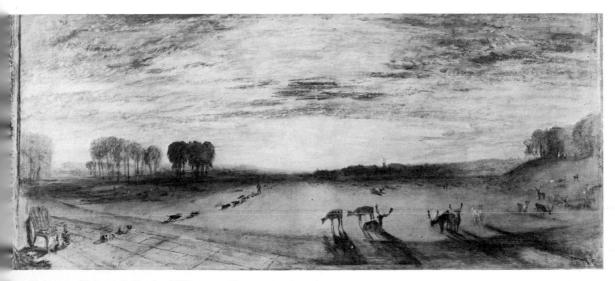

13 Turner, Petworth Park: Tillington Church in the distance

room for their existence: that the windows are theirs.' Lord Egremont was a generous patron of the arts but he did not lay down the law in matters of taste any more than he did in matters of morals. He did not need to. He had won the Derby oftener than anyone alive.

Turner, who nated high society, loved the informality of Petworth. Everything he painted there – and he painted a great deal – is shining with the happiness of liberation. One of the most endearing represents Lord Egremont with his dogs, walking back to the house at sunset, with the deer casting long shadows on the terrace. [193]. Incidentally, it shows clearly Turner's preference for the ellipse as a basis of design. He also painted inside the house and felt sufficiently at ease to record the other guests. He noted down their colours and their characteristic silhouettes immediately – as a bird or a fish might see them – without bothering about what they ought to be like. 'Do what you will': the result was the *Interior at Petworth*, surely the most liberated picture of the nineteenth century [192].

That Turner was at his best when completely free from all restraints and obligations, which means painting to please himself and a few friends, is I think unquestionable. But as I said in the preceding chapter, he gradually learned to use this new freedom in his exhibited pictures. Even in such an eminently exhibitable work as the Keelman heaving in Coals by Night, painted in 1834 [16], he has used his new range of colour in a way that satisfied his contemporaries, and yet was entirely personal. In the same year accident provided him with a historical subject made to his hand - the Burning of the Houses of Parliament [17]. He spent the whole night doing dozens of notes in watercolour; and his experience in painting the fiery sunsets, and contrasting the glowing sky with the blue of distant hills, enabled him to expand them into two splendid and convincing pictures. Both his versions of this historic event are in American museums and are among the very few works of art which I would have felt justified in forcibly retaining in England.

These two pictures, exhibited in 1835, were well received, but we must admit that in the 1840s the exhibited pictures must have put the critics and fellow-Academicians under a severe strain. I have already mentioned *The Snowstorm*. Two years later came the most extraordinary of all his private pictures to become public – *Rain*, *Steam*, *Speed* [194]. I suppose that everybody today would accept it as one of the cardinal pictures of the nineteenth century, on account 256 of its subject as well as its treatment. One must think back to a time

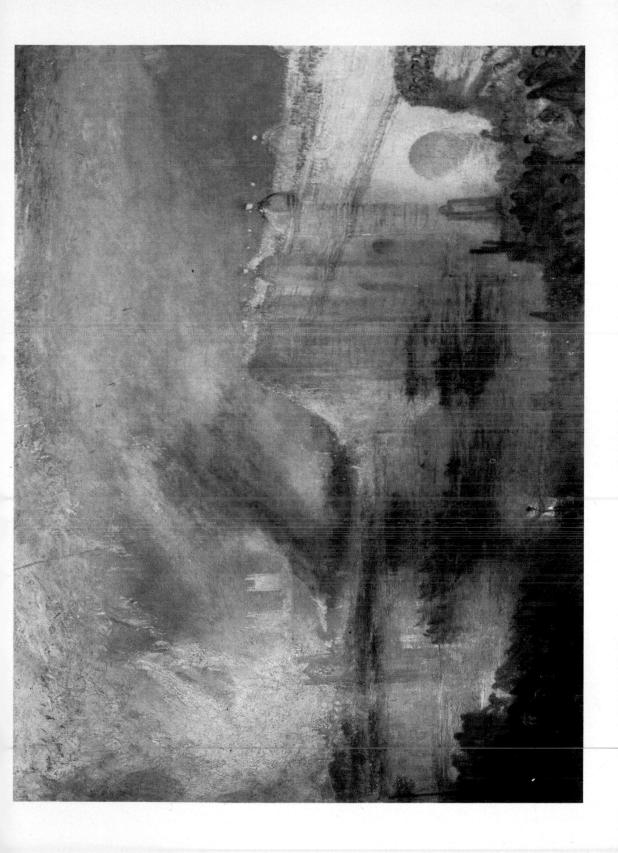

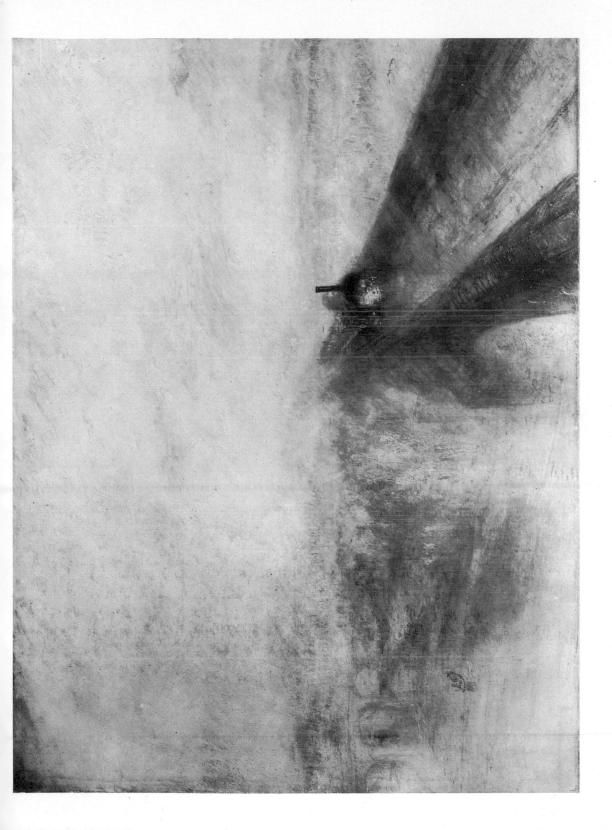

194 Turner, Rain, Steam, Speed.

18 Turner, Sunrise between two Headlands

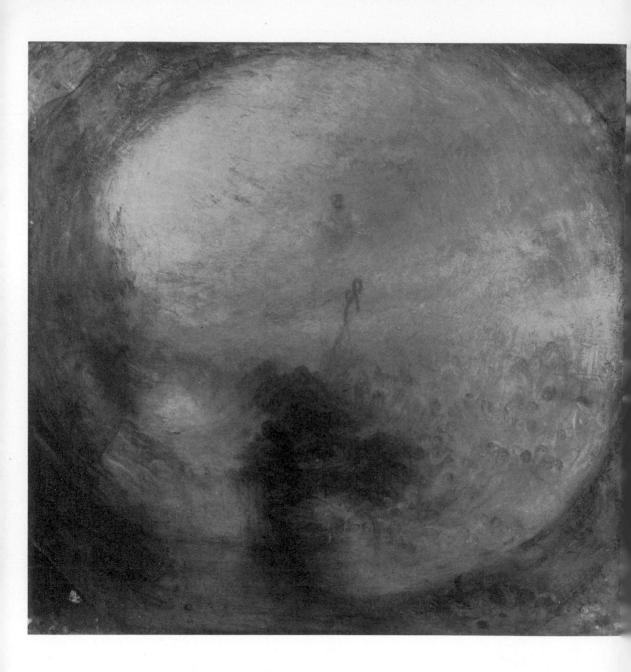

195 Turner, Light and Colour

when most sensitive men, Ruskin above all, felt that railways were an abomination, and the lack of definition in this picture must have been perfectly incomprehensible. It must have seemed to justify, twenty years later, Hazlitt's two famous descriptions of Turner's pictures: 'tinted steam' and 'portraits of nothing, and very like'. As a matter of fact, I think it a misfortune that Turner did not paint more subjects from the new industrial age. In the 1840s smoking chimneys, furnaces and swathes of mist suited both his style and his pessimism better than the sunny enchantments of the Mediterranean. He could have been, in addition to everything else, the great poet of romantic industrialism.

At the same date he made his most determined effort to master the theory of colour, in the course of which he read, and annotated, that very remarkable book on the subject, Goethe's *Farbenlehre*. Newton, as everybody knows, had said that light consisted of seven prismatic

196 Turner, Shade and Darkness

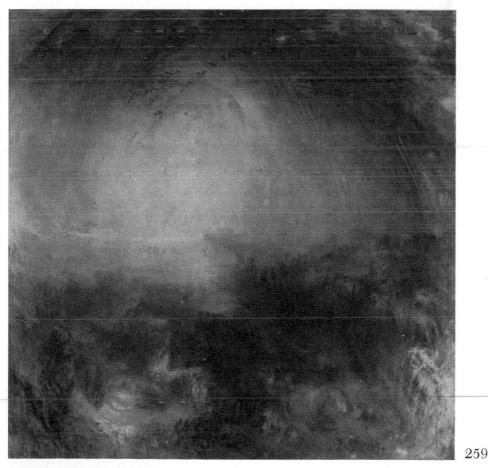

colours which when combined produced a white. Goethe maintained that this could not be true, because every light that has taken a colour is darker than colourless light. He believed that white light is simple and homogeneous, and becomes coloured only when it has passed through some opaque substance. An opacity in front of light produces warm colours, growing warmer as it becomes denser yellow sky, red sky, red sun on the horizon. Opacity in front of darkness produces blue tones - cigarette smoke in front of a dark background, or the blue sky itself, which is only a great density of opaque atmosphere in front of total darkness. It was the protest of common sense against science, similar to Samuel Butler's attack on Darwin. Naturally scientists have supported Newton, just as orthodox biologists continue to support Darwin, although in each case common sense raised some questions which have never been answered. In so far as Goethe's theory is based on visual experience rather than mathematics, it appealed strongly to Turner. It was closely connected with his own practice as a painter, in which many of his most beautiful effects of colour have been achieved by Goethe's 'transparencies'. He made many reservations, but on the whole his verdict is contained in the words, 'Yes, this is a true shot, but has not winged the bird'. I suppose that it was as a sort of tribute that he sent to the Academy of 1843 two of the strangest of all his exhibited pictures. They are entitled Shade and Darkness - the Evening of the Deluge [196], and Light and Colour (Goethe's Theory) – the Morning after the Deluge, Moses writing the Book of Genesis [195]. To both titles are added several lines of Turner's poem The Fallacies of Hope. Goethe's theories are illustrated more or less correctly. But in addition several other Turnerian obsessions are evident. For one thing they are unusually complete examples of Turner's use of the vortex, or whirlpool, a form of composition which was always associated in his mind with the expendability of man, and which became more usual in his work as he himself grew more pessimistic. 'He was without hope', said Ruskin, in his famous summary at the end of Modern Painters, and there is no doubt that both these pictures are apocalyptic visions. The Evening of the Deluge, in spite of the rather ridiculous collection of animals that are to be found in the depths of the composition, looking like newts and tadpoles in a pool, is a moving and convincing dream of destruction, similar to one of Leonardo's Deluge drawings. Light and Colour is not so easy to take seriously, partly because of the subject - because even Turner must have known that Moses was not 260 present on the morning after the Deluge - and in introducing

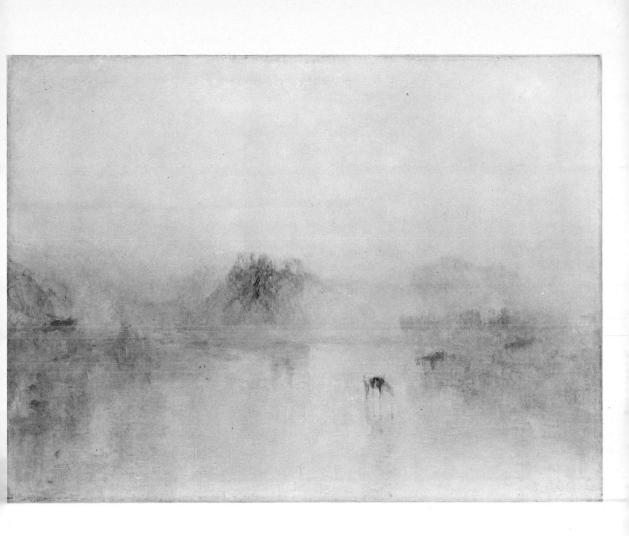

197 Turner, Norham Castle

Moses at all, I fancy that, like many other explorers of the subconscious, he was fascinated by the symbol of the brazen serpent, and has made it into a small key to his whirlpool design. Partly it fails because there is a fundamental contradiction between the yellow and orange colours, which should express the joy of humanity at being saved, and the vortex movement which suggests that, on a deeper level, all is not well with the human race – and in fact the extract from *The Fallacies of Hope* printed in the catalogue, confirms that this was Turner's real meaning.

The returning sun

Exhaled earth's humid bubbles, and emulous of light Reflected her lost forms, each in prismatic guise Hope's harbinger, ephemeral as the summer fly Which rises, flits, expires and dies.

Not in the purest lyric vein, but strikingly Turneresque.

In the 1840s Turner's interest shifted from sunset to sunrise. The splendid blazing outbursts that had been released at Petworth gave place to a paler, more delicate and more magical contemplation. Sunrise differs from sunset because, instead of a contrast between earth and sky, the mists rising from water or the cold earth unite the foreground with the sky. The whole scene becomes one continuous web of light, in which the few objects that detach themselves take on prismatic colours of indescribable subtlety – colours which have no independent existence, but are a sort of optical necessity in relation to the translucent whole. In later life Turner owned a number of houses so placed that he could see the sun rise over water, either at a bend in the Thames, or on the Kent coast. He never missed a sunrise, so that his dreams and his waking moments must have grown together. An example of how this process affected his vision is Norham Castle [197]. Turner had painted Norham Castle many times in his life, and the earlier pictures contain a number of recognisable details. Yet they are much more artificial, in their general effect, than the completely liberated vision. The greater feeling of truth in the final picture has been achieved by an instinctive certainty in the use of colour equivalents for observations. It also involves miraculous skill in the areas of transition: the main accents are not in fact bright colours, but colours which become bright in only their setting.

In the comparison of a Persian miniature and a Turner watercolour Ruskin asks: 'What made him take pleasure in the low colour that is 262 only like the brown of a dead leaf? In the cold grey of dawn, in the one white flower among the rocks?' He answers by giving a rhapsodic summary of the events and impressions in Turner's life that had contributed to the growth of his spirit. Here and elsewhere, Ruskin is at pains to prove that colour is what Matthew Arnold said of poetry, a criticism of life. Fine colour, like everything which relates to the half-conscious experiences of our daily life, must reflect our real sense of values; it is what provides the basis of our observations. It gives, so to speak, the colour-structure of a painter's mind, into which he fits the delights of everyday perception.

Turner shows that the perceptions of great colourists are not those of our ordinary waking hours; almost all writers on his works have referred to them as dreams. The word is no longer appropriate: dreams have changed their connotation since the nineteenth century. The state of ecstasy, or hyper-aesthesia, of a great colourist is something on the borderline of dream and reality. I feel that many of Turner's most moving works were done in this condition of dreamlike ecstasy, which is revealed not only in their colour, but their content. Here, as elsewhere, Turner's liberation of colour, like all romantic arts, was a triumph of the irrational.

263

198 Constable, Dedham Vale

11

Constable

Nature, the goddess of the early eighteenth century, had, like most divinities, two aspects: the ferocious, vengeful and destructive and the tranquil, comforting and creative. We may call them (with reservations) the Byronic and the Wordsworthian. In painting Géricault and a great part of Turner represent destructive nature; comforting, health-giving nature is represented by Constable.

Constable was born in 1776 in a valley on the borders of Suffolk and Essex. Down this valley the River Stour meanders with innumerable twists. Constable drew a kind of diagram to describe its character to a friend [199]. The river had been made navigable by locks and the life of the valley was regulated by the slow movement of the barges. Constable's father is usually described as a miller, which gives rather a misleading impression because he owned most of the mills in the valley and lived in a house much larger than most people in England could afford to maintain today. Constable grew up in this enclosed world. He wrote: 'The sound of water escaping from mill dams, willows, old rotten planks, slimy posts and brick work - I love such things. These scenes made me a painter, and I am grateful.' Beyond the banks was cultivated, productive land, and he took a countryman's joy in fine weather and a good harvest; 'the solitude of mountains oppresses my spirit', he wrote. Exactly the reverse of the standard romantic reaction.

As a boy Constable decided to be a painter, but he seemed to have had very little talent. Turner, who was only one year older, became an Associate of the Royal Academy when Constable was still making feeble copies of Reynolds, and a Royal Academician before Constable had painted a single good picture. The reason was his difficulty in realising the almost obsessive experiences of his youth. He could not, like Turner, create a style by imitating other artists, although, of course, he studied the work of his predecessors. As a young man, handsome and charming, he had been taken up by the great collector Sir George Beaumont, who showed him a favourite picture by Claude 265

199 Constable, study of a winding river valley

representing Hagar and Ishmael, and Constable, says Leslie (who wrote his life with reticent benevolence), 'always looked back to this exquisite work as an important epoch in his life'. We can feel the half-conscious memory of the Claude in the first dated picture in which Constable is recognisably himself. A picture of *Dedham Vale* of 1802 [198]; and twenty-six years later, it appears again [200], full of sparkling details that would not have fitted into Claude's ideal scheme.

As picturesque beauty was then associated with mountains, Constable made an expedition to the Lake District in 1806. He felt uneasy there, and although some of his watercolours achieved a certain romantic solemnity, most of them are without conviction. Then in about 1811, for some mysterious reason, he suddenly found a means of expressing his emotions in paint, and he did the oil sketches of the Stour [203] which were something new in European art. Of course the Dutch had painted straight landscapes without a subject in the seventeenth century, and a few French artists, such as Moreau and Granet, had done naturalistic landscape studies as a side-line, but no one before Constable had responded to effects of light and shade with the dash of freedom of these oil sketches – done as if he had to hit the bird of sensation on the wing before it vanished. In some other studies, probably painted about a year later, he uses a no 266 less urgent, but quite different technique, more violent, more graphic,

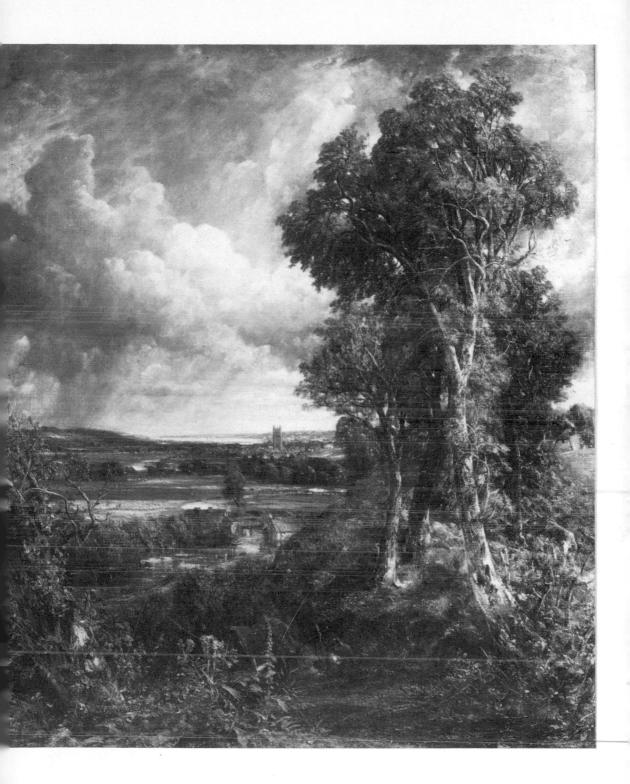

0 Constable, Dedham Vale

201 Constable, page from a sketch book

and more expressive. Through the strength and urgency of his feelings he has ceased to be a painter of passive nature, and become what we can reasonably call an Expressionist: and the character expressed is not exactly that of the tranquil, life-accepting, countryman of the other early studies.

In the years 1813 and 1814 Constable was inspired. He carried round with him two tiny sketch-books, in which he made pencil studies, sometimes no more than two inches square. They contain the germs of nearly all his great pictures; sometimes the whole picture is there, hardly altered when he came to paint it ten or twenty years later [201]. Leslie, tells us how Blake – 'The amiable but eccentric Blake' as he calls him – saw one of Constable's pencil drawings and said, 'This is inspiration', to which Constable replied with his usual fear of high-sounding words, 'I took it for a drawing'. Blake was right.

Perhaps the background of Constable's life had something to do with these years of heightened perception. He had fallen deeply in love with a local lady named Maria Bicknell. Her family thought he was not good enough for her (she was in fact to become a considerable 268 heiress) and prevented the marriage for ten years. During those years

202 Constable, Barges on the Stour

203 Constable, The Stour

he lived by painting portraits, and dared not undertake any large landscapes. But his tiny pencil drawings were done under circumstances of such high emotional tension that they lasted him all his life. In 1815, when his chances of matrimony began to improve, he painted a finished landscape of a fair size, Boat Building near Flatford Mill [204]. It lacks the brilliance of the sketches, but the majestic architecture of the barge, set in an idyllic landscape, is the equivalent of a Greek temple in a Poussin. At last, in 1816, he was married, and almost immediately set about the first of the six-foot canvases which he was to paint every year till 1825. They all represented canals or backwaters in the Stour valley - in fact the subjects are never more than three miles distant from one another, and almost all the mills he painted belonged to his father. During these same years Turner was travelling all over Europe, France, Switzerland, Italy, in search of pictorial excitement - and finding it. Constable said, 'My limited and restricted art may be found under every hedge.'

I must admit that the first of these large canal scenes, which shows a white horse being ferried across the river in a barge, does seem to

204 Constable, Boat Building near Flatford Mill

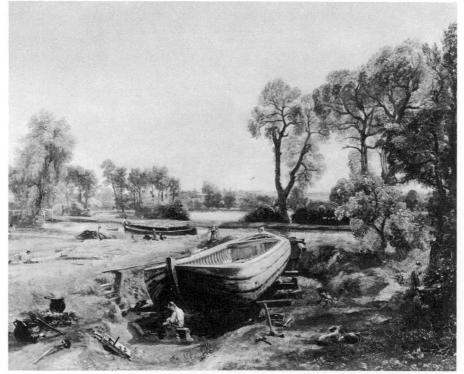

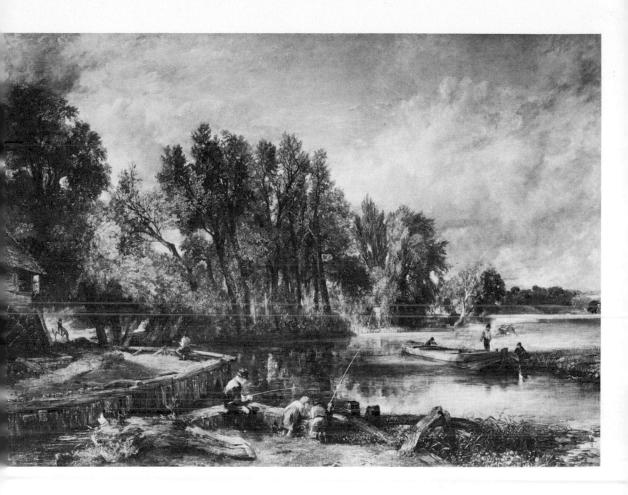

05 Constable, Stratford Mill, with Boys Fishing

me rather limited. It is altogether too tame and blissful, and lacks concentration of design: but the next one, of Stratford Mill with boys fishing in the foreground, is a superb composition, with the massing of light and dark that was one of Constable's great achievements [205]. In his letters he is always writing about 'the chiaroscuro of nature', and it is hard to make out what he means. Of course chiaroscuro simply means light and shade; and to some extent he was referring to a favourite piece of advice given him by Benjamin West (of all unlikely people), 'Remember, light and shade never stay still.' But by chiaroscuro he also meant that in a great landscape some drama of light and shade must dominate the composition, and give the keynote of feeling in which the picture was conceived. In the same letters he often refers to 'the morality' of landscape painting - an even more mysterious phrase, but I think with rather the same meaning: that human life involved a contrast of light and dark, and that this could be discovered in even the simplest, and most natural-looking scenes: Stratford Mill is more freely painted than his White Horse, but it is still a long way from his astonishing oil sketches. Then for his third big picture he tried a method that should bridge the gap between them. He made an oil sketch the size of the original. This sketch for The Hay Wain [206] is in the Victoria and Albert Museum in London, and when we look at it we have no doubt that this is the picture which his demon wanted him to paint. It is almost incredible that this slow beginner, the timid, tentative painter of fifteen years earlier, should have been able to turn what Cézanne called his 'petite sensation devant la nature' into bursts and blots of paint - and still make us believe that he is telling us the truth. Today Constable seems to us the least subversive of all the romantics, but if we judge him, not only by his subjects, but by the way his hand attacks the canvas he is, next to Goya, the most revolutionary. Of course the first version of The Hay Wain could never have shown in the Academy in that condition, and when Constable turned it into an exhibition picture he gained something - a greater certainty in the realisation of the planes, a number of beautiful details. When one looks at the background of The Hay Wain, there is, heaven knows, enough brilliance and sparkle to outshine all the other naturalistic landscape-painters of his time. One could apply to it the words Constable wrote about his picture of a lock on the Stour, 'silvery, windy, delicious. All health and absence of everything stagnant'.

In his next six-footer, *Barges on the Stour*, the full-size sketch is 272 carried far further, and is to our eyes an entirely finished picture.

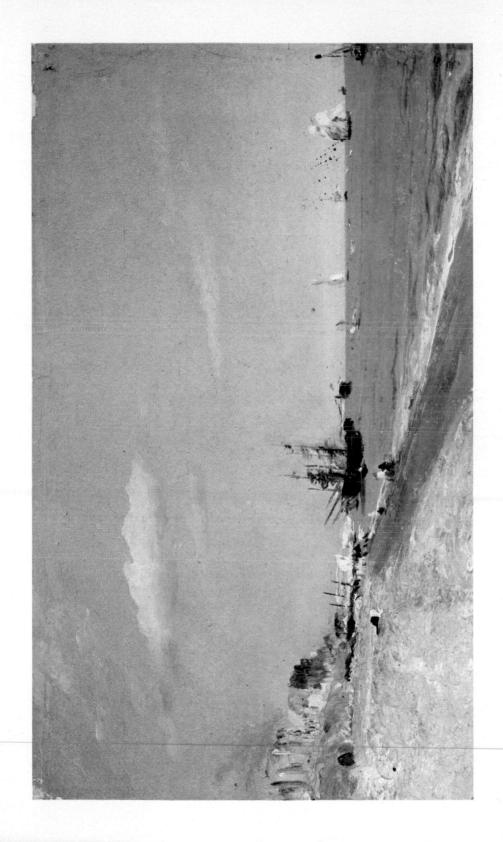

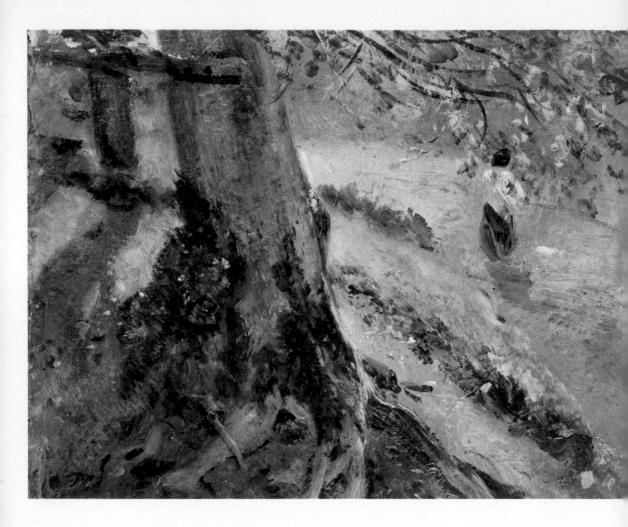

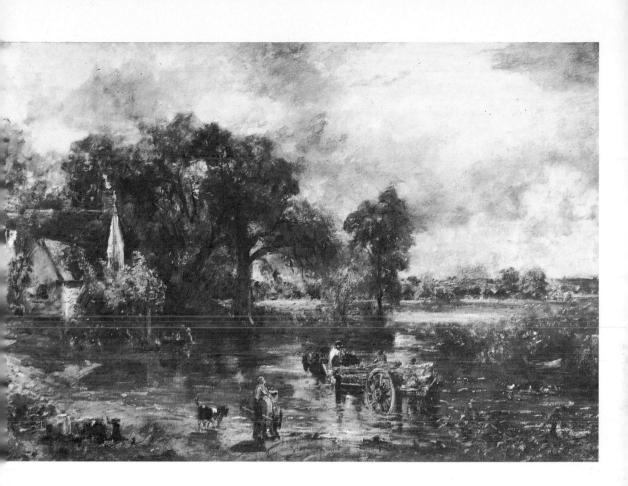

6 Constable, sketch for The Hay Wain

20 Constable, Tree trunks

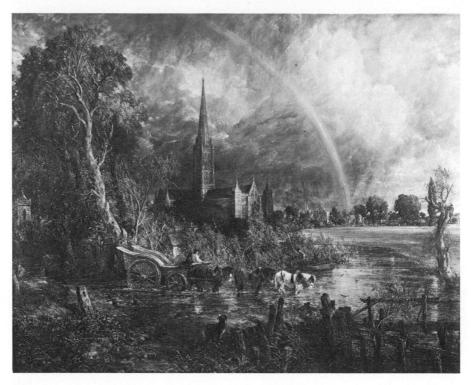

207 Constable, Salisbury Cathedral from the Meadows

The power of transforming feeling into paint, apparent in his small sketches, is achieved on a large scale, and in consequence the full-size sketch in Holloway College [202] is a good deal less optimistic than *The Hay Wain*. Constable tried to make the exhibited picture more tranquil, and perhaps for this reason it is one of the dullest of his mature works.

All these large pictures were exhibited at the Royal Academy, and the first two were bought by a man who was to become Constable's greatest friend and most loyal patron, John Fisher, Archdeacon of Salisbury. *The Hay Wain* had even more important consequences, as it was seen in the Academy by Géricault and Isabey and they arranged for Constable to send *The Hay Wain* and *Barges on the Stour* to the Paris Salon of 1824. Both pictures had a huge success; Delacroix repainted the background of his *Massacre of Chios*, and there grew up a school of landscape-painters 'à la Constable', from which there emerged a great artist, Théodore Rousseau. In England Constable had practically no influence on his contemporaries, and after his death Turner, backed by the eloquence of Ruskin, carried all before him. 274 But in France he was the source of the whole Barbizon school of landscape-painters, not only Rousseau, but Diaz and Daubigny. A French dealer, with the English name of Arrowsmith, had begun to buy Constables as early as 1821, and altogether he brought over twenty to France which are presumably hidden in French collections together with hundreds of fakes. No painter (except perhaps Corot) has been as much forged as Constable. He had discovered a form of vivid notation that could be easily pepped-up into an effective formula. He seems to have been forged even in his lifetime, so that age and provenance are no guarantee; and I confess that there are some pictures attributed to his later years that still leave me in doubt.

Although in the 1820s the subjects of his large pictures were all drawn from the Stour valley, Constable had gone to live in London. He also visited his friend Archdeacon Fisher in Salisbury, and undertook to paint a view of the cathedral for the bishop. It is a charming and conscientious work; but it shows very well where his strength lay. It lacks altogether that quality he called 'the morality of nature' which reflected his obsession with the scenes of his childhood. He also painted a number of landscapes of Hampstead Heath, where, on account of his wife's health, he had taken a house [20]. Some of the sketches he did there are among the most brilliant and exhilarating of his works, chiefly because at this time he was obsessed by clouds and the sky. He had studied Luke Howard's classification of clouds which had so much delighted Goethe, and confidence in his knowledge allowed him an even greater freedom of handling. It is typical of the romantic conjunction of science and ecstasy that Constable should have written on the back of his cloudscapes the time of year, the hour of the day and the direction of the wind when they were painted. Thirty years ago these Hampstead sketches were considered the most admirable of all Constable's work, because they seemed to foreshadow the Impressionists, but, in fact, they are not really like mature impressionism, because they show no interest in the division of colours and are for the most part in a dark key. Finally, he took his wife to Brighton for the sea air. He had nothing but contempt for the countryside there, but he did a few beachscapes which are far more 'modern' in handling than Boudin or even Monet - more like Matisse [19].

In 1825 he returned to the Stour valley to paint his masterpiece, *The Leaping Horse.* Canals and barges again, but an entirely new idea – the placing of the protagonists on a high stage, so that they achieve the dignity of monumental sculpture. The idea first came to him in a drawing [208] and perhaps he never improved on it. 275 However, he wanted a more dynamic composition, so in the next drawing the horse is jumping the lock gate (barge horses really did that) and a willow to the right of the horse also shoots up in the air. Then comes the full-sized sketch [209], which is no longer a sketch at all, and Constable at one time thought of exhibiting it, though I doubt if it would have been accepted, because it is painted with even bolder pictorial equivalents than Turner was using at that date. There is no logical reason why the slabs of paint, laid on with a palette-knife, should convince us, at a certain distance, that they represent a small barge on a canal. Finally, Constable followed his usual practice and made another version which is a good deal more subdued, although still very vigorous. After the picture was first exhibited he changed the position of the tree which, he thought, stopped the movement of the horse. The final version is in every respect better composed, and the horse has the weight of an equestrian monument. But if we judge the two versions by Constable's own dictum 'painting for me is but another word for feeling' the first is the more moving.

In the years after *The Leaping Horse* was painted Mrs Constable's health grew steadily worse. Constable was a most devoted husband and they had seven children, whom he adored, and his emotional life was centred on his family. It was his emotional life that gave him strength to paint. Even in his early sketches one sees evidence of the demon of depression hiding just round the corner. One can feel a storm blowing up in the sky and trees of The Leaping Horse. Then, in 1829 his wife died. 'Every gleam of sunshine is blighted for me', he said. 'Tempest on tempest rolls. Still the darkness is majestic.' Personally, I do not think Constable ever recovered from the blow. He painted some moving pictures, such as the sketch of Hadleigh Castle. He also painted a picture of Salisbury Cathedral with a rainbow, which he believed to be his masterpiece, and went on retouching for years. It is one of the richest and most dramatic of his works; but it is restless and contrived [207]. Constable's declared ambition – to be a 'natural' painter – has been abandoned. The tree on the left might come from one of those mannerist landscape-painters of the sixteenth century against whom he was always inveighing. Constable's greatness lay in his love of certain familiar aspects of English scenery and his style was created to express this love as vividly and directly as possible. When he could no longer, so to say, embrace nature, style began to take control.

276

5 In his later years Constable became restless and irritable. He was

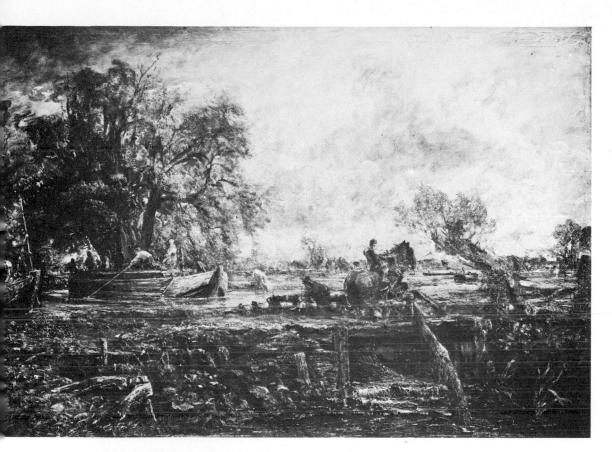

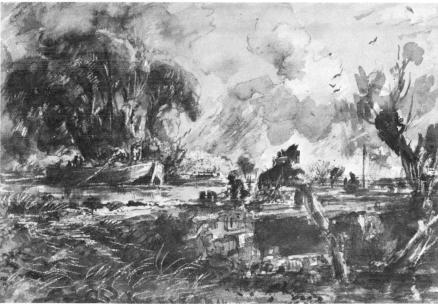

208 & 209 Constable, The Leaping Horse, sketch and drawing

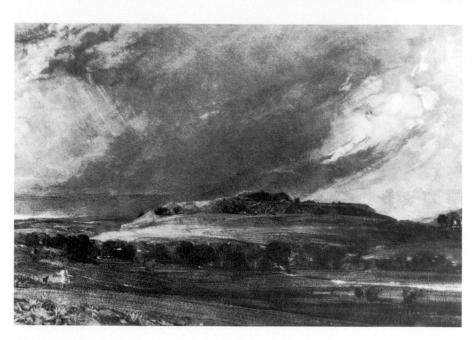

210 Old Sarum. Mezzotint by David Lucas after Constable

made a Royal Academician, too late to give him any pleasure, and said sarcastic things about his colleagues, which Leslie omits from his biography. He spent much of his time fidgeting over the beautiful mezzotints that the engraver David Lucas did of his work, [210], repeatedly altering them, so that finally Lucas took to drink. It was a sad end for the painter who in The Hay Wain seemed to have achieved the ordinary man's idea of peaceful, happy life. However, in the year before his death (his enemies said suicide) he was able to express his desperate melancholy in two magnificent works, Stonehenge and The Cenotaph [213]. They succeed precisely because they are far removed from the subject matter of his happy years, and make no pretence of being the record of a joyful sensation. The large water-colour of Stonehenge was based on a prosaic drawing, done sixteen years earlier, which was miraculously transformed into a watercolour sketch. I find the small study [211] more effective than the final painting, finished up to Academy standard. 'Still the darkness is majestic.' No trees, no cornfields, no canals: only the ancient stones defying the elements; 'as much unconnected with the events of past ages as with the uses of the present', as Constable wrote on the picture's mount. With the Stonehenge, exhibited at the Royal 278 Academy, was a touching memorial of his vanished youth. It repre-

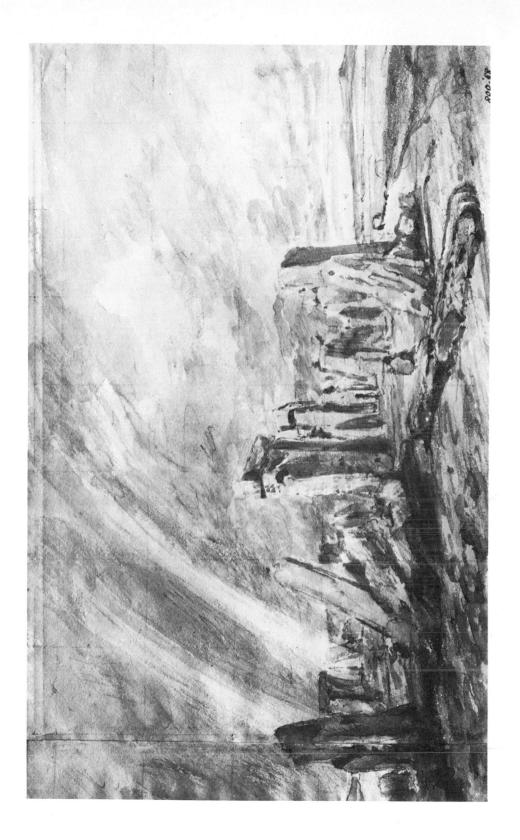

sents the cenotaph to Joshua Reynolds that his first patron, Sir George Beaumont, erected in his park – Reynolds who had so deeply influenced Constable's thoughts and his first steps in the practice of painting. The trees are back again, but without their leaves; gone are the swelling curves of Summer. For the first time Constable has painted the gothic architecture of Winter. The drawing he used of Sir George Beaumont's park at Coleorton was made in November, thirteen years earlier. This relatively commonplace drawing [212] has been made into an elegy. It is a touching farewell to the goddess he had loved so passionately.

As I said at the beginning of this chapter, Constable represented the Wordsworthian aspect of the romantic worship of nature. Both poet and painter had inherited from the eighteenth century a mechanical universe working under the dictates of common sense, and each had discovered in the surroundings of his boyhood – flowers and mountains, rivers and trees – a harmony that seemed to them to reflect something of the divine; something which, if contemplated

212 Constable, The Cenotaph (drawing)

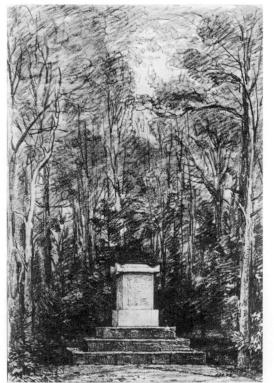

280

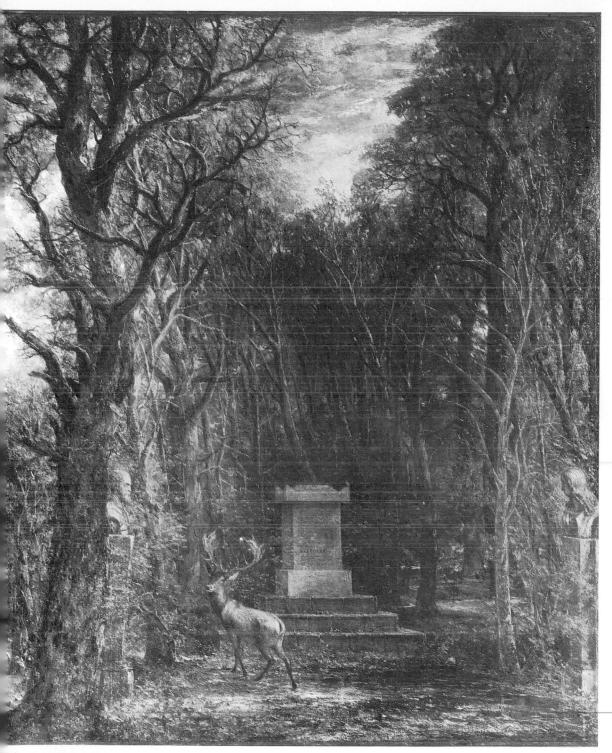

13 Constable, The Cenotaph

with sufficient devotion, would reveal a moral and spiritual quality of its own. In both, this belief was based in Wordsworth's words on 'a passion and an appetite' which he elaborated into a philosophy. How completely Wordsworth's preface to the *Lyrical Ballads* expresses the beliefs that inspired Constable's painting. Wordsworth said he wrote about rustic life because 'in that condition our elementary feelings co-exist in a state of greater simplicity, and consequently may be more accurately contemplated and more forcibly communicated.' Or take Wordsworth's other reason for writing about humble themes, that 'in them the passions of man are incorporated with the beautiful and permanent forms of nature', an accurate description of Constable's landscape of the Stour valley.

One may sometimes feel that Wordsworth's subjects of contemplation – the daisy or the small celandine – were almost too humble. The same is true of Constable. His *Willows by a Stream* [214] looks at first sight very commonplace, and was rejected by the Royal Academy when Constable was present on the Hanging Committee – no wonder he said some unpleasant things about his colleagues. In fact, the longer you look at it, the more sensitive and delicate it becomes. As for his *Cottage in a Cornfield* [215], in its simplicity of style, as well

214 Constable, Willows by a Stream

282

²¹⁵ Constable, Cottage in a Cornfield

as subject, it is the perfect counterpart of an early lyric by Wordsworth. I used to think it boring; I now think it touching and far preferable to the later Constables. In its unobtrusive way it is really an inspiration, going straight back to a drawing in the 1814 sketch-book. Without any doubt the great works of Constable were done at the point when his desire to be a 'natural' painter and his need to express his restless, passionate character overlap. Through his violence of feeling, concealed under a conventional exterior, he was able to revolutionise our own feelings about our surroundings. The conviction that open spaces and areas of rural scenery must be saved for the refreshment of our spirits owes more to Constable than to any other artist. While Turner, with greater gifts, was transforming the 'beauty spots' of Europe, Constable was teaching us all to realise that our own countryside could be taken exactly as it is, and yet become more precious to us.

283

216 Millet, Gréville Church

Millet

That the distinction between classic and romantic art is more convenient than real – a sort of art-historical fiction – I have said before in this series. Of course there is an immense difference of intention and circumstance between Ingres' *Baigneuse* and Turner's *Snowstorm*, but the two schools often overlap; and never more so than in the work of Jean-François Millet. The subjects of some of his finest works are intensely romantic. In his treatment of the human figure his procedure is classical. This may be one reason why he is still underrated. People are afraid of admitting that the painter of such popular pictures was a painter of the first rank. I agree with Van Gogh, Daumier, Seurat, Tolstoy and Berenson in thinking him one of the greatest painters of the mid-nineteenth century.

Millet was born in 1814 in the village of Gruchy, near Gréville in Normandy [216], a countryside where one passes abruptly from fields and orchards to the sea, from a monotonous struggle with the soil to a dangerous struggle with the waves. As most people know, he was the son of a peasant and worked in the fields from his earliest youth; but what is often forgotten is that in the countryside of Western Europe there were peasant aristocracies with a high degree of culture. In reading about the youth of Millet we are reminded of the early life of Thomas Carlyle, and of those 'grave livers' (as Wordsworth called them) whose choice words and measured phrases seemed to him above the reach of ordinary men. At the age of twelve Millet, under the instruction of the local curé, was reading the Georgics in Latin; and his friend Sensier tells us that he devoured greedily The Confessions of St Augustine and the works of Pascal, Bossuet, Fénelon and St Jérome, especially his letters, which he liked to re-read all his life; such was pre-Welfare State education.

Like Giotto, Millet drew while watching the sheep, and his drawings were at once taken seriously by his family and shown to a local painter in Cherbourg. When his parents were told that their 285

²¹⁷ Millet, Madame Roumy

eldest son must leave the farm and become an artist they accepted it as the will of God. This rich, consistent culture of the mind was succeeded by an equally consistent and nourishing culture of the eye. The young Millet was set to copy prints after Poussin and Michelangelo and, together with the Bible and the works of Virgil, they formed the basis of his imagination throughout the whole of his life; but as was natural in a provincial society he made his way by painting portraits. A number of these remain in the Museum of Cherbourg, and show that he was a natural painter with a strong sense of character [217].

In 1837 Millet arrived in Paris. He was too shy to ask his way to the Louvre and wandered about trying every big building till at last he struck the right one. He told his biographer that the artists who 286 impressed him were Mantegna and le Sueur. Here a curious fact

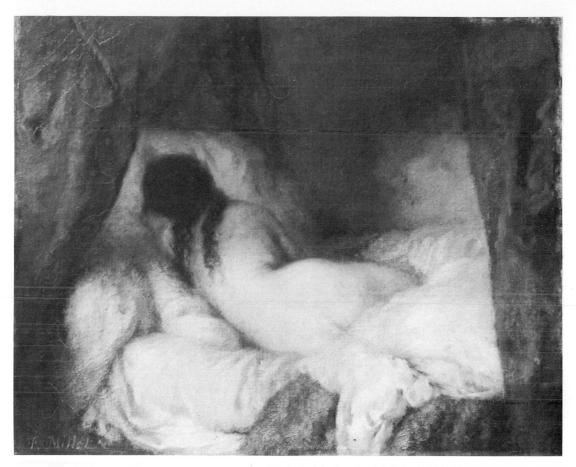

218 Millet, Nude in Bed

219 Millet, Nude

220 Millet, The Quarriers

221 Millet, Two Bathers

emerges: that for the next ten years Millet's work consists in skilful pastiches of Correggio and Fragonard. Writers on Millet, seriousminded people, have tried to excuse these frivolous pictures [218] as attempts to gain a livelihood. They cannot, of course, be explained by external circumstances alone, and they leave us in no doubt that Millet, like his heroes Poussin and St Augustine, was a man of intense sensuality, whose paintings and drawings of the nude were very far from being academic exercises or pot-boilers [219]. But they represented only half his character.

One day he was standing in front of a picture-dealer's window, looking, as artists do, at his own work, when he heard the conversation of two passers-by, 'Who painted that picture?', 'Why Millet of course; he is a specialist in bosoms and bottoms.' Returning home he told his wife, and added, 'If you consent, I will never again paint a picture of that kind.' He did not quite succeed in his resolution. This episode took place in 1849 and an admirable picture in the Louvre of two bathers [221] is datable about 1850. Still, he succeeded to a degree that is, as far as I know, without parallel in the history of art and which carried with it peculiar dangers. A great artist must put the whole of himself into his work and at the age of thirty-five to cut out such a large part of his persona, and one so closely connected with the art of painting, was to risk impoverishing, or even crippling, 288 his creative faculties. I do not think Millet altogether escaped.

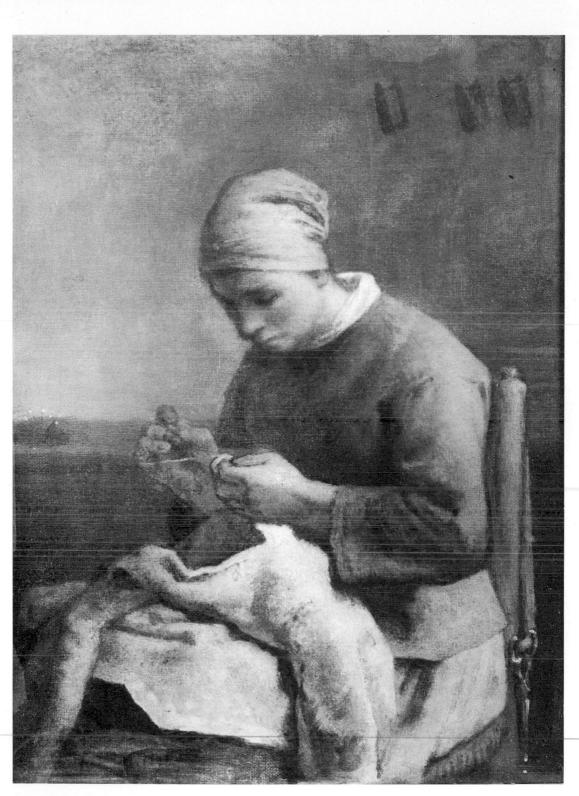

222 Millet, La Couseuse

Psychologists could find in his pictures of rustic life plenty of evidence of unconscious eroticism. What is more important, his mature work sometimes shows a certain drabness which may be attributed to the heavy hand with which he had to hold down the old Adam. In compensation one may suppose that the noble solidity of Millet's peasantwomen [222] could not have been achieved without a physical passion for substance. As with Poussin, he could hardly have escaped the endemic disease of ideal art — insipid emptiness — unless he had started with a double dose of sensuality.

Millet's conversion was of crucial importance and must be examined further. Had he begun to paint pictures of rustic or working-class subjects before 1847? One or two are recorded, and at least one has survived, The Quarriers [220], now at Toledo, Ohio. In addition to a vividness reminiscent of Goya, it is painted with the colouristic bravura of Decamps. One begins to wonder if it was really necessary to renounce these qualities, as well as his frivolous subjects, in order to achieve the gravity of his mature work. The answer is, I think, that the two were almost inseparable. When he paints a rustic subject with an ingratiating touch and rich broken colour, the vision automatically assumes some of the artificiality of Fragonard. The result is quite pleasant but it adds nothing to our experience or to the sum of European art; whereas if we turn to the peasant family of his maturity [223] we may feel a little irritated or, perhaps, be put out of countenance, by their solemnity, but must admit that they are, both as style and vision, a new creation. The earlier picture looks back to the eighteenth century, this looks forward to Picasso, or, even more strikingly, to Henry Moore.

It is usually said that the turning-point in Millet's work was the picture of a winnower [224], exhibited at the Salon in 1848. On the question of style this is unenlightening as the original *Winnower* has been destroyed, and we know it only from two replicas, which are obviously of a later date. It must be supposed that the original of *The Winnower* was closer in style to the admirable picture of two men sawing a log, which on grounds of style I would date quite early. *The Winnower* was a great success, and was bought by Ledru-Rollin, a Minister in the revolutionary Government. This leads one to ask how closely Millet was connected with the theories and sentiments which led up to the revolution of 1848. At intervals in his life his pictures were attacked as Socialist and subversive, and on each occasion Millet protested that he was entirely unpolitical. On the 290 whole I think this is true. The patient resignation of his workers, and

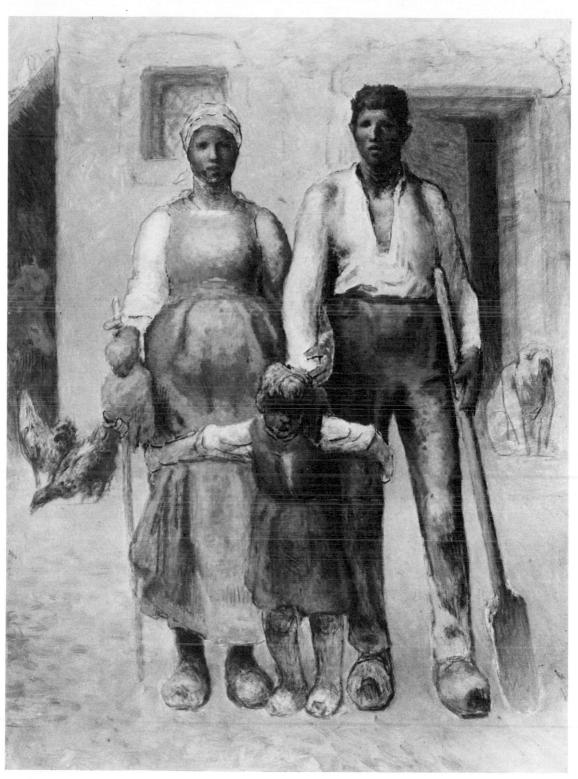

223 Millet, Peasant Family

the feeling that they are part of an unchangeable order of things, speaks exactly the opposite message to that of Marxism. All the same, it is no coincidence that his first successful pictures of workers date from 1848. A number of other painters also contributed peasant pictures to the 1848 Salon and to the next two Salons, but after 1851 they all returned to fashionable subjects, whereas Millet became more and more convinced that, as he wrote, 'peasant subjects suit my tempera-

224 Millet, The Winnower

292

225 Millet, The Faggot Carriers

ment best; for I must confess, even if you think me a socialist, that the human side of art is what touches me most'. This letter was written in 1850. By that time Millet had moved to Barbizon. He had left Paris suddenly to avoid an epidemic of cholera, and had not known where he was going, except that there was said to be a village near Fontainebleau ending in 'zon' which his friend Charles Jacques (who was a professed Communist) had liked. He stayed in Barbizon for the rest of his life.

So these are the three coincidental causes of Millet's conversion, we may say of Millet's art as we know it: a revulsion from the frivolous and sensual character of his painting during the first ten years – what modern cant describes as 'guilt'; a support for his own way of thinking in the intellectual fashions of 1848; and a return to the countryside where he was surrounded by the only life which had ever influenced his imagination.

Millet was one of those artists on whom a few formal ideas make so deep an impression that they feel compelled to spend the whole of their lives in trying to lever them out. Perhaps this is the chief distinguishing mark of the classical artist; certainly it is what distinguishes his use of subject matter from that of the illustrator. The illustrator is essentially a reporter, his subjects come to him from outside, lit by a flash. A subject comes to the classic artist from inside, and when he discovers confirmation of it in the outside world he feels that it has been there all the time. He must give to his subjects an 293

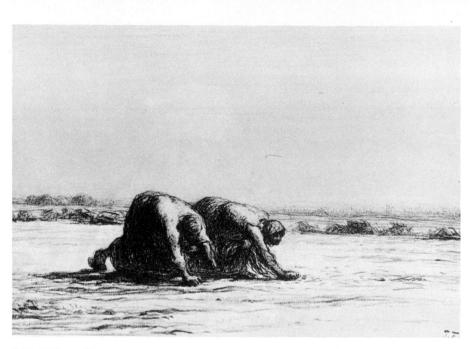

226 Millet, Gleaners

air of unchangeable inevitability, and this becomes a problem of formal completeness. That is why the classic artists, Degas no less than Poussin, return to the same motives again and again, hoping each time to mould the subject closer to the idea.

Let me give an example of this process in Millet's work which introduces almost his first and last picture painted in Barbizon. The motive is women carrying faggots, one of the fortunate occasions in his work where the actual shape of the subject is beautifully expressive of its human meaning. One finds it first in the picture that must have been painted soon after he went to Barbizon, for the drawing is rather loose and Millet's personal style has not yet developed. In a drawing, done almost ten years later, the feeling is far more articulate, the shapes more compact. There are several later drawings [225]: and finally comes the picture [21], left unfinished at his death and part of a commission given a year or two earlier. One can see how he has pulled all the motives together and put the earlier faggot carriers into the background. The main role has been given to a relatively new arrival in his imagination, the women in profile.

In *The Faggot Carriers* the dramatic quality of the theme is obvious, but it is often very difficult to say what gave Millet's recurring motives their fascination for him – and for us. An example is 294 the man pushing a wheelbarrow through a half-opened door, a design which reappears in Millet's work dozens of times at all periods. Millet seems to have been unable to explain to himself the obsessive quality of this image, and, feeling that it did not by itself justify a picture, he tried combining it with other figures; but they always looked superfluous and unreal compared with the relentless wheelbarrower. No doubt a Freudian could interpret it as a symbol of sexual frustration.

Of all his obsessive motives the one to which he was able to give

227 Millet, Gleaners

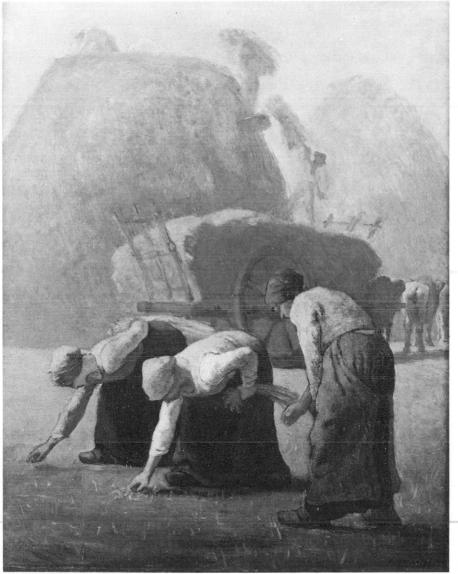

295

the most complete expression is *The Gleaners*. It appears in drawings which must date from the first years at Barbizon. These drawings have an almost Rubens-like *brio* which together with a certain artificiality he was soon to suppress [226]. Then the motive returns in something more like its final form – a drawing of the early 1850s, and after comes a long series for the picture itself, in which, sometimes, vitality is sacrificed in pursuit of the idea [227]. Millet also took the, for him, exceptional course of making a large-scale oil study for the right-hand figure.

Finally, he came to the picture itself [228] in which, to my mind, the classic process has produced one of the great classic masterpieces of French art. The ambition to 'do Poussin over again from nature', of which so much was heard at a time when Millet's reputation was at its lowest, has been magnificently achieved. Every line is perfectly calculated, even the blades of corn in the gleaner's hands. We know from drawings how much thought he gave to the relation of the figures to the background, intending, up to the last moment, to have a huge haystack rising behind them. In the end how satisfying the solution is, both more monumental and more expressive of the burden of labour in the sun. In *The Gleaners* Millet also achieves a beauty of atmospheric colour rare in his paintings, and this colour substantiates the unusually dense modelling of the forms.

In calling Millet's preoccupation with certain pictorial ideas, or motives, classic, I have not forgotten his inherent romanticism. It was the fusion of these two qualities which led to his most notorious achievement, the creation of popular images. The purely classic artist struggling with his motive tends to deprive it more and more of its overtones of association. But Millet never lost sight of the human, or as we used to say, literary, idea from which, at birth, his formal idea had been united. Furthermore, he was often conscious that these ideas had the character of symbols - that is to say he related an incident to a general scheme of things, and used the resultant shape to awaken a train of vaguely impressive emotions. This is a dangerous procedure. We all know how gladly the popular mind takes comfort in easy and reassuring generalisations; and so it is with the popular image. How few popular images have resisted the scrutiny of centuries: Michelangelo's Birth of Adam and Raphael's Sistine Madonna are among the few inspired ideas which have somehow gratified the mass mind, yet which even the sepia prints in our school-teachers' sitting-rooms have not destroyed.

296

I fear that the same cannot be said of Millet's more popular works.

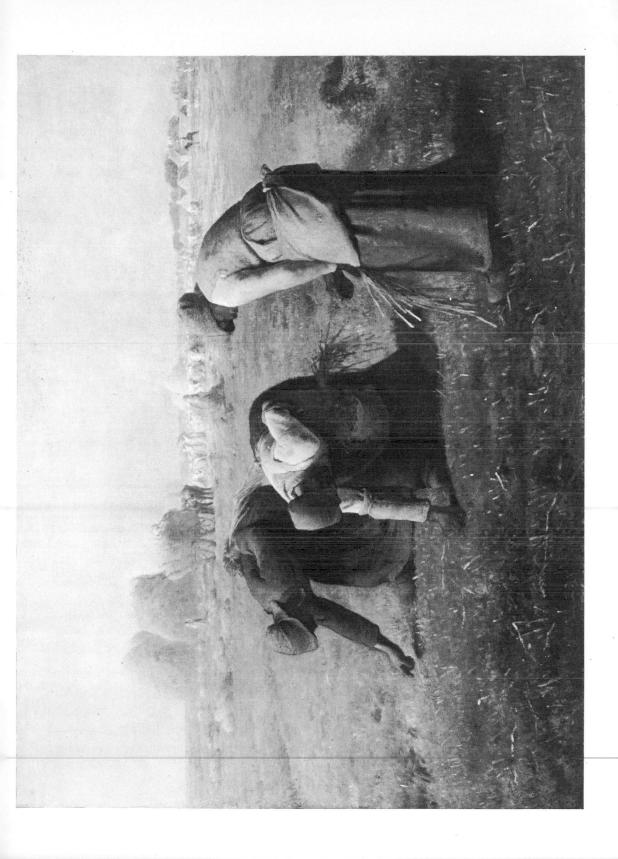

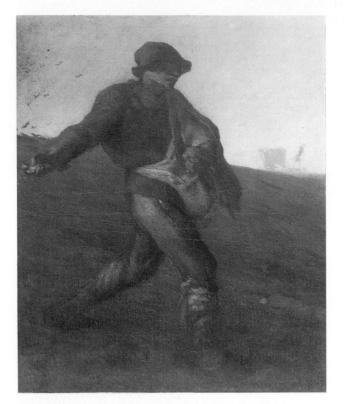

²²⁹ Millet, The Sower

The Sower [229], although considered on its appearance as socialistic in its realism, now seems to us slightly theatrical; and as I have said it belongs to the period when Millet was still content to employ a good deal of romantic eloquence. In The Angelus [230] the bareness of the composition has been carried so far that we suspect a conspiracy of the opposite kind. He has used the devices of extreme simplicity - the empty rectangle with figures far apart, the parallel planes, the lack of movement – quite consciously as a means of affecting our feelings, and although this kind of calculated simplicity has been practised with success by great poets, it has also led to an embarrassing sentimentality. Personally I feel that although the bare outlines of the man and his fork are rather self-conscious, the woman with the wheelbarrow is a remarkable image and records a real moment of vision. Her strange silhouette is as complex and memorable as one of Seurat's studies for the Grande Jatte, and its relation to the wheelbarrow has an obsessive quality which must involve some unconscious 298 physiological analogy. Sentimentality alone does not give a picture

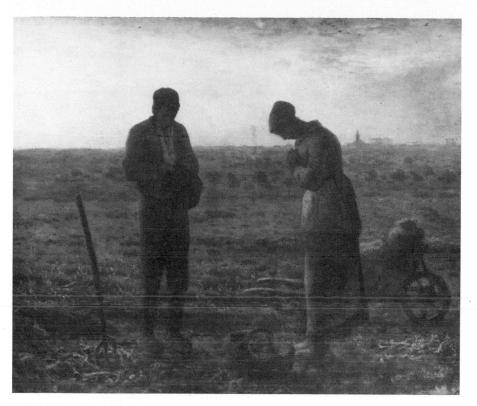

230 Millet, The Angelus

universal popularity unless it is propelled by some effective image, but the universal appeal of *The Angelus* may also be due in part to a certain falsity of tone and colour; for although the public loudly demands truth to nature, it does not really want it, but prefers a glossy coating of unreality which seems to make life easier to accept.

The Angelus was Millet's most popular picture. Almost equally popular was another exercise in the kind of simplicity which verges on simplesse, The Shepherdess [231]. This, more than any of his works, was to give him a bad name with twentieth-century critics. Yet, if we look at a preliminary drawing, obviously done some years earlier, we see how, by deep thought, Millet has contrived to make this quite commonplace image memorable. The solitary figure rising above the low horizon, the repeated globes of the feeding sheep, the silhouette of the black dog, reveal a pictorial imagination far superior to the original drawing.

However, there is something wrong with both *The Angelus* and *The Shepherdess*: the way in which they are painted. We expect a 299

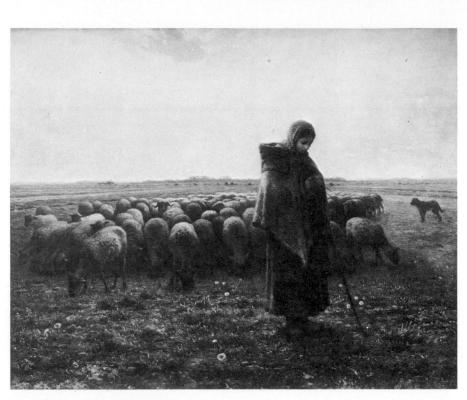

231 Millet, The Shepherdess

small picture (and both of them are quite small) to have a particular richness or delicacy of colour and texture; but as Millet's sobriety of style grew upon him, his colour tended to become muddy and the paint surface uninteresting. *The Shepherdess* seems to have been painted in blackcurrant syrup. Fromentin, that most perceptive lover of pure painting, in a lukewarm obituary of Millet, asks several times if he is 'un beau peintre', and on the whole the answer is 'no'. Those who look first for what the French call une jolie matière must look elsewhere; and I must confess that I find several of Millet's later works are more impressive in black and white reproduction than in the originals. In the last fifty years our response to painting has been overwhelmingly a response to colour, and this, I think, is one reason why we prefer Millet's pictorial ideas when they are translated into the brilliant colours and agitated brush strokes of Van Gogh.

The Angelus was begun in 1857 and finished in 1859. Several times in the next ten years Millet again attempted the perilous task of creating immediately effective images. I mean, of course, perilous artistically, but one of them proved to be perilous materially as well – 300 The Man with a Hoe of 1863 [232]. In front of this disturbing symbol

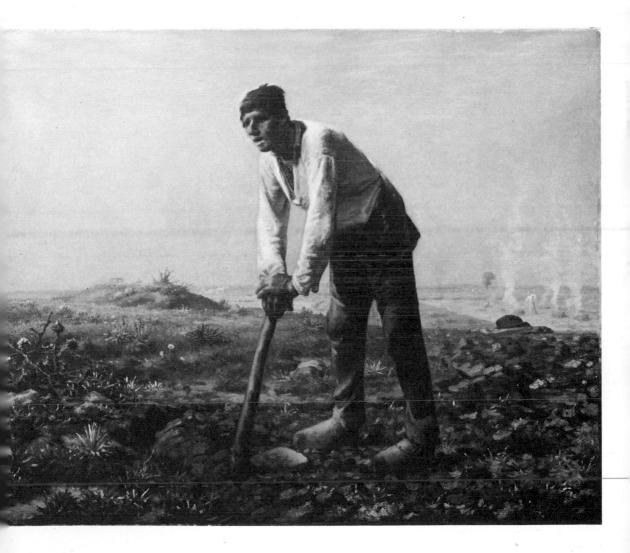

of hard work all the old accusations were raised again. He was a Socialist, a follower of Saint Simon, he saw only the brutalities of the country and not its beauties, and so forth. Many of his old supporters, including Gautier, deserted him; only Thoré, who must hold the record for having anticipated the judgements of posterity more often than any critic that has ever lived, came to his support, and drew from Millet a letter of thanks which is worth quoting, for it is the simplest and best apologia for his own painting.

'I should like [he writes] to set down some of my beliefs which I try to make clear in all that I do: that things do not look as if they had been brought together by chance or for the moment, but have between them an innate and necessary connection. In this picture, of a woman carrying water [233], I tried to show that this woman was not a water-carrier, or even a servant but a woman going to draw water for the house, for soup, for her husband and children; that she should not seem to be carrying any greater or less weight than the buckets full; that under the sort of grimace which the weight on her shoulders causes, and the closing of the eyes at the sunlight, one should see a kind of homely goodness. I have avoided (as I always do with horror) anything that can verge on the sentimental. I wanted her to do her work good-naturedly and simply, without thinking anything about it – as if it were a part of her daily labour, the habit of her life. I wanted to show the coolness of the well, and meant that its antique form should suggest that many before her had come there to draw water.'

This must be one of the very few statements about art made after 1860 which would have been comprehensible to a man of the Renaissance. It is, of course, this very fact which makes us hesitate, because Millet was not painting in the Renaissance, and although his beliefs are eternally valid they were not part of the intellectual currency of the time. What a Renaissance painter did with a full weight of water behind him, Millet had to do in self-conscious isolation. Perhaps this is why we often prefer Millet's drawings to his pictures. I do not think that anyone who has looked through a big collection of Millet's sketches, such as that in the Louvre, will dispute the statement that he was one of the finest draughtsmen of the nineteenth century. Almost the only one of his contemporaries who equalled him was Daumier, and who has never suffered Millet's fall in reputation. One can see why. There is a gusto about Daumier's 502 hypocritical lawyers and mountebanks that is more to our taste than

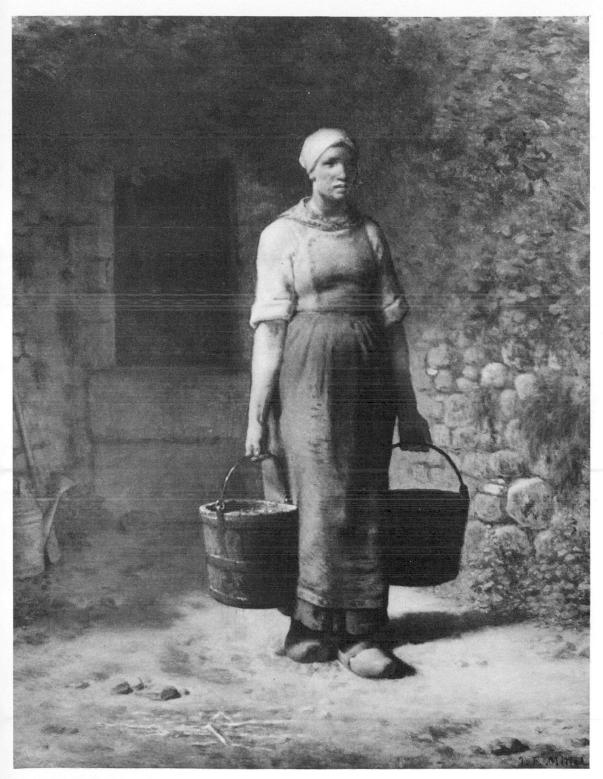

233 Millet, The Water Carrier

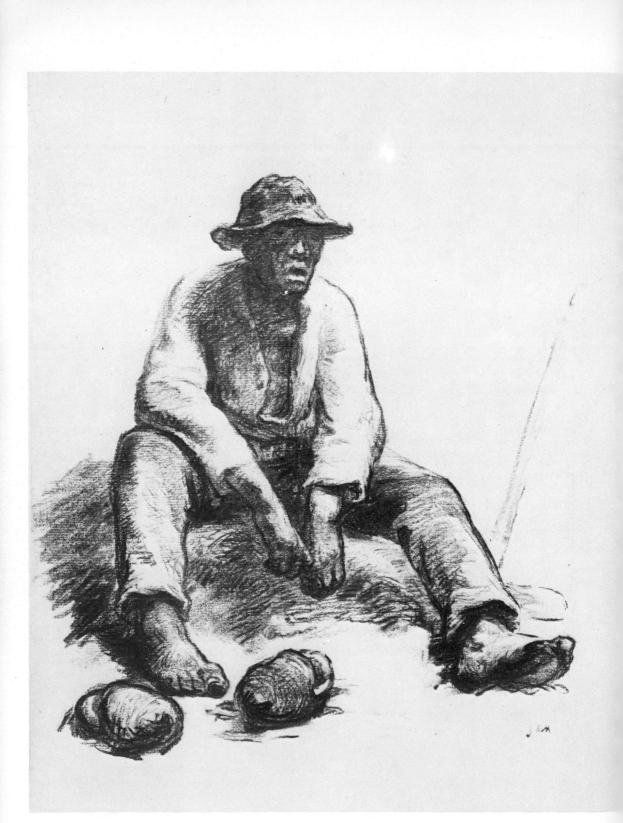

234 Millet, Vigneron

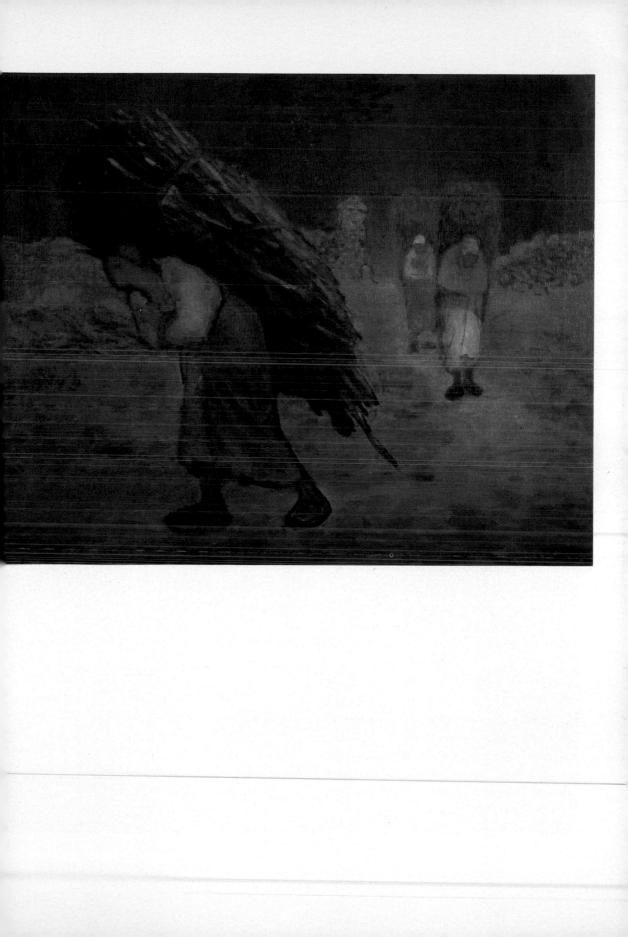

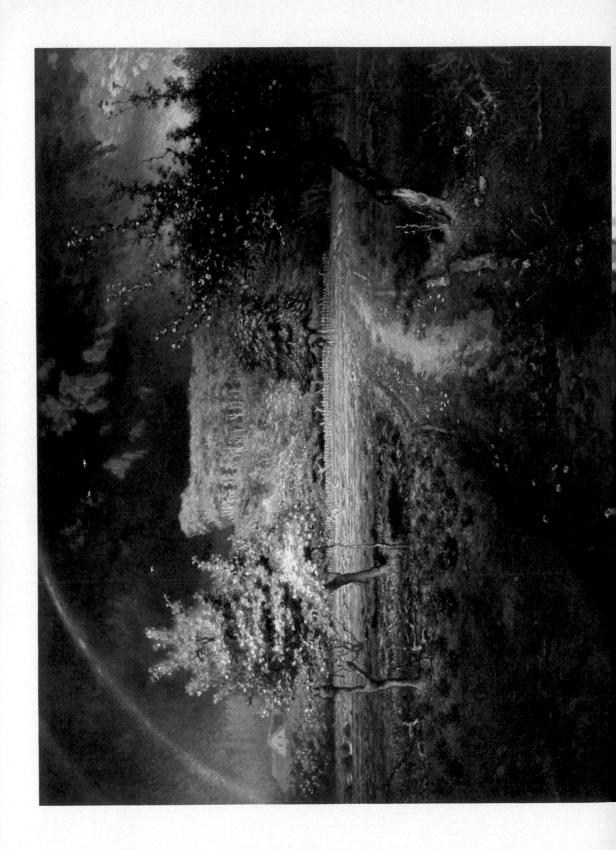

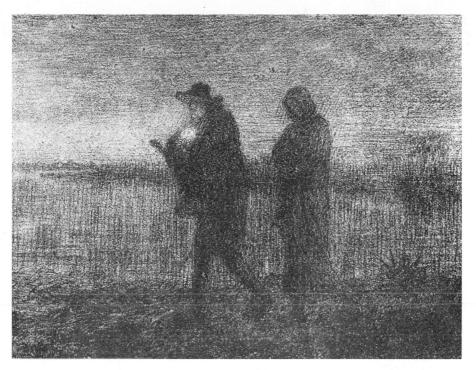

²³⁵ Millet, The Flight into Egypt

Millet's solemn peasants, but in grasp of form and movement there is little to choose between them. Did Daumier ever do a solider and more powerful drawing than the *Vigneron* [234]? In one respect Millet is in my opinion unrivalled, and that is his gift of relating figures to their surroundings. His sense of the unity of man with nature was supported by a remarkably delicate eye for atmospheric truth. In the drawing of women raking, the lengthwise movement of the figures is perfectly related to the vertical lines of the trees. Had Millet not been so interested in human-beings he would be remembered as a great landscape painter; he responded particularly to two states of nature – night and winter – which can be appreciated only by those who spend their whole lives in the country. His sheepfold will remind an English amateur of Samuel Palmer, although the mastery of drawing implied in the suggestion of the sheep is outside Palmer's range. One of the most poetic of all his night-pieces is a drawing of The Flight into Egypt [235], which reminds one immediately of the drawings of Seurat, who admired and studied his work.

Millet was also one of the first painters since Brueghel to perceive that the beauty of landscape does not depend on the swelling curves of growth – the late summer landscape which, from Rubens to 305

236 Millet, The Storm

Constable, had been the painter's chief delight. He recognised that the pictorial architecture of the countryside was, in fact, enhanced by the bare horizontals and verticals of Winter, though, of course, his response was not purely visual. Perhaps all great landscapes are to some extent a comment on human life. In the composition known as November [237], the flat, deserted fields were consciously intended as a reminder of the great antagonist with which Man has to cope in his struggle for survival, the death to which he must oppose his life; and the abandoned plough has a symbolic character, clearly related to the wheelbarrow, as an image of frustration. In Millet's last years dread of poverty was replaced by appalling headaches which prevented him from working, and these Winter scenes are the expression of an increasing melancholy. His Coup de Vent [236] where an ancient tree is overwhelmed and uprooted by the storm can be interpreted as a symbol of his state of mind. However, I must add as a pendant to this desolate scene, his amazing evocation of Spring [22], one of his last paintings and one of the few which have never passed out of favour. By an accumulation of images it achieves something, I believe, which a mere impression could not do. Nowhere else in art does the sensual pressure, the riot, the uproar of Spring strike us with greater force. It is a last, wonderful outburst from the old Adam that he had so nobly repressed.

307

237 Millet, November

13

Degas

Degas cannot be labelled. He had a mania for independence. He said that he wished to be illustrious but unknown, and when, after he had become illustrious, anyone wrote an article about him, Degas never spoke to the writer again. One may call this kind of behaviour aristocratic, although, in fact, all aristocrats are by no means averse from publicity, and Degas was not, strictly speaking, an aristocrat by birth. In the French Revolution his grandfather had escaped from the Terror by the skin of his teeth, and had gone to Naples, where he founded a prosperous bank. The portrait painted in Naples by his grandson shows him a wary, disillusioned old man, with the mournful eyes that he bequeathed to all his family. He married an aristocratic Neapolitan. His son, Degas' father, went out to New Orleans and married a Creole lady: so Degas, although a most ardent French patriot, was of mixed parentage. His father was a lover of art and Degas from the first had access to fine collections.

Of all the great painters of the nineteenth century, Degas was the most dyed-in-the-wool traditionalist, spending his time in galleries and print collections. He was an indefatigable copyist and particularly admired the painter who had become the little god of 'Orthodoxy', Monsieur Ingres: a strange beginning for an artist who was to be considered a revolutionary. In fact, Degas was by nature a classicist: one could claim that he was the last great classical artist in European painting. Like David, the painter with whom this book began, he had a passion for truth: not simply for truth of the eye, as Monet had, but, one might almost say, for moral truth. Nothing must be glossed over or smoothed out in the name of art. The same characteristic made Degas dislike fine phrases or easy solutions. He was what Auden called 'a vertical man', but, from the first, melancholy and aloof. With his admiration for Ingres, his first thought was to paint historical compositions, and he did three or four. The best of them, now in the National Gallery, London, tells us a great deal about Degas. To begin with the subject: it represents the girls of ancient 309

238 Degas, Girls of Ancient Sparta inciting the Roys to wrestle

Sparta inciting the boys to wrestle with them [238]. In this Degas satisfied his sense of truth, finding a subject in Greek history where the figures really were nude, and not just shown as nude for art's sake. The next thing that strikes one is that Degas has not drawn his nudes from well-covered academy models, who used to strike conventional attitudes professionally, but has painted ordinary boys and girls, whom he found in the streets of Paris. Indeed, they may seem to us, as they did to his contemporaries, exceptionally plain boys, but that is because we are so used to the figures in a historical composition being idealised. As usual, truth is a surprise. If the models are commonplace, the skill with which they are grouped is altogether exceptional. One sees how Degas already had the gift - which became an obsession, of uniting his figures by a flow of line and balance of direction, so that the groups become living units. In the Jeunes Spartiates he has also achieved a contrast between the tightly knit group of the girls, which has the compressed counter-movements of Poussin, and the open rhythm of the boys, which, in fact, was inspired by fifteenth-century Italian painters, such as Pollaiuolo. An extraordinary combination of truth and learning – but it did not satisfy Degas, who refused to exhibit the picture for about twentyfive years; and he never again painted a picture with a historical subject.

Degas' first contact with the contemporary scene was through portraiture; not through the conventional figure posing against a pillar and curtain, but through portraits which are really human situations. The largest and earliest of them is *The Belleli Family* [239]. As early as 1856 Degas had gone to Naples to visit his aunt, the Baroness Belleli, and for the next four years he went on making sketches and studies for this grave and noble picture. His aunt has the family face, melancholy and proud. The design has all the art of the Jeunes Spartiates, but more carefully concealed; look, for example, at the line of the Baroness's hand on the table, leading to the seated daughter.

Degas never became a portrait painter in the professional sense. All his portraits are of relations or friends, his sister and brother-in-law. The finest is of his sister, the Duchesse de Morbilli and her Neapolitan husband [240]. She has the melancholy Degas eyes: he does not look oppressively spiritual. But it is a noble picture, as fine as a portrait by Ingres; and, like the later Ingres, it makes one think of photographs of the 1860s. Degas was, in fact, much interested in photography, and 310 a little portrait in the National Gallery, London, seems to have

39 Degas, The Belleli Family

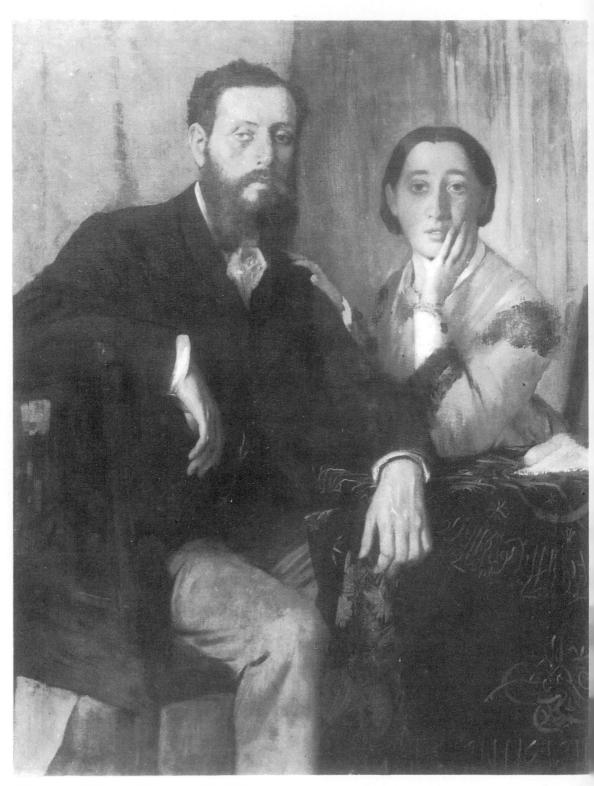

240 Degas, Duke and Duchess of Morbilli

been done direct from a daguerreotype – Degas had never seen the sitter. Only the bad artists of the nineteenth century were frightened by the invention of photography; the good ones all welcomed it and used it. Degas liked it not only because it provided an accurate record, but because the snapshot showed him a means of escape from the classical rules of design. Through it he learnt to make a composition without the use of formal symmetry. An example is the *Portrait of a Lady with Chrysanthemums*, painted in 1865 [241]. Before then I doubt if any painter would have dreamt of putting the principal subject on the very edge of the picture. Incidentally, this is one of the few occasions on which Degas painted flowers; the sensuous disorder of real flowers, which delighted Courbet, Manet and, of course, Renoir, disturbed him. Later in life when he went out to dinner he used to ask for them to be removed from the table. At most he would admit an aspidistra.

Although Degas' portraits were really human situations, he did paint one or two pictures of dreams in the accepted sense; pictures which quite shamelessly tell stories and so have been rather an embarrassment to his more austere admirers. As in the case of Royal

241 Degas, Portrait of a Lady with Chrysanthemums

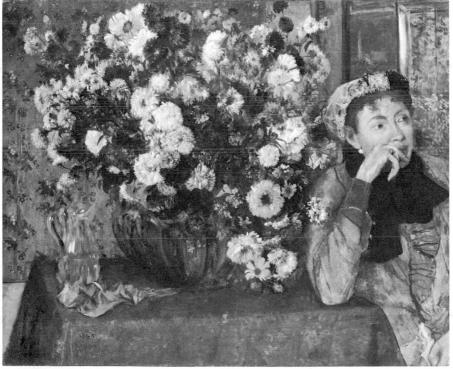

313

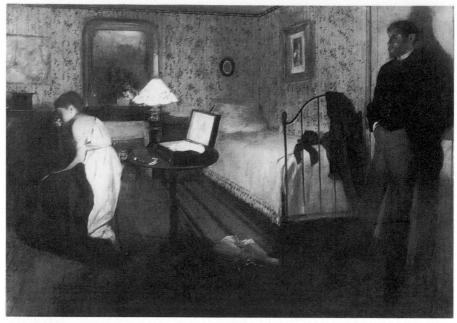

²⁴² Degas, The Rape

Academy 'problem pictures', Sulking leaves one wondering what has happened. In another of these pictures there is no doubt about what is happening: has he gambled away her money? especially as its title is *The Rape*. Perhaps because I was educated during the years of reaction against the 'problem picture', I do not find these the best or most characteristic of Degas' works. Indeed the only part in The Rape [242] that I really like is the delicate painting of the bed and the wallpaper. Leaving this aesthetic prejudice aside, I do not think that they are the result of any real inner compulsion. But at about the same time Degas discovered two subjects that really did correspond with something within himself; horse racing and the ballet. Both involved traditional movements and costumes. An element of style had already established itself. On the race-course there were the aristocratic shapes of the horses, and the stylised, traditional costumes and bearing of the jockeys. This was a subject to which Degas returned all his life. In the early days he also did a few other scenes at the races, of which the most astonishing is a little picture in the Museum of Fine Arts in Boston, not much bigger than a large postcard [244]. It looks as direct, as purely visual, as a Manet. Degas came to paint fewer of these chance subjects; and sometimes 314 we may regret this. What could be more entertaining, and more

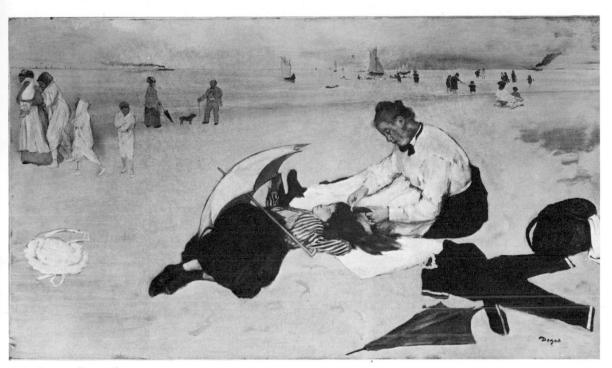

243 Degas, Beach Scene

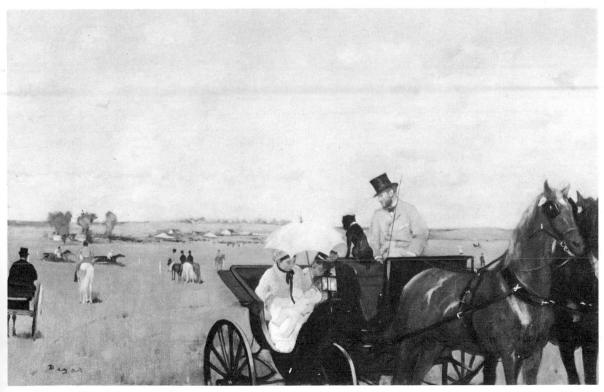

244 Degas, Carriages at the Races

245 Degas, Mademoiselle Fiocre in the Ballet 'La Source'

admirable in its way than the picture in the National Gallery, London, of a girl having her hair combed on a sandy beach [243], where not only the main group, but all the figures in the background are seen with such exquisite clarity? But like all classic artists Degas came to concentrate on the few themes which had developed a peculiar importance to him.

Of all these digested themes – themes which had entered his blood-stream – the most obsessive was, of course, the ballet. If you say Degas to most people they automatically think of a ballet-dancer; but he came to the subject gradually. His first ballet picture was a scene in a ballet called *The Fountain*, and the subject is composed so that one does not realise it is on the stage; in fact the scene has simply become a pretext for painting one of his historical pictures [245]. The dancer, or *figurante*, for she shows no sign of movement, was called Mademoiselle Fiocre. The horse in the scene really came on, drank 316 real water and is said to have behaved perfectly. The curious thing

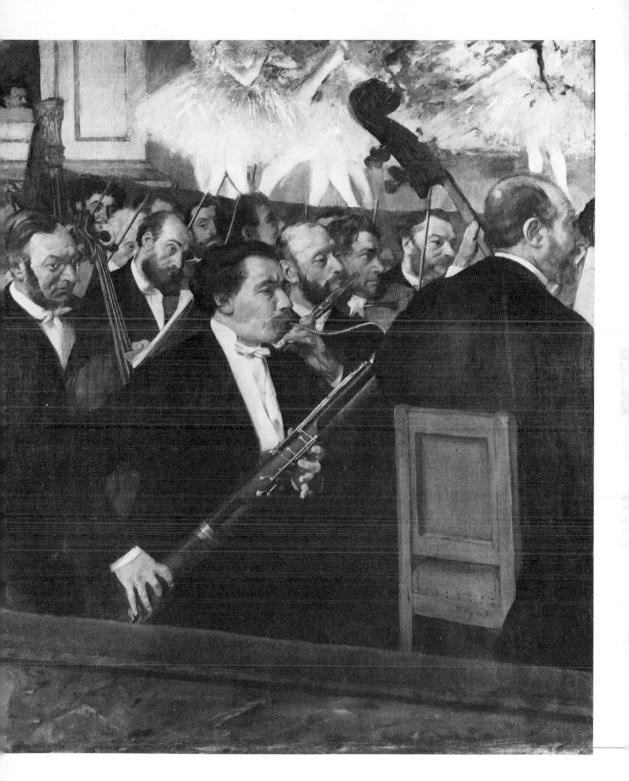

46 Degas, The Musicians of the Orchestra

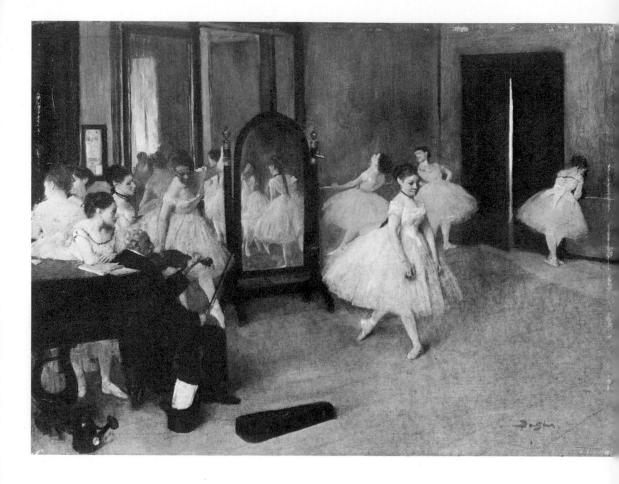

247 Degas, The Dancing Class

about the picture is its absolute stillness: so that one may say that it was not originally the movement of ballet which fascinated Degas, but the quality of truth in illusion.

Degas approached the stage from the front, and in his next theatrical picture he got as far as the orchestra. Just as *Mademoiselle Fiocre* was really one of his historical paintings, so the orchestra is made into one of his portrait groups. He began it as a portrait of the bassoonplayer [246]. In the next opera-house pictures the orchestra recedes, the ballet on stage takes up more space, and we see the two front rows of the audience, who, by the way, were important people called the *abonnés*, the season-ticket holders of the Paris Opéra. Their prejudices ruled, and artistically often ruined, the productions: for example, it was they who insisted on having a ballet in every opera, however much it destroyed dramatic tension. They were still going in my day, and when the curtain fell they used to put on their top-hats and stalk out, grumbling. In 1872, for the first time, Degas went behind the scenes. The Paris Opéra is in every way an extraordinary place – perhaps the most creditable monument to Napoleon III – and the

248 Degas, Rehearsal on the Stage

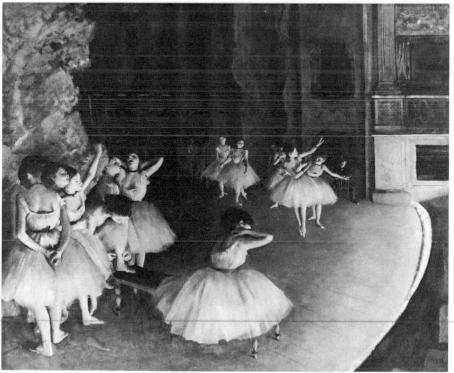

319

back premises are magnificent, one great room after another. In 1872 these rooms had only just been opened, and they became a place of social resort for the young men of Paris; they were said to provide the pleasantest society in Paris.

It was in one of these rooms that Degas painted his first great ballet picture [247]. Having said 'great', I must immediately add that it is very small - less than eleven inches long. The heads are all miniatures. But the picture creates such a convincing illusion of space, and is so broadly painted, that it might be any size. It is an amazing technical feat. Then he did a small picture of a rehearsal on the stage [248], in which for the first time one sees the characteristic poses which were to haunt him for the rest of his life – the girl doing up her shoes, the girl stretching and yawning, the girl scratching her back and the girl on her points, in a pose he was to repeat dozens of times. To anyone who is not an artist it must seem rather strange that Degas who could draw anything - for whom setting down what he saw presented no difficulties at all – should have continued to draw the same poses year after year - often, it would seem, with increasing difficulty. Just as a classical dancer repeats the same movements again and again, in order to achieve a greater perfection of line and balance, so Degas repeats the same motifs, it was one of the things that gave him so much sympathy with dancers. He was continually struggling to achieve an idea of perfect form, but this did not prevent him looking for human truth in what might seem an artificial situation. He had a particular sympathy for the little girls, known as the 'rats of the opera', who came there with their mothers; and apparently they loved him. He has left a most curious memento of his affection for them, a life-size figure which exactly reproduces one of them, even down to a real ballet-skirt [249]. It is the closest imitation of life by art that one can imagine, and if anyone but Degas had done it, it would have been horrible. The little creatures in their ballet-skirts are still half immersed in the world of illusion; their mothers bring a memory of the dingy world from which they came. Once, and only once, Degas allowed himself a memorable image of the butterfly and the chrysalis, in the picture called *Waiting*. The 'chrysalis' is waiting for an audition and the scene marvellously evokes the endless boredom which seems to be inseparable from the preparation of any form of entertainment.

Up to the age of forty-four Degas seems to have been quite sociable. He had a small private income and, unlike Manet, the unfavourable 320 reception of his work did not worry him at all: he thought all critics

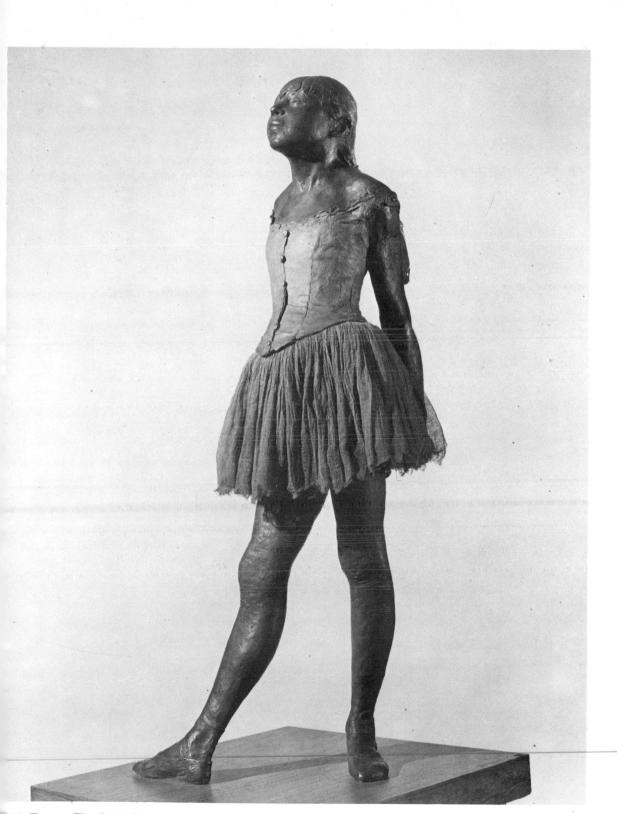

949 Degas, The Little Dancer aged Fourteen

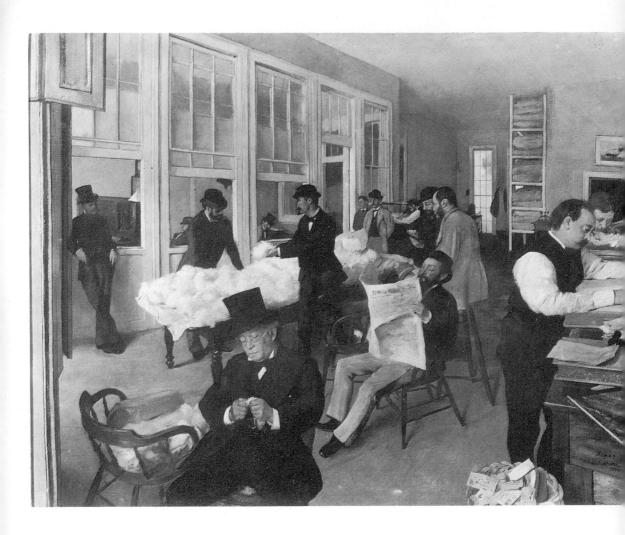

250 Degas, The Cotton Exchange at New Orleans

were imbeciles anyway. He travelled. He went to Italy to see his relations and to look after a large palazzo in the centre of Naples, which he and his sisters had inherited; and he went out to New Orleans where his brothers were employed in his maternal grandfather's cotton business. It was there that he painted another of those technical miracles like the first ballet pictures (painted a year earlier) – an interior of the Cotton Exchange [250]. What amazing skill he had, what certainty of tone and design! Look at the heads, even those of the small figures in the background. One can see why he had nothing to fear from the camera.

In spite of his melancholy expression Degas seems to have been, as he always said he was, a happy man. Then, in 1878, his brother went bankrupt, and shot himself in the Paris Stock Exchange. Degas was a man of intense family feeling and pride; the humiliation must have been appalling. He resolved to pay off all his brother's creditors. He moved to a small studio, shut himself off from all but his intimate friends, and lived like a poor man. Ludovic Halevy, who knew him well, thinks that this disaster affected his art. I cannot find much evidence for this. He continued to paint race-courses, and, of course, ballet-dancers; and he enlarged his range. For example, he did a series of pictures of hat-shops [23], once again taking the creations of style and combining them with truth (the artificial flowers on the hats worried him less than real ones); and then he could make the most surprising designs by taking a viewpoint from among the

251 Degas, The Ironers

252 Degas, The Ironers

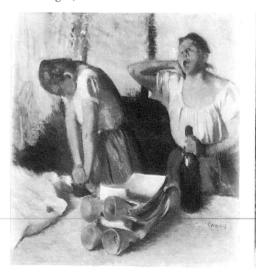

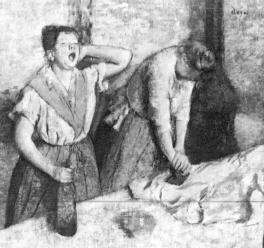

hat-stands. In the end, though, it was the people who interested him. A friend who had taken him to a fitting was flattered to see him staring intently at her new coat and asked him what it was he liked so much. He replied, 'the red hands of the little girl who holds the pins'.

Another subject that had entered Degas' blood-stream was women ironing. His five or six pictures of laundresses are among his master-

253 Degas, L'absinthe

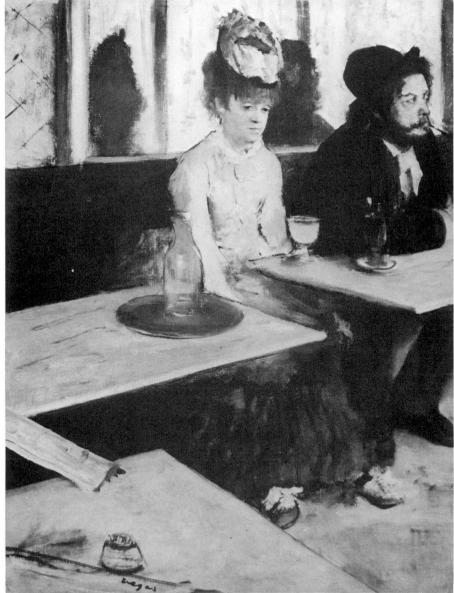

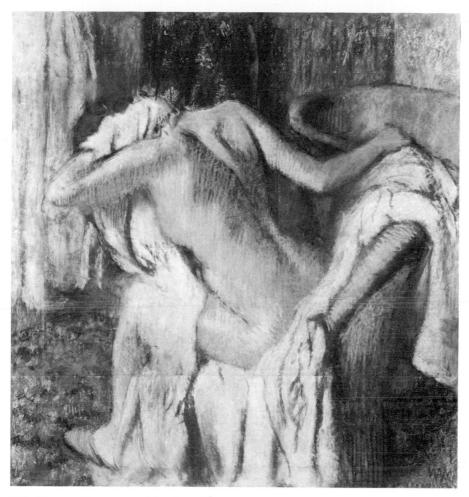

254 Degas, Woman washing herself

pieces. He loved the contrasted movements, concentration and relaxation, and the way in which each woman is totally absorbed in what she is doing. Incidentally, he liked the pile of shirts. To see how Degas worked on a theme, compare an early version of this theme [251] with a slightly later and, so to say, definitive version in the Louvre [252]. The earlier picture still records the first impression. The yawning woman has the disorderly vividness of life itself. In the later version her form is much more complete and worked out. She has become classical and sculptural, and, as part of this discipline, the luminous pile of shirts has disappeared.

Before his withdrawal from society Degas had already begun to paint café scenes. One of the first and most famous, painted in 1876, 325 was called L'absinthe [253]. The somewhat blousy lady is about to drink rather a large glass of absinthe and this perfectly normal event was attacked as representing the depths of depravity. English critics, in particular, said that it proved how far France was sunk in vice: they had not looked very far in their own country. The old boy on the right was an artist called Desboutins, a sweet character much beloved by all the Impressionists, and the lady was an actress called Ellen Andrée, whom Renoir also painted, and made her look enchanting. Degas' classic love of truth has produced a somewhat different effect. In some of his café scenes the characters do definitely belong to what used to be called *demi monde*. Degas' attitude to these ladies is rather hard to define. Of course, he is neither engaged, nor indignant; he is not even satirical. Yet, one cannot say he is wholly detached; these characters have a certain fascination for him, and he can make them look, in the immediate occupations, as timeless as an Assyrian relief.

Degas' treatment of the female figure caused, in his own day, violent indignation. Because he wanted to paint the nude without deviating from truth, he did a large number of drawings and pastels of women having baths or drying themselves. These were considered a gross libel on feminine charm [254]. 'Monsieur Degas, why do you always paint such ugly women?' a lady asked him, to which he replied, 'Madame, because women in general are ugly.' But he was doing himself an injustice; nearly all Degas women have figures much above the average. If a gigantic hand were to pick up at random a clutch of ladies shopping in Oxford Street and divest them of their clothes, very few of them would look as attractive as Degas' models. Of course, he did not try to make them seductive. That element, which plays so great a part in nearly all paintings of the nude, was severely omitted, and perhaps scarcely felt. His aim was similar to that of the great figure painters of the Italian Renaissance, to convey movement through the use of line, and often he achieved a largeness and nobility of form which does remind one of the great Italians, only their nudes had been male, not female.

During the 1880s Degas began to worry about his eyesight. Strong light hurt his eyes, which may be one reason why he did so many night scenes, and refused to leave his studio till after dark. By 1890 his friends were convinced that he would soon become totally blind. But he went on painting for another fifteen years and, as so often happens with people who are deaf or blind, I fancy he sometimes used 526 his affliction as an excuse for doing what he wanted. Vollard says that

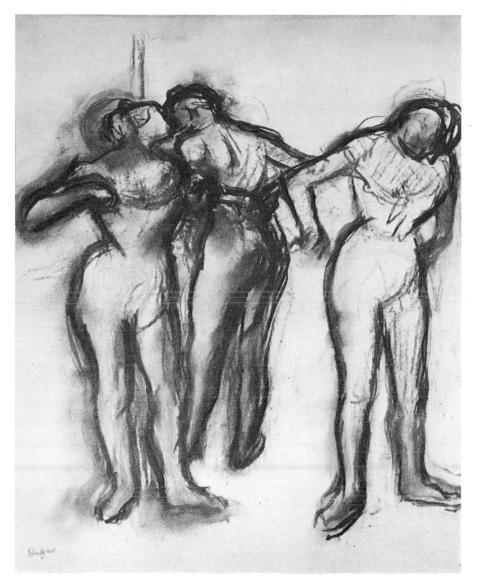

²⁵⁵ Degas, Three Dancers

he would fail to recognise acquaintances who bored him, blaming his eyesight, and immediately afterwards pull out his watch and look at the time. He made a collection of pictures, chosen with sure taste – he was one of the first to recognise Gauguin and Cézanne – and he must have been able to see something of their work in order to do so. No doubt, though, his eyes gave him pain and continual trouble, and for the painter of those miniature ballet scenes not to see clearly was a tragedy. Degas became more inaccessible than ever, and when he 327

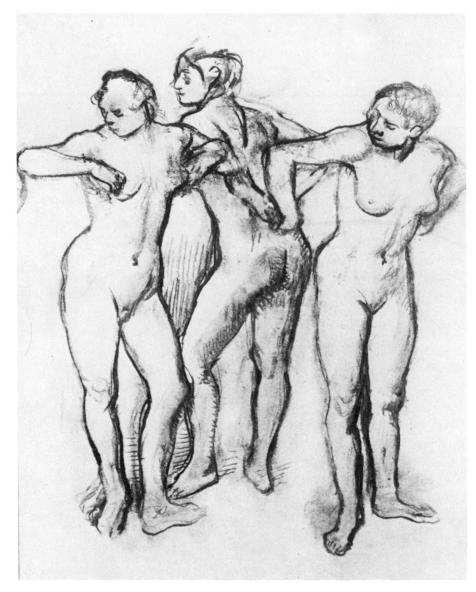

²⁵⁶ Degas, Three Figures

went out to see old friends, his opinions became more intransigent and his comments on people of whom he disapproved – critics, reformers, all politicians, and, of course, bad painters - more devastating. He said things about them which are still funny and like most wits, he was a violent Conservative. All the time he went on painting. On the whole he tended to use the same motives over and over again, but he did take up one new subject, women having their hair brushed. I 328 suppose it was the undulating line and the pull of the hair which

fascinated him. The best, on the whole, is in the National Gallery of Oslo [24], and it shows very well the characteristics of his late style. It is bold and summary, almost a sketch or beginning, with simplifications which may be due to failing sight, or may be due to artistic development, because almost all great painters in old age arrive at the same kind of broad, simplified style, as if they wanted to summarise the whole of their experience in a few strokes and blobs of colour. To this Degas added his mania for going over the same theme again and again, each time making the forms bolder, more complete and, as it would seem, more final. Certain groups of dancers he also treated in this way, and he ended by concentrating so severely on the form that they are not dancers any longer. This pastel [255] looks final but Degas wanted to get still more out of the rhythmic movement of these three figures, and so he did a series of nudes in the same pose [256]. He did the same for several other groups that interested him, which started as dancers and ended as formal constructions. One cannot help thinking of the deaf Beethoven writing the Diabelli variations. These great, authoritative outlines are certainly not purely the result of failing sight.

All great art involves sacrifices and Degas' sacrifice was enormous a sacrifice of the most brilliant talent for truthful, witty notation since Rembrandt. We may sometimes regret it, but it was a necessary part of his proud, independent character and part of his endless fight against humbug and mediocrity. For this reason alone there is in some of these late works an ultimate greatness which direct transcripts of life could never achieve. But beyond this there is the classic discipline. In this series it may seem as if the romantics have come out on top; certainly in the first half of the nineteenth century Turner and Delacroix were the dominant figures. Degas is classic. That, perhaps, is one reason why he is still underestimated. If one thinks about classical art in Europe as a continuous whole, from the fourteenth century onwards, it reaches its conclusion in Degas; and this is not the false classicism of antique armour or Apollo and the Muses, but the real classicism which aims at the final presentation of truth and the long chiselling away of form till it reaches the idea.

329

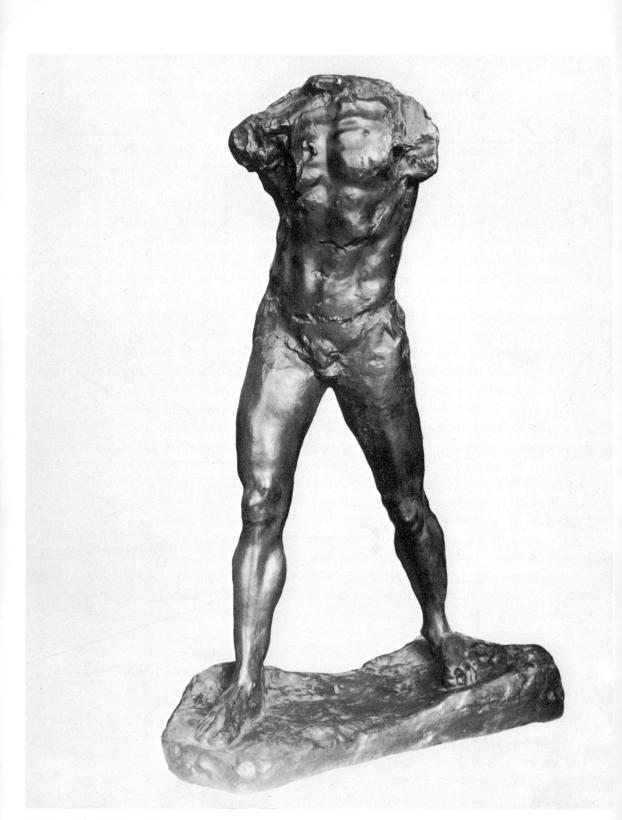

257 Rodin, Walking Man

14

Rodin

Changes of taste in the arts take place with astonishing speed. Only twenty-five years ago people with good taste recoiled in horror at the mention of Rodin's name. He was considered literary, bombastic, vulgar, unsculptural. Now for no obvious reason the climate of opinion has completely changed. When I speak enthusiastically about Rodin people no longer draw away from me as if I had said something indecent, but look at me pityingly as if I had said something commonplace.

It remains true that Rodin could be very good or very bad; and if he is to take his proper place as one of the greatest artists of the nineteenth century, and perhaps the greatest sculptor since Michelangelo, one must make an effort to discriminate between the genuine and the counterfeit in his work. Good or bad, he must be included in this series because he is, without question, the last heir to the great Romantics of the early nineteenth century.

Rodin was born in 1840 and like some of the other great pathfinders of the nineteenth century – Constable, Millet, Cézanne, Wagner, Ibsen – it took him a long time to find his own way. The first piece of sculpture which is recognisably his is the so-called Aged'Airain [258] done when he was thirty-six; and even this is not altogether characteristic of him. Rodin always tried to prevent its inclusion in exhibitions (it had become one of his most acceptable pieces) because he said, quite rightly, that the modelling had not sufficient force. The next year he corrected this fault in the superb figure of a walking man [257], done from an Italian model who had forced his way into the studio and jumped on the stand before Rodin could stop him.

L'Homme qui Marche embodies nearly all the qualities of Rodin's finest sculpture. In its original form it had no subject. He used the figure as the basis for his St John the Baptist [259]. I think that, from the literary point of view, it makes a satisfying image, which holds its own with, and in a way completes, the great series of Florentine 331

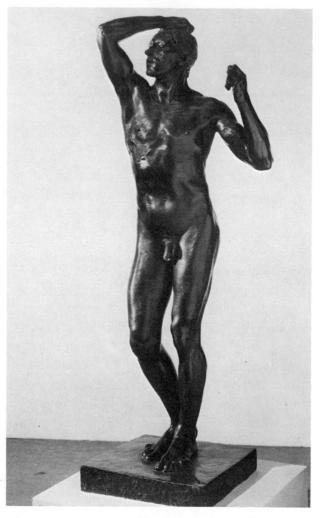

258 Rodin, The Age of Bronze

Baptists. But the straightforward, formal idea came first, and Rodin frequently said that he preferred it to the *St John*.

I am not suggesting that all Rodin's best work is without a subject: in face of the *Balzac* and *The Burghers of Calais* that would be absurd. I do believe, however, that almost all of them, even the *Burghers*, start from some pose or movement which caught his eye, fired his imagination, and almost unconsciously, in the actual modelling, became the embodiment of an emotional state. When the reverse took place, and he set out to represent Paolo and Francesca a fatal formlessness is immediately perceptible, and the rhythms of *art nouveau* take the place of the rhythms of life.

52 The *Walking Man* fits naturally into the tradition of European art.

332

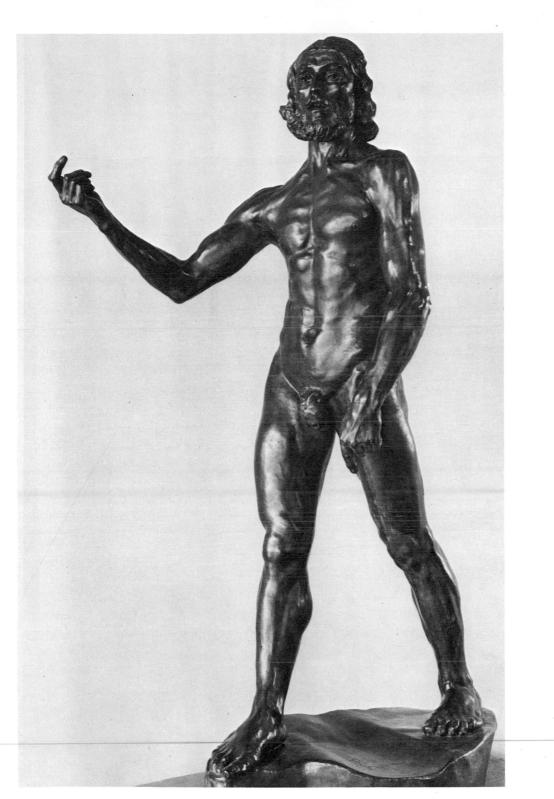

259 Rodin, St John the Baptist

There are some artists who delight us by their acceptance of contemporary chic. But this is not true of Rodin. He aims to strike too deep for that. The more his works exhale the aroma of the late nineteenth century the less successful as sculpture they are. He is at his best when he is the heir of all the ages. And how stylistically all-embracing he is! He often said himself that he was the child of the eighteenth century, and this surprising statement can be illustrated and supported by the fact that the only one of his immediate predecessors to influence him was Carpeaux. Maillol, when asked what he thought of Rodin said: 'He seems to me like the sculptors under Louis XIV.' The influence of Michelangelo is overwhelming, sometimes almost too obvious; he has often been compared with Donatello, and he himself claimed to have learnt most from the Greeks and from the gothic cathedrals. Yet we do not for a moment feel that Rodin is an eclectic, still less that his style has been made in museums. It is a proof of his greatness that he could interpret any style as a means of expressing some truth about organic structure. He knew this, and in his best moments, he struggled to make his work look as if it were part of the whole European tradition, without sacrificing its vital immediacy. He believed that he had achieved this in his last great work. We may allow that he also did so in his first.

The *Walking Man* was modelled in clay. Rodin, and in this, too, he is at one with the tradition of the seventeenth and eighteenth centuries, was a modeller, and not a carver. After his youthful period as an artisan it is doubtful if he ever held a chisel; perhaps that is not quite true, for he used to go to meet visitors holding a chisel and covered with marble dust. But there is good evidence to believe that the chisel was laid aside when he returned to his studio. All his marbles were carved for him by professionals, and very beautifully carved too, with a freedom and sensibility which would certainly not have been achieved if Rodin had not been standing at their elbows. I do not think there is anything discreditable in this, but it is true that Rodin's qualities come through best in his bronzes, when they are cast from models he made himself and under his own direction. In later casts the sharpness of accent is often lost, and with it one of Rodin's most precious qualities: the communication of life.

Rodin's instruments of power and communication were his fingers. His hands were like those of a healer or a bone-setter, able to promote life through the actual touch. No wonder that hands were an obsession to him, so that he kept drawers full of little terracotta hands, which he 334 used to pull out and contemplate. I believe that all the hands of *The* Burghers of Calais are to be found in those drawers. I find, therefore, that (with one exception) Rodin's finest works are on a scale in which we can still feel that the rhythmic interplay of the planes is established by the stretch and thrust of Rodin's thumb and fingers. In fact, all his figures were first done on this scale - which means that nudes were about a sixth or a tenth of life size; later on they were mechanically enlarged by pupils, and thus lose some of that unity of hand and mind which gave them their power. This dependence on physical touch confirms the earthy, troll-like character which appears so often in Rodin's work. Many of his contemporaries called him 'a thinker in stone'. Others called him 'an old satyr'. The latter is nearer the truth and by no means disqualifies him as a great artist. He was a naturmensch, who was aware that his emotions and sensations were analogous to those of animals or trees. The abstractions necessary to ordered thought or architectural design were not natural to him.

When I was young I spent a good deal of time walking up and down the Promenade des Anglais at Nice, waiting for my father to emerge, flushed and victorious – as he always was – from the Casino. One of my favourite objects of distraction was a building, egregious even in that strip of architectural monstrosities, known as the Villa Neptune. All over the façade, I seem to remember, polychrome figures heaved and wriggled with tropical abundance; but I do not,

260 Rodin, Torse d'Adèle

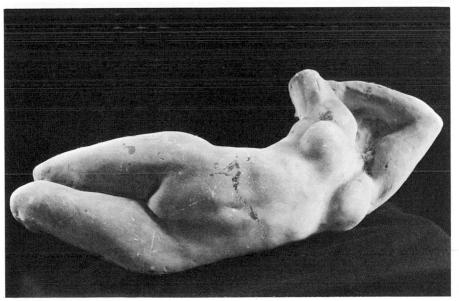

335

unfortunately, recall the two carvatids who supported the principal window. They were signed by the sculptor Cordier, but they were the work of Rodin; not of the youthful unknown Rodin, who still remains unknown, but of the mature Rodin who in the very next year was to receive his first public commission, La Porte de l'Enfer, The Gate of Hell. A plaster from the Villa Neptune of one of the figures survives in the Musée Rodin, where it is known as Torse d'Adèle [260], and is one of the most admired of Rodin's minor works. For almost twenty years of his working life Rodin made his living by doing anonymous decorative sculpture in 'the worst possible taste', if those words mean anything. He had worked on the façades of public buildings in Brussels and Strasbourg, those cities of huge, indigestible meals; he had designed richly carved sideboards and colossal four-poster beds. Of course an artist can earn his bread by craftwork in a way which does not taint his art; but this was not the case with Rodin's decorative sculpture. The fact that these oppressive artifacts really reflected one side of his nature is made all too clear by The Gate of Hell [261].

The commission for *The Gate of Hell* was given him in 1880 by an enlightened Minister of Fine Arts, Antonin Proust. They were to be the doors of the new Musée des Arts Décoratifs. Rodin immediately decided to make them embody the imaginative world of Dante; but, as with Liszt's symphonic poem, Après une lecture de Dante, I fancy that he had not got much further than the anthologised passages in the Inferno. The plan brought out the worst and best of Rodin: the worst because it was inevitably in the manner of his decorative architectural sculpture; the worst, because it encouraged the illustration of spiritual anguish which he did not feel at all, but took second-hand from his literary friends. But in the end it turned out to be exactly the sort of scheme which suited Rodin's genius best. He did not, however, think of himself as the illustrator of Dante for long. In the early stages he included some episodes from the Inferno - the Ugolino (which had been modelled prior to the commission) and Paolo and Francesca. Then he began to put in any figure which expressed a certain kind of emotion. The kneeling youth with upraised arms [264] is a real native of the Porte de l'Enfer; his gesture of despair should be the *leit-motif* of the whole composition. He is indeed among Rodin's most remarkable inventions, and was rightly augmenté and made into a separate piece, which he first called Fugit Amor, then The Spirit of the Age, and finally The Prodigal Son. 336 The nude girl [263] is also, I think, in the spirit of the Porte de l'Enfer

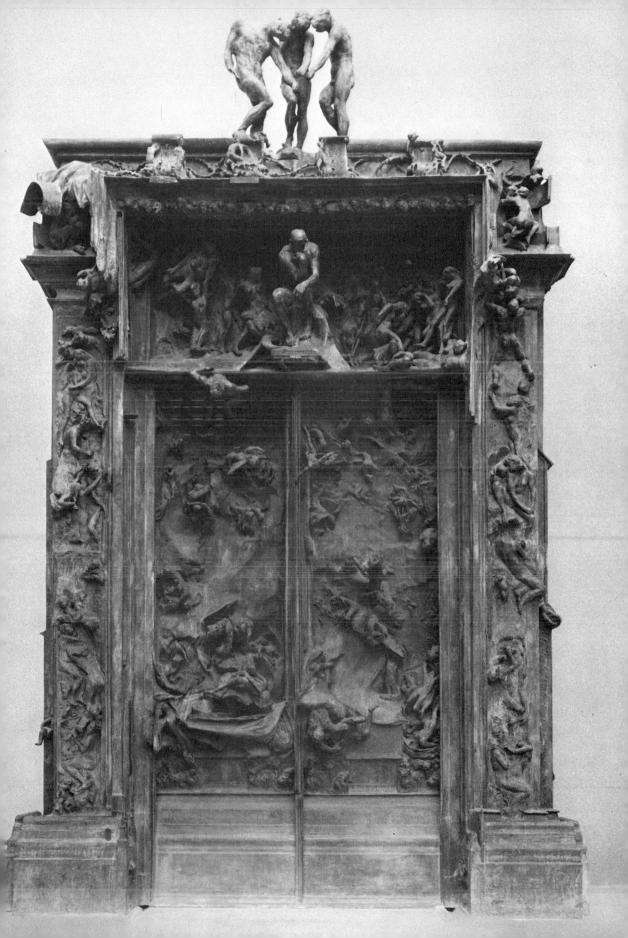

- a spirit of Baudelairean despair - although when she was cast separately she was called *Meditation*. This shows the convenience of his over-populated inferno. If a motif pleased Rodin it could be taken out and made into a separate piece; and a large proportion of his most famous figures came into existence in this way, figures with such

262 Rodin, La Belle Heaulmière

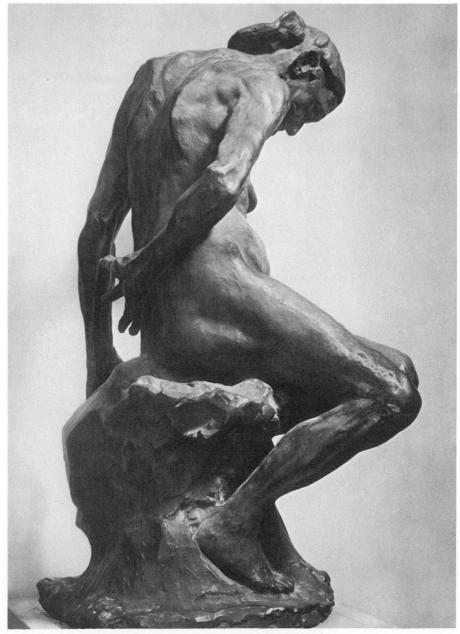

338

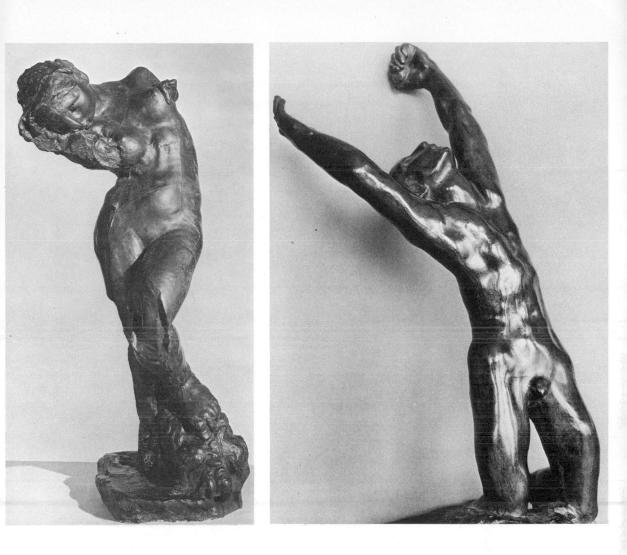

263 & 264 Rodin, Meditation and The Prodigal Son

different characters as the standing Fauness of a healthy, Maillolesque sensuality [266] or the pitiful, marvellously expressive invention of La Belle Heaulmière [262]. Conversely, he came to use the Gate as a kind of dump – or shall we say the equivalent of a writer's notebook – where ideas could be stored until they were needed. Many of the nude figures which he added were obviously no more than records of poses which had appealed to him and could by no stretch of the imagi-

265 Rodin, Woman squatting

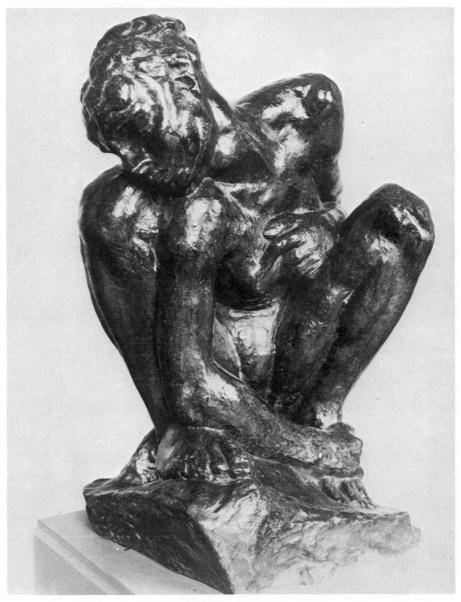

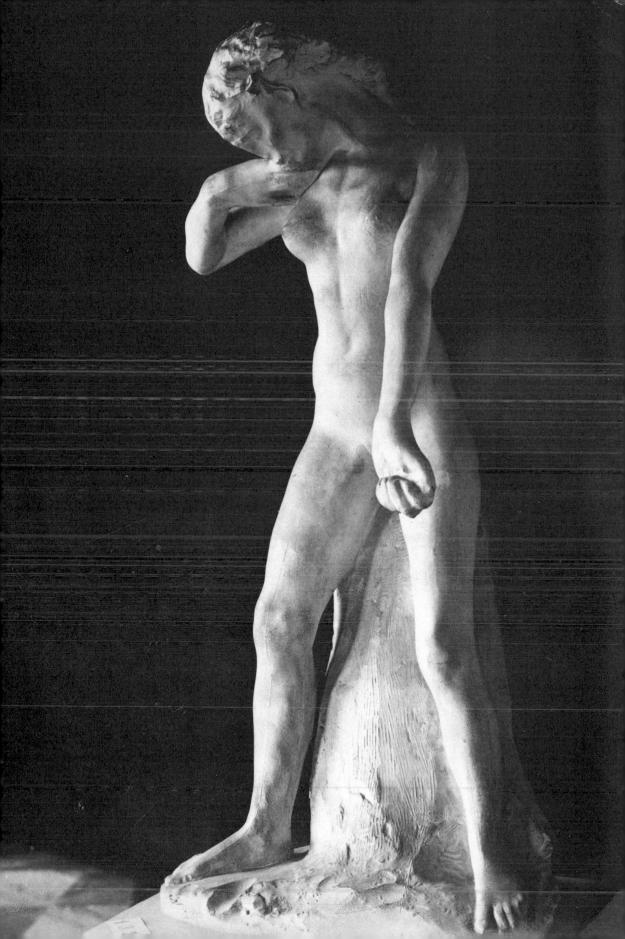

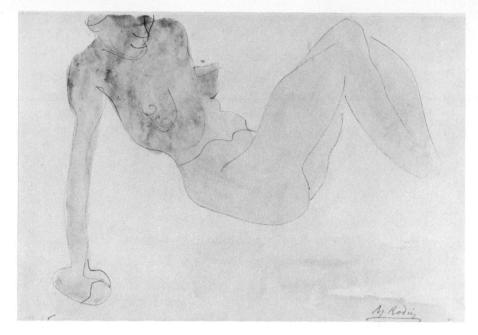

nation be associated with The Gate of Hell. This treatment of motifs is fundamentally different from the classic procedure of Millet or Degas. At the back of their minds were those obsessive shapes which they needed to bring to perfection by contact with the visible world. Nothing could be less applicable to Rodin's drawings. He saw a gesture or movement which excited him and drew or modelled it immediately, in a frenzy of haste lest it should suddenly escape him. The result was final. It could be enlarged but not altered. In this way Rodin made more discoveries in the expressive possibilities of the body than any artist since Rubens. The figure of a squatting woman [265], an invention undreamed of by earlier sculptors, has a completeness that situates it in the great tradition of European sculpture. The fact that it could be included in The Gate of Hell shows why I said that this project, pointless as it seems to us, had a real value for Rodin; and, although the total effect is oppressive, we may wonder if he would have felt free to pour out this wonderful series of plastic inventions if he had not convinced himself that they were necessary parts of some grandiose scheme.

The way in which these discoveries were made, has a bearing on the whole of Rodin's art. Being rightly scornful of the self-conscious postures of professional models, he insisted on having in the studio at the same time two or three naked girls who were told to move about 342 and disport themselves until they got used to the feeling of having no

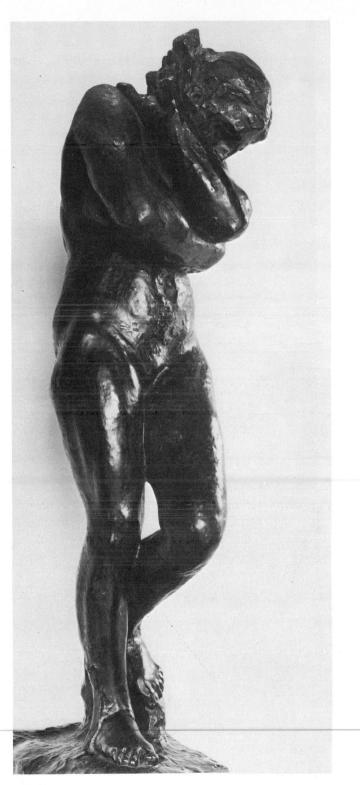

268 Rodin, Eve

clothes on. In this way he discovered a number of new poses and saw old poses with a new vividness. But to try to banish the inhibitions of centuries, taboos which held good almost as much in antiquity as in medieval times, was a perilous operation, and a visitor to the Musée Rodin must feel that in the course of it some element of condensation has been lost. We feel, moreover, that Rodin did not need such abandoned poses to excite him. He remained until his sixties vigorously responsive to physical excellence and was, I am sure, speaking quite sincerely when he said that to him the beauty of a woman was the same as the beauty of a mountain or a wave.

This lack of concentration comes out very clearly in his drawings. In a way they are the most untrammelled and revolutionary of all his works. But in the end, how monotonous they become! There are said

269 Rodin, The Three Shades

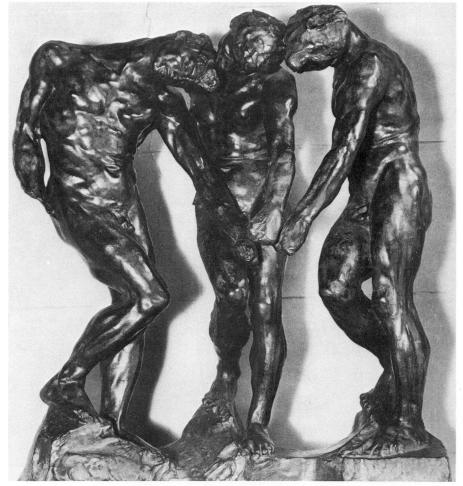

to be over four thousand in the Musée Rodin alone, and I must confess that even after a hundred or so this endless belt of sprawling women has a depressing rather than an exhilarating effect on me, and seems to reveal a kind of promiscuity which is foreign to the concentrated passions of the greatest artists [267].

What a contrast they are to the plastic power and richness of Rodin's finest pieces, for example, the *Eve* [268], where every inch of the modelling is alive, and certain passages, for instance the shoulders, have a vigour that is equalled only by Donatello. It illustrates Rodin's dictum that the sculptor should concentrate on the points of the greatest tension, where the form seems to thrust out most strongly. The pose, too, has a simplicity and completeness which places it with the greatest sculpture of any epoch.

Rodin, at different moments, acknowledged his debt to the gothic cathedrals, the Renaissance, and the eighteenth century - but he never mentioned the Romantics of the 1830s. However, like it or not, our spiritual fathers are usually just a generation older than ourselves, and we need only compare a group like The Three Shades [269] to see how Rodin has extended into sculpture the spirit and many of the forms of Géricault and Delacroix. For example, the lost souls who cling to the Barque of Dante, in Delacroix's painting might come from the Porte de l'Enfer and the nude woman drooping before the Crusaders' horses, recalls one of Rodin's most beautiful marbles, the so-called Danaïd [270]. If we regard The Three Shades as the last fruit of a glorious tree, the romanticism of the 1830s, I think we may find the rhetorical overemphasis of their poses is more tolerable. One can say the same about the Penseur [271]. It was originally called The Poet, and was intended to be a symbolic portrait of Dante brooding over all his creations. Of all the figures from The Gate of Hell it alone seems to me best in the original setting. Although the general design of this sort of tympanum is chaotic the conception of the abstracted figure surrounded by the panic-stricken children of his dreams, seems to me very moving. Taken out of its context the poet loses that concrete character which is the saving of symbolic art, and takes on some of the painful banality of popular imagery.

Infinitely gullible though he turned out to be in his old age. Rodin was never misled by popular approval. He could easily have exploited the vein of the *Penseur*. Instead he followed the dictates of his conscience so scrupulously that almost all of his major pieces aroused a public outcry. The only exception is *The Burghers of Calais* [272] which, almost from the beginning, was popular in the best possible 345

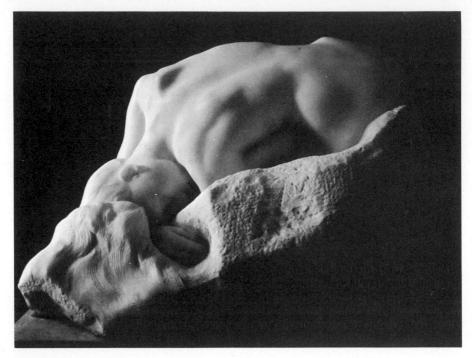

²⁷⁰ Rodin, Danaïd

sense. It is comprehensible to anyone who will pay attention; the dramatic element is inherent, not additional; and the burghers, in every movement, give sculptural form to the feelings of common humanity. Rodin, in a moment of insight, asked that the group should be put flat on the ground in the middle of the square in Calais, so that the burghers might still seem to be part of the people who circulated round them, and who thus, in the midst of their daily business, would feel more vividly the nature of heroic sacrifice.

Rodin's other great monumental figure, the *Balzac* [274] was not, and perhaps never will be, popular. Nevertheless, it is a work of genius and to my mind the finest thing Rodin ever did. The story of its creation shows him as a true artist, with all the elements of charlatanism temporarily stowed away. It was commissioned in 1892 by a body called the Société des Hommes de Lettres, and was to be completed in 1894 and be placed in the centre of the Palais-Royal.

Rodin found the task exceptionally difficult. In his best work he was entirely dependent on nature. All his conceptions, however abstract or literary their ultimate title, had started as a truthful record of a living model. Balzac had been dead for over thirty years, and the 346 records of his appearance were unsatisfactory. Rodin took immense

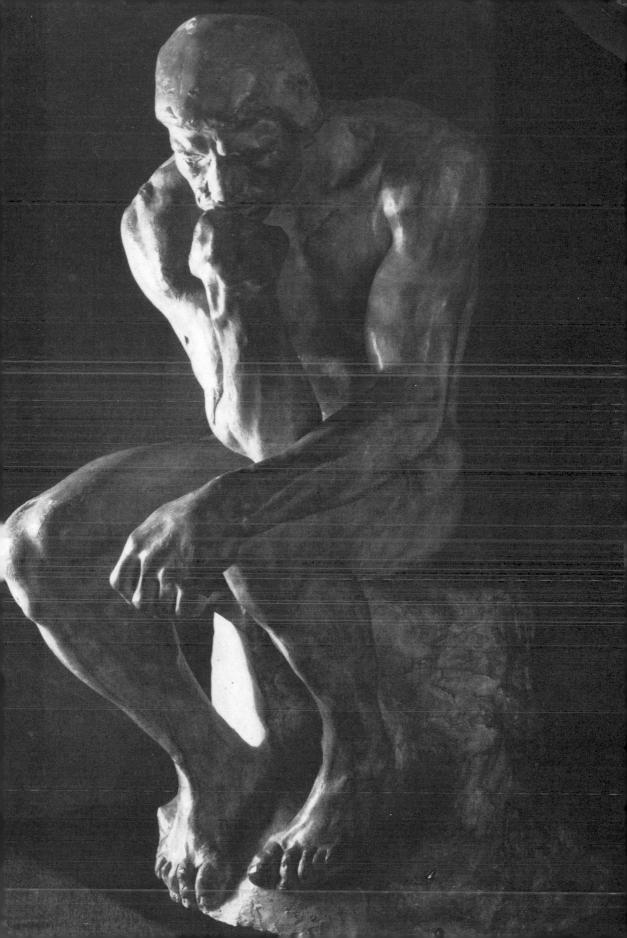

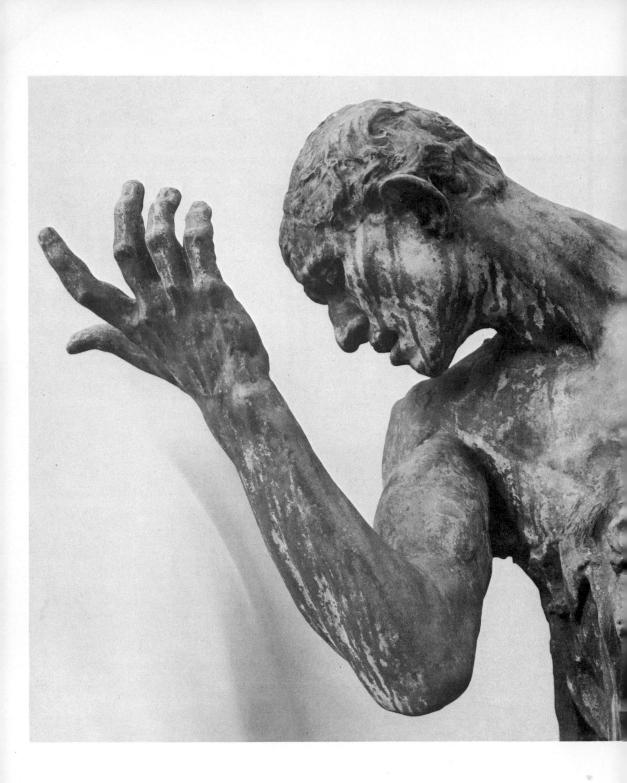

272 Rodin, The Burghers of Calais (detail)

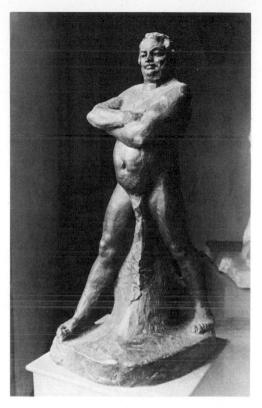

273 Rodin, study for Balzac

pains to document himself, and finally went to Tours to try and find someone who looked like Balzac. The only result of his enquiries was to realise that Balzac in his maturity was fat, squat and unheroic looking. Yet he had somehow to construct a dominating figure nine feet high. It was a test for his doctrine of truth. Finally, inspired by the famous photograph by Nadar which had just come to light, he made seven large models of Balzac without his clothes on and placed them round his atelier for further contemplation [273]. All of them do full justice to Balzac's figure, and seen together they make an alarming effect. The candle-bearing visitors to his workshop, whose raptures before his more sentimental marbles have often been described, might well have felt that, like Per Gynt, they had strayed into the hall of the Troll King. Yet these monsters have a plastic density which he never surpassed, and an absence of emotional rhetoric which makes them particularly acceptable to us. They would not, I think, have been as acceptable to members of the Société des Hommes de Lettres had they been allowed to visit the atelier. But they were not, and when, in 1894, the two years were up several of the members 349 put it about that Rodin had done nothing at all – that he was a quack and a swindler and the commission must be taken away from him and given to a safer man. Rodin continued to contemplate the seven naked Balzacs, and finally decided to cover each one with a cast of drapery suggestive of the famous dressing-gown. The draperies were then treated with wet plaster and worked on after they had dried. The figure then had to be brought into relation with the head, which became more of an expressive idea and less of a portrait; and the final result was sent to the Salon of 1898.

It surpassed the wildest hopes of his enemies. Before this extraordinary apparition they had little difficulty in persuading the members of the Society and a majority of the public that Rodin was mad and that he had insulted France. The man who came most strongly to Rodin's support was that indefatigable defender of just causes, Emile Zola. Unfortunately it was the time of the Dreyfus case and the Balzac became involved in the cry, 'La patrie en danger'. The Hommes de Lettres, with a whoop of joy, refused to accept the statue. Meanwhile in the Salon, what Rodin's biographer calls indécentes manifestations, went on. The crowds surging round the base of the figure, insulting it and threatening it with their fists, were unanimous on one point of technical criticism: that the attitude was impossible and that no body could conceivably exist under such draperies. Rodin, sitting near by, knew that he had only to strike the figure with a hammer and the draperies would come off, leaving the body visible. Instead he wrote a dignified letter withdrawing it from the Salon and set it up in his garden at Meudon.

The *Balzac* continued to be an object of abuse for ten years after Rodin had withdrawn it from the Salon. It was said to be like a snowman, an owl, a dolmen and a heathen god – all quite true, though we no longer regard these as terms of abuse, but rather as valid analogies with objects which may have contributed to the total imaginative effect of the *Balzac*. In 1908 there was a new and even more violent attack and a newspaper asked Rodin for his comments. His answer was, 'If truth is to die, my Balzac will be torn to pieces by generations to come. If truth is imperishable, I predict that my statue will make its way. This work, which has been the subject of so much laughter, is the outcome of my whole life and the pivot of my aesthetic. From the moment I conceived it I was a different man. It was a radical step in my evolution; I had forged a link between the great, lost traditions of the past and my own time, which each day 350 will strengthen.'

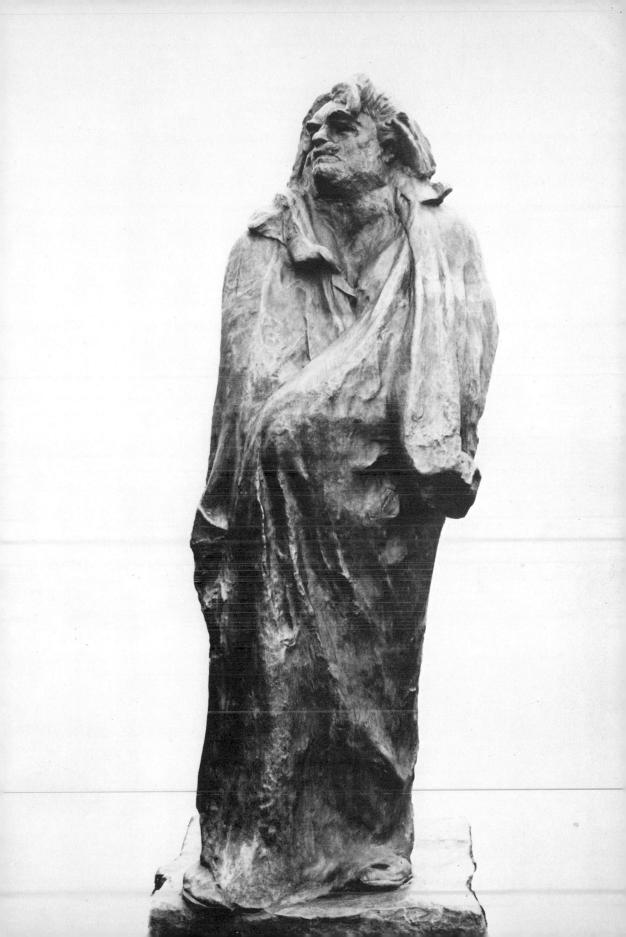

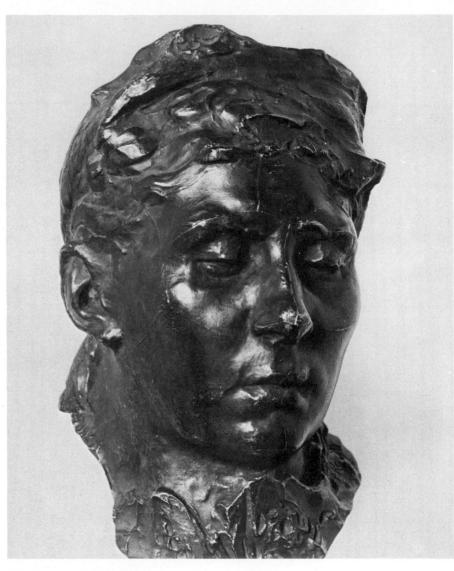

²⁷⁵ Rodin, Rose Beuret

To my mind the *Balzac* does exactly what Rodin says. After all his adventures in other styles he has achieved something which is entirely his own and yet seems to spring from the heart of a universal tradition of sculpture. At the same time it is the most modern of Rodin's works, in the sense that the imitation of appearances is entirely subordinate to a sculptural idea. In the gardens of the Museum of Modern Art in New York, which contains the masterpieces of the twentieth-century sculpture, by far the oldest work is Rodin's 352 *Balzac*. There they all are – Matisse, Laurens, Gargallo, Zadkine, Henry Moore, Giacometti – and the *Balzac* seems to meet them on their own terms and to dominate them.

There is, however, a tragic irony in Rodin's statement. It implies that the *Balzac* was to inaugurate a new stage in his development. As a matter of fact, it was the last great work he executed. He did, indeed, achieve some beautiful minor works, but some mainspring in his creative machinery seems to have snapped. The *Balzac* had been executed against the background of a tragedy in Rodin's personal life from which, I believe, he never recovered. Early in life he had set up house with a fierce and almost illiterate woman named Rose Beuret, who had helped make his moulds for him, looked after the casting of his statues, and waited on him at meals [275]. In compensation she made jealous scenes almost every night and, of course, Rodin was consistently unfaithful to her. (I may add that all those I have talked to who knew her, including Sir Gerald Kelly and Mr Steichen, have told me that she was a perfect dear.)

In 1887 Rodin accepted as pupil Camille Claudel, sister of the poet. She had considerable talent as a sculptress and also great beauty, as may be seen from one of Rodin's most famous marbles [276]. They fell passionately in love with one another and in 1897 she demanded that Rodin should leave Madame Rose and marry her. The conflict in his mind may be imagined as we contemplate the heads of the two women which confront each other in the Musée Rodin. In the end he decided to remain with his faithful companion; less, I think, from fear or sentiment, than from the feeling that she was more fundamentally connected with his work. As a result Camille Claudel went out of her mind and the most pitiful dramas ensued, in the course of which Camille appeared in the shrubbery at Meudon and Rose shot at her.

Most great acts of renunciation have unfortunate results. To do something contrary to natural impulse is always dangerous, and for a *naturmensch* such as Rodin it was almost suicidal. As with Rossetti after the death of Miss Sidall, the loss of a great love drove him into the most degrading adventures. He fell victim to an American lady called the Duchesse de Choiseul, no longer young but, as we can see from his portrait of her, full of vitality [278]. She took him away from his old friends, dressed him in a silk top-hat and frock-coat and led him round Europe in a black limousine like a dancing bear. His friends finally persuaded him to get rid of *l'affreuse duchesse*, but the only result was that fresh waves of parasites beat on the doors at Meudon every month. Rodin had accumulated a large collection of ³⁵³ his own works and, as by now his sculpture was exceedingly valuable, these ladies were often accompanied by their solicitors. In his last years Rodin appears to have signed several hundred wills. From an artistic point of view it is a misfortune for posterity that Rodin's *Balzac* could not have been followed by Balzac's *Rodin*. This macabre comedy lasted for about ten years, and (in a sense) ended well, because Rodin's collection was finally accepted by the State, and in the very last months of his life he was persuaded to marry Madame Rose. Unfortunately by this time both he and she were more or less out of their minds, and had only the haziest notion of what was being done to them.

I have recorded this sad story because it helps us to understand several things about Rodin which would otherwise have been incomprehensible. It explains the lack of major works in his later years. It also tells us something about the decline in his reputation after his death, for those critics who wrote about him then were prejudiced by the memory of a frock-coated figure, impatient, arbitrary, spoilt, thinking only of his glory, greedily devouring the grossest flattery. The chorus of praise from enthusiastic ladies and *littérateurs* was calculated to bring out the worst in his genius for it dwelt on the pseudo-mystic. qualities in his work. The mastermodeller and lover of things seen became overshadowed by the bogus philosopher, and it is significant that the chief part of his later work consists of marbles (not one of which, as I have said, he ever carved), for marble had always been for him the vehicle of dreams, clay the vehicle of truth.

Finally I think we can say, without wishing to give ourselves moral airs, that the last twenty years of Rodin's life indicate the source of some flaw in his character which affected his art, and they help me to account for a certain feeling of malaise which I used to experience when I entered a room full of Rodins. It is very difficult for a great artist to cope with success. We conventionally deplore Rembrandt's bankruptcy and Mozart's pauper's grave; but did not their worldly failures give them unparalleled freedom? How often successful artists have had to create artificially the solitude which society was good enough to impose on Rembrandt, which Michelangelo and Beethoven achieved by bearishness, Turner by assumed miserliness, and Hokusai by eccentricity. If this struggle to retain independence was difficult enough in the Renaissance, how much more formidable had it become in the early years of this century, 354 when easy communications had already begun to corrupt good manners. No doubt it had its effect on Rodin. However, the feeling of flux and dissolution that we feel in much of his later work is not really important. By no means all artists, and practically no poets, improve with time, and the faults of their later work have little bearing on the qualities of their earlier work. Take away inspiration and an entirely new *persona* emerges. Who could have believed that the author of the 'Lucy' poems would become prosaic and the author of *Sordello* unintelligent? With Rodin the remarkable thing is how Rodinesque his sculpture remained, so that even in the years of

276 Rodin, L'aurore

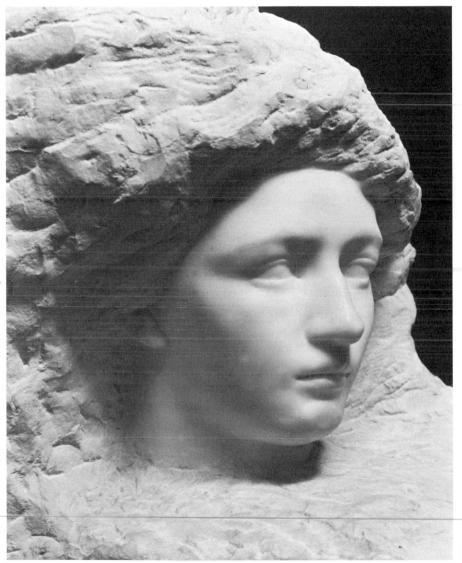

355

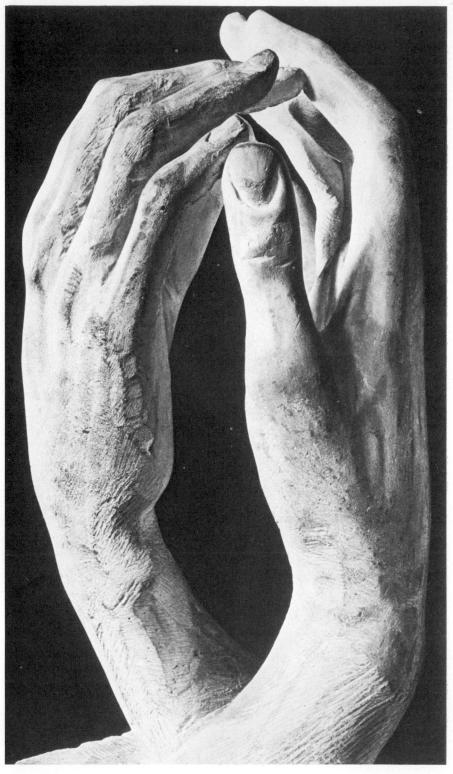

²⁷⁷ Rodin, The Cathedral

disintegration he could still do things as fine as *The Cathedral* (hands to the end) [277]. And if we look back at the greatest pieces, the *Walking Man*, the *Burghers of Calais*, the *Balzac* and the figures incorporated into the *Gate of Hell*, we feel that the tradition of Géricault and Delacroix has come to a worthy close.

Painters and sculptors will continue to do work that can be called romantic; but they will not draw on those motifs that had originated in the early nineteenth century and changed so little in almost a hundred years. To use the body as a means of expressing the anguish of the human soul is no longer a possible enterprise; we do not know how to represent the body and do not believe in the existence of the soul. As for the imagery of fear which occupied the earlier chapters of this book: it has become part of our ordinary life, accessible to millions every day on their television screens. Bad money drives out good, and our present diffusion of horror makes the Gate of Hell a commonplace part of our daily life.

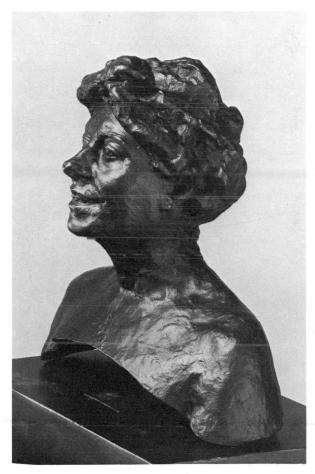

278 Rodin, La Duchesse de Choiseul

Index

Index

Illustrations of pictures by artists who are the subject of each chapter are not included in this Index as they appear numerically in the List of Illustrations.

- Aegina, pediment of temple, 115
- Aikin, On the Pleasures derived from Objects of Terror (1773), 62
- Akenside, 223
- Alba, Duchess of, 75
- Albani, Cardinal Alessandro, 21
- Albert Memorial, sculptural programme, 215
- Andrée, Ellen, 326
- Antiquity: eighteenth-century attitudes to, 46; antique forms in Ingres' late portraits, 133; Blake influenced by engravings of, 152; Géricault's view of, 181; Delacroix's vision of, 209, 210; and Turner's, 237; see also David
- Arnold, Matthew, 263
- Arrowsmith, Charles, 274
- 'Art for art's sake', 99
- Balzac, Honoré de, 349, 350
- Barbizon school, 274, 275, 293
- Baroque painting, 207, 220
- Basire, James, 154
- Baudelaire, Charles (1821–67), 133, 199; on Ingres, 111; compares Delacroix with a tiger, 199; Sonnet on Delacroix's Tasso, 215
- Beauharnais, Josephine, 177
- Beaumont, Sir George, 248, 265, 280
- Beckford, William, 228
- Beethoven, Ludwig van, 54, 187
- Belvedere, Torso of the, 69
- Beuret, Rose, 353
- Bianconi, Giovanni Lodovico, biographer of Piranesi, 56
- Bibiena family, 46
- Bicknell, Maria (Mrs Constable), 268
- Blake, William (1757-1827), 45, 147-75; style influenced by Fuseli, 67, 154; maxim in his Descriptive Catalogue, 103; visionary experiences and inspiration of, 147, 150, 151, 169, 170, 174; influences, 152-4, 151, 161, 167; as illustrator of others' books, 152, 172; and the Rococo style, 154; as book decorator, 154;

prophetic books of, 160; and the French Revolution, 161; 'Tyger, tyger burning bright', 189; opinion of Constable, 268; Macbeth, illustrations, 174; Marriage of Heaven and Hell, The, 159, 168; 'One Law for the Lion and the Ox is Oppression', 168; Poison Tree, The, 157; St Michael, 154; Songs of Experience, 152, 154, 157; Songs of Innocence, 152, 154, 157; engraving for Steadman's Expedition against the Revolted Negroes, 161; Urizen, 159, 160, 162, 163, 167, 168; Visionary Heads, 149; Werewolf (Rossetti MS.), 168

- Bonington, Richard, 124, 207
- Brazen serpent, Moses': symbol, 266 Burke, Edmund, 58; *Inquiry into the*
- Origins of the Sublime, 19, 45
- Burne-Jones, Sir Edward, 111
- Byron, Lord, 220; compared with Géricault in expression of malaise of romanticism, 177; his view of nature, 197; poetry read by Turner, 223; Turner's journeys as anticipation of *Childe Harold*, 234

Canaletto, Antonio, 46

- Caravaggio, M. A. A. da, 19, 25, 185
- Carlyle, Thomas, 285
- Carpeaux, Jean-Baptiste, 334
- Cervantes, 73
- Cézanne, Paul, 272, 327
- Charles III of Spain, 75, 78
- Chassériau, Théodore, 123
- Chinese painting: compared with Ingres', 97
- Chopin, Frédéric, 199
- Claude Lorrain, 264, 266
- Claudel, Camille, 353
- Coleridge, Samuel Taylor: his distinction between fancy and imagination and Piranesi's *Carceri*, 54; his remarks on Piranesi's *Carceri*, 56
- Colour: in Ingres' work, 119, 132; in English painting and its influence on Géricault, 188; in Turner's work, 223, 245, 246, 248, 250; discovery of importance of, by Romantic movement, 245; Turner's study of, 251; fine colour distinguished from bright colour, 251; theory of, 253, 259; modern response to painting based
- on, 300; see also Turner
- Columns, Greek, 145
- Constable, John (1776–1837), 207, 265– 361

83; represents Wordsworthian view of nature, 265, 282, 283; to Lake District, 266; 'Expressionist' qualities of, 268; Blake's opinion of, 268; marriage, 268; exhibited in Paris Salon, 274; with Corot, most forged painter, 275; lives in London, 275; cloudscapes, 275; Hampstead Heath landscapes, 275; wife dies, 276; pictures of Stour Valley, 275, 282; visit to Salisbury, 275; Hadleigh Castle, 276; Sketch book, 268

Corneille, Pierre, 23

Corot, Jean-Baptiste Camille, 275

Correggio, Antonio, 288

Costume, see Fashions

Courbet, Gustave, 203, 208

Cranach, Lucas, 168

Daguerreotype: influence of, 136, 310 Dancers, 40, 316, 320

Daniele da Volterra, 64

Dante Alighieri: Blake's response to, 172; Rodin's illustration of Inferno in The Gate of Hell, 336; see also Delacroix

Darwin, Charles, 260

Daubigny, Charles François, 275

- Daumier, Honoré (1808-79), 302, 305
- David, Jacques-Louis (1748-1825), 21-42; in Rome, 21, 23, 25; open-palm motif, 21, 23, 25, 27; as a revolutionary, 21, 25; sources of subjects, 21; influence of Caravaggio, 25; as an official artist, 30, 36; administration of the Academy, 30; as enemy of academism, 35; exiled to Brussels, 40; influence of ballet on, 40; compared with Ingres, 42; Oath of the Tennis Court (projected) drawings for, 30
- Degas, Edgar (1834–1917), 309–29; aristocratic character, 309; portraits of family and friends, 309, 310; early historical compositions, 309, 310; interest in photography, 310; 'problem pictures', 314; interest in horseracing and ballet, 314, 316, 320; painting at Paris Opéra, 319; pictures of laundresses, 324, 325; pictures of café scenes, 325, 326; failing sight, 326, 327, 329; pictures of women having hair brushed, 329
- Delacroix, Eugène (1798–1863), 199– 220; master of Romantic painting, 199; model for figure in Géricault's Raft of the 'Medusa', 187, 197; takes

over subjects and spirit of Géricault, 197; visits England, 207; visits Morocco, 209, 213; paints lions and tigers, 215; paints ceiling of library of Chambre des Députés, 215; only great religious painter of nineteenth century, 218, 220; on Ingres, 132, 220; Attila and his hordes annihilating the culture of Italy, 216; Dervishes at Tangier, 213; Justice of Trajan, 215; Moroccan sketch books, 210; Orpheus bringing the benefits of civilisation to the Greeks, 216; drawings of tigers and lions, 200, 215

De Quincey, Thomas, 56

Desboutins, 326

Destruction: an element in early Romanticism, 58; Turner's visions of, 266

Deutsch, Nicklaus Manuel, 67

Diaz de la Peña, N. V., 275

Donatello, 331, 334

Doré, Gustave, 193

Dreams: expression of, in Piranesi's work, 56; in Fuseli's, 65, 67; quality of, in Turner's *Bay of Baiae*, 238, in recollected views of Venice, 251, and the Mediterranean coast scene, 263

Dumas, Alexandre, 215

Edward III, tomb of, 154

Egremont, Lord, 255, 256

Elgin marbles, *see* Parthenon sculptures Export of works of art, 256

Farrington, Joseph, 226

- Fawkes, Hawksworth, 234
- Ferdinand VII of Spain, 95
- Fisher, John, Archdeacon of Salisbury, 275

Flandrin, 123

- Flaxman, John (1755-1826), 25, 35; illustrations to Homer (1783), 102, 115; influenced by Greek vase designs, 102; David's opinion of, 102; influence on Ingres, 102, 115
- Fragonard, Jean-Honoré, 30, 288
- French Revolution, 21, 42, 161
- Friedrich, Caspar David, 185
- Fromentin, Eugène, 300
- Fuseli, Henry (1741–1825), 60, 61–7, 189; influence on David's Oath of the Horatii, 23; translator of Winckelmann, 60; exponent of Mannerist romanticism in Germany and England, 61; erotica of, 65; Blake on, 67

362

- Garrick, David, 23
- Gauguin, Paul, 327
- Gautier, Théophile, 255, 302 Georget, Etienne, Jean, 196
- Géricault, Théodore (1791–1824), 177, 179–97, 274, 345, 357; visits Rome, '58; studies of horse-race in the Corso, 182; so-called self-portrait really of Jamar, 187; visits England, 188; horses in art of, 188, 190; preoccupation with suffering, disease and cruelty, 195; lunatics as models for, 196, 197; The Derby (Louvre), 190, 192; drawings of lions, 215
- Ghiberti, Lorenzo, 133
- Giants: in Romantic art, 64
- Gilray, Thomas, 203
- Giorgione, 19, 224
- Girodet, Anne-Louis, 185
- Goethe, Johann Wolfgang von, 58, 275; on classicism and romanticism, 95; Farbenlehre (Theory of Colour), 259, 260
- Goltzius, 67
- Goya y Lucientes, Francisco (1746-1828), 69-95; portrait of, by Vicente López, 67; tapestry designs of, 69, 70; deafness of, 75, 82; attitude towards the Church, 81, 82; 'House of the Deaf Man', 90; letters of, 95; and the Duchess of Alba; San Antonio de la Florida: frescoes in dome, 82
- Gros (Baron), Jean-Antoine (1771 -1835), 142, 177-9; pupil of David, 21, 177; oriental collection of, 142; and Napoleon's Italian campaign, 177; official painter to Napoleon, 177; decline of his art, 178; Battle of Nazareth, 178
- Guérin, Pierre, 185, 205

Guys, Constantin, 133

- Halevy, Ludovic, 323
- Hamilton, Sir William, 102
- Haydon, Benjamin Robert: Journal, 187; Christ's entry into Jerusalem, 187; on Petworth, 255
- Hazlitt, William, 248, 259
- Herculaneum frescoes, 40; pose of Ingres' Madame Moitessier derived from, 134, 136; The Antiquities of Herculaneum, 152

Hilliard, Nicholas, 121

- Hogarth, William, 81
- Holbein, Hans, the Younger: as model for Ingres, 110, 121
- Hooke, Robert, Micrographia, 151

Horse-racing: Degas and, 314

Horses: in Romantic art, 64; in English painting, 188; importance of, to Géricault, 187, 188; painted in England by Delacroix, 207

Howard, Luke, 275

- Ingres, Jean-Auguste-Dominique (1780-1867), 97-145; worked on David's Mme Récamier, 42, 101; his reputation contrasted with his work, 97, 130; influence of Flaxman on, 102; study of Greek vases, 105, 108; opinion of Holbein's portraits, 110, 121; opinion of Raphael's portraits, 110; his pencil portrait drawings, 121, 123, 124; feeling for contemporary costume and fashion, 121-4, 130, 133. 134; a violinist, 124; influence of Raphael on, 129, 130; Delacroix's opinions of, 132, 220; late painted portraits of, 133; and Baronne de Rothschild, 134; The Christ Child among the Doctors, 132; Dormeuse de Naples, 113; The Golden Age, 141; Madame de Senonnes, 132; Princesse de Broglie, 134
- Ingres, Madame, 134

Isabey, Eugène Louis Gabriel, 274

Jacob, Georges, ébéniste, 28 Jamar, see under Géricault Jimson, Gully, 187

- Lavater, J. K., 196
- Lebrun, Madame Vigée, 30
- Ledru-Rollin, Alexandre-Auguste, 290
- Leonardo da Vinci, 203, 260
- Leslie, Charles Robert: biographer of Constable, 266, 268, 278
- Linell, John, 149
- Lion, in Romantic art, 189, 200, 215

Lisbon earthquake, 45, 58

Liszt, Franz, 336

López, Vicente, 67, 95

- Lucas, David: engraver of Constable's pictures, 278
- Madhouses: in Goya's work, 81; in Géricault's work, 196

Maillol, Aristide, 334

Malraux, André: on Goya, 95

Manet, Edouard, 106, 210

Marat, 30

Martin, John, 234 Marxism, 163, 292

Matisse, Henri, 210

- Maurois, André: David, ou le Génie malgré lui, 32
- Mayhew, Henry: his writings anticipated by Géricault, 193
- Medici, Villa, 21
- Mengs, Raphael, 20, 22, 69; Parnassus (ceiling, Villa Albani), 20

Messerschmidt, Franz Xaver, 196

- Michelangelo, 58, 61; influence on Blake, 161, 167; influence on Géricault, 181; copied by Millet, 286; influence on Rodin, 334; Birth of Adam, 296; Crucifixion of St Peter, 153; Last Judgement, 58, 61, 151
- Millet, Jean François (1814–75), 285– 307; early life compared with Carlyle's, 285; early portraits, 286; gives up painting nudes, 288; and Socialism, 290, 302; moves to Barbizon, 293; recurring motives and images, 294; sexual connotations of his themes and images, 294; wheelbarrows, 299, 300; compared with Daumier, 302; landscapes of, 305, 307; winter landscapes, 307
- Milton, John: *Paradise Lost*, Blake's illustrations to, 170
- Mondrian, Piet, 19
- Montagu, Lady Mary Wortley, 142
- Moore, Henry, 290
- Mortimer, John Hamilton, 67
- Mozart, The Marriage of Figaro, 26
- Murat, Caroline, Queen of Naples, 119, 121
- Nadar: photograph of Balzac, 349
- Napoleon Bonaparte, 36, 98, 177, 178 Nazarenes, 124
- Neo-classicism: in David's *Leonidas*, 40; style adopted by Ingres, 42
- Nice; Villa Neptune, 335
- Nightmares, see Dreams
- Nîmes: Maison Carrée, 144, 145
- Noverre, Jean Georges, 23
- Official painters: David, Coronation of Napoleon, 36, 38; Gros, 177, 178 Opium, 56
- Orientalism, 16; in Delacroix 209; in Ingres, 98, 142; Gros' oriental art collection, 142

Orozco, José, 26

Paganini, 124 Palmer, Samuel, 305 Paris: Opéra, 319 364 Parthenon sculptures, 181, 182, 207 Peasantry: cultural life of, 285

- Petworth House, Sussex, 255
- Photography, 77, 87, 124, 136, 313, 349
- Picasso, Pablo, 25, 64, 100, 218, 290 Pıranesi, Giambattista (1720–78), 45–

58; impression of Rome given in his engravings, 46; lost autobiography of, 56; Dark prison with instruments for punishment (series of etchings), 46

Pius VII, Pope, 36

- Plato, 27
- Plutarch, 21, 28
- Poe, Edgar Allan, 196
- Political propaganda: pictures as, 23, 25, 26, 28, 178, 209
- Pompeii, 21
- Poussin, Nicolas, 19, 25, 142, 145, 228, 286, 290, 296; Rape of the Sabines, 25; Testament of Eudamidas. 25
- Proust, Antonin, 336
- Prud'hon, Pierre Paul, 181

Quatremère de Quincey, 34

- Raphael, 19; seventeenth-century reaction against, 58; and Ingres, 110, 129, 130, 132; Loggie decorations, 154; School of Athens, 110, 132; Sistine Madonna, 296
- Rembrandt, 19, 253, 354
- Renaissance: inspiration for Ingres, 106; figure painting of Degas compared with that of, 326; debt of Rodin to, 334
- Revolutionary art, 21, 42, 185, 209
- Reynolds, Sir Joshua, 28, 60, 61, 280; The Dream, 65
- Richmond, George, 170
- Rivera, Diego, 26
- Rodin, Auguste (1840–1917), 331–57; last great Romantic, 331, 345; lesser work reflects contemporary fashions, 334; a modeller rather than a carver, 334, 354; interest in hands, 334, 357; his models, 342; his drawings, 345; tragedy in his private life, 353, 354; Balzac, 346–53; Paolo e Francesca, 332; Rose Beuret, 353
- Roman history, 21, 27, 28, 42
- Rome: David in, 21; Piranesi's, 46; effect of its ruins on eighteenthcentury painters, 46; appearance in eighteenth century, 50; anti-classical movement in, 58; Fuseli in, 61; Ingres, a portrait painter in, 108, 121; Géricault visits, 179; Turner's views of, 237

- Romney, George, 67
- Rothschild, Baronne de, 134
- Rousseau, Jean-Jacques, 26
- Rousseau, Théodore, 274
- Rubens, Sir Peter Paul, 19, 177, 207

Runge, Philip Otto, 154

- Ruskin, John: on Turner's youth, 226; his view of nature, 196; on poetic element in Turner, 223; *Elements of Drawing*, 251; on colour, 252, 253, 263
- Sade, Marquis de, 196
- Saint-Sulpice, Paris, 132, 220
- Sand, Georges, 199
- Scamozzi, Architecture, 151
- Sergel, 35, 58
- Seurat, Georges, 25, 298, 305
- Shakespeare, William, 61, 62, 220
- Shipwrecks, 69, 185
- Silvestre, Théophile, 97, 142
- Société des Hommes de Lettres, 346, 350
- State art, see Political propaganda
- Steadman, Captain: Expedition against the Revolted Negroes of Surinam (1793), 161
- Stubbs, George, 188, 215; Anatomy of the Horse, 188; Horses fighting, 188; Lion attacking a horse, 189
- Supernatural, the, 64, 75, 78, 147, 149
- Talleyrand Périgord, Charles Maurice de, 199
- Tasso, Torquato, 215, 216
- Thiers, Louis Adolphe, 215
- Thomson, James, 223
- Thoré, Théophile, 302
- Tibaldi, Pellegrino, 58, 64, 67, 151, 167
- Tiepolo, Giovanni Battista, 46, 69
- Tiepolo, Giovanni Domenico, 69
- Tiger: in Romantic art, 189, 215; Delacroix compared with, 199, 200
- Tischbein, 105
- Titian, 228, 248
- Totalitarian art, 32
- Turner, James William Mallord (1775– 1851), 199, 223–63; master of Romantic painting, 199; his pessimism, 199, 237, 259, 262; effects of his visit to Italy, 209, 237, 253; most of his pictures not exhibited in his lifetime, 223; those pictures admired by contemporaries, 223; and poetry, 223, 234, 245, 262; his early watercolours of picturesque scenery, 224,

225, 246; expedition to Lake District and Yorkshire, 226;historical paintings of, 228; influence of Poussin on, 228; influence of Claude on, 230; sea-pieces, 230; alpine pictures, 234, 236; see also Byron; storm paintings, 234; composition of his pictures: lozenge, 236; vortex, 236, 262; ellipse, 237; his uses of watercolour, 246, 248, 253; visits to Venice, 248, 251; and colour, 248, 253; his public and private personalities, 248;paintings of sunsets and sunrises, 253-62; at Petworth, 255, 256; as painter of industrialism, 259; author of The Fallacies of Hope, 262; Pilate washing his hands, 224; Return from the Ball, 251; Slave Ship, 185; Somer Hill, 248

Tuscan Doric Order, 23

- Van Dyck, Sir Anthony, 177
- Van Gogh, Vincent, 220, 300
- Varley, John: Zodiacal Physiognomy, 149
- Vases, Greek: published by Sir William Hamilton, 102; influence on Flaxman, 102; models for Ingres, 105, 108
- Velasquez, 73
- Venice: theatres in, 46; Ruskin on, 224; Turner's visits to, 248
- Verdi, Giuseppe, 241
- Vernet, Horace, 124
- Veronese, Paolo, 228, 248
- Villa Item, 117
- Visconti, Ennio Quirino: Museo Pio-Clementino, 102
- Visions: in Blake's work, 149, 150, 151; explanation of visionary art, 169
- 'Vitruvian man', 108, 151
- Voltaire: Candide, 45
- Wallace, William, 149
- Walpole, Horace, 56; Castle of Otranto, 45, 56
- Ward, James, 189, 207; Lioness with a heron, 189
- Watteau: Enseigne de Gersaint, 253
- West, Benjamin, 272
- Westminster Abbey: Blake's drawings of, 154
- Whistler, James McNeil, 255
- Wilkie, Sir David, 241
- Winchester Bible, 154
- Winckelmann, Johann Joachim (1717-
 - 68): theorist of classicism, 20; Monu- 365

menti inediti, 40; Reflections on the imitation of Greek Art, 19; Reflections on the paintings and sculptures of the Greeks, 60

Witches: in Romantic art, 64, 69, 75, 77

Wordsworth, William, 124, 196, 226, 282, 355

Yeats, William Butler, 237

Zola, Emile, 350

Stockton - Billingham LIBRARY Technical College